MW00328957

LUXURY HOTELS

BEST OF EUROPE VOLUME 2

edited by Martin Nicholas Kunz

teNeues

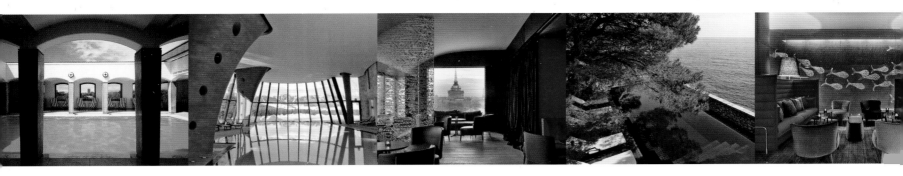

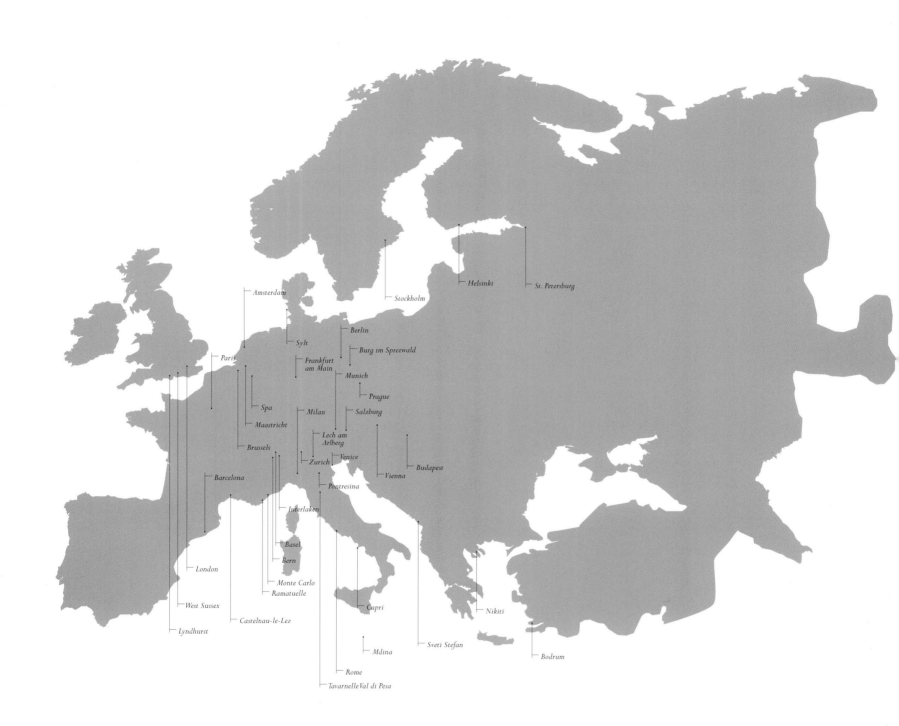

Amsterdam

Stockholm

Helsinki

St. Petersburg

Berlin

Sylt

Burg im Spreewald

Paris

Frankfurt
am Main

Munich

Prague

Spa

Milan

Salzburg

Maastricht

Lech am
Arlberg

Brussels

Venice

Zurich

Vienna

Budapest

Barcelona

Pontresina

Interlaken

Basel

Bern

London

Monte Carlo

Ramatuelle

West Sussex

Capri

Nikiti

Castelnau-le-Lez

Lyndhurst

Mdina

Sveti Stefan

Bodrum

Rome

Tavarnelle Val di Pesa

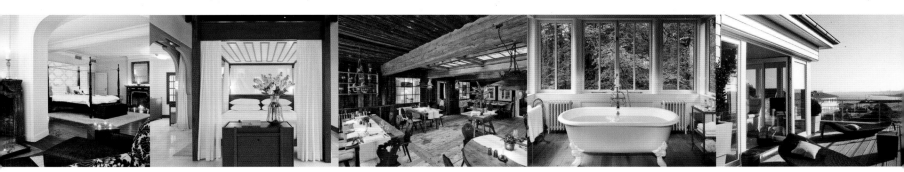

Luxury Hotels

BEST OF EUROPE VOLUME 2

The return of elegance

This lavish book provides a glimpse of the European luxury hotel landscape that is more varied than ever before. It ranges from classic grand hotels that are reinventing themselves to the cool elegance of recently constructed urban retreats, from fortresses that retain the spirit of bygone eras to vacation oases that help guests forget their everyday lives.

Grand hotels are clearly experiencing a revival, and elegance has returned to the luxury hotels of European cities. Fortunately they have discarded stiffness in favor of cultivating an atmosphere of glamorous relaxation. The reopening of the Savoy in London created quite a furor. A hefty 220 million pound was invested in the stylish comeback of the legendary hotel on the Thames. In Paris, the arrival of Asian luxury hotel groups on the established palace hotel scene triggered a surge of innovations. The newcomers employ creative concepts to counter the unmatched tradition of the grand hotels. Philippe Starck turned the Royal Monceau into a meeting place for the world of fashion and arts that includes a bookstore specializing in art, a gallery, spectacular art exhibitions, and an art concierge. The Mandarin Oriental, opened in 2011 on the elegant Rue Saint-Honoré, hired star chef Thierry Marx, known for his avant-garde creations which are served in an ultra-cool ambience.

But just what is it that makes the stars of some elegant establishments shine so bright? Precious materials, the finest workmanship, fantastic bathrooms, exquisite artwork, valuable carpets and antiques, sumptuous design classics, and beds as soft and inviting as clouds: That is just the beginning. Luxury hotels that stand out from the crowd have a story to tell. They provide guests with an experience that cannot be found anywhere else.

Those who spend the night behind the massive walls of Amberley Castle sleep in the same place where nearly all the rulers of England have laid their crowned heads to rest. In the middle of the New Forest in Southern England, Lime Wood provides guests with an exciting reinterpretation of an English country house hotel and tops it off by introducing an innovative wellness concept in its Herb House Spa. As a fitting complement to the Milan fashion label, the designers at Maison Moschino have created an ambience that enchants guests with magical ideas—thereby capturing the sense of place of the Italian fashion metropolis. Because in a globalized world, cosmopolitan travelers want to know where they are when they wake up in their hotel room.

Real luxury means that even the most discriminating guests find something they don't have at home. The Four Seasons George V spends over one million euros per year on its world-famous flower arrangements. Fresh flowers are brought in by the truckload directly from Rotterdam, arranged by floral designer Jeff Leatham into elaborate creations, and then placed in the lobby and public rooms to create breathtakingly beautiful vignettes.

In the end, it is precisely this kind of passion that creates luxury.

Bärbel Holzberg

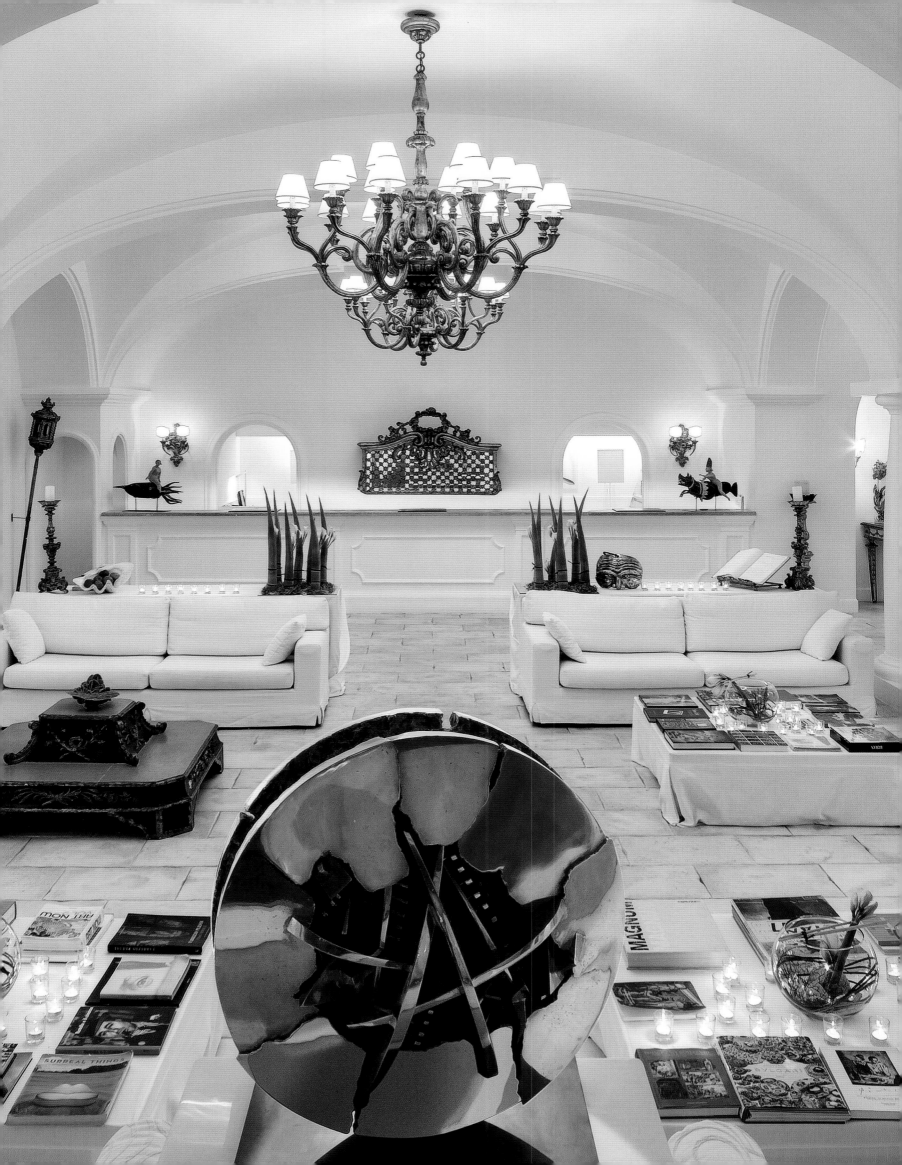

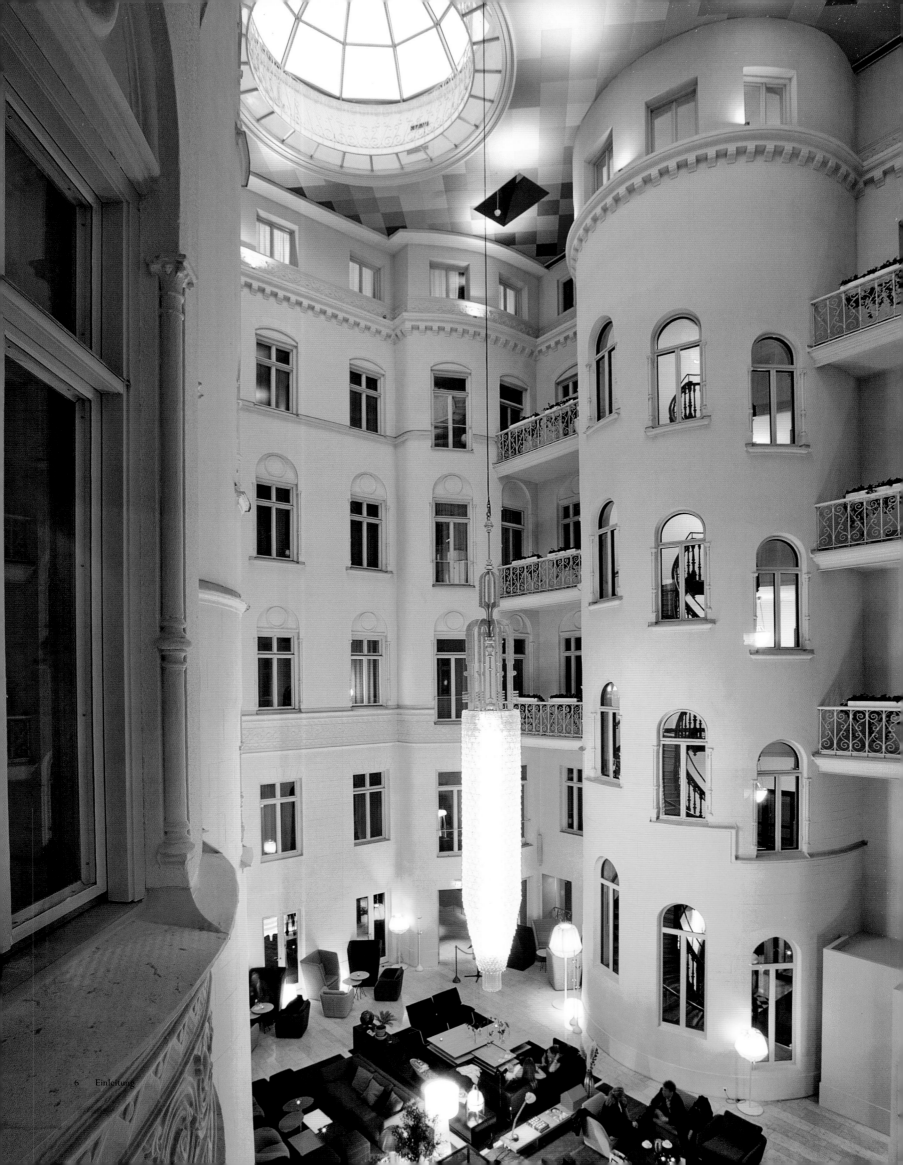

Die Rückkehr der Eleganz

Facettenreich wie nie zuvor präsentiert sich die Luxushotellandschaft Europas, die dieser aufwendig gestaltete Bildband vorstellt. Die Bandbreite reicht von klassischen Grandhotels, die sich neu erfinden, bis zur kühlen Noblesse vor kurzem errichteter Stadtrefugien, von Trutzburgen, die den Geist vergangener Jahre bewahren, bis zu Urlaubsoasen, die den Alltag vergessen machen.

Unübersehbar erlebt das Grandhotel ein Revival, die Eleganz ist zurück in den Luxushotels der europäischen Metropolen. Erfreulicherweise hat sie die Steifheit abgelegt: Kultiviert wird glamouröse Entspannung. In London sorgte die Wiedereröffnung des Savoy für Furore. Nicht weniger als 220 Millionen Pfund wurden investiert, um der Hotellegende an der Themse zu einem stilvollen Comeback zu verhelfen. In Paris hat die Ankunft der asiatischen Luxushotelgruppen bei den etablierten Palasthotels einen wahren Innovationsschub ausgelöst. Gegen die unübertreffliche Tradition der Grandhotels setzen die Neuankömmlinge einfallsreiche Konzepte. Philippe Starck machte das Royal Monceau zu einem Treffpunkt der Mode- und Kunstwelt, mit einer Kunst-Buchhandlung, Galerie, spektakulären Kunstausstellungen und einem Kunst-Concierge. Das an der feinen Rue Saint-Honoré 2011 eröffnete Mandarin Oriental leistet sich den Sternekoch Thierry Marx, der für seine avantgardistischen Kreationen bekannt ist, die stilgerecht in einem ultracool gestylten Ambiente serviert werden.

Aber woran liegt es, dass die Sterne mancher Nobelhäuser heller strahlen? Kostbare Materialien, beste handwerkliche Verarbeitung, fantastische Bäder, ausgesuchte Kunst, wertvolle Teppiche und Antiquitäten, edle Designklassiker und nicht zuletzt Betten, in denen man am liebsten versinken würde – das sind gewissermaßen die Basics. Luxushotels, die aus der Masse herausragen, haben eine Geschichte zu erzählen. Sie bereiten dem Gast ein Erlebnis, das er so nirgendwo anders findet.

Wer hinter den mächtigen Mauern des Amberley Castle nächtigt, schläft dort, wo nahezu sämtliche Herrscher Englands ihre gekrönten Häupter zur Ruhe gebettet haben. Mitten im New Forest im südlichen England lässt sich im Lime Wood die spannende Neuinterpretation eines englischen Country House Hotels erleben, das darüber hinaus in seinem Herb House Spa ein innovatives Wellness-Konzept präsentiert. Passend zum Mailänder Modelabel kreierten die Designer des Maison Moschino ein Ambiente, das Gäste mit märchenhaften Ideen verzaubert – und fangen damit die Stimmung der italienischen Modemetropole ein. Denn in einer globalisierten Welt will gerade der kosmopolitische Reisende wissen, an welchem Ort er sich befindet, wenn er morgens in seinem Hotelzimmer aufwacht.

Zu echtem Luxus gehört, dass selbst der anspruchsvollste Gast etwas vorfindet, was er zu Hause nicht hat. Mehr als eine Million Euro pro Jahr lässt sich das Four Seasons George V seine Blumenarrangements kosten, für die es weltberühmt ist. Lastwagenweise werden frische Blumen direkt aus Rotterdam geliefert. Floral-Designer Jeff Leatham arrangiert sie zu kunstvollen Gebilden, die der Lobby und den öffentlichen Räumen zu einer traumschönen Anmutung verhelfen.

Letztendlich ist es diese Leidenschaft, die Luxus schafft.

Bärbel Holzberg

Le retour de l'élégance

Les hôtels de luxe européens présentés dans ce superbe volume illustré se montrent plus variés que jamais : des grands hôtels classiques qui se réinventent, des refuges urbains récents au raffinement sobre, des châteaux qui ont conservé l'âme d'autrefois et des oasis de vacances qui font oublier le quotidien.

Le grand hôtel connaît de toute évidence un renouveau, l'élégance fait son retour dans les hôtels de luxe des métropoles européennes. Heureusement, elle a fait disparaître la rigueur. C'est désormais la décontraction glamour qui est entretenue. À Londres, la réouverture du Savoy a fait sensation. Pas moins de 220 millions de livres sterling ont été investies pour que l'hôtel de légende situé au bord de la Tamise puisse faire son grand retour avec style. À Paris, l'arrivée des groupes d'hôtellerie de luxe asiatique a provoqué un véritable sursaut d'innovation au sein des palaces établis. Pour contrer la tradition difficile à surpasser, les nouveaux arrivants établissent des concepts très originaux. Philippe Starck a fait du Royal Monceau le carrefour de l'univers de la mode et de l'art en associant à l'établissement une librairie d'art, une galerie, de fabuleuses expositions et un concierge spécialiste de l'art. Le Mandarin Oriental, qui a ouvert ses portes dans la très huppée rue Saint-Honoré en 2011, s'offre le chef étoilé Thierry Marx, renommé pour ses créations avant-gardistes, qui sont servies dans une atmosphère stylée et ultra décontractée.

Pourquoi les étoiles de certaines grandes maisons brillent-elles plus que d'autres ? Des matériaux précieux, des finitions sur mesure parfaites, des salles de bain fantastiques, des œuvres d'art soigneusement sélectionnées, de sublimes tapis et antiquités, d'élégants classiques du design et surtout des lits qu'on aimerait ne plus quitter, ce sont en quelque sorte les basiques. Les hôtels de luxe qui sortent du lot ont une histoire à raconter. Ils réservent aux clients une expérience qu'ils ne pourront vivre ailleurs. Ceux qui passent une nuit entre les murs imposants du Amberley Castle dorment à l'endroit où ont séjourné presque tous les souverains d'Angleterre. En plein cœur de la New Forest au sud de l'Angleterre, on découvre au Lime Wood la captivante réinterprétation d'un hôtel country house à l'anglaise, qui présente, par ailleurs, un concept bien-être innovant dans son Herb House Spa. Les créateurs de la Maison Moschino ont créé une atmosphère à l'image du label de mode milanais. Les clients sont charmés par de fabuleuses idées et transportés dans l'ambiance de la métropole italienne de la mode. Dans un monde globalisé, le voyageur cosmopolite souhaite en effet savoir à quel endroit il se trouve lorsqu'il se réveille le matin dans sa chambre d'hôtel.

Le luxe ultime veut que le client le plus exigeant découvre quelque chose qu'il n'a pas chez lui. Le Four Seasons George V dépense plus d'un million d'euros par an pour les compositions florales qui font sa célébrité dans le monde entier. Les fleurs sont livrées directement par camion de Rotterdam pour être ensuite composées telles des œuvres d'art par le créateur d'art floral, Jeff Leatham, afin de sublimer le lobby et les pièces communes.

Finalement, c'est cette passion qui crée le luxe.

Bärbel Holzberg

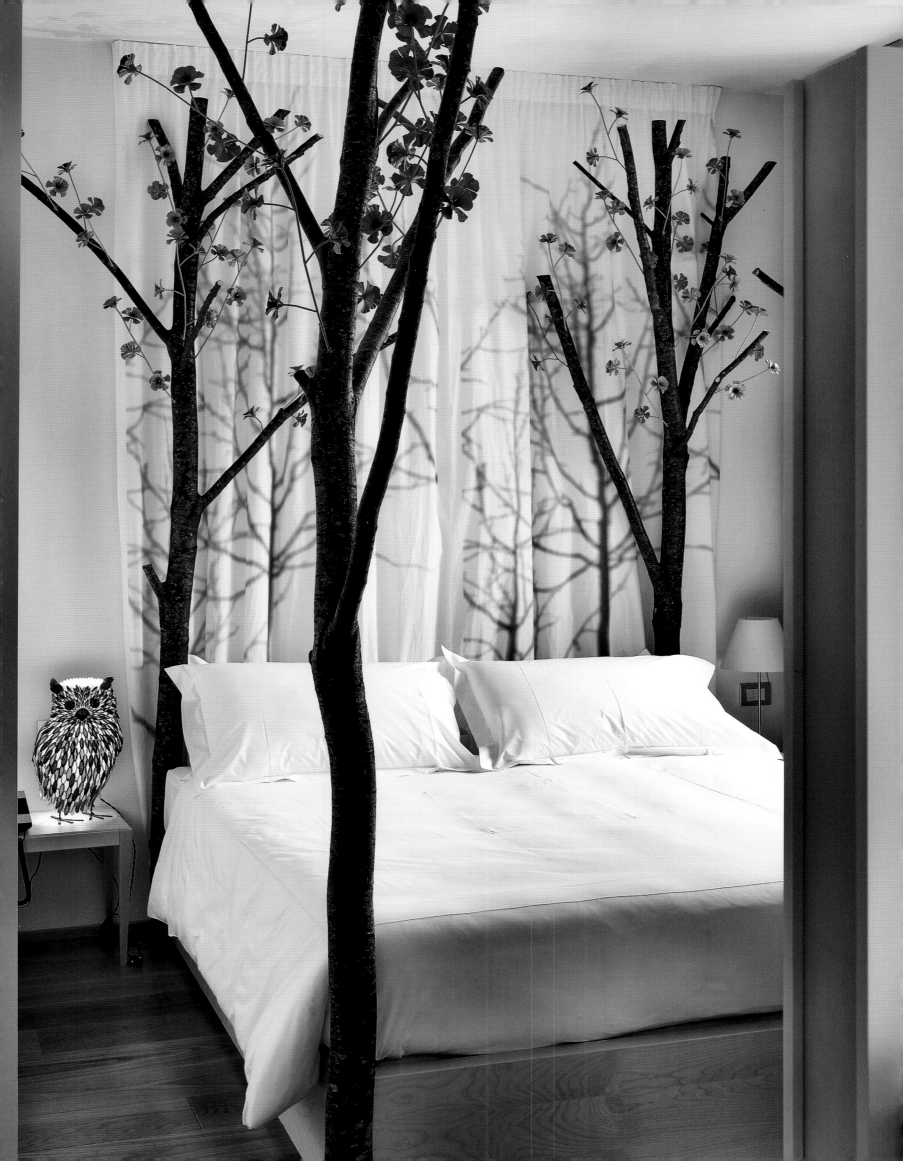

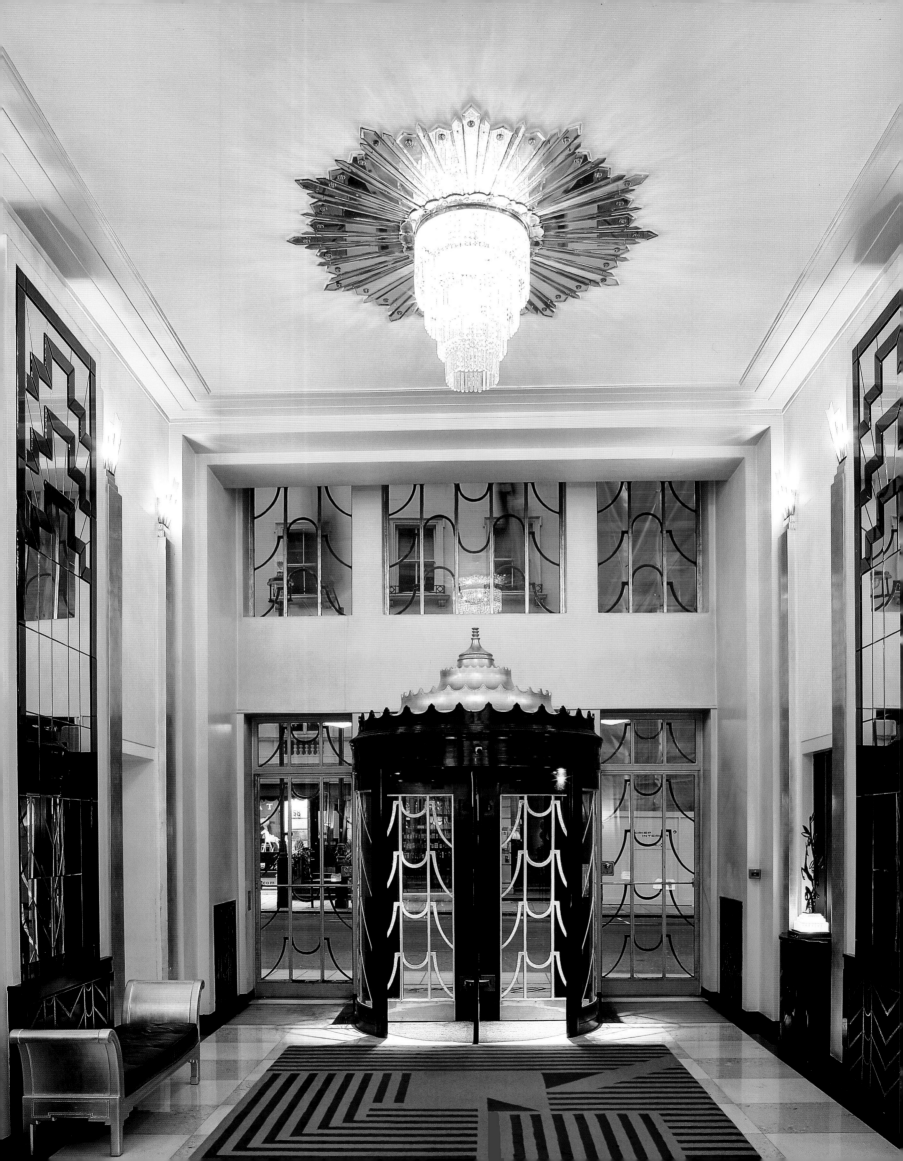

Claridge's
London, United Kingdom

The guest book at Claridge's reads like a Who's Who of nobility and politics: Here is where Queen Victoria met Empress Eugénie in 1860. Here is where Churchill declared a suite to be Yugoslavian territory during World War II in order to support King Peter of Yugoslavia in exile. Here the Queen has been received for numerous banquets. Each of the 203 rooms draws a line between history and the present—the new 970-square-foot Linley Suites are the best art deco revival that London has to offer.

Das Gästebuch des Claridge's liest sich wie ein Who's who des Adels und der Politik: Hier trafen sich 1860 Königin Victoria und Kaiserin Eugénie, hier erklärte Churchill während des Zweiten Weltkriegs eine Suite zum jugoslawischen Staatsgebiet, um König Peter von Jugoslawien im Exil zu unterstützen, und hier wurde die Queen bereits zu diversen Banketten empfangen. Jedes der 203 Zimmer verknüpft Geschichte und Gegenwart – die neuen und 90 Quadratmeter großen Linley-Suiten sind das beste Art déco-Revival, das London zu bieten hat.

Le registre des clients du Claridge's se lit comme le Who's Who de la noblesse et de la politique : en 1860 la Reine Victoria et l'Impératrice Eugénie s'y sont rencontrées, c'est ici, pendant la Seconde Guerre Mondiale, que Churchill a déclaré une suite territoire yougoslave afin de soutenir le roi exilé Pierre de Yougoslavie, et la Reine y a assisté à de nombreux banquets. Chacune des 203 chambres relie l'histoire au présent : les nouvelles suites Linley de 90 mètres carrés offrent le meilleur du revival Art déco londonien.

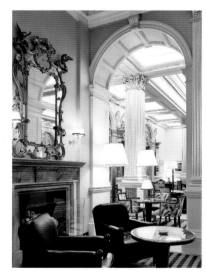 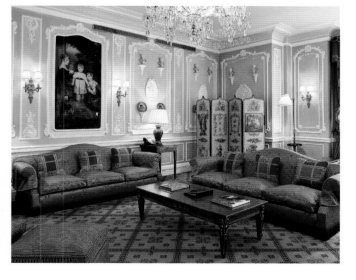

Art deco can't get any more glamorous than the foyer of this grand hotel located in exclusive Mayfair.

Glamouröser kann Art déco nicht sein als im Foyer der großen alten Hoteldame im exklusiven Mayfair.

L'Art déco atteint l'apogée du glamour dans le hall de ce grand hôtel situé au cœur du quartier chic de Mayfair.

The bar has retained all of its original charm and is a favorite meeting spot for champagne connoisseurs, the suites are opulently luxurious.

Für Champagnerkenner ist die ganz im Original erhaltene Bar ein beliebter Treffpunkt. In schwelgerischem Luxus gefallen sich die Suiten.

Pour les connaisseurs de champagne, le bar d'origine qui a été conservé est un lieu de rencontre apprécié. Les suites arborent un luxe voluptueux.

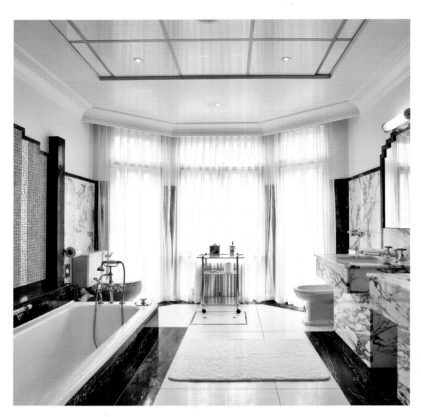

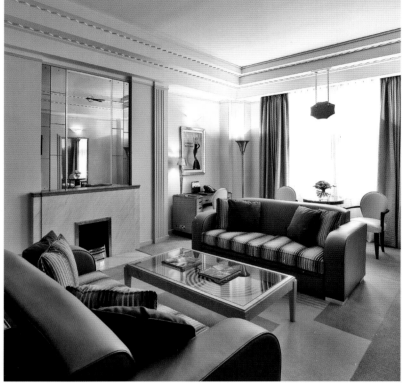

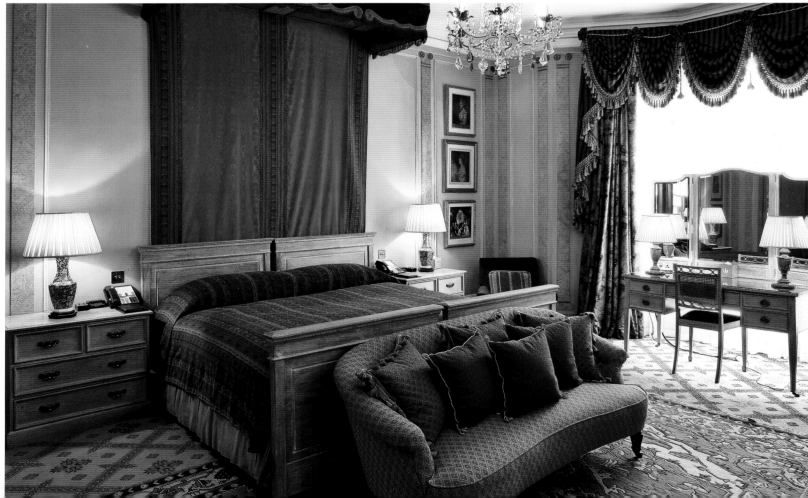

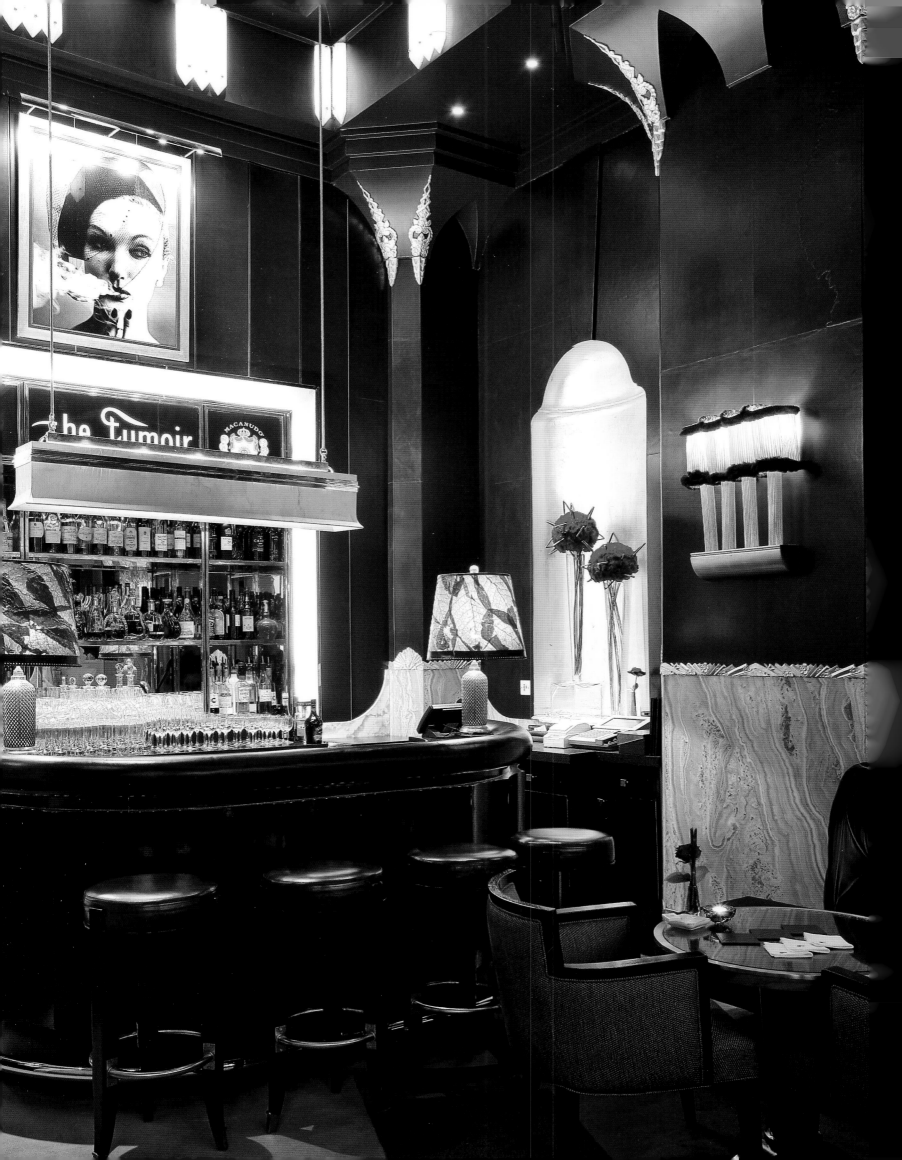

The Berkeley

London, United Kingdom

Whether guests are in town on business or just looking for somewhere to base themselves between mad bursts of frenetic shopping, it is difficult to think of a nicer place to stay than The Berkeley. The hotel, which has been operating for over 100 years, oozes quiet sophistication without losing any of its cozy charm. The suites are the most impressive part. Those who are after a sense of space should book the Grosvenor Conservatory Suite—it comes with its own private roof terrace with sweeping views of St Paul's Church.

Ob man sich nun auf Geschäftsreise befindet oder nur eine Zwischenstation für wilde Shoppinglaunen benötigt, es gibt keinen schöneren Ort für so einen Aufenthalt als das Berkeley. Das Hotel ist bereits seit mehr als 100 Jahren in Betrieb und strahlt eine ruhige Perfektion aus, ohne dabei etwas von seinem anheimelnden Charme einzubüßen. Besonders beeindruckend sind die Suiten. Steht einem der Sinn nach viel Platz, dann sollte man die Grosvenor Conservatory Suite reservieren, die über eine private Dachterrasse mit einem herrlichen Blick auf die St Paul's Church verfügt.

Que l'on se trouve en ville pour affaires ou simplement à la recherche d'un lieu de repos après du shopping frénétique, il est difficile de recommander plus agréable que le Berkeley. L'hôtel est ouvert depuis plus de 100 ans. Il fleure bon la sophistication tranquille, sans rien perdre de son charme douillet. Les suites y sont particulierement impressionnantes. Pour les hôtes avec besoin d'espace, la suite du Grosvenor Conservatory est le choix idéal : elle possède sa propre terrasse privée avec une vue imprenable sur la St Paul's Church.

Interior designer *David Collins turned the Blue Bar into a completely blue work of art that draws a stylish after-work crowd from surrounding offices and boutiques.*

Interior Designer *David Collins machte die Blue Bar zum blauen Gesamtkunstwerk, in dem sich allabendlich eine stylishe After-Work-Crowd aus den umliegenden Kanzleien und Boutiquen trifft.*

Le décorateur *d'intérieur David Collins a transformé le Blue Bar en une œuvre d'art aux tons azur où la clientèle stylée des boutiques et les avocats des cabinets environnants se retrouvent tous les soirs après le travail.*

For the fancy "Prêt-à-Portea" afternoon tea, The Caramel Room serves incredible pastry creations—shaped like high heels or Prada clothes.

Zum aparten „Prêt-à-Portea" im Caramel Room werden unglaubliche Törtchenkreationen serviert — in Form von High Heels oder Prada-Kleidern.

Le chic « Prêt-à-Portea » du Caramel Room sert d'extraordinaires créations pâtissières en forme de talons aiguilles ou de robes Prada.

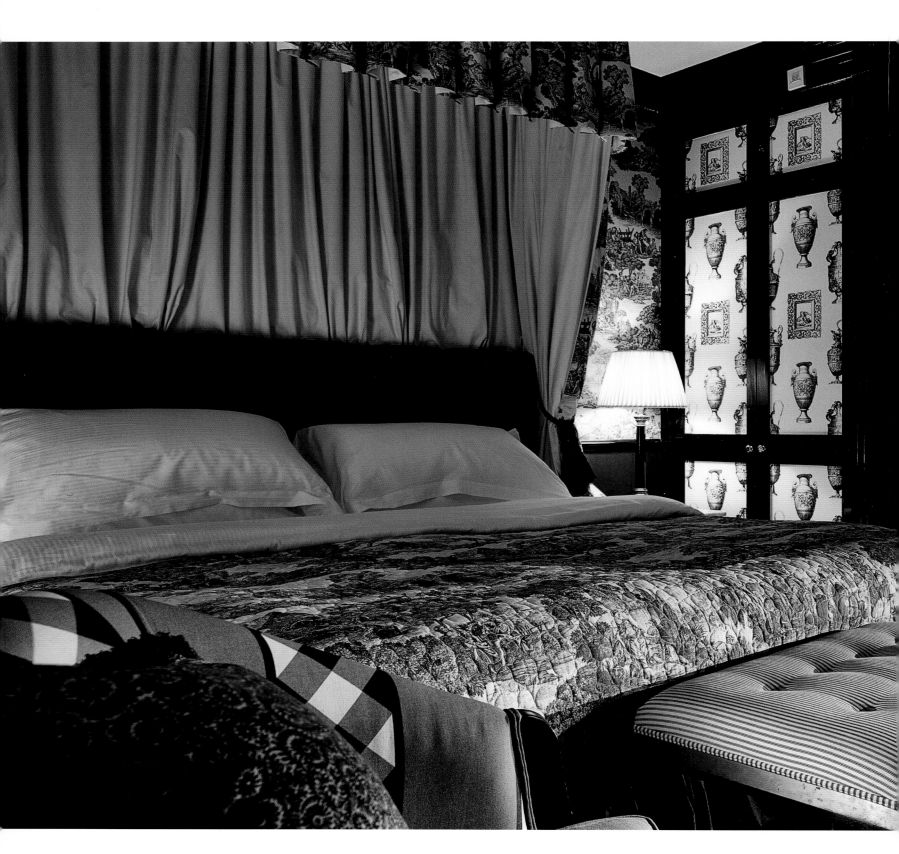

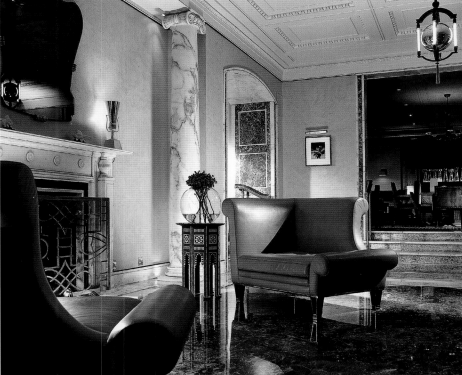

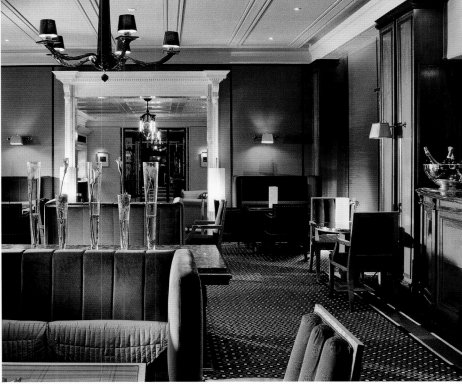

The Berkeley *London, United Kingdom* 17

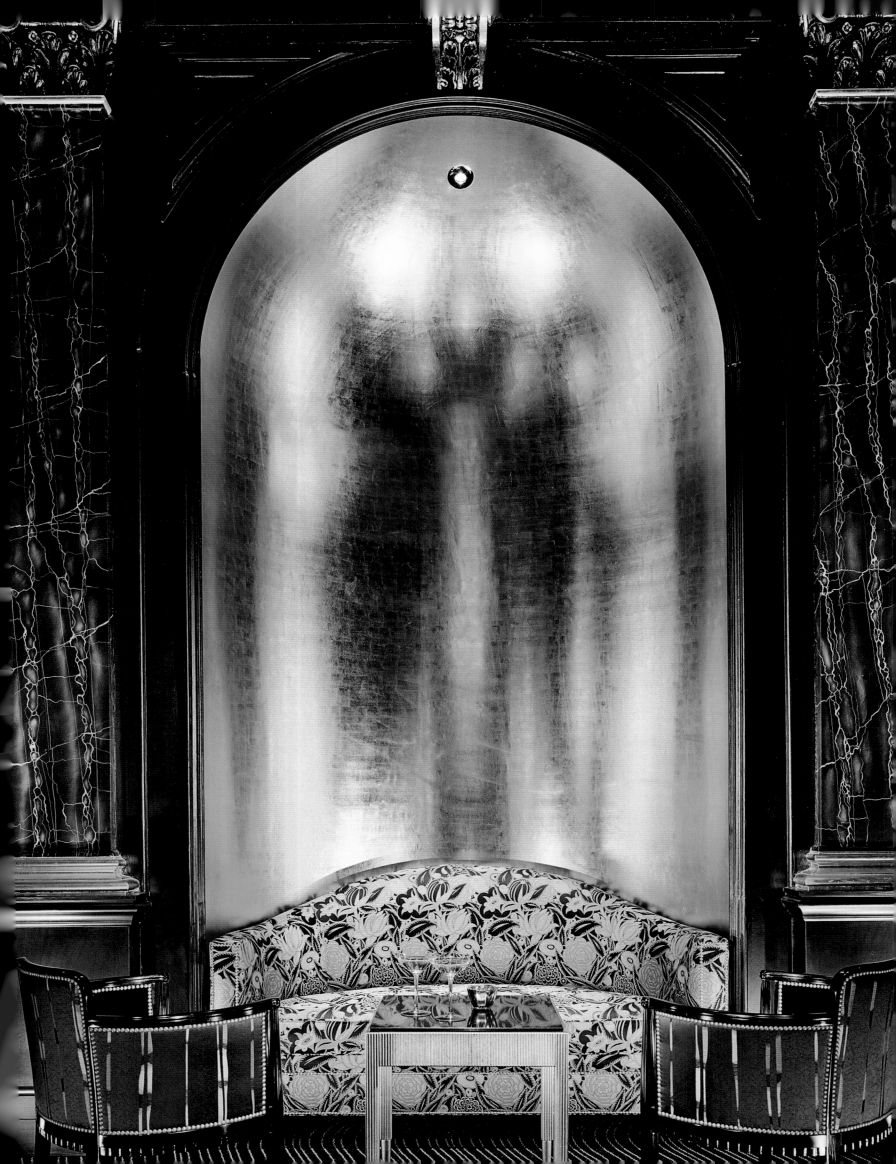

The Savoy

London, United Kingdom

The Savoy is to luxury hotels in London what Big Ben is to landmarks. Countless movie scenes have been filmed in this legendary building located on The Strand, London's historic artery. Oscar Wilde and George Bernard Shaw enjoyed setting their upper-class protagonists against the backdrop of the Savoy Grill. This hotel icon was closed for almost three years; it was reopened in 2010 after undergoing a complete restoration originally budgeted at 100 million pounds, but which ended up costing 220 million. The results exceed glamor. Offering champagne and cabaret performances, the Beaufort Bar is a new addition.

Das Savoy ist unter den Londoner Luxushotels das, was Big Ben unter den Wahrzeichen ist. Unzählige Filmszenen wurden in dem legendären Haus an der historischen Achse The Strand gedreht und auch Oscar Wilde und George Bernard Shaw ließen ihre Upperclass-Protagonisten gerne im Savoy Grill agieren. Beinahe drei Jahre war die Hotel-Ikone geschlossen, bevor sie 2010 nach einer kompletten Restauration wieder öffnete, die mit 100 Millionen Pfund budgetiert war und letztendlich 220 Millionen kostete. Das Ergebnis ist mehr als glamourös. Ganz neu ist die Beaufort Bar – sie bietet Champagner und Kabaretts.

Le Savoy est aux hôtels de luxe londoniens ce que Big Ben est aux symboles de la capitale. D'innombrables scènes de films ont été tournées dans cet établissement situé dans la célèbre rue de The Strand, chargée d'histoire. Oscar Wilde et George Bernard Shaw aimaient faire jouer leurs protagonistes bourgeois au Savoy Grill. Cette icône de l'hôtellerie est restée fermée durant presque trois ans, avant de rouvrir ses portes en 2010 après une restauration complète qui devait s'élever à 100 millions de livres et en a finalement coûté 220 millions. Le résultat est plus que glamour. Nouveauté : le Beaufort Bar, qui propose champagne et cabarets.

With its golden niches, the Beaufort Bar is the new centerpiece of the reopened hotel legend and immediately became a successful London hotspot.

Neuer Glanzpunkt der wiedereröffneten Hotellegende ist die Beaufort Bar mit ihren goldenen Nischen, die sofort als Hotspot Londons reüssierte.

Depuis la réouverture de cet hôtel légendaire, le Beaufort Bar et ses niches dorées en sont la principale attraction et en ont fait le lieu phare de Londres.

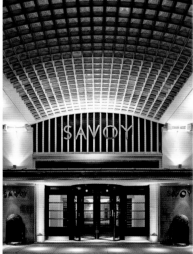

In his redesign of the Front Hall and the Thames Foyer, Pierre-Yves Rochon references the Edwardian style *of the original building. A perfect place for afternoon tea.*

Die Neugestaltung der Lobby und des Thames Foyer durch Pierre-Yves Rochon greift den edwardianischen *Stil des Originalgebäudes auf. Perfekt für den Afternoon Tea.*

Le réaménagement *du lobby et du Thames Foyer par Pierre-Yves Rochon a rehaussé le style édouardien du bâtiment original. Parfait pour prendre le thé.*

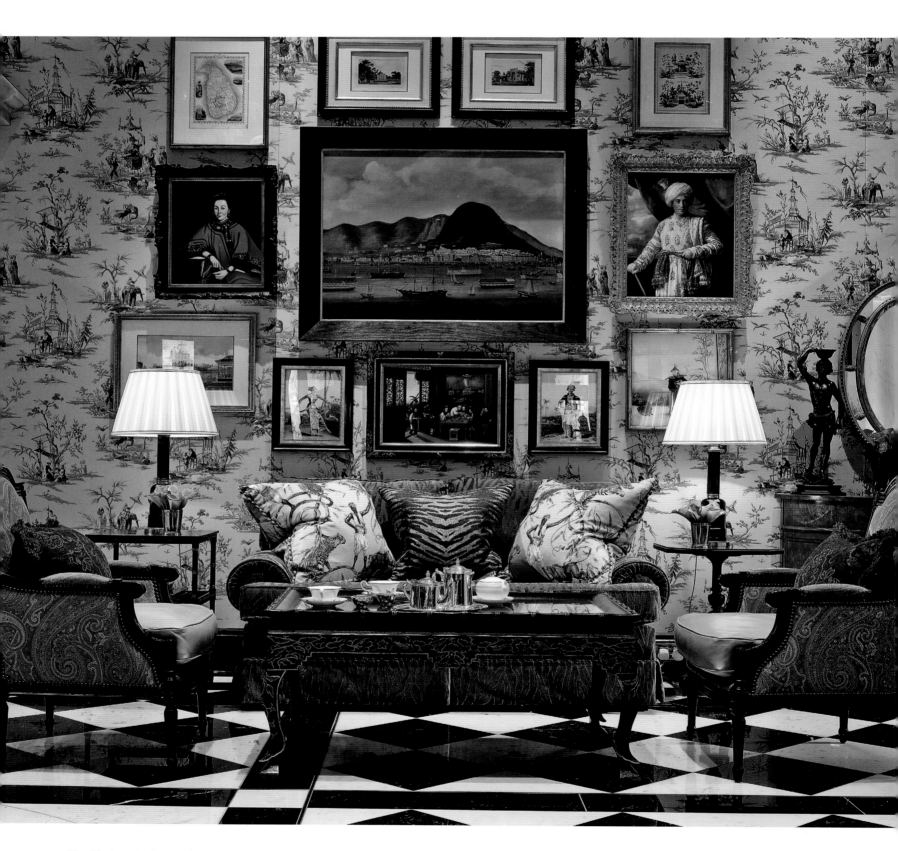

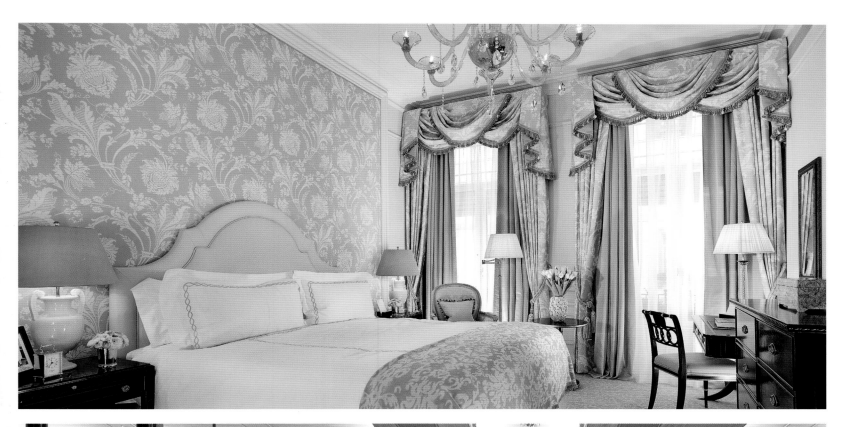

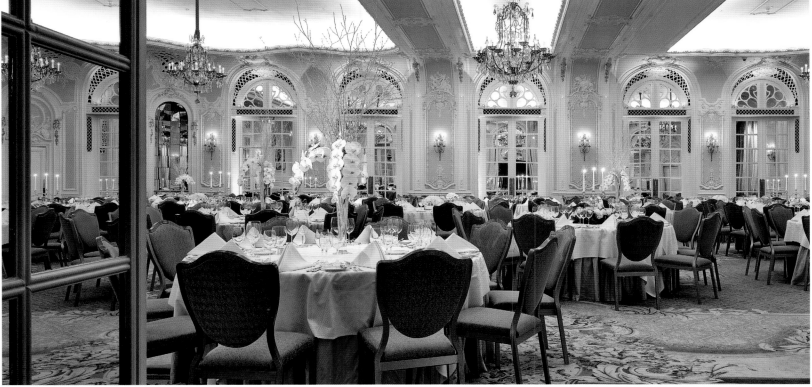

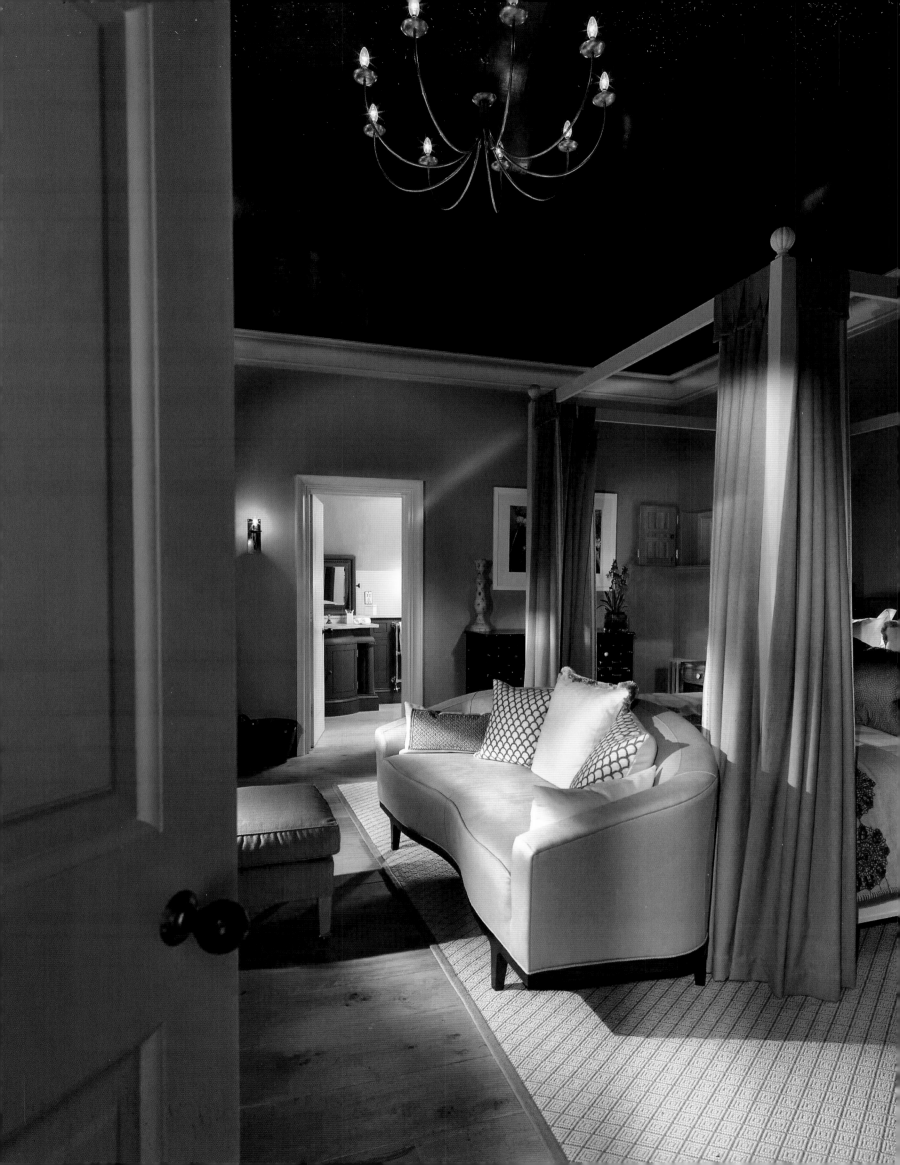

Lime Wood

Lyndhurst, United Kingdom

Located in the heart of New Forest National Park, the origins of this impressive estate can be traced back to the 13th century when it was a hunting lodge. Later, in the 18th century, it became the residence of the Duke of Clarence. After a five-year renovation, Lime Wood is equally impressive today in its new role as a luxury country house hotel. An eclectic mix of antiques, custom furniture, and modern art creates an air of relaxed luxury in the hotel's 14 suites and 15 rooms.

Die Anfänge des imposanten Anwesens im Herzen des New Forest National Park reichen bis ins 13. Jahrhundert zurück, als es Jagdschloss war, bevor es im 18. Jahrhundert dem Duke of Clarence als Sitz diente. Nicht weniger beeindruckend präsentiert sich Lime Wood heute nach einem fünf Jahre dauernden Umbau zu einem ultraschicken Country House Hotel. Ein eklektischer Mix von Antiquitäten, maßgefertigten Möbeln und moderner Kunst vermittelt einen entspannten Luxus in den 14 Suiten und 15 Zimmern.

Cette imposante bâtisse en plein cœur du parc national de New Forest National Park trouve ses origines au XIIIᵉ siècle, où elle faisait office de pavillon de chasse, avant de devenir la résidence du duc de Clarence au XVIIIᵉ siècle. Les cinq années de rénovation qu'a connues Lime Wood n'ont rien enlevé à sa superbe. Il est devenu aujourd'hui un élégant hôtel manoir de la campagne anglaise. Un mélange éclectique d'antiquités, de meubles fabriqués sur mesure et d'art moderne apporte une touche de luxe décontracté aux 14 suites et 15 chambres.

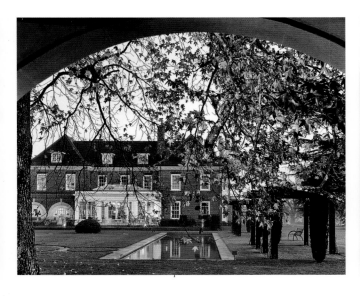

Both the guest rooms and the public spaces display a skillful reinterpretation of tried-and-true favorites. Guests can explore the New Forest on marked hiking trails.

Gästezimmer wie auch öffentliche Räume zeigen eine gekonnte Neuinterpretation von Altbewährtem. Auf ausgewiesenen Wanderwegen lässt sich der New Forest erkunden.

Les chambres comme les espaces communs présentent une réinterprétation parfaitement réussie des éléments anciens. Des sentiers de randonnée balisés permettent d'explorer la New Forest National Park.

One highlight is the Herb House Spa tucked away in the woods. The herbs for some of the treatments are grown in the hotel's own garden.

Ein Highlight ist der mitten in den Wald eingebettete Herb House Spa. Die Heilkräuter für einige der Anwendungen werden im eigenen Garten angebaut.

Le Herb House Spa, niché en plein cœur de la forêt, est une véritable merveille. Les herbes médicinales qui y sont utilisées poussent dans le jardin appartenant à l'hôtel.

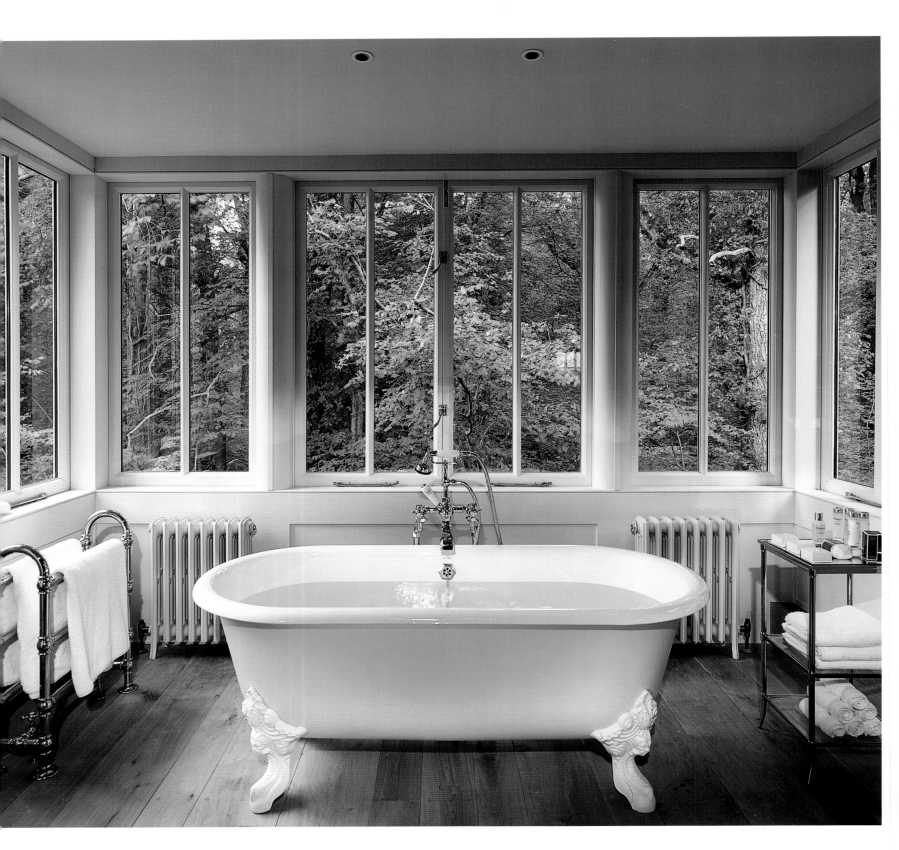

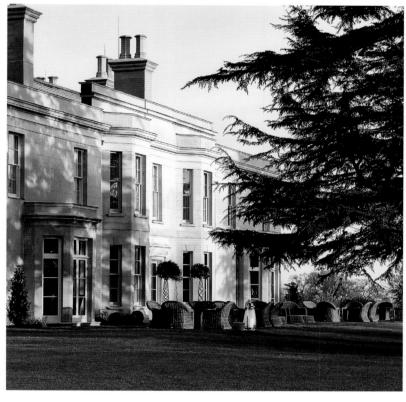

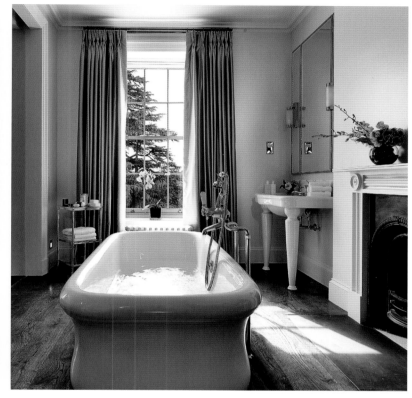

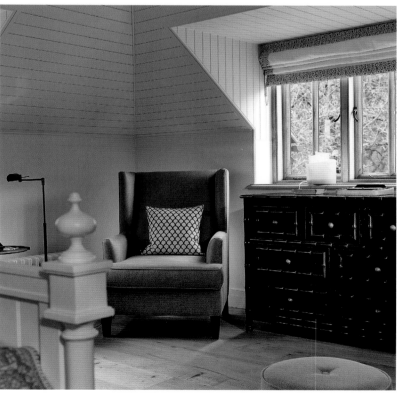

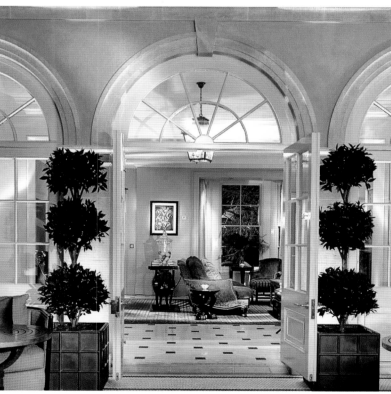

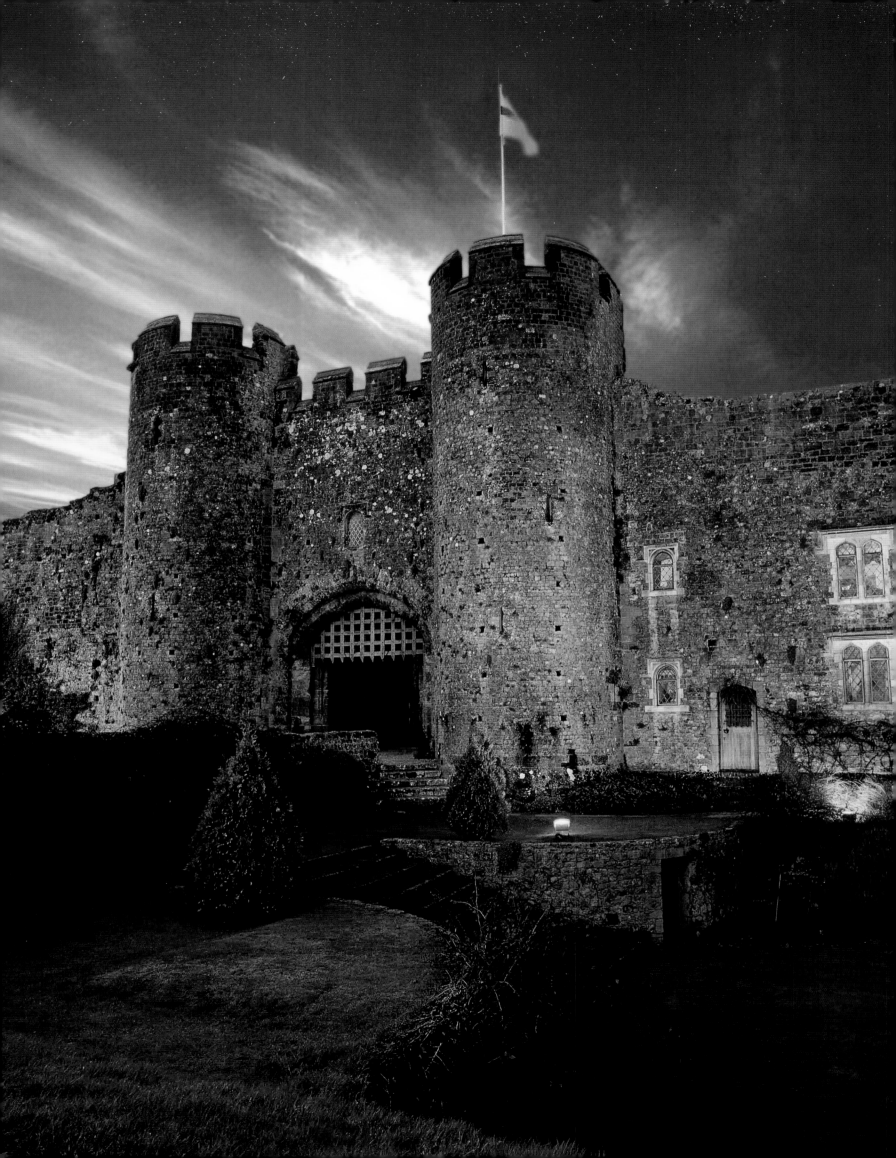

Amberley Castle

West Sussex, United Kingdom

For nine centuries, the awe-inspiring walls of Amberley Castle in West Sussex have withstood all hostilities and accommodated heads of state from Henry I to Elizabeth II. Today, 19 rooms and suites are furnished with heavy fabrics and massive antiques and offer an authentic castle experience, while jacuzzis provide contemporary comfort. With sweeping manicured English lawns punctuated with koi ponds, the extensive gardens are sure to enchant visitors.

Neun Jahrhunderte haben die Ehrfurcht gebietenden Mauern des Amberley Castle in West Sussex allen Anfeindungen standgehalten, haben von Heinrich dem Ersten bis Elisabeth der Zweiten die gekrönten Häupter des Inselreiches beherbergt. Heute vermitteln die mit schweren Stoffen und massiven Antiquitäten eingerichteten 19 Zimmer und Suiten den Gästen ein authentisches Burgerlebnis, Whirlpools sorgen für zeitgemäßen Komfort. Bezaubernd sind die weitläufigen Gartenanlagen mit manikürten englischen Rasenflächen und Teichen, in denen Koi-Karpfen schwimmen.

Neuf siècles durant, les murs de l'Amberley Castle, dans le comté du Sussex de l'Ouest, ont imposé le respect et résisté à toutes les attaques. Ils ont également abrité les têtes couronnées du Royaume, d'Henri Ier à Elisabeth II. Aujourd'hui, les 19 chambres et suites donnent aux invités l'impression de vivre dans un authentique château-fort, à grands renforts d'étoffes lourdes et d'antiquités massives, tandis que des jacuzzis fournissent un confort moderne. Les immenses jardins, avec leurs pelouses à l'anglaise parfaitement taillées et leurs étangs dans lesquels nagent des carpes koï, sont quant à eux absolument magiques.

 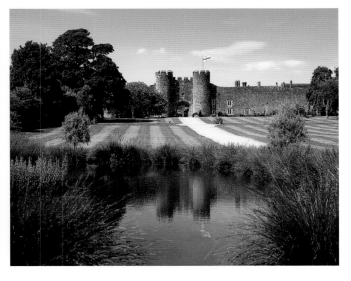

A spectacle not to be missed: The heavy portcullises are lowered every night shortly before midnight.

Ein Spektakel, das man nicht verpassen sollte: Wenn allabendlich kurz vor Mitternacht die schweren Fallgitter heruntergelassen werden.

Un spectacle à ne pas rater : la lourde herse qui s'abaisse tous les soirs peu avant minuit.

In most of the rooms, huge four-poster beds highlight the historic character. Antique window glass immerses the rooms in warm light.

In den meisten Gästezimmern unterstreichen mächtige Himmelbetten den historischen Charakter. Antikes Fensterglas taucht die Zimmer in warmes Licht.

D'imposants lits à baldaquin dans la plupart des chambres soulignent le caractère historique du lieu. Le verre ancien des fenêtres diffuse une lumière chaleureuse dans les chambres.

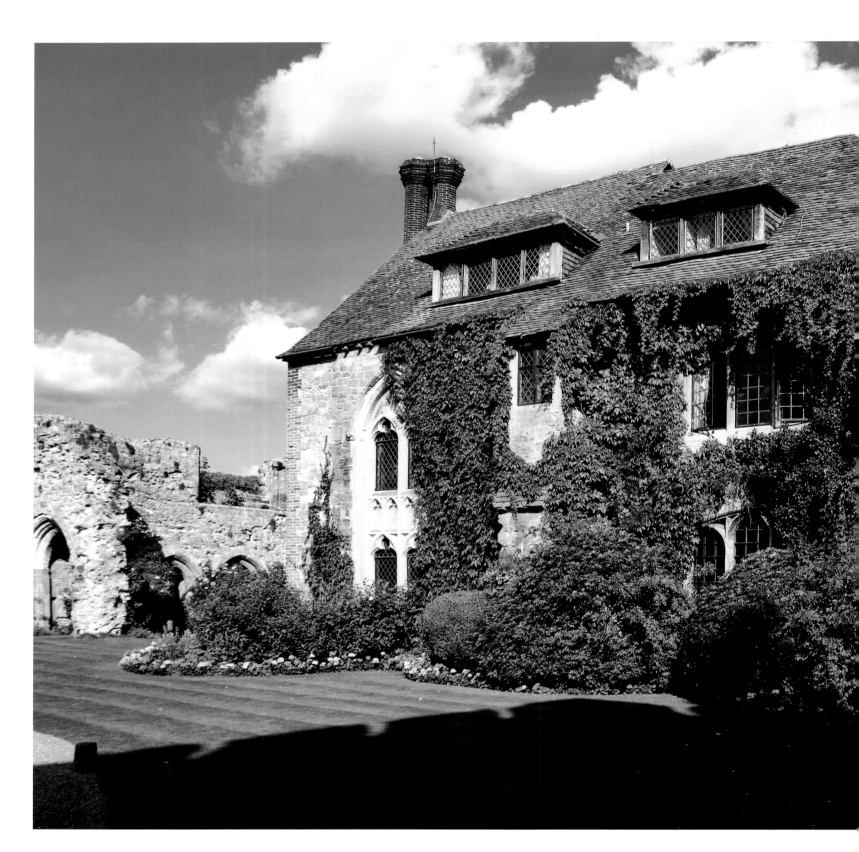

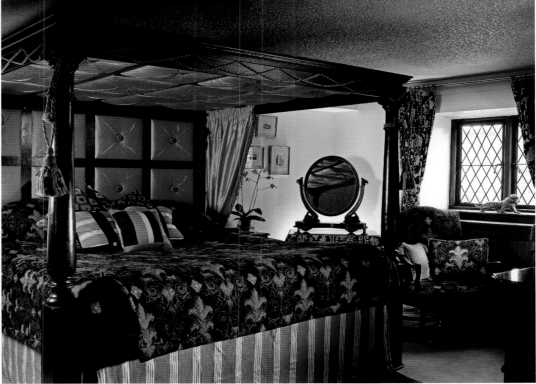

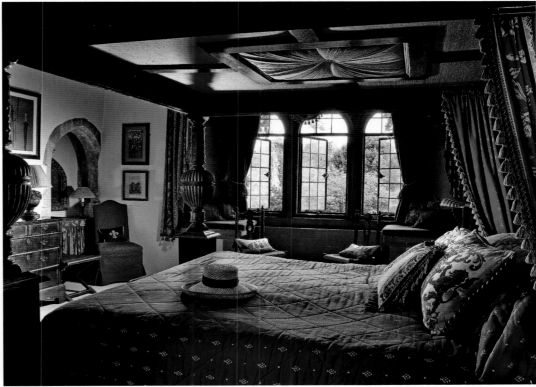

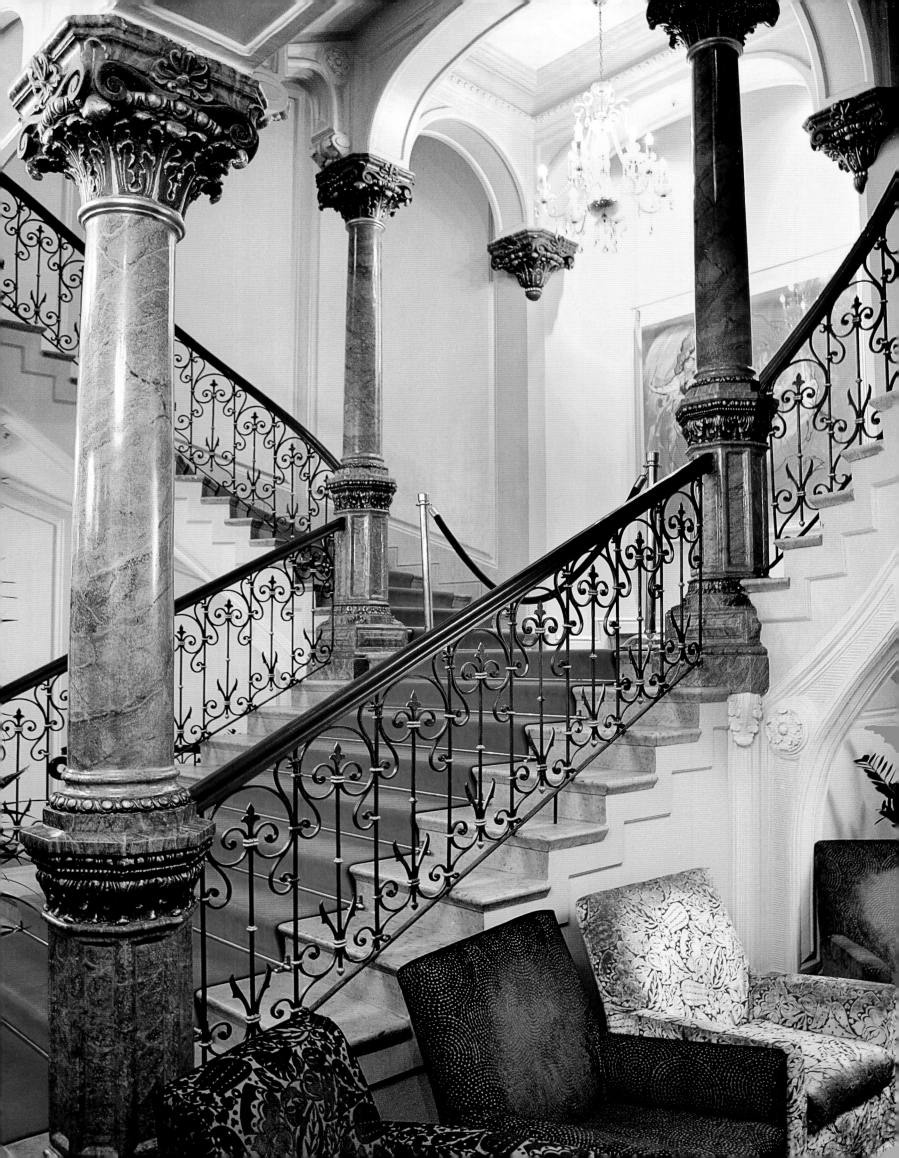

Hotel Kämp

Helsinki, Finland

This neoclassical hotel building is one of the most remarkable structures in the heart of Helsinki. Carl Kämp was a visionary. In 1887, when Kämp constructed the building, he demonstrated that he could bring high society to the capital of Finland. The 179 rooms and suites as well as the public spaces have retained their 19th-century charm even after a complete renovation. The highlight is the Mannerheim Suite with its sumptuously furnished marble bathroom and private dining room featuring a view over Esplanade Park.

Das neoklassizistische Hotelgebäude ist eines der bemerkenswertesten Bauwerke im Herzen Helsinkis. Carl Kämp war ein Visionär, der 1887 mit der Gründung des Hauses den Beweis lieferte, dass er die große Welt in die finnische Hauptstadt holen konnte. Auch nach einer umfassenden Renovierung haben sich die 179 Zimmer und Suiten, wie auch die öffentlichen Räume, ihren 19.-Jahrhundert-Charme bewahrt. Highlight ist die Mannerheim-Suite mit einem kostbar ausgestatteten Marmorbad und eigenem Speisesaal mit Blick über den Esplanade Park.

Cet hôtel néo-classique est l'un des bâtiments les plus remarquables du centre-ville d'Helsinki. Carl Kämp était un visionnaire. En faisant construire cet édifice en 1887, il a prouvé qu'il pouvait ouvrir la capitale finlandaise sur le monde. La rénovation complète n'a rien enlevé au cachet très XIXᵉ de l'hôtel, que ce soit dans les pièces communes ou dans les 179 chambres et suites. Le joyau de cet hôtel est sans conteste sa suite Mannerheim, avec salle de bains en marbre et salle à manger privée dont les fenêtres donnent sur le parc de l'Esplanade.

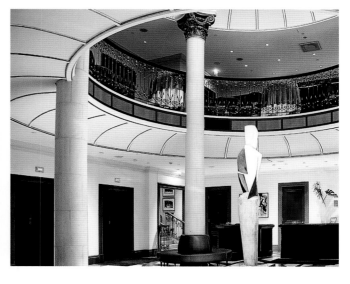

The flight of stairs with its marble columns and richly decorated capitals is a testament to the 19th century's love of splendor.

Die Freitreppe mit ihren Marmorsäulen und den reich geschmückten Kapitellen zeugt von der Lust des 19. Jahrhunderts an der Repräsentation.

Avec ses colonnes de marbre et ses chapiteaux richement décorés, l'escalier témoigne du goût pour la splendeur au XIXᵉ siècle.

The more casual Brasserie Kämp is a favorite spot for informal meetings. The lobby's rotunda is impressive.

Die eher legere Brasserie Kämp ist ein beliebter Spot für informelle Treffen. Beeindruckend ist die Rotunde der Lobby.

La brasserie Kämp, où l'ambiance est plutôt décontractée, est un endroit apprécié pour les rencontres informelles. La rotonde du lobby est impressionnante.

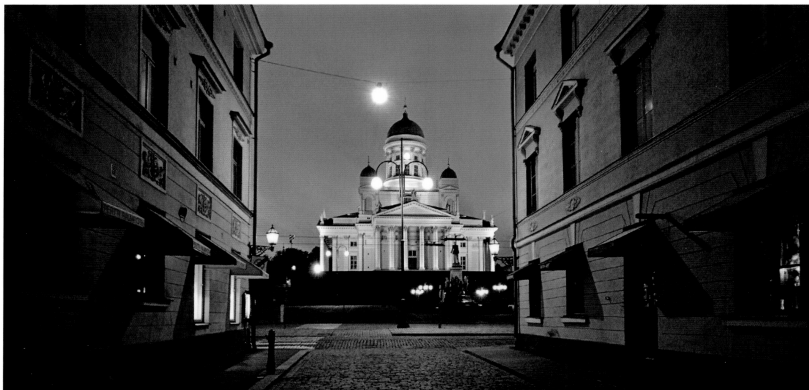

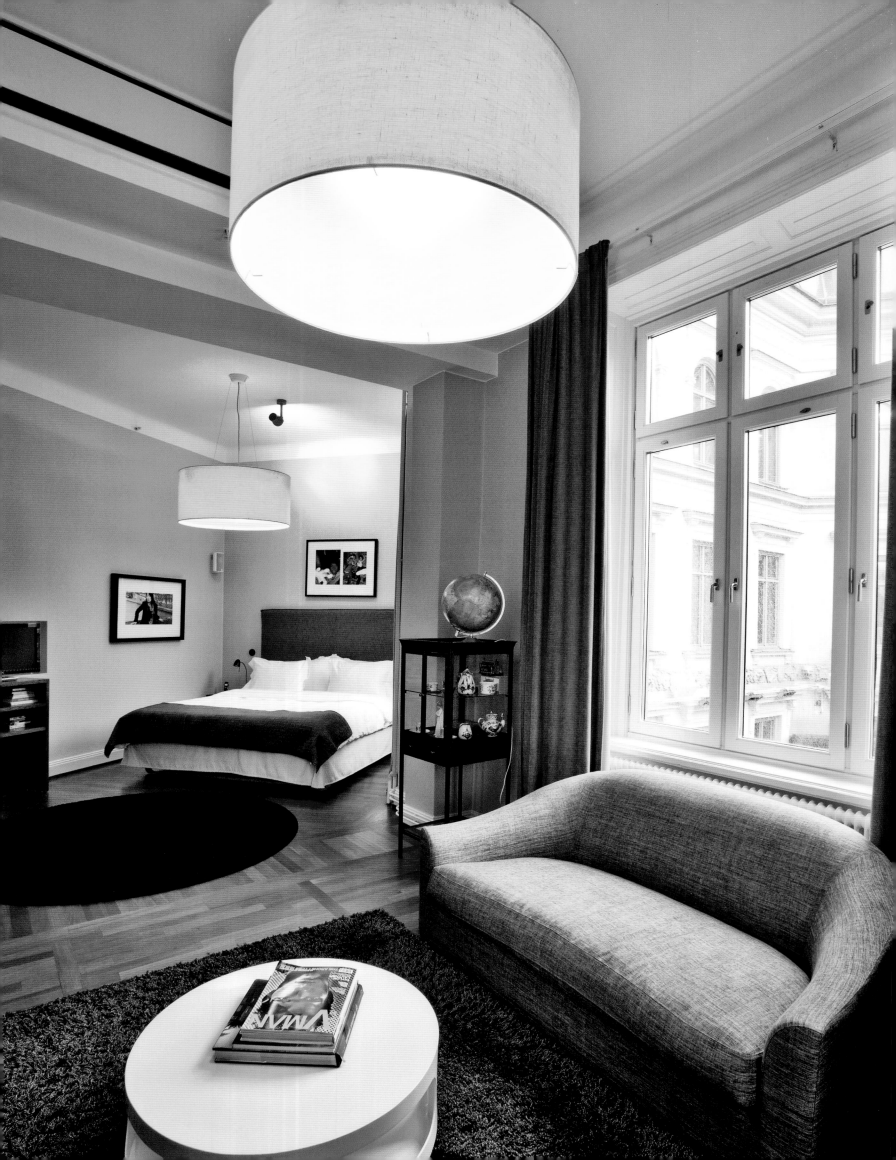

Lydmar Hotel

Stockholm, Sweden

When entering the Lydmar, guests might think they are in an art gallery. Offering a forum for ambitious works of art is a matter near to the heart of owner Per Lydmar, who wants to make guests feel like they are staying with cosmopolitan friends. Rooms are available in four sizes (S to XL). Part lounge, part library, the restaurant is one of the hippest spots in Stockholm, frequented by very stylish patrons. The fin de siècle building has a magnificent setting on the water, and the interior boasts an eclectic mix. Stockholm's old town, Gamla stan, and the Royal Palace are just a few minutes away on foot.

Wer das Lydmar betritt, glaubt sich in einer Kunstgalerie. Ambitionierter Kunst ein Forum zu bieten ist eine Herzensangelegenheit für Besitzer Per Lydmar, der Gästen das Gefühl vermittelt, bei kosmopolitischen Freunden zu Besuch zu sein. Zimmer gibt es vom S- bis zum XL-Format. Das Restaurant ist ein wenig Lounge, ein wenig Bibliothek und einer der angesagtesten Spots Stockholms mit sehr stylishen Gästen. Im Innern zeigt das prachtvoll am Wasser gelegene Jahrhundertwendehaus einen eklektischen Mix. Zur Altstadt Gamla stan und dem Königsschloss sind es nur wenige Gehminuten.

Quiconque pénètre dans le Lydmar croit se retrouver dans une galerie d'art. Le propriétaire Per Lydmar a en effet à cœur de proposer un véritable forum pour un art ambitieux. Les clients doivent avoir l'impression d'être invités chez des amis cosmopolites. Les chambres sont disponibles du format S à XL. Le restaurant qui allie pour sa part lounge et bibliothèque, constitue l'un des lieux les plus prisés de Stockholm où se rencontrent des clients très en vogue. L'intérieur de cet élégant bâtiment fin de siècle érigé au bord de l'eau présente un mélange éclectique. La vieille ville Gamla stan et le château royal ne sont qu'à quelques minutes de marche.

Expansive seating areas on every floor provide inviting spots for informal gatherings.

Auf jeder Etage laden großzügige Sitzbereiche zu ungezwungenen Treffen ein.

À chaque étage, de généreux espaces avec fauteuils permettent de se rencontrer en toute simplicité.

The beautiful *fin de siècle façade on the Södra Blasieholmshamnen doesn't hint at the informal coolness guests will encounter inside.*

Die schöne *Jahrhundertwendefassade an der Södra Blasieholmshamnen verrät nichts von der lässigen Coolness, die im Innern vorherrscht*

La belle *façade érigée au tournant du siècle et située sur Södra Blasieholmshamnen ne dévoile rien du style décontracté et branché qui règne à l'intérieur.*

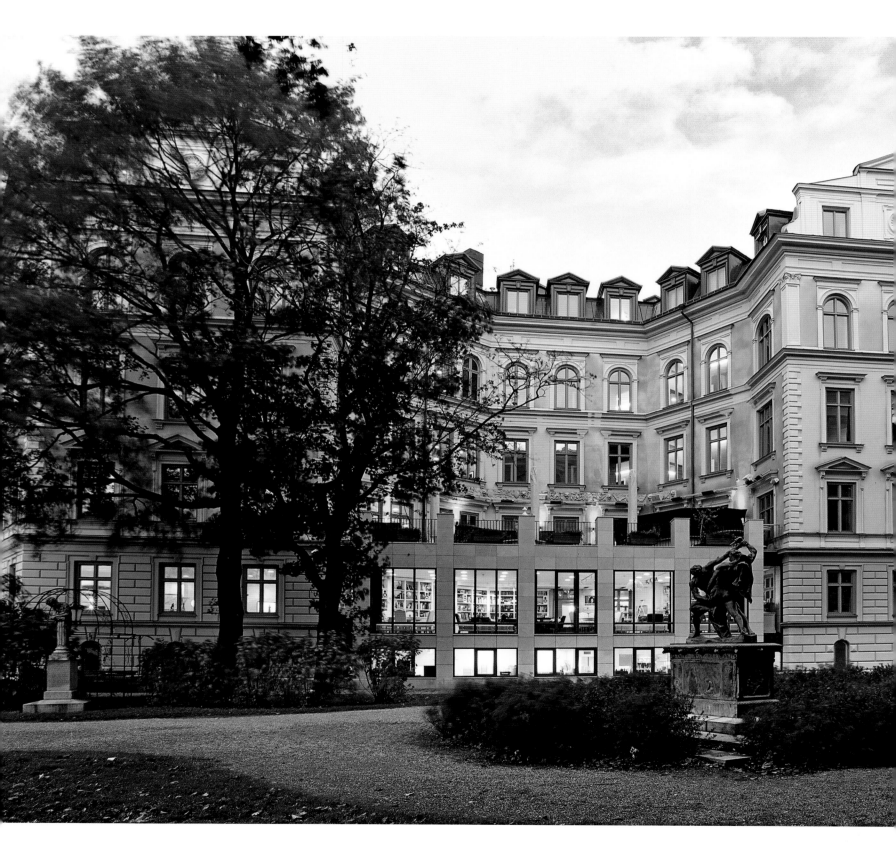

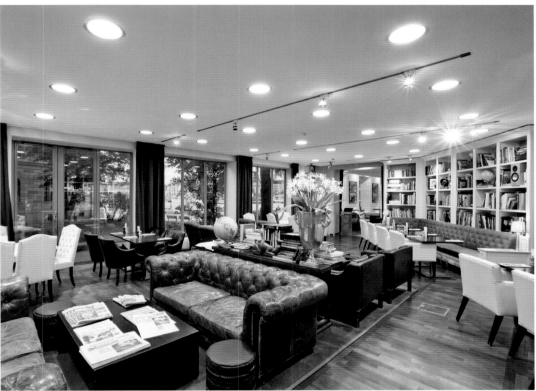

Nobis Hotel

Stockholm, Sweden

Norrmalmstorg square is one of the the most expensive places in Sweden. It is centrally located, and the flagship stores of luxury labels are within easy walking distance. Two brick buildings from the late 19ᵗʰ century house the Nobis Hotel, which opened in 2010. Designers from Claesson Koivisto Rune drew inspiration from Stockholm's winter colors when creating the interior where materials such as wool, wood, stone, and leather set the tone. The technology is distinctly 21ˢᵗ century: Guests can check in using their cell phone, which also functions as a room key.

Der Norrmalmstorgplatz ist einer der exklusivsten Orte Schwedens. Er ist zentral gelegen, die Flagshipstores der Luxuslabels befinden sich in Gehweite. Zwei Backsteingebäude aus dem späten 19. Jahrhundert beherbergen das 2010 eröffnete Nobis. Die Winterfarben Stockholms lieferten den Designern vom Studio Claesson Koivisto Rune die Vorlage für das Interieur, in dem die Materialien Wolle, Holz, Stein und Leder den Ton angeben. Entschieden 21. Jahrhundert ist die Technik: Man kann mit dem eigenen Mobiltelefon einchecken, das auch als Zimmerschlüssel fungiert.

La place Norrmalmstorg est une des rues les plus chères de Suède. Elle se trouve en plein centre, à deux pas des enseignes de luxe. Deux bâtiments de brique de la fin du XIXᵉ siècle y abritent le Nobis, qui a ouvert en 2010. Pour la décoration intérieure, les designers du studio Claesson Koivisto Rune se sont inspirés des couleurs dont Stockholm se pare en hiver. Ils ont choisi de donner le ton avec des matériaux tels que la laine, le bois, la pierre et le cuir. Toutefois, la technologie l'inscrit bel et bien dans le XXIᵉ siècle : les hôtes peuvent s'enregistrer avec leur téléphone portable, qui fera d'ailleurs office de clé pour la chambre.

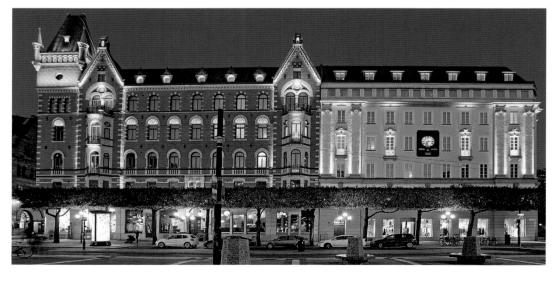

The modern furnishings underscore the classic elegance of the Nobis Suite with its original wood paneling and plasterwork from the late 19ᵗʰ century.

Das moderne Mobiliar betont die klassische Eleganz der Nobis-Suite mit ihren originalen Holzpaneelen und den Stuckaturen, die aus dem späten 19. Jahrhundert stammen.

Le mobilier moderne rehausse l'élégance classique de la suite Nobis avec ses boiseries d'époque et ses stucs datant de la fin du XIXᵉ siècle.

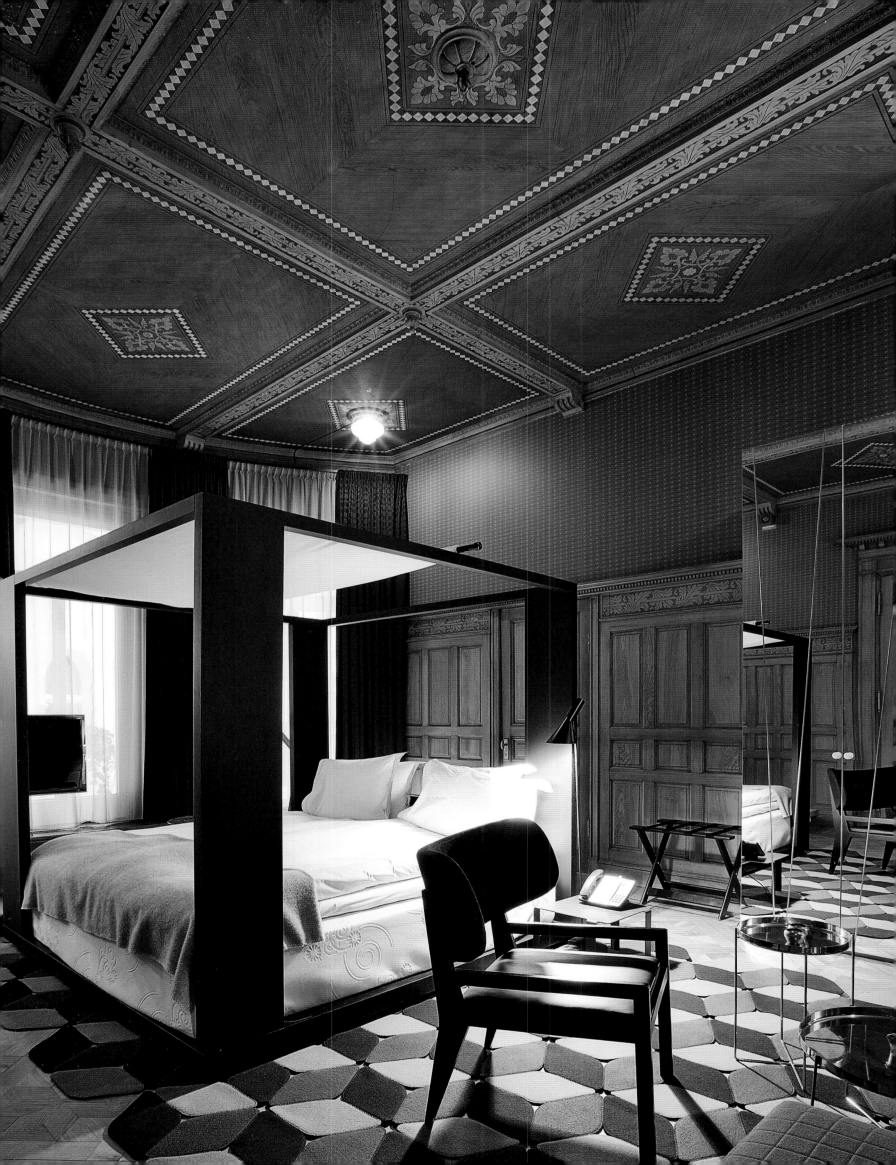

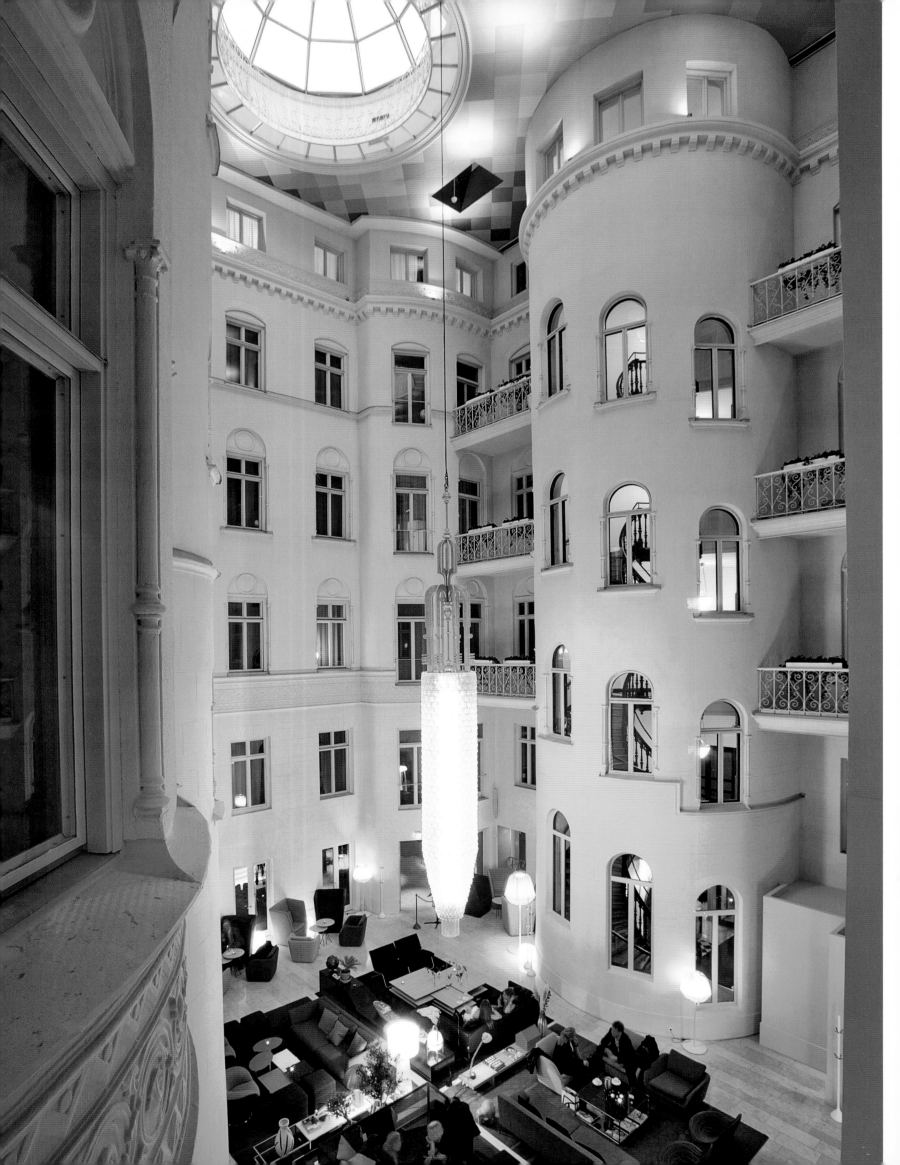

Floor-to-ceiling windows in the lobby provide a view of the hustle and bustle on the Norrmalmstorg. Glass domes arch over the atrium which serves as a lounge.

Raumhohe Fenster in der Lobby lassen das geschäftige Treiben auf dem Norrmalmstorg hereinfluten. Glaskuppeln überwölben das Atrium, das als Lounge fungiert.

Les baies vitrées du lobby laissent filtrer l'animation de la place Norrmalmstorg. Les coupoles de verre surplombent l'atrium qui fait fonction de lounge.

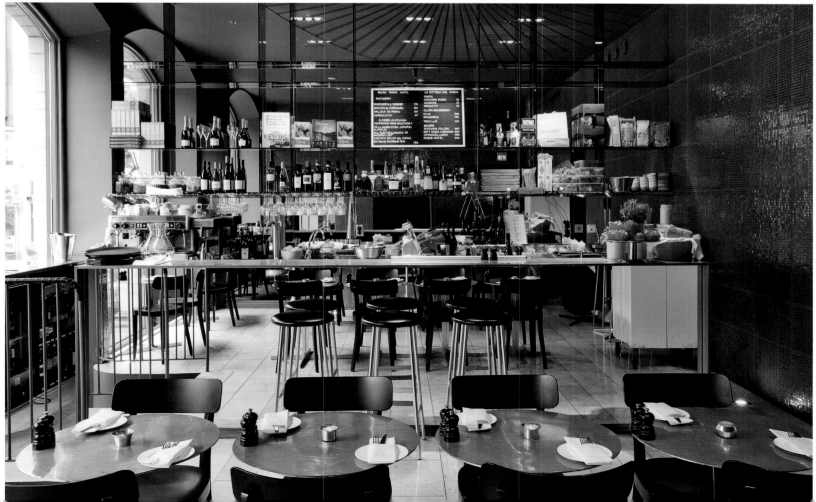

W St. Petersburg

St. Petersburg, Russia

From the miXup Bar on the 8th floor, guests have a view of St. Isaac's Cathedral, and the Hermitage Museum with its vast array of art treasures is just a few steps away. Opened in June 2011, this W Hotel is ideally located in the center of St. Petersburg. Inspired by the Fabergé eggs of the czars, architect Antonio Citterio and his partners created a modern design world with extravagant light installations. New facets are revealed to guests with every step. The main difference can be found in the typical W vibe: lively, hip, and a little "bling bling."

Von der miXup Bar im achten Stock schaut man auf die Isaak-Kathedrale, zur Hermitage mit ihren unermesslichen Kunstschätzen sind es nur wenige Schritte. Die Lage des im Juni 2011 eröffneten W Hotels im St. Petersburger Stadtkern könnte nicht besser sein. Inspiriert von den Fabergé-Eiern der Zaren kreierten die Architekten um Antonio Citterio eine moderne Designwelt mit extravaganten Lichtinstallationen. Schritt für Schritt eröffnen sich den Gästen neue Facetten. Der entscheidende Unterschied liegt im typischen W-Vibe: lebhaft, hip und mit ein wenig Bling-Bling.

Le miXup Bar du huitième étage offre une vue imprenable sur la cathédrale Saint-Isaac, tandis que le musée de l'Ermitage et ses inestimables trésors sont à quelques pas. L'hôtel W qui a ouvert ses portes en juin 2011 est idéalement situé en plein cœur de Saint-Pétersbourg. L'équipe d'architecte d'Antonio Citterio, inspirée par les Œufs de Fabergé impériaux, a créé un design moderne aux installations lumineuses extravagantes. Pas à pas, les hôtes en découvrent les nouvelles facettes. Mais ce qui fait toute la différence, c'est l'atmosphère particulière du W : vivante, branchée et légèrement bling-bling.

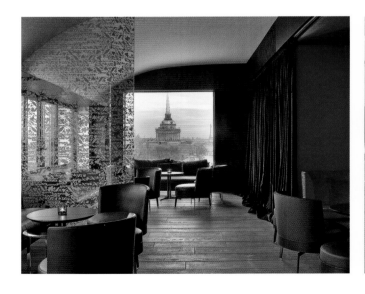

One can meet for a cocktail in the Living Room before taking the elevator up to the spectacular roof terrace later in the evening.

Im Living Room verabredet man sich auf einen ersten Cocktail, bevor man am späteren Abend den Aufzug hoch zur spektakulären Dachterrasse nimmt.

On se retrouve au Living Room pour déguster un premier cocktail avant de prendre l'ascenseur plus tard dans la soirée pour rejoindre l'extraordinaire terrasse sur le toit.

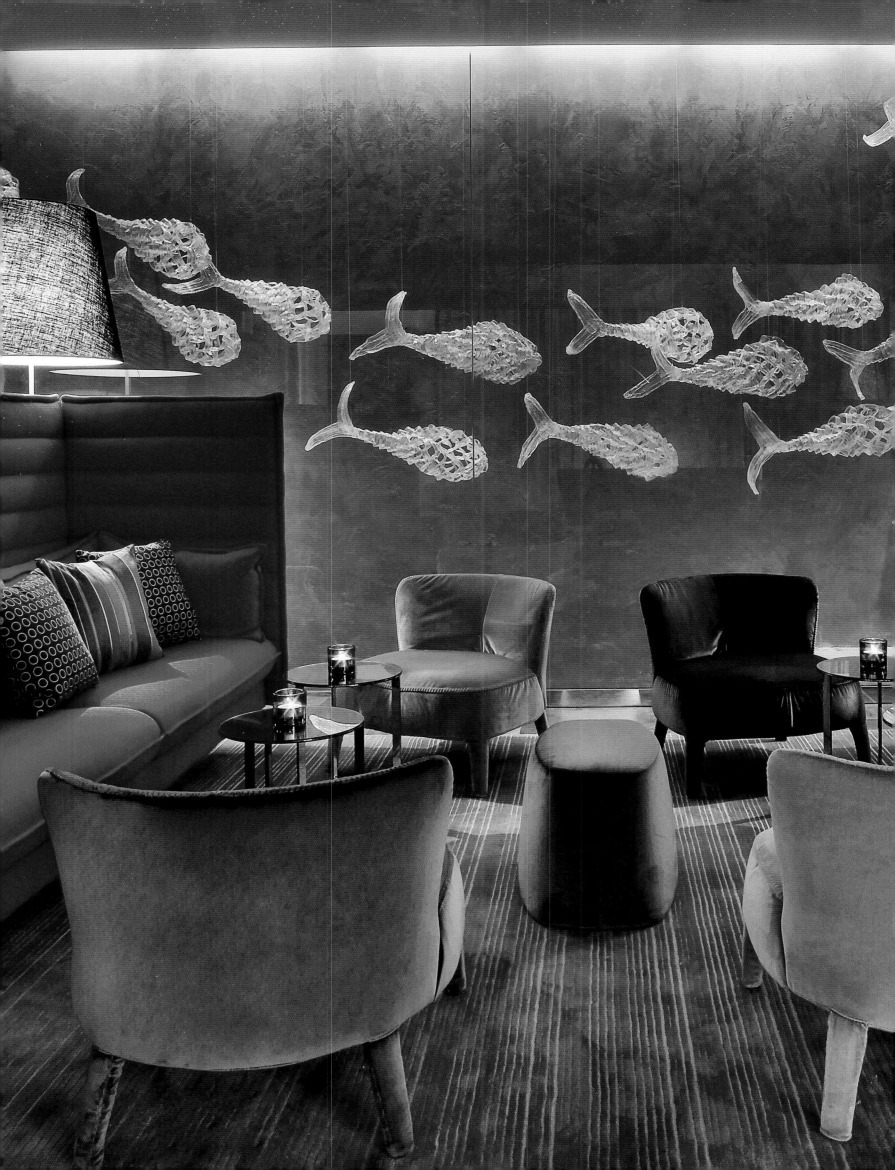

Oversized globe lamps illuminate the restaurant, for which Alain Ducasse has created a mix of international and Russian cuisine.

Überdimensionierte Kugellampen bringen das Restaurant zum Strahlen, für das Alain Ducasse einen Mix aus internationaler und russischer Küche kreiert hat.

D'énormes globes illuminent le restaurant, pour lequel Alain Ducasse a créé une cuisine d'inspiration internationale et russe.

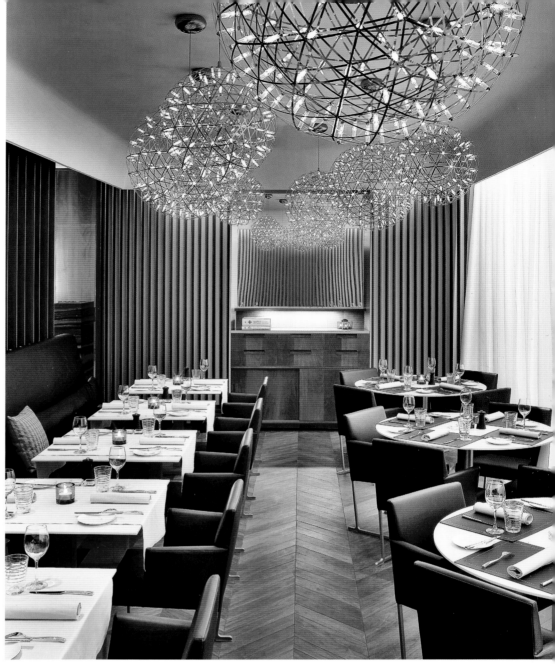

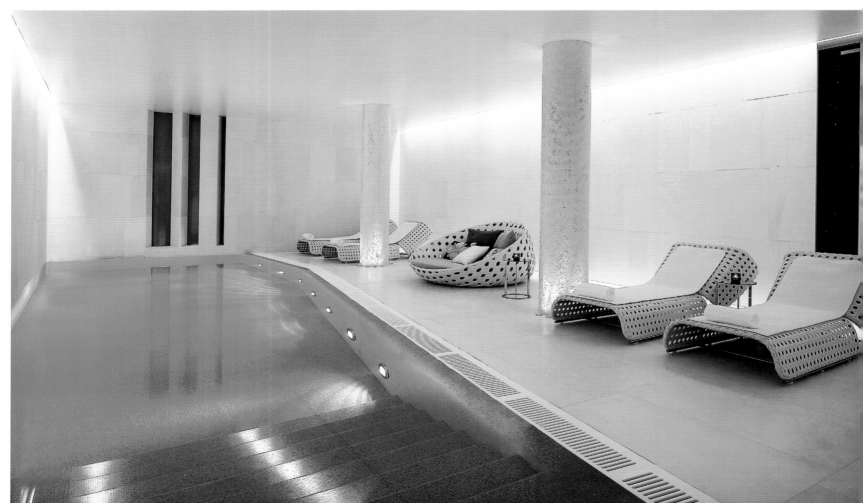

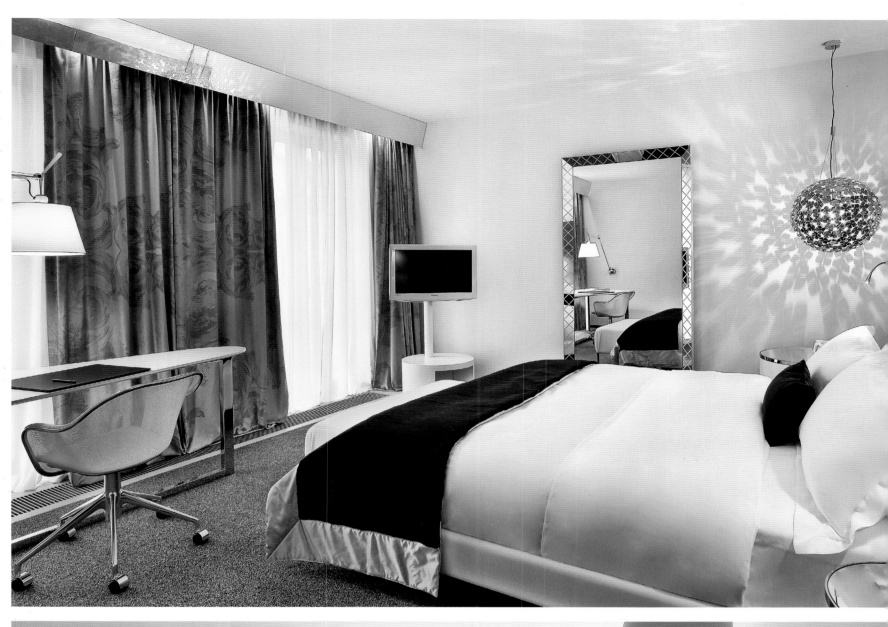

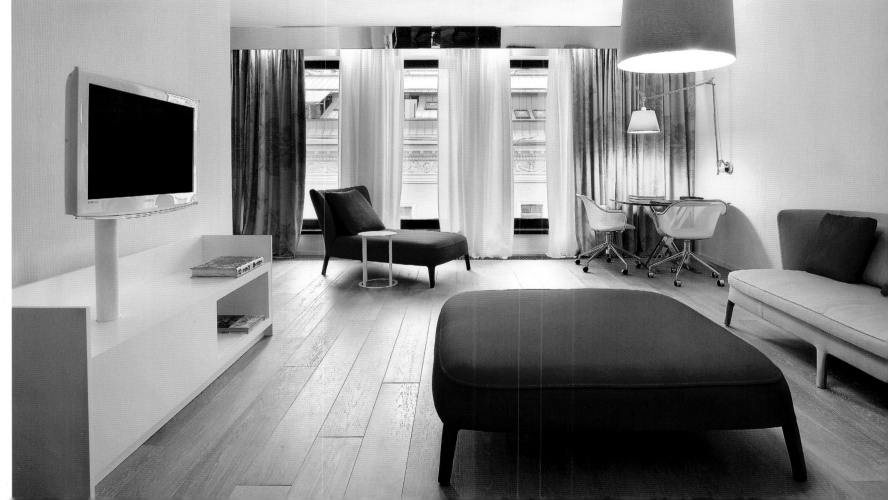

Augustine Hotel Prague

Prague, Czech Republic

The fact that monks still live and practice here gives the Augustine Hotel a unique aura. Located in the area of Prague referred to as Malá Strana, seven historic buildings—the most significant among them being the 13th- century Augustinian St. Thomas Monastery—house the 85 rooms and 16 suites of this luxury hotel. The architects respected the structural conditions, and the entire complex with its countless steps and interior courtyards seems like a labyrinth designed to be explored.

Dass immer noch Mönche hier leben und praktizieren, verleiht dem Augustine Hotel auf der Prager Kleinseite eine ganz eigene Aura. Sieben historische Gebäude – das Bedeutendste das Augustinerkloster St. Thomas, dessen Ursprünge im 13. Jahrhundert liegen – beherbergen die 85 Zimmer und 16 Suiten des Luxushotels. Die Architekten respektierten die baulichen Gegebenheiten und so erscheint die ganze Anlage mit zahllosen Treppen und Innenhöfen wie ein Labyrinth, das man erforschen kann.

L'Augustine Hotel, situé dans le quartier praguois de Malá Strana, possède une ambiance tout à fait particulière grâce aux moines qui y vivent encore. Sept bâtiments historiques – le plus remarquable étant le monastère augustin Saint-Thomas dont les origines remontent au XIIIe siècle – abritent les 85 chambres et 16 suites de cet hôtel de luxe. Les architectes se sont attachés à respecter l'agencement des lieux et la propriété apparaît comme un labyrinthe aux innombrables marches et cours intérieures que l'on se plairait à explorer.

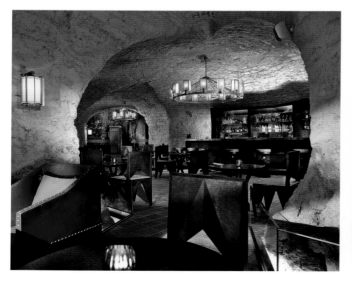 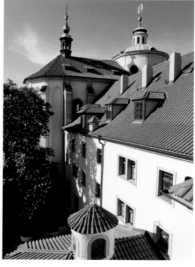

Hotel guests have direct access to the library at St. Thomas Monastery (by appointment). The Brewery Bar is aptly located in the vaulted cellar of a former brewery.

Hotelgäste genießen nach vorheriger Anmeldung direkten Zugang zur Bibliothek des St.-Thomas-Klosters. In den Kellergewölben einer ehemaligen Brauerei befindet sich die Brewery Bar.

Les clients de l'hôtel bénéficient d'un accès direct à la bibliothèque du monastère Saint-Thomas (sur rendez-vous). Le Brewery Bar se trouve dans la cave voûtée d'une ancienne brasserie.

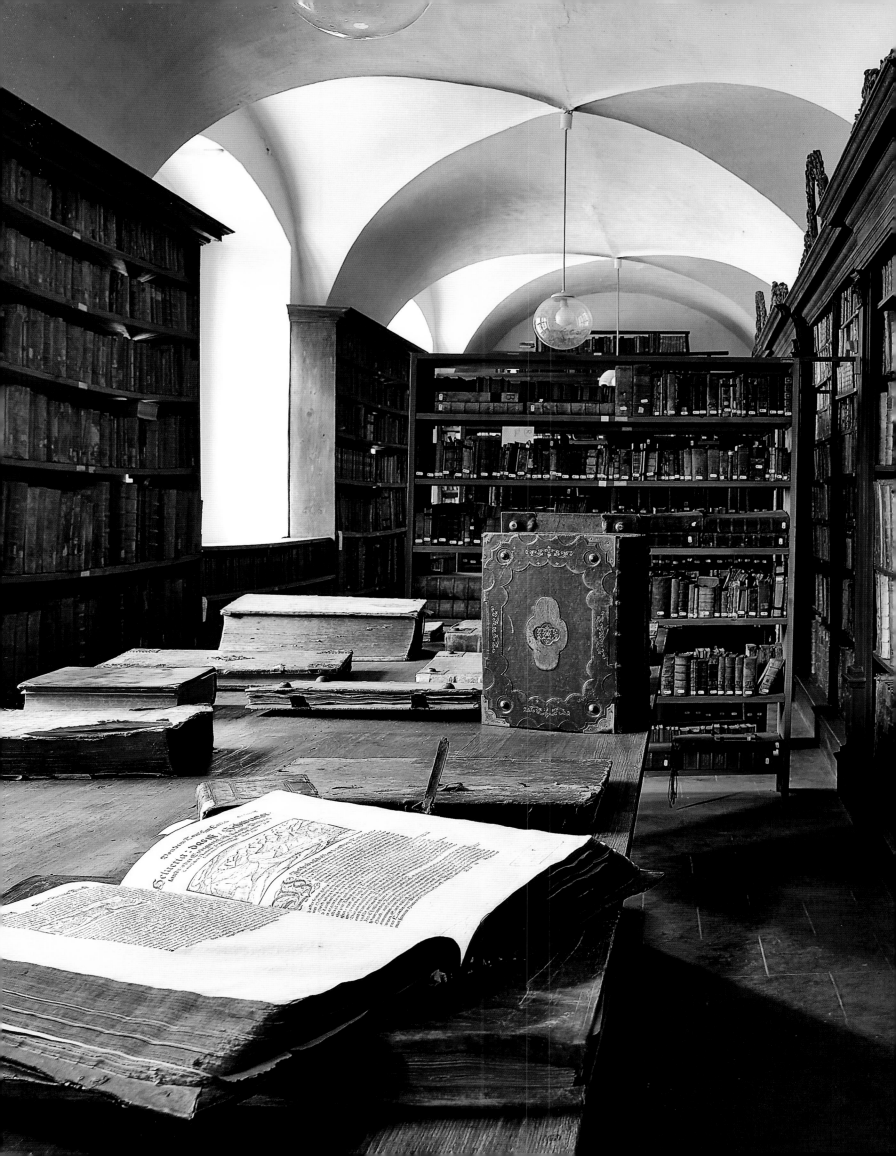

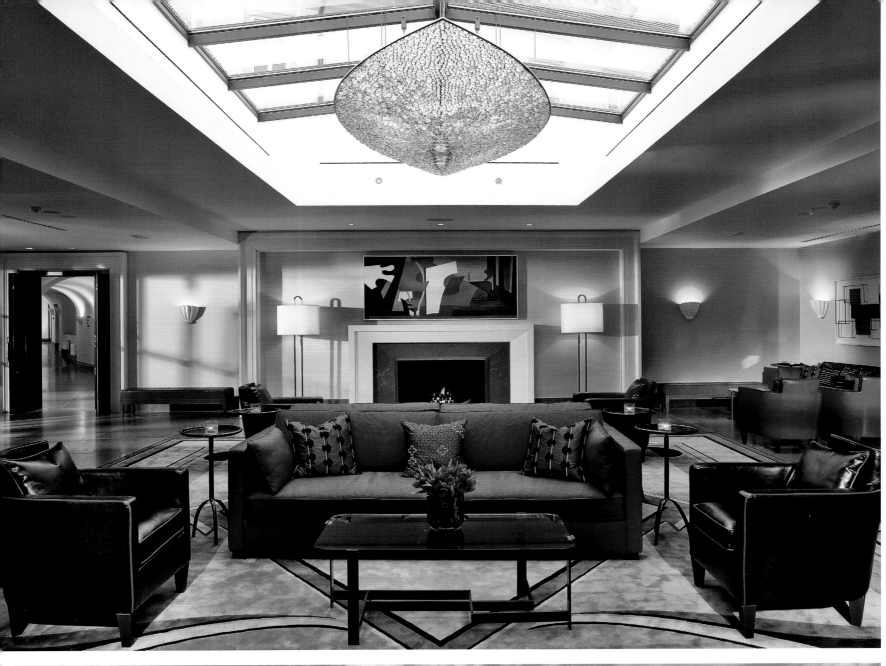

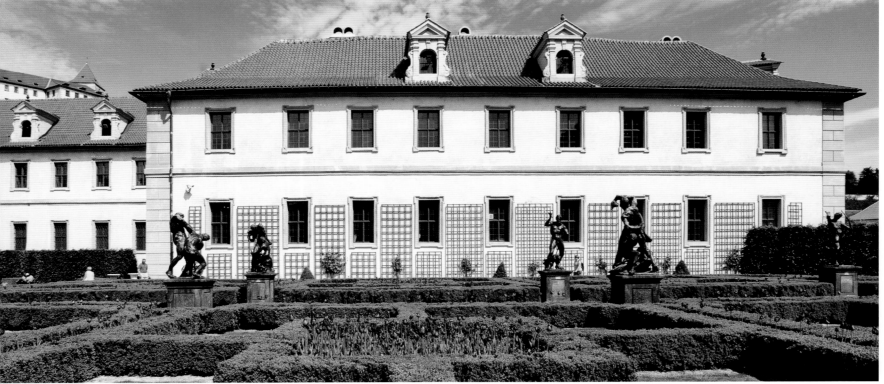

The rooms feature accessories inspired by 1930s-era Czech cubism, which establish a direct link to the location.

In den Zimmern stellen Accessoires im Stil des tschechischen Kubismus der 1930er Jahre eine Verbindung zum Ort her.

Dans les chambres, des accessoires inspirés du cubisme tchèque des années 30 créent un trait d'union avec le lieu.

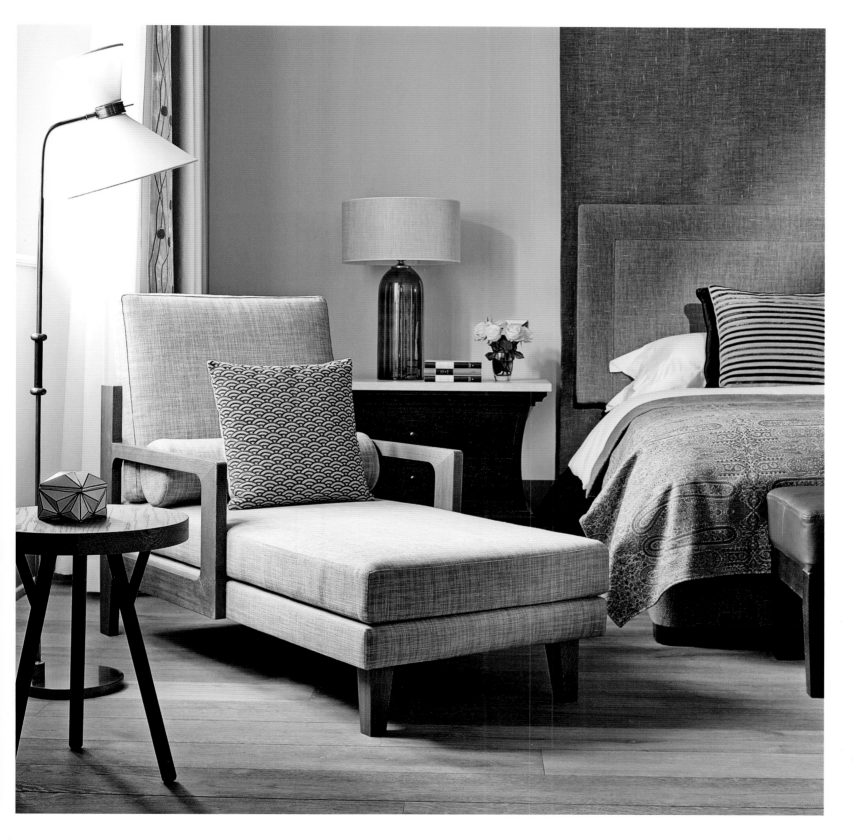

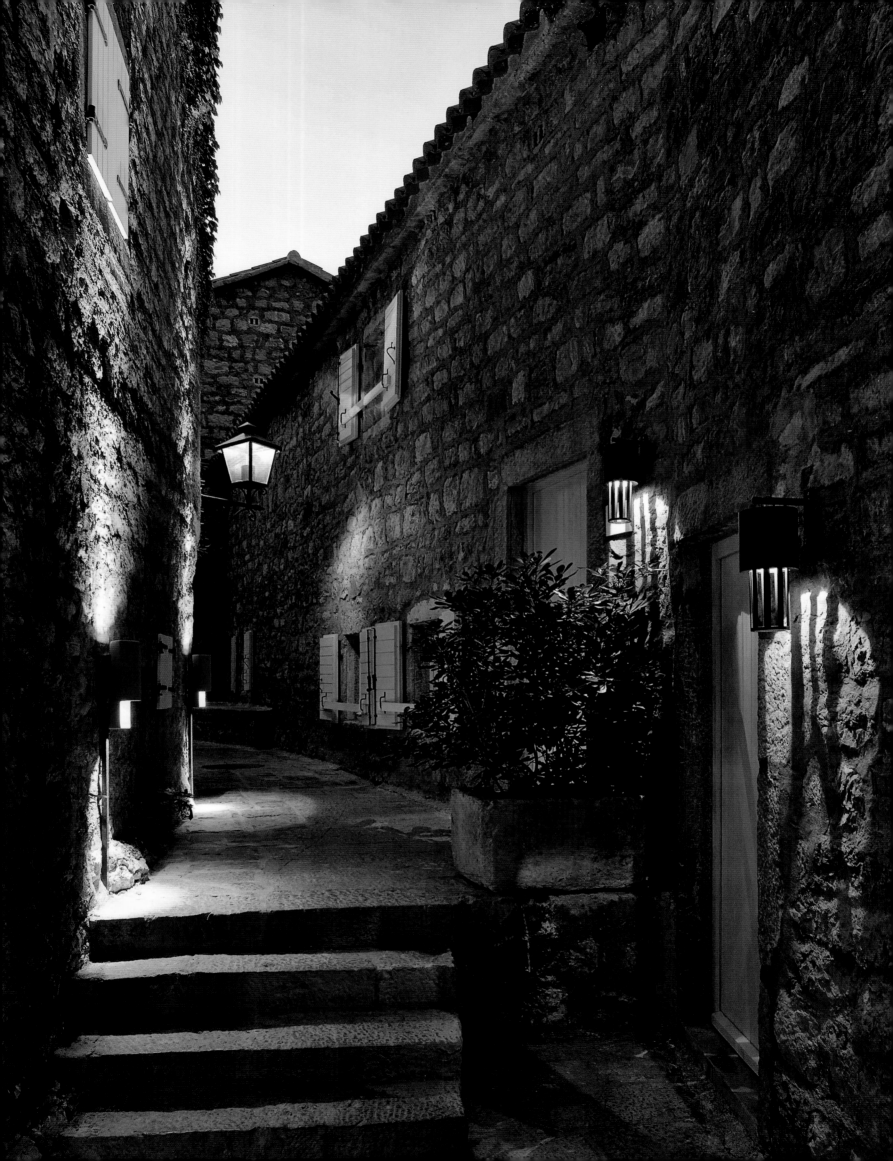

Aman Sveti Stefan

Sveti Stefan, Montenegro

A narrow isthmus just a few yards in length connects the nearly circular islet of Sveti Stefan to the mainland, yet guests at this Aman resort opened in 2010 feel like they are in a world apart. Resembling small fortresses, the compact village houses offered protection to a family clan in centuries past. Custom furnishings preserve the originality of the rooms, while the lavish details are pure luxury.

Es sind nur wenige Meter über einen schmalen Damm, der die kreisrunde Insel Sveti Stefan mit dem Festland verbindet, und doch können sich die Gäste des 2010 eröffneten Aman-Resorts wie in einer anderen Welt fühlen. Kleinen Festungen gleichen die gedrungenen Dorfhäuser, die in früheren Jahrhunderten einem Familienklan Schutz boten. Die maßgefertigte Einrichtung bewahrt die Ursprünglichkeit der Räume, der Luxus liegt in den aufwendigen Details.

Une étroite digue longue de quelques mètres seulement sépare la terre ferme de la petite île circulaire de Sveti Stefan. Pourtant, les invités ont déjà l'impression de se trouver dans un tout autre monde lorsqu'ils séjournent dans ce complexe du groupe Amanresorts, qui a ouvert ses portes en 2010. Les maisons de village forment une sorte de rempart qui servait au cours des siècles passés à protéger un clan familial. L'aménagement sur mesure a permis de préserver le caractère authentique des pièces, le luxe se cachant dans les moindres détails.

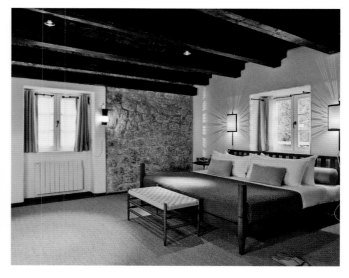

Many years of restoration preserved the island's historic atmosphere with its narrow streets, churches, and passageways.

Bei der langjährigen Restaurierung wurde das historische Ambiente der Insel mit ihren engen Gassen, Kirchen und Durchgängen bewahrt.

La rénovation qui a duré plusieurs années n'a rien enlevé à l'ambiance historique de l'île, ni à ses ruelles étroites, églises et passages.

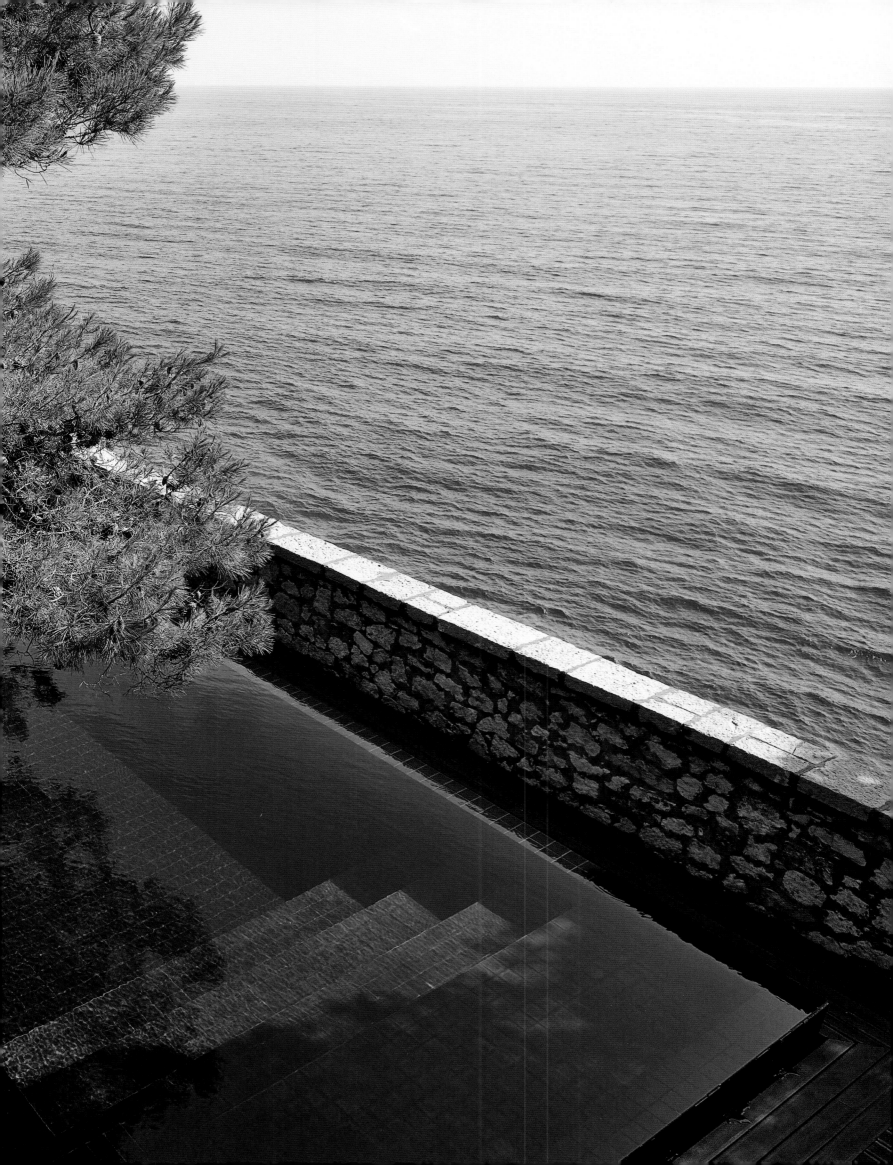

With eight different restaurants and three beaches (Sveti Stefan, Milocer Beach, and Queen's Beach) for only 58 rooms, including 50 suites and cottages on the island, guests are guaranteed an exclusive experience.

Acht verschiedene Restaurants und drei Strände — Sveti Stefan, Milocer Beach und Queen's Beach — für nur 58 Zimmer, davon 50 Suiten und Gäste-Cottages auf der Insel, garantieren ein exklusives Erlebnis.

Les huit différents restaurants et les trois plages — Sveti Stefan, Milocer Beach et Queen's Beach — pour seulement 58 chambres, dont 50 suites et cottages sur l'île — garantissent une expérience des plus exclusives.

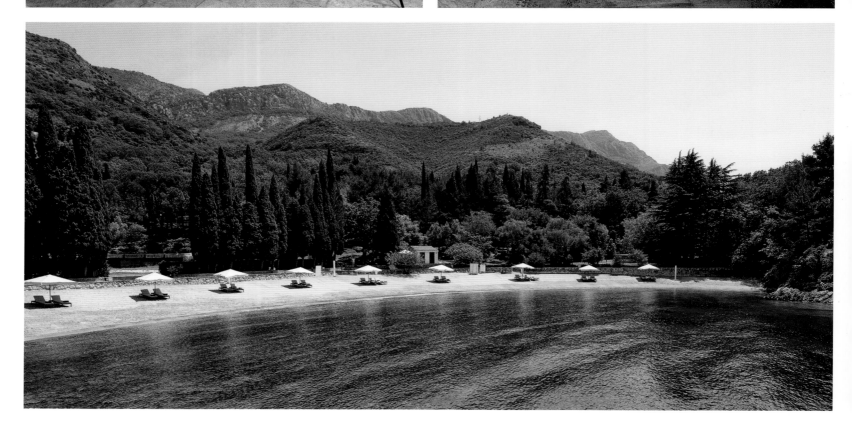

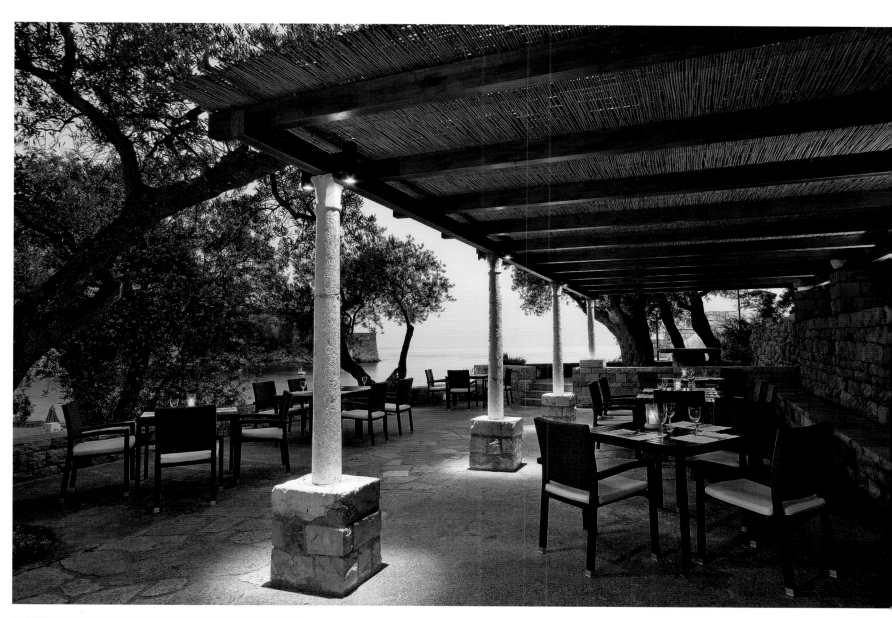

Boscolo Budapest

Budapest, Hungary

Constructed between 1892 and 1894 as the Hungarian offices of a New York insurance company, this impressive building experienced a period of decline before the Italian Boscolo Group helped it achieve a glorious rebirth as a five-star hotel following a careful restoration in cooperation with Italian conservation authorities. Those who enter the lobby in the early evening will experience a magnificent light show when the fading daylight mixes with the attractive lighting of the splendid atrium.

Zwischen 1892 und 1894 als Budapester Firmensitz einer New Yorker Versicherung erbaut, durchlebte das imposante Gebäude eine Zeit des Niedergangs, bis ihm die italienische Boscolo-Gruppe durch eine gewissenhafte Restaurierung, an der auch italienische Denkmalbehörden beteiligt waren, zu einer strahlenden Wiedergeburt als Fünf-Sterne-Hotel verhalf. Ein grandioses Lichtschauspiel erlebt, wer am frühen Abend die Lobby betritt, wenn sich das schwindende Tageslicht mit der effektvollen Beleuchtung des großartigen Atriums vermischt.

Construit entre 1892 et 1894 à Budapest pour abriter le siège d'une assurance new-yorkaise, l'imposant édifice est tombé ensuite en décrépitude jusqu'à ce que le groupe italien Boscolo entreprenne une méticuleuse rénovation, en collaboration avec le service italien de protection des monuments historiques, pour lui rendre toute sa splendeur et le transformer en un hôtel cinq étoiles. En pénétrant dans le lobby en fin de journée on se laissera éblouir par la lumière du jour qui faiblit, qui se mêle au merveilleux éclairage du magnifique atrium.

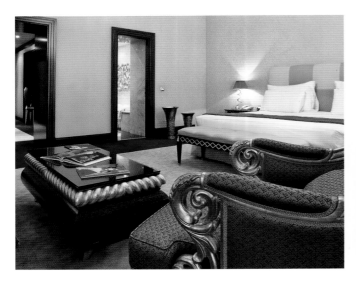

With details *referencing classical styles and the Baroque and Renaissance eras, the façade bears witness to a time when Budapest was one of the most important metropolises in Europe.*

Die Fassade *mit ihren antikisierenden Details, ihren Barock- und Renaissancezitaten legt beredtes Zeugnis ab von einer Zeit, als Budapest zu den bedeutendsten Metropolen Europas zählte.*

Sa façade *aux détails anciens, accents baroque et Renaissance témoigne avec éloquence d'une époque à laquelle Budapest comptait parmi les métropoles les plus importantes d'Europe.*

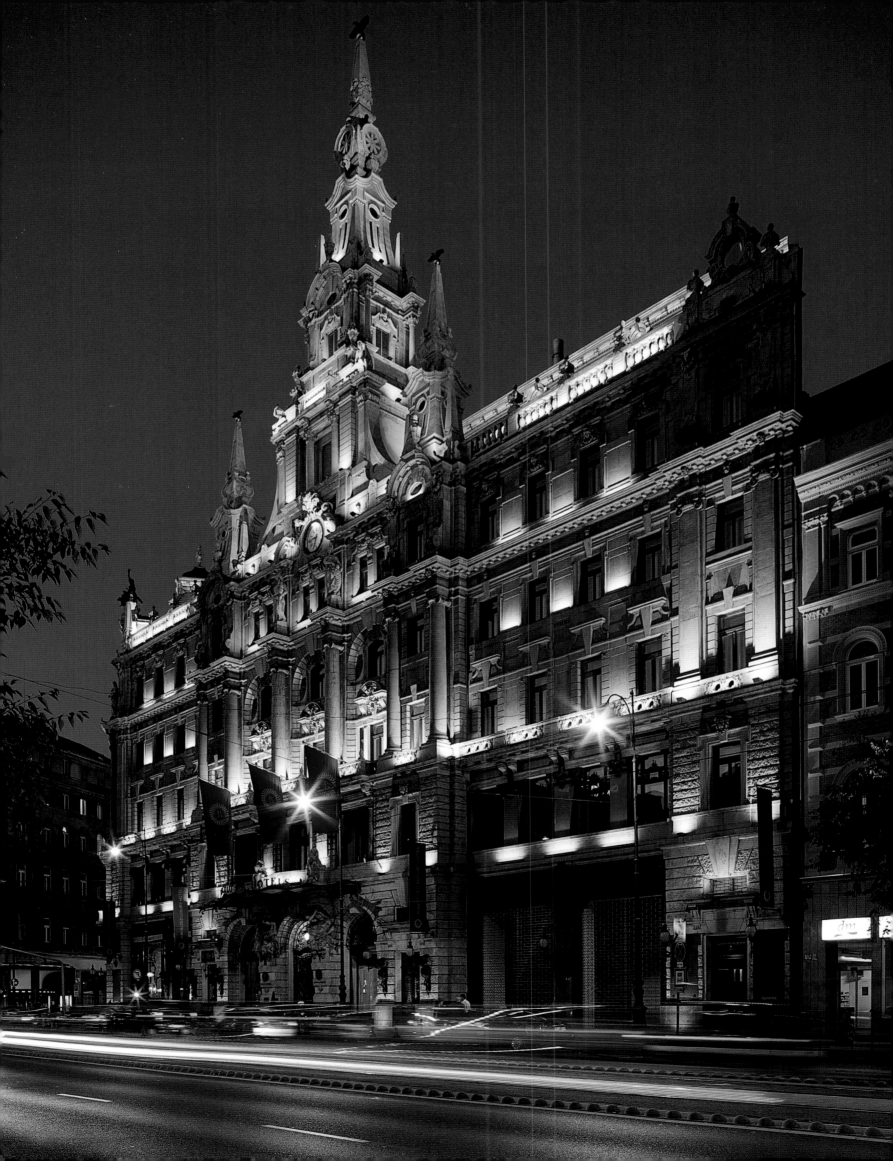

In the best coffee house tradition: At the splendid New York Café, a legendary meeting place for the literati, visitors can still indulge in the opulence of a bygone era.

In bester Kaffeehaustradition: Noch immer lässt sich im prunkvollen New York Café, einem legendären Literatentreff, in alter K.-u.-k.-Herrlichkeit schwelgen.

Au New York Café, lieu de rendez-vous littéraire mythique, on continue d'apprécier l'ancienne splendeur de l'Empire austro-hongrois, dans la plus belle tradition des maisons de café.

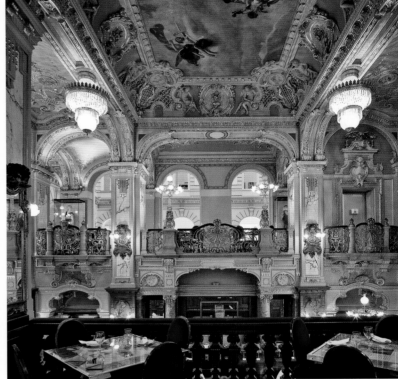
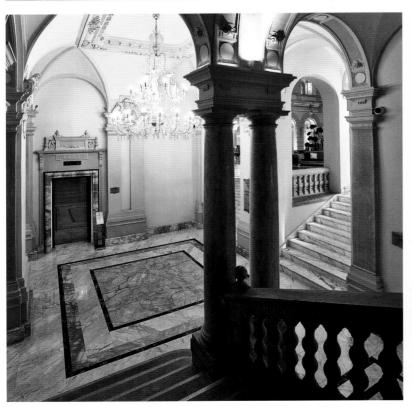

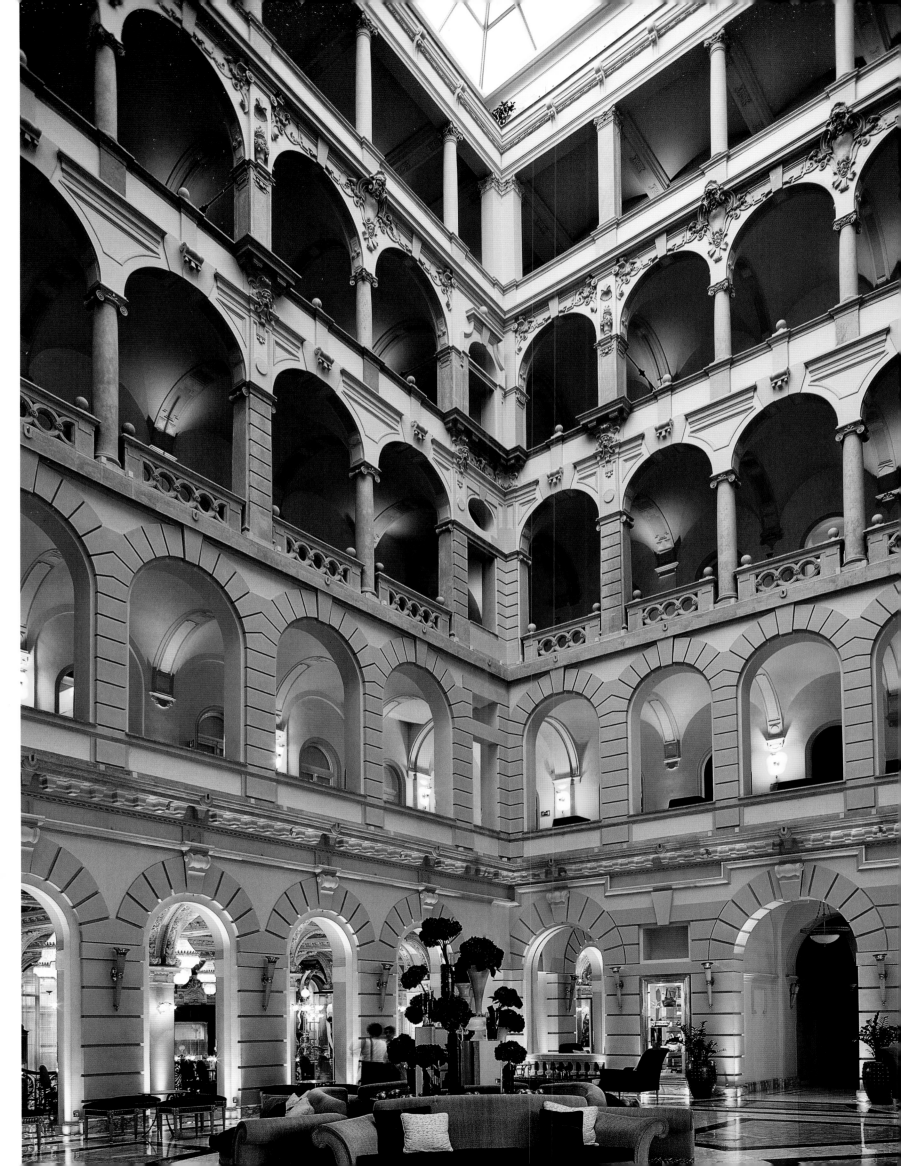

Four Seasons Hotel Gresham Palace Budapest

Budapest, Hungary

Considered one of the most beautiful examples of the art nouveau style, this hotel created quite a sensation when it opened back in 1906. Located on the Danube, the Gresham Palace reopened as a Four Seasons Hotel in 2004, following a 30-month restoration. An army of skilled craftsmen devoted their efforts to restoring the fantastic art nouveau elements, the curving stairways, the conservatory, and the valuable lead glass windows with their floral motifs.

Er gilt als eines der schönsten Beispiele des Art nouveau-Stils und sorgte schon bei seiner Eröffnung 1906 für Aufsehen: der an der Donau gelegene Gresham Palace, der 2004 nach einer 30 Monate langen Restaurierungsphase als ein Four Seasons Hotel wiedereröffnete. Ein ganzes Heer an Restauratoren war damit befasst, die fantastischen Jugendstilelemente, die geschwungenen Treppen, den Wintergarten und die kostbaren Bleiglasfenster mit ihren floralen Motiven wiederherzustellen.

Le Gresham Palace, au bord du Danube, a rouvert ses portes en 2004 après 30 longs mois de restauration sous l'enseigne Four Seasons. Le bâtiment, considéré comme l'une des plus remarquables créations de style Art nouveau, ne passait déjà pas inaperçu au moment de son ouverture en 1906. L'équipe de restaurateurs a d'ailleurs pris le plus grand soin pour réhabiliter les fantastiques éléments Art nouveau, les escaliers tout en courbes, le jardin d'hiver ainsi que les précieux vitraux aux motifs floraux.

Contemporary exhibitions of Hungarian artists round out the carefully preserved art nouveau features of the magnificent lobby.

Zeitgenössische Exponate ungarischer Künstler ergänzen die aufs Sorgfältigste konservierten Jugendstildetails in der grandiosen Lobby.

Dans le prestigieux lobby, des pièces contemporaines réalisées par des artistes hongrois accompagnent les détails de style Art nouveau conservés avec le plus grand soin.

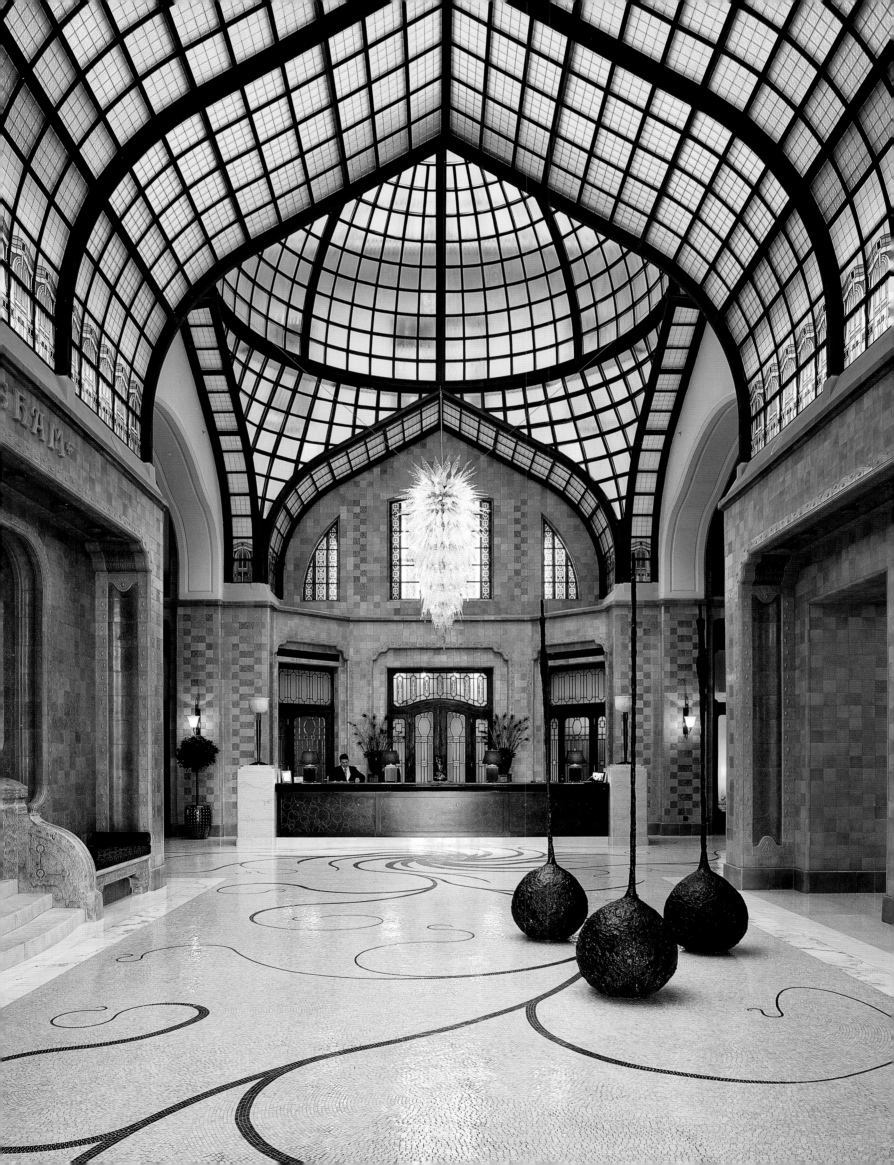

Some of the 179 rooms and suites offer a view of the Chain Bridge, which has connected the two parts of the city, Buda and Pest, since 1849.

Einige der 179 Zimmer und Suiten bieten Ausblick auf die Kettenbrücke, die seit 1849 die beiden Stadtteile Buda und Pest verbindet.

Quelques-unes des 179 chambres et suites offrent une belle vue sur le pont suspendu à chaînes qui relie les quartiers Buda et Pest depuis 1849.

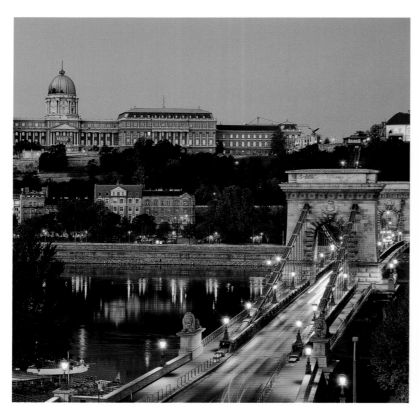

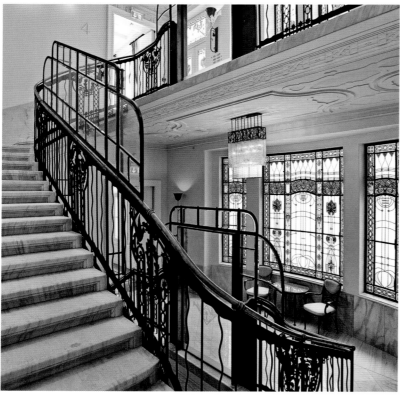

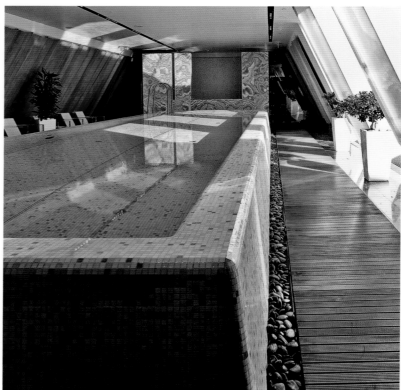

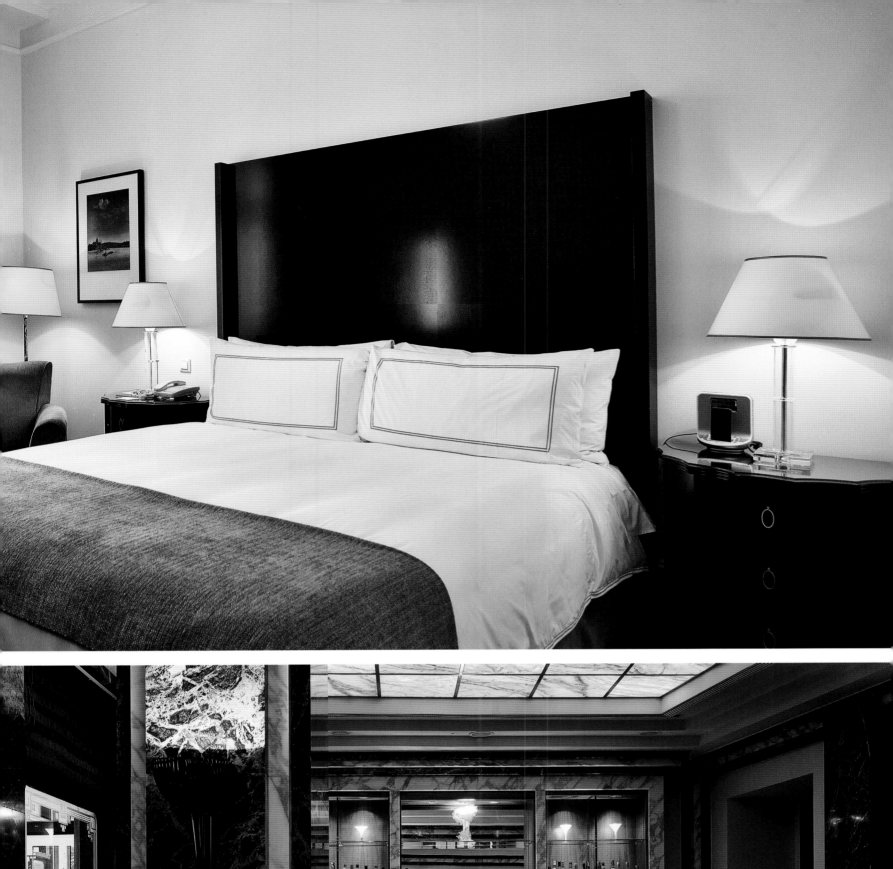
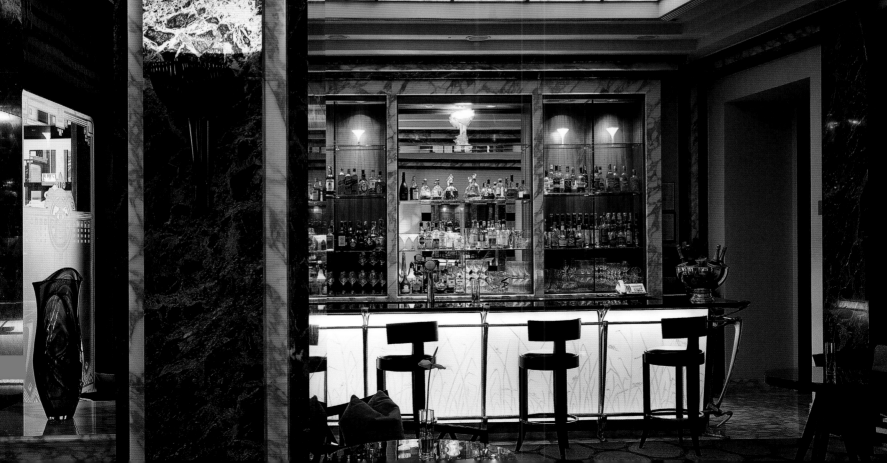

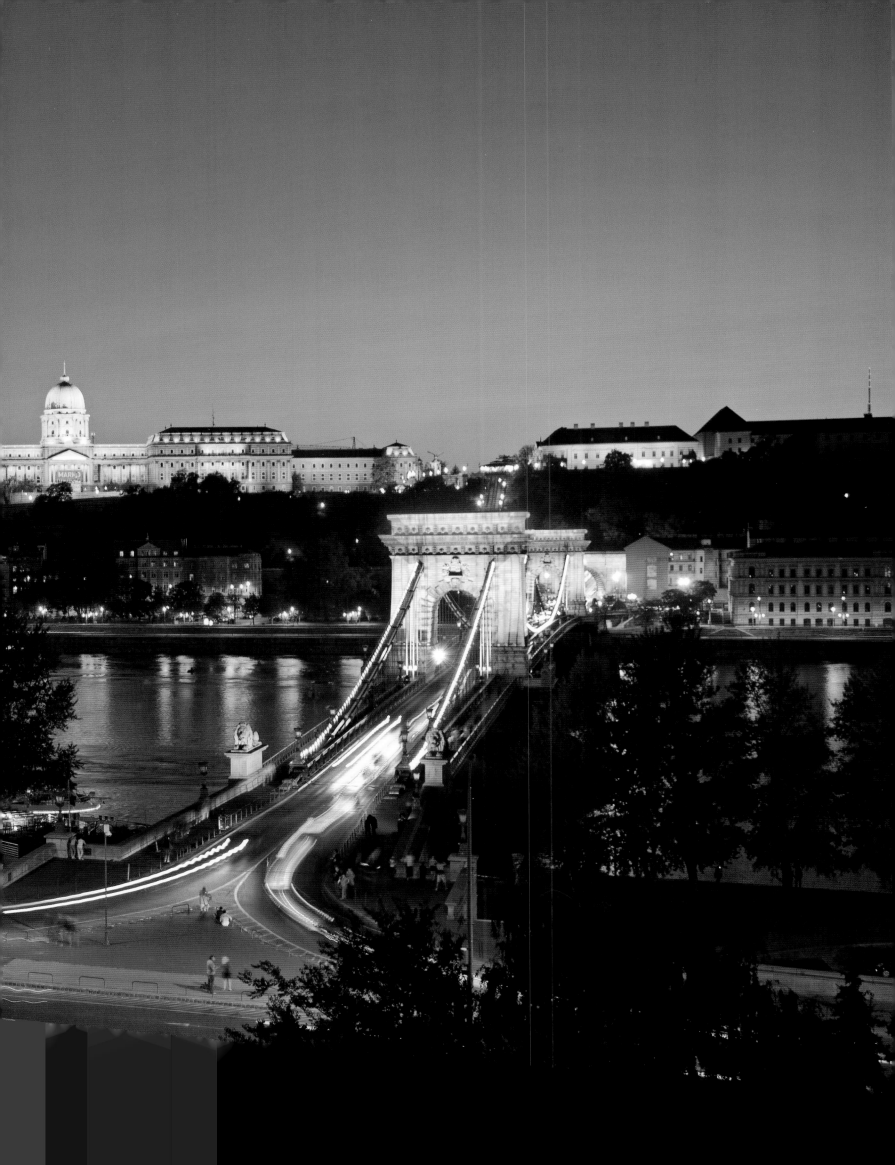

Hotel Pulitzer

Amsterdam, Netherlands

Façades with narrow parapets, decorative gables made of sandstone, and bright white transom windows with multiple panes provide Amsterdam's canal houses with their unique charm. No less than 25 of these canal houses dating from the 17th and 18th centuries along the Prinsengracht and Keizersgracht canals house the 230 rooms and suites of the Hotel Pulitzer. For 33 million dollars, the establishment, part of the Luxury Collection of the Starwood Group, was recently renovated, allowing modern interior and historical architecture to enter a successful partnership. Especially charming are the inner gardens with an original art deco glasshouse. And for guests arriving on their own boat, there are private slips.

Schmalbrüstige Fassaden, Schmuckgiebel aus Sandstein und vielfältig gegliederte, strahlend weiße Sprossenfenster machen den Charme der Amsterdamer Grachtenhäuser aus. Nicht weniger als 25 dieser Grachtenhäuser aus dem 17. und 18. Jahrhundert an Prinsengracht und Keizersgracht beherbergen die 230 Zimmer und Suiten des Hotel Pulitzer. Mit einem Aufwand von 33 Millionen Dollar wurde das Haus, das zur Luxury Collection der Starwood-Gruppe gehört, in jüngster Zeit renoviert, wobei modernes Interieur und historische Architektur eine gekonnte Verbindung eingehen. Ein besonderes Kleinod sind die in den Innenhöfen gelegenen Gärten und Terrassen mit dem original Art déco-Glashaus. Für Gäste, die mit dem eigenen Boot anreisen, gibt es einen privaten Anleger.

Des façades étroites, des pignons décoratifs en grès, des fenêtres à barreaux agencées de manière multiple, au blanc étincelant font tout le charme des maisons sur pignons d'Amsterdam (les « Grachten »). Pas moins de 25 de ces maisons du XVIIe et du XVIIIe siècle situés sur le Prinsengracht et le Keizersgracht abritent les 230 chambres et les suites de l'hôtel Pulitzer. L'établissement, qui appartient à la Luxury Collection du groupe Starwood, a été récemment rénové avec un budget de 33 millions de dollars. L'intérieur moderne et l'architecture historique forment une alliance très réussie. Le point d'orgue est constitué par les jardins intérieurs avec la maison en verre typiquement Art déco. Et pour les hôtes qui arrivent avec leur propre bateau, il existe un embarcadère privé.

 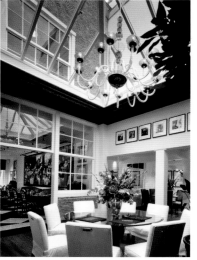

On the famous Amsterdam canal belt stands the Pulitzer, composed of 25 of the typical canal houses.

Am berühmten Amsterdamer Grachtengürtel liegt das Pulitzer, das aus 25 der typischen Grachtenhäuser besteht.

Le Pulitzer est situé sur la célèbre ceinture des maisons sur pignons aux bords des canaux d'Amsterdam, avec en tout 25 de ces bâtiments typiques pour Amsterdam.

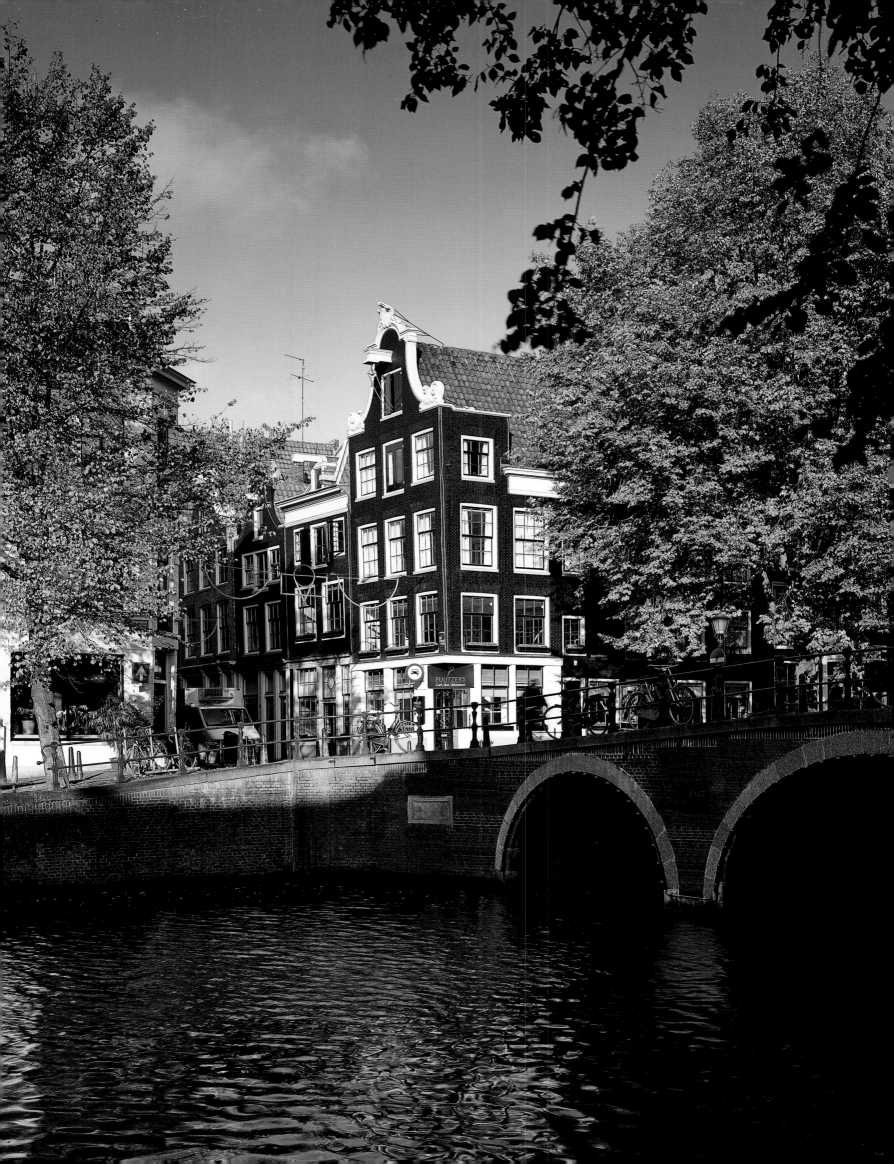

All rooms display works of art by contemporary Dutch artists.

In sämtlichen Räumen finden sich Kunstwerke zeitgenössischer niederländischer Künstler.

Tous les des chambres abritent des œuvres d'artistes hollandais contemporains.

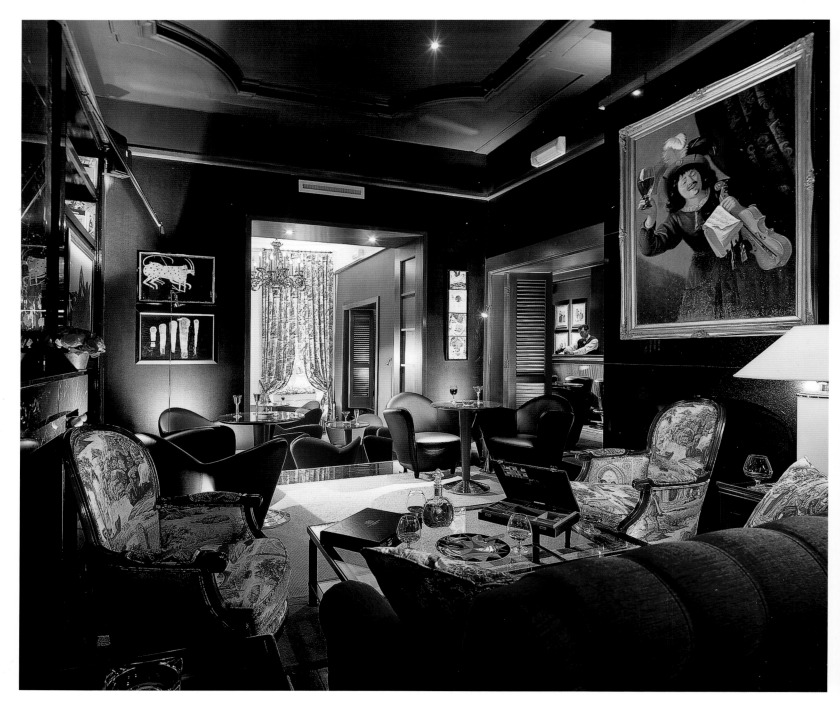

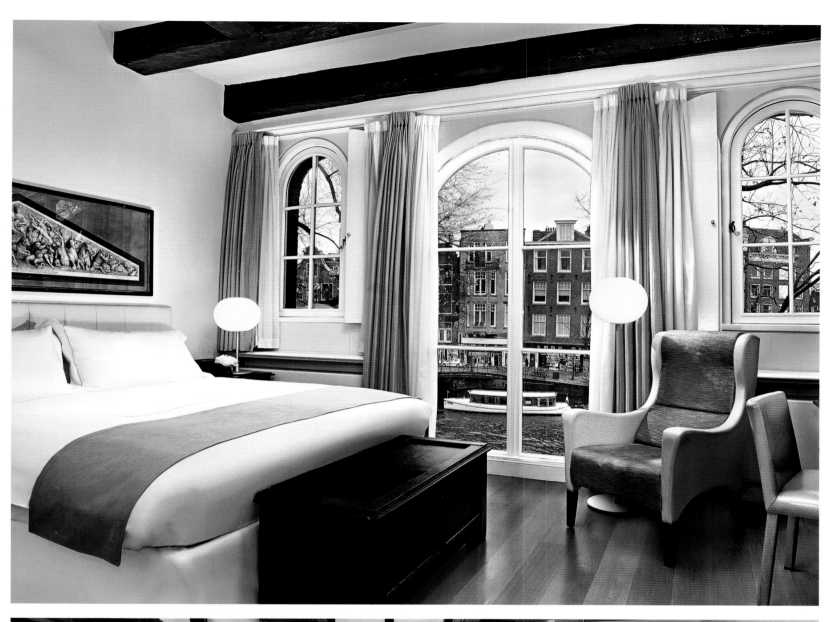

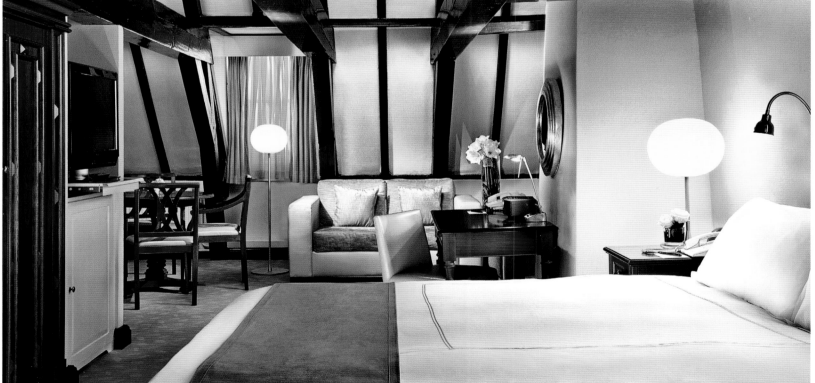

Kruisherenhotel Maastricht

Maastricht, Netherlands

Guests waking up in this magnificent hotel might imagine at first that they are dreaming: Instead of seeing white walls, some guests look through ancient Gothic stained glass church windows. After undergoing a state-of-the-art renovation, this 15th-century monastery with its idyllic gardens transports travelers into another dimension. Classic furniture pieces, murals, and a lighting concept by Ingo Maurer round out the artistic interior design. Breakfast is served in the gallery with breathtaking views of Maastricht.

Wer in diesem Prachthotel die Augen aufschlägt, glaubt im ersten Moment an eine Sinnestäuschung: Statt auf weiße Wände blickt mancher Gast durch uralte Buntglasmosaike gotischer Kirchenfenster. Das nach allen Regeln der Kunst renovierte Kloster aus dem 15. Jahrhundert mit idyllischem Garten versetzt Reisende augenblicklich in eine andere Dimension. Designklassiker, Wandmalereien und ein Beleuchtungskonzept von Lichtmagier Ingo Maurer runden das künstlerische Ensemble ab. Frühstück wird auf der Empore serviert, mit atemberaubenden Ausblicken auf Maastricht.

Lorsque l'on ouvre les yeux dans ce magnifique hôtel, on croit être victime d'hallucination : au lieu des murs blancs, l'hôte regarde à travers les hauts vitraux colorés d'église gothique dans certaines chambres. Ce monastère du XVe siècle, rénové en employant les dernières techniques, et ses jardins idylliques transportent immédiatement les voyageurs dans une dimension totalement différente. Des classiques du design, des peintures murales et un concept d'éclairage élaboré par le magicien des lumières Ingo Maurer complètent cet ensemble artistique. Le petit-déjeuner est servi sur la galerie, avec une vue imprenable sur Maastricht.

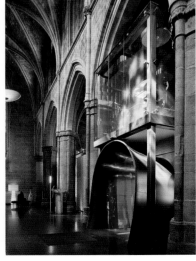

The design and lighting concept forms an exciting contrast to the building's sacred beginnings. Visitors can meet up in the restaurant or the wine bar located on the mezzanine of the gothic church.

Das Design- und Lichtkonzept setzt auf den spannungsvollen Kontrast zum sakralen Ursprung des Gebäudes. Im Chor der gotischen Klosterkirche trifft man sich im Restaurant oder an der Weinbar.

Le concept de design et d'éclairage mise sur un contraste fascinant avec l'origine sacrée de l'édifice. Le chœur de l'abbatiale gothique abrite un restaurant et un bar à vin.

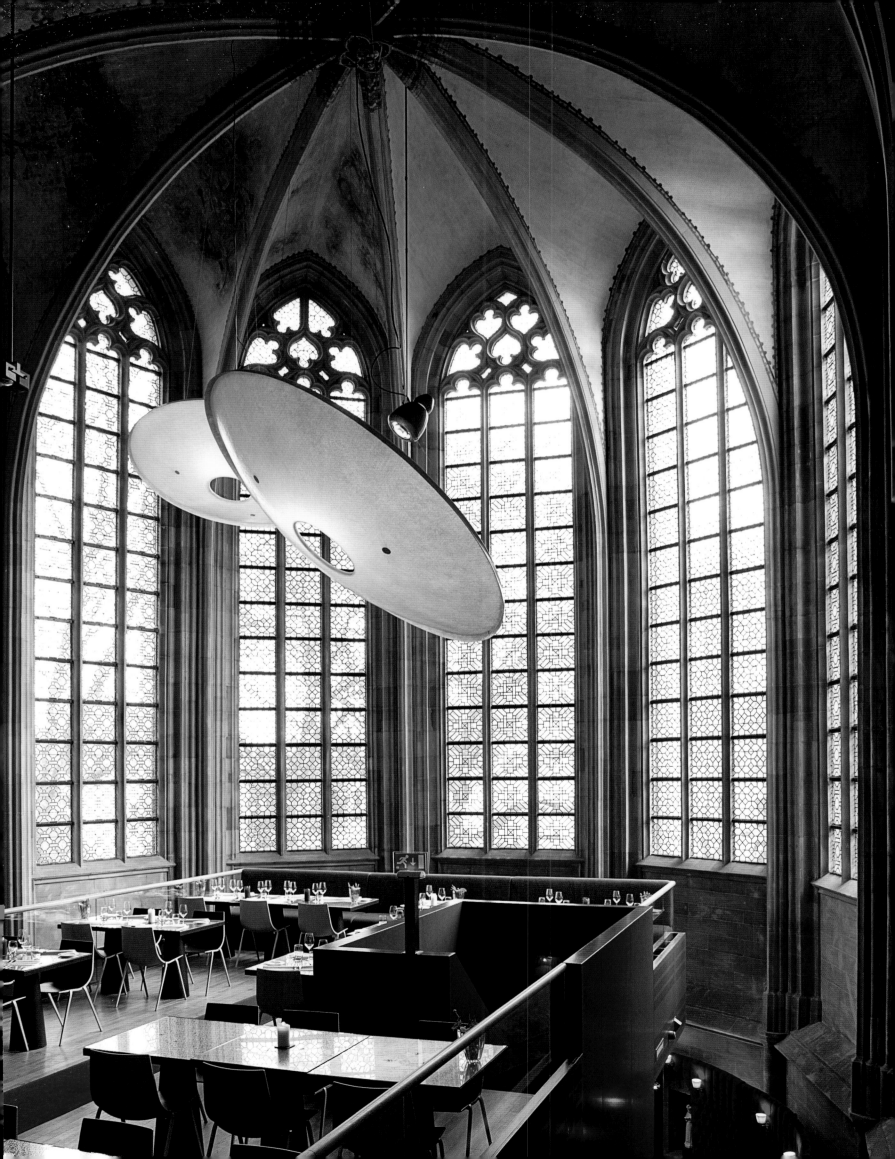

Featuring classic design accents, the 60 comfortable rooms have erased all traces of monastic asceticism.

Von klösterlicher Askese ist in den 60 komfortablen Zimmern, in denen einzelne Designklassiker Akzente setzen, nichts mehr zu spüren.

Rien de l'ascétisme monacal n'a été conservé dans les 60 chambres confortables, où différents classiques du design sont désormais mis en scène.

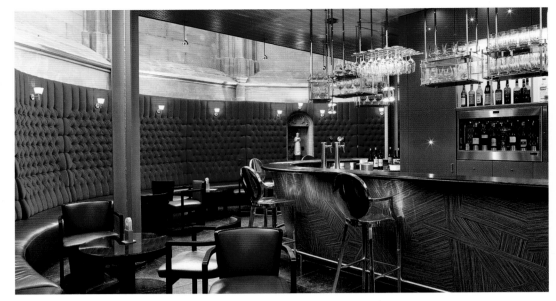

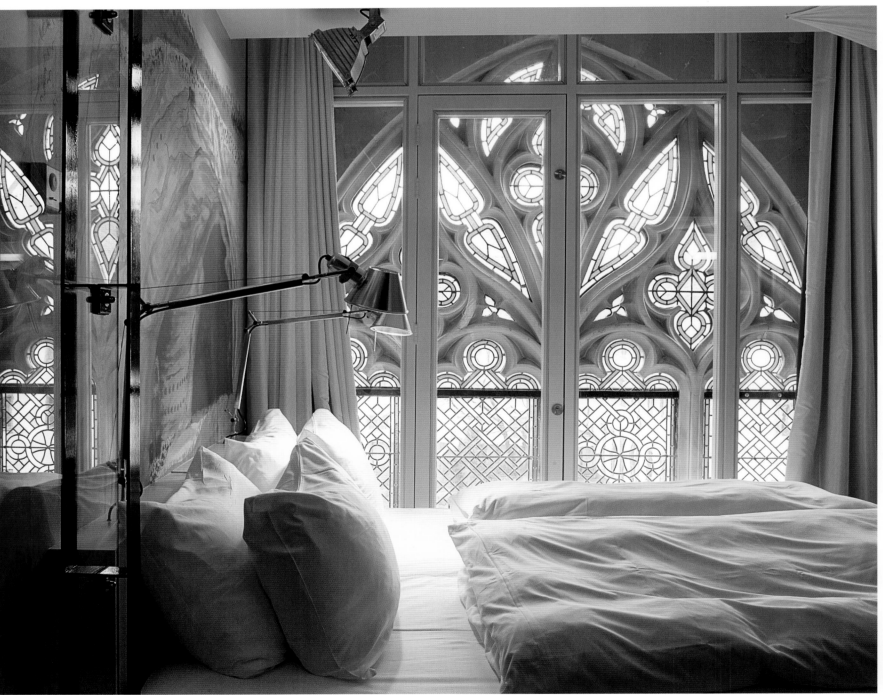

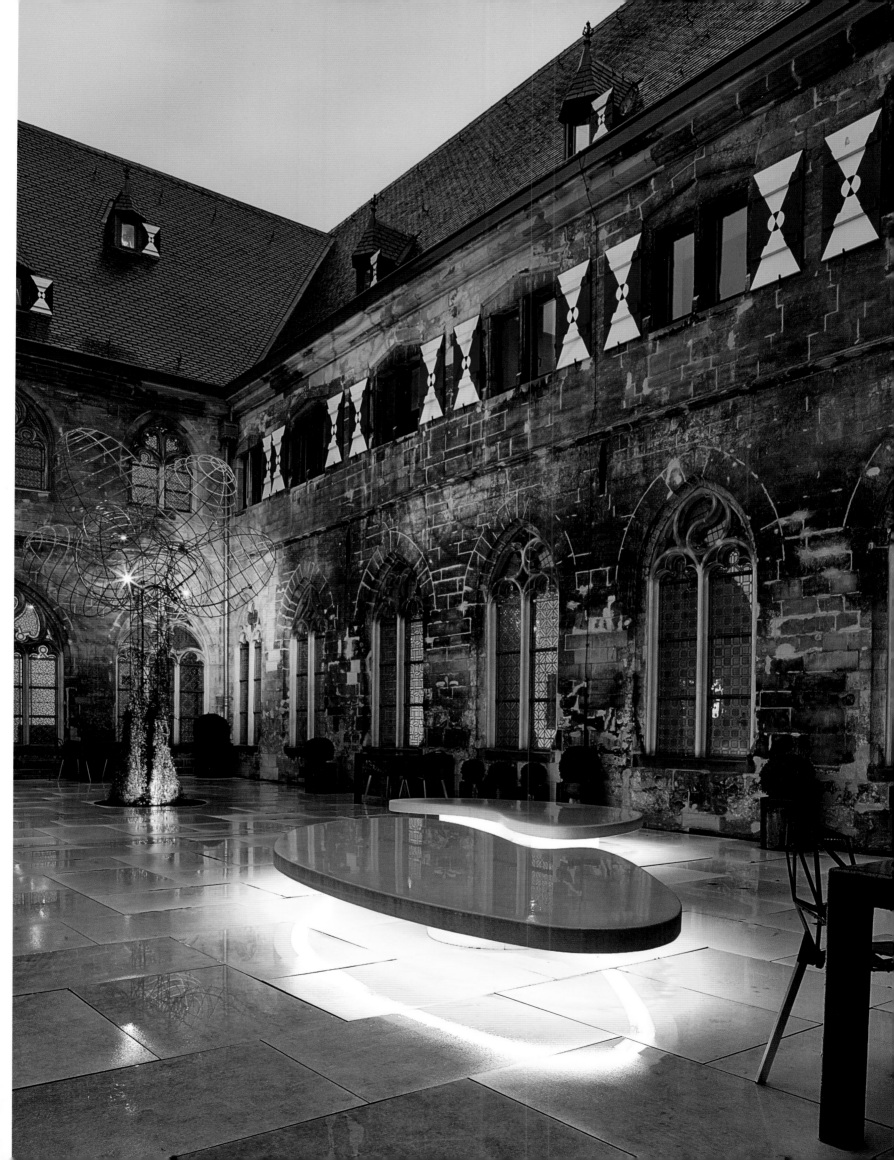

Hotel Amigo

Brussels, Belgium

Misunderstandings can sometimes have a touch of irony. The people of Brussels were amused by the fact that the reviled Spanish rulers translated the Flemish name of the building, which served as a prison in the 16th century, as "friend." As a result, the name Amigo continues to adorn the imposing, red brick building with the Renaissance façade, only a few steps away from Brussels' famous Grand Place. Since its renovation in 2002 by the Rocco Forte Group, this distinguished luxury hotel no longer harbors any traces whatsoever of its former function. Designer Olga Polizzi has clearly left her mark, lending the 188-room building an air of elegant, contemporary understatement. Traditional Flemish elements, such as the authentic Brussels paving stone in the lobby or the valuable Gobelins on the walls, set a special tone.

Missverständnisse können manchmal eine feine Ironie haben. Den Brüsselern gefiel es, dass die ungeliebten spanischen Machthaber den flämischen Namen des Hauses, das im 16. Jahrhundert als Gefängnis diente, mit „Freund" übersetzten. Und so ist der Name Amigo dem stattlichen roten Backsteinhausbau mit der Renaissancefassade, nur wenige Schritte entfernt von Brüssels berühmtem Grand Place, erhalten geblieben. An seine frühere Bestimmung erinnert in dem distinguierten Luxushotel seit der aufwändigen Renovierung 2002 durch die Rocco Forte-Gruppe rein gar nichts mehr. Unübersehbar ist die Handschrift der Designerin Olga Polizzi, die dem 188-Zimmer-Haus ein elegantes, zeitgemäßes Understatement verlieh. Traditionelle flämische Elemente wie der authentische Brüsseler Pflasterstein in der Lobby oder wertvolle Gobelins an den Wänden setzen besondere Akzente.

Parfois, les malentendus peuvent avoir une ironie raffinée. En tout cas, les Bruxellois eurent leur plaisir à ce que les dirigeants espagnols, qu'ils n'aimaient pas du tout, traduisirent le nom flamand de l'établissement, qui servait de prison au XVIe siècle, par « ami ». Et c'est ainsi que ce majestueux bâtiment en briques de terre cuite avec façade style Renaissance, qui est situé à quelques pas seulement de la célèbre Grand Place de Bruxelles, a conservé jusqu'à ce jour le nom « Amigo ». Cependant, depuis la rénovation extensive réalisée en 2002 par le groupe Rocco Forte, rien, absolument plus rien ne rappelle l'ancienne destination de cet hôtel de luxe distingué. La signature de la styliste Olga Polizzi, qui a conféré à cette résidence de 188 chambres une élégance et une modernité empreintes d'understatement. Des éléments flamands traditionnels comme le pavé mosaïque bruxellois authentique dans le lobby ou des Gobelins précieux sur les murs attireront aussi l'attention particulière des hôtes.

Soft pastel tones characterize the warm, elegant style of the 188 rooms and suites.

Sanfte Pastelltöne bestimmen den warmen, eleganten Stil der 188 Zimmer und Suiten.

Le style chaleureux et élégant des 188 chambres et suites est déterminé par des tendres coloris pastel.

Meeting point for Brussels diplomats: lobby lounge and restaurant Le Verlaine.

Treffpunkt für Brüsseler Diplomaten: Lobby Lounge und Restaurant Le Verlaine.

Point de rencontre pour diplomates de Bruxelles : Lobby Lounge et Restaurant Le Verlaine.

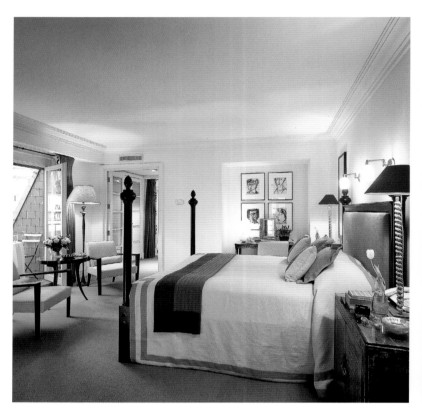

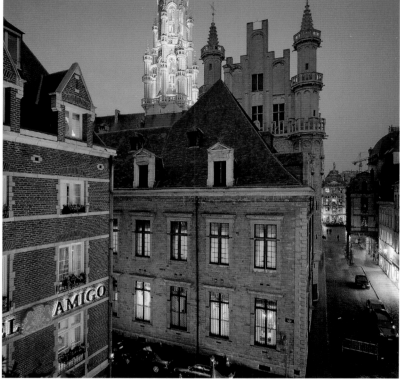

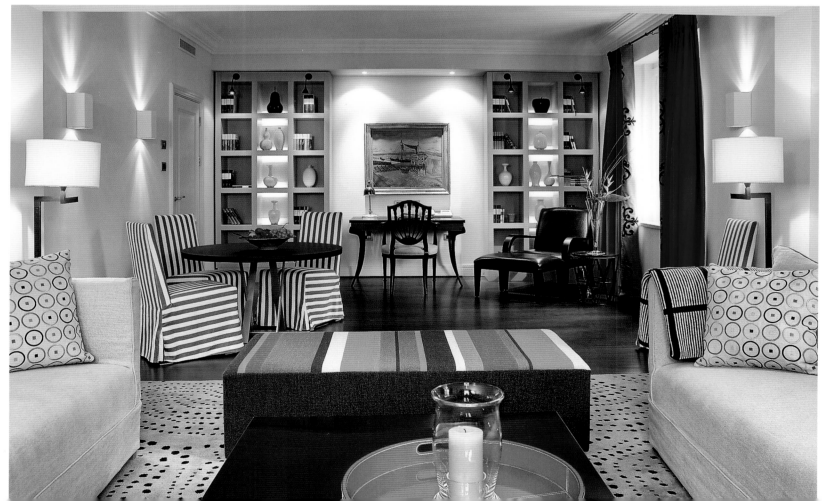

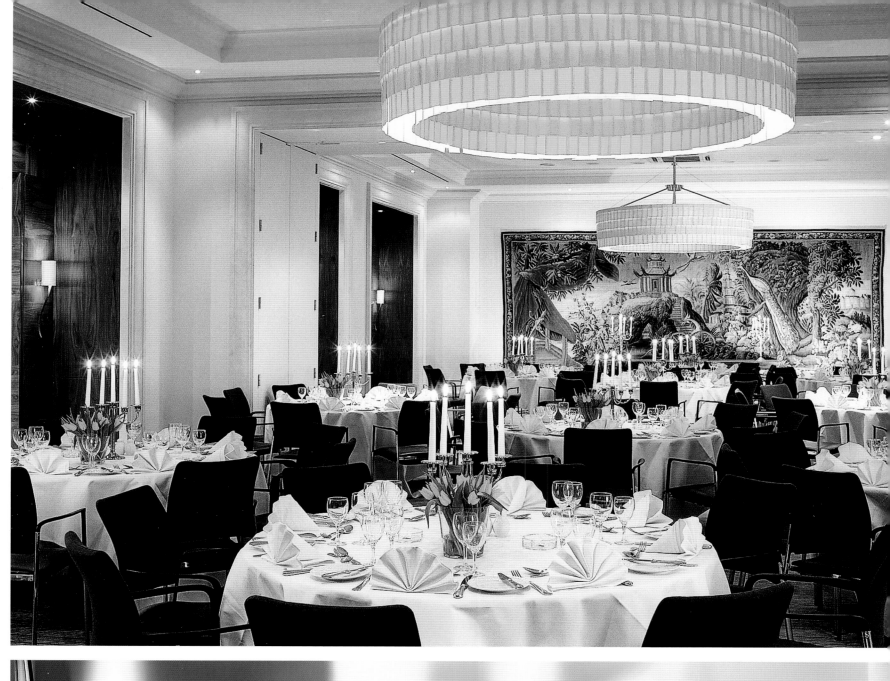

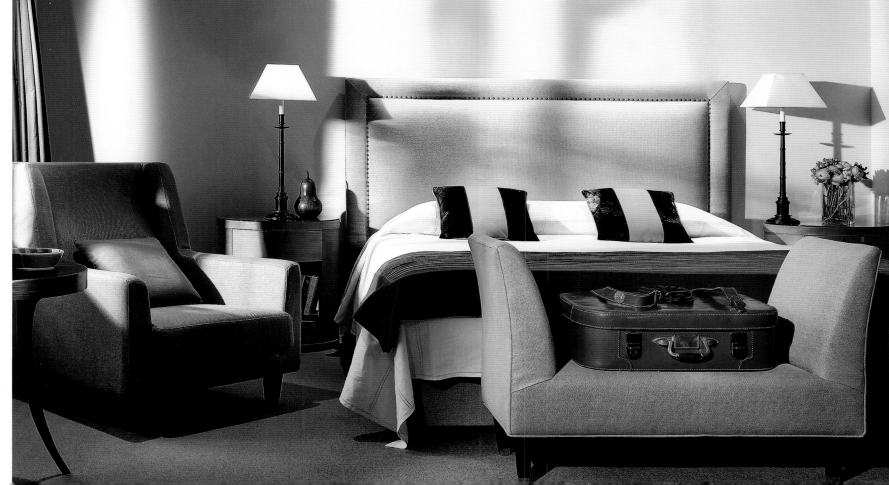

Manoir de Lébioles

Spa, Belgium

In 1910, diplomat Georges Neyt built his own personal "little Versailles of the Ardennes" just outside the town of Spa. Situated on a slight rise with a marvelous view of the Ardennes forest, this Neo-Renaissance mansion was a family estate for many years before it was converted into a hotel. However, it was only after Anne Lüssem, an entrepreneur from Aachen, Germany, acquired the estate and renovated it with such great care in 2006 that it regained its original purpose as an elegant sanctuary.

Vor den Toren Spas baute sich der Diplomat Georges Neyt 1910 sein ganz persönliches „kleines Versailles in den Ardennen" auf eine lichte Anhöhe mit Traumblick über den Ardenner Mischwald. Das Herrenhaus im Neorenaissance-Stil diente viele Jahre als Familiensitz, bevor es zum Hotel wurde. Aber erst seit die Aachener Unternehmerin Anne Lüssem das Anwesen erwarb und es 2006 mit feinem Gespür renovierte, wird es seiner ursprünglichen Bestimmung als elegantes Refugium wieder gerecht.

En 1910, le diplomate Georges Neyt s'est construit son propre « petit Versailles ardennais » aux portes de Spa, sur une colline baignée de lumière jouissant d'une vue magnifique sur la forêt mixte des Ardennes. Le manoir de style néo-renaissance a été la propriété de la famille pendant de nombreuses années avant de devenir un hôtel. Cependant, c'est seulement depuis que l'entrepreneuse Anne Lüssem, originaire d'Aix-la-Chapelle, a acquis la propriété et l'a habilement rénové en 2006 qu'il fait de nouveau honneur à son rang et son élégance d'origine.

Depending on the weather, guests might choose to relax in cozy armchairs in front of an open fireplace or on the spacious terrace.

Je nach Wetterlage laden behagliche Sessel vorm offenen Kamin oder die weitläufige Terrasse zu entspannenden Mußestunden ein.

Selon le temps, on se détend dans de confortables fauteuils devant la cheminée ou sur la spacieuse terrasse à ses heures perdues.

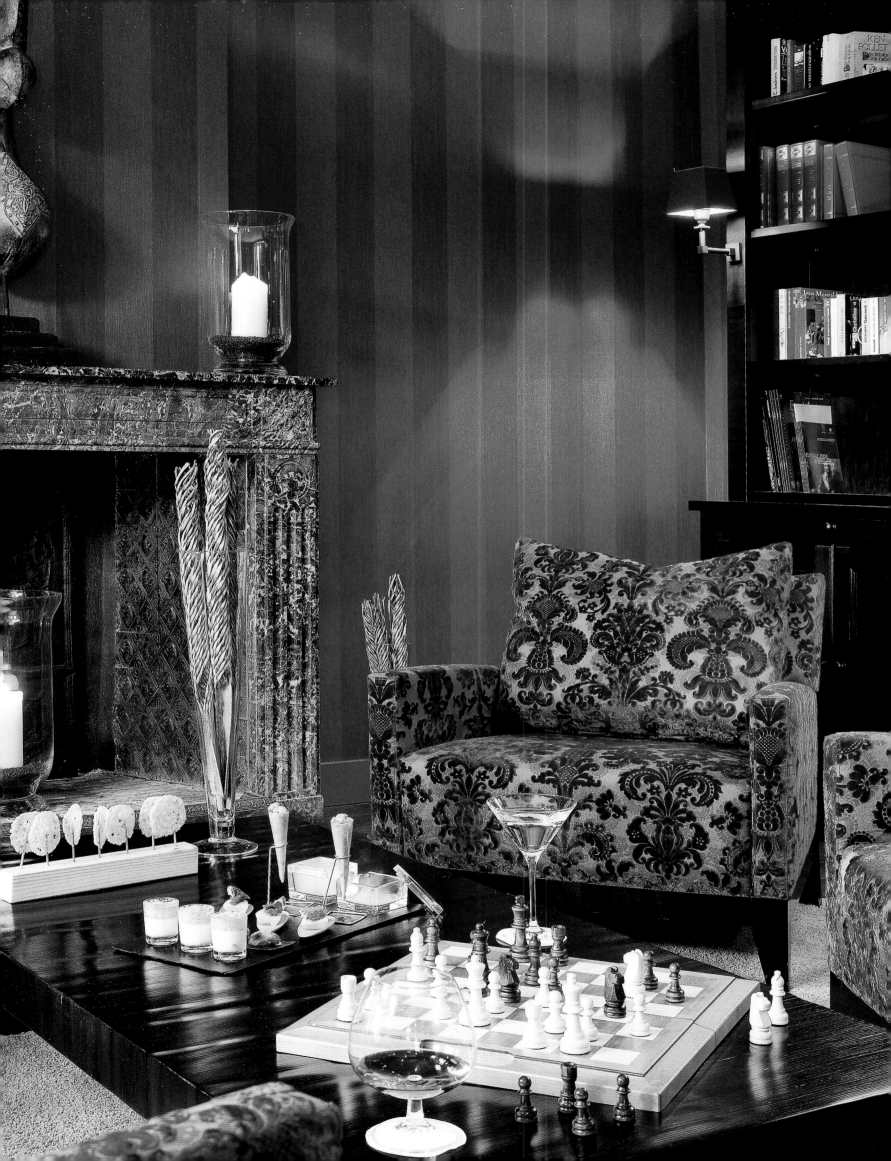

The 16 rooms and suites were individually furnished. The timelessly elegant style and warm colors complement the historic walls.

Die 16 Zimmer und Suiten wurden individuell eingerichtet. Der zeitlos-elegante Stil und die warmen Farben nehmen den historischen Mauern nichts von ihrer Wirkung.

Les 16 chambres et suites ont été aménagées de manière personnalisée. Le style élégant et intemporel et les tons chaleureux n'enlèvent rien au charme des murs anciens.

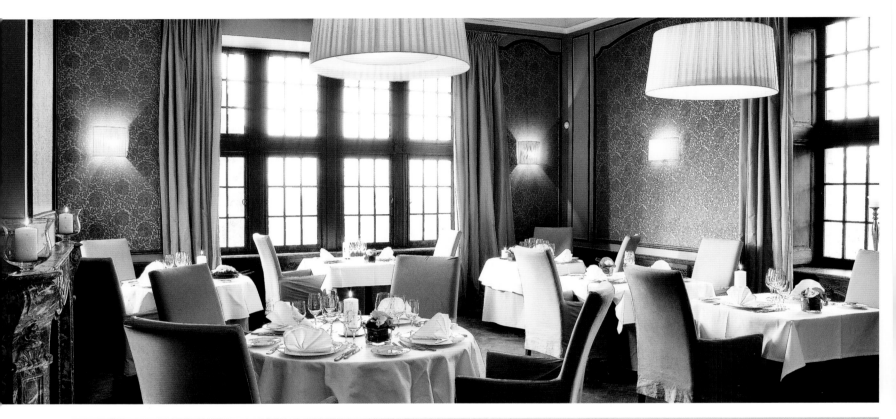

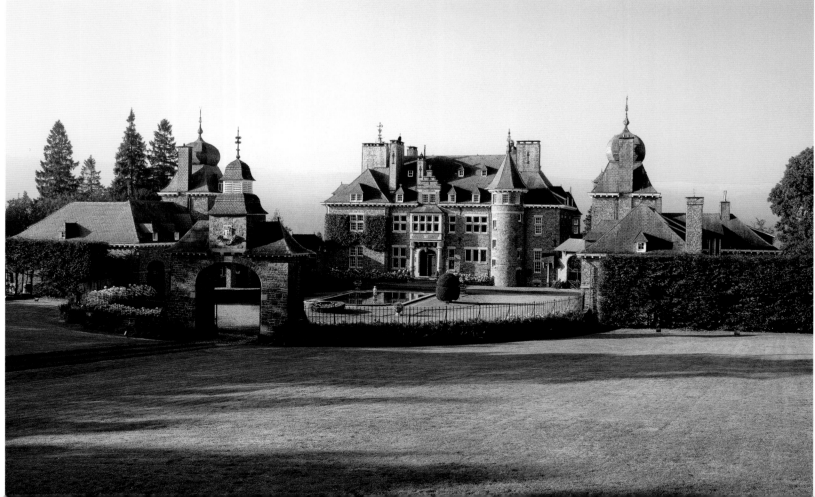

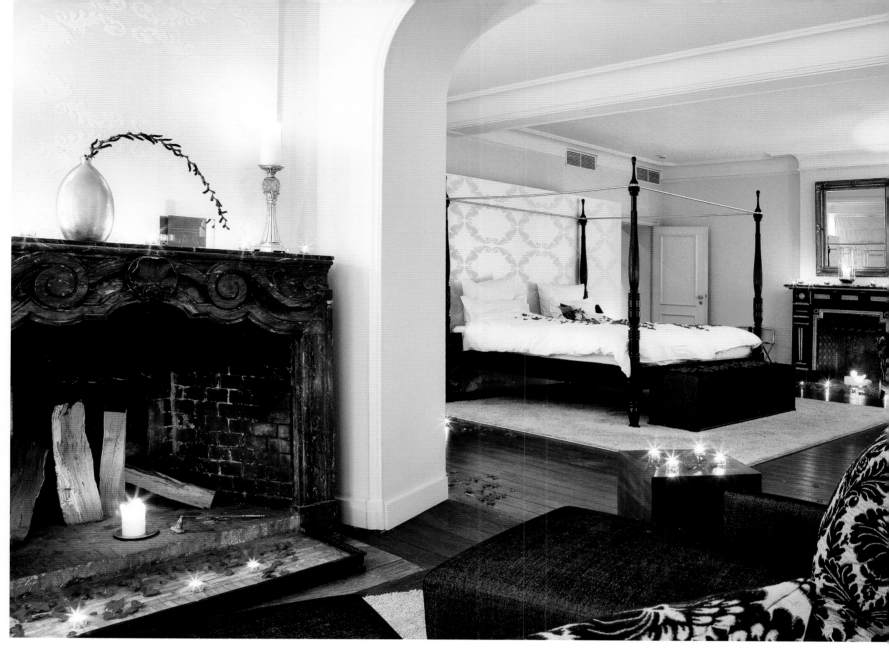

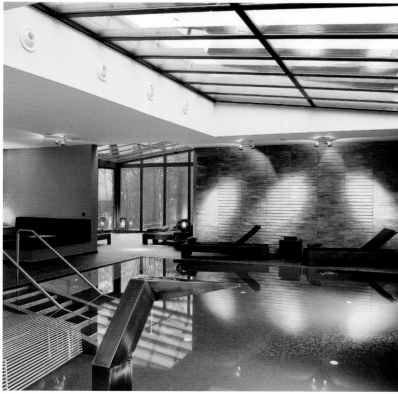

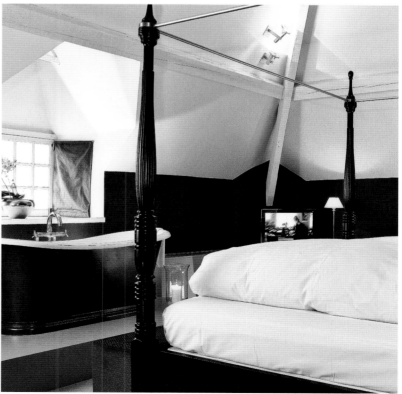

Regent Berlin

Berlin, Germany

The location on what is perhaps Berlin's most beautiful square, the Gendarmenmarkt, is first class, and the interior is flawlessly elegant. Yet the greatest asset offered by the Regent Berlin is the discretion and the personal service with which famous guests from the world of entertainment, business, and politics are cared for. Seeing and being seen is simply not an option here. Gourmet restaurant Fischers Fritz offers consistently high quality and has maintained its two Michelin stars for years.

Die Lage an Berlins vielleicht schönstem Platz, dem Gendarmenmarkt, ist erstklassig, das Interieur makellos elegant. Der größte Pluspunkt des Regent Berlin ist jedoch die Diskretion und der persönlich-familiäre Service, mit dem die berühmten Gäste aus Showbiz, Wirtschaft und Politik umsorgt werden. Sehen und Gesehenwerden ist hier definitiv keine Option. Gleichbleibend hohe Qualität bietet das Gourmet-Restaurant Fischers Fritz, das seit Jahren seine zwei Michelin-Sterne behaupten kann.

Cet hôtel bénéficie d'une situation idéale sur la place du Gendarmenmarkt, considérée comme l'une des plus belles de Berlin, et son intérieur est d'une élégance immaculée. Le plus grand atout du Regent Berlin reste cependant la discrétion ainsi que le service personnalisé et familial dont bénéficient toutes les célébrités du show-business, de l'économie et de la politique, qui peuvent aller et venir sans crainte d'être dérangées. Le restaurant gastronomique Fischers Fritz, décoré de deux étoiles Michelin depuis de nombreuses années, propose une cuisine à la qualité jamais démentie.

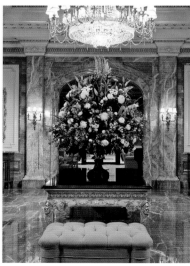

Guests lucky enough to stay in the Presidential Suite on the 8th floor can enjoy a spectacular view of the Gendarmenmarkt and the French Dome.

Den glücklichen Bewohnern der Präsidenten-Suite in der achten Etage bietet sich ein Traumblick auf den Gendarmenmarkt und den Französischen Dom.

Les heureux résidents de la suite présidentielle du huitième étage peuvent admirer la vue magnifique sur le Gendarmenmarkt et le Französischer Dom (cathédrale française).

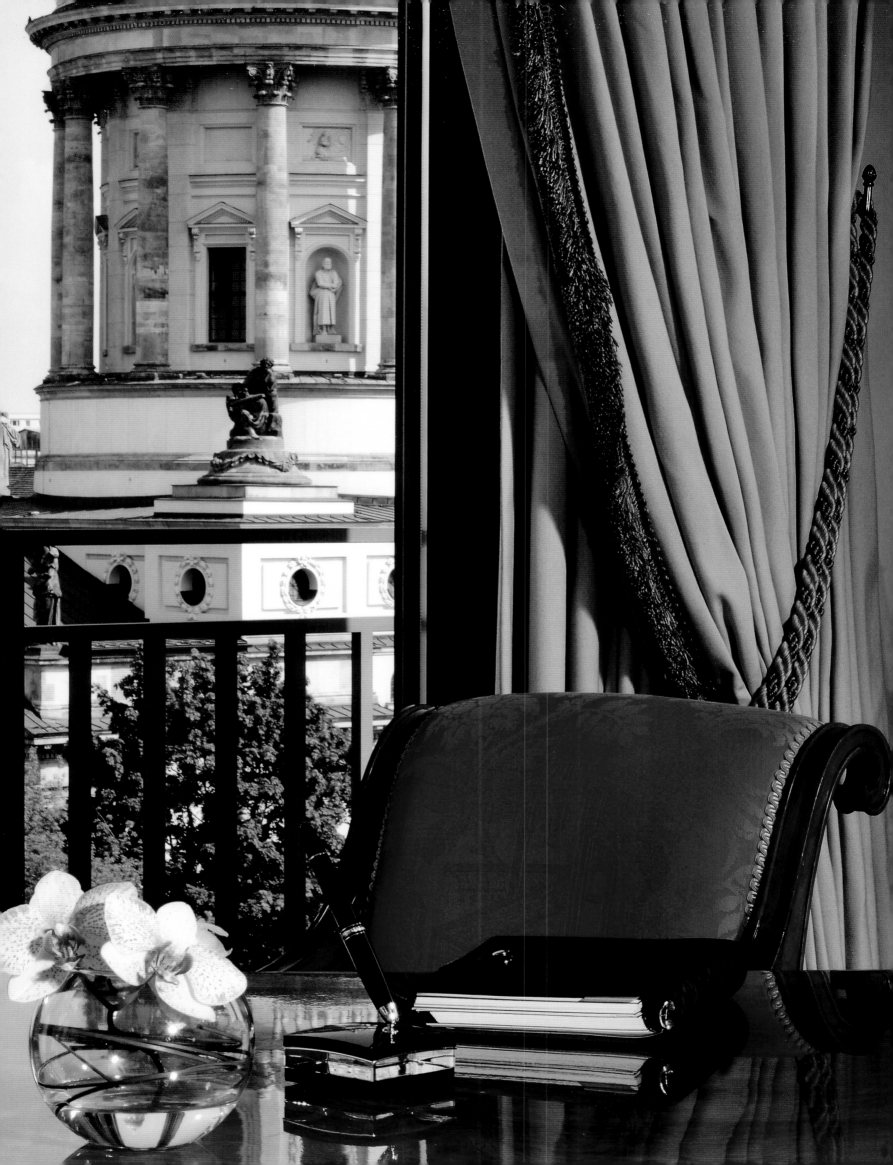

Valuable Biedermeier furniture lends sophistication to the ambience in the 156 rooms and 39 suites.

Wertvolle Biedermeiermöbel veredeln das Ambiente in den 156 Zimmern und 39 Suiten.

De précieux meubles Biedermeier subliment l'ambiance des 156 chambres et 39 suites.

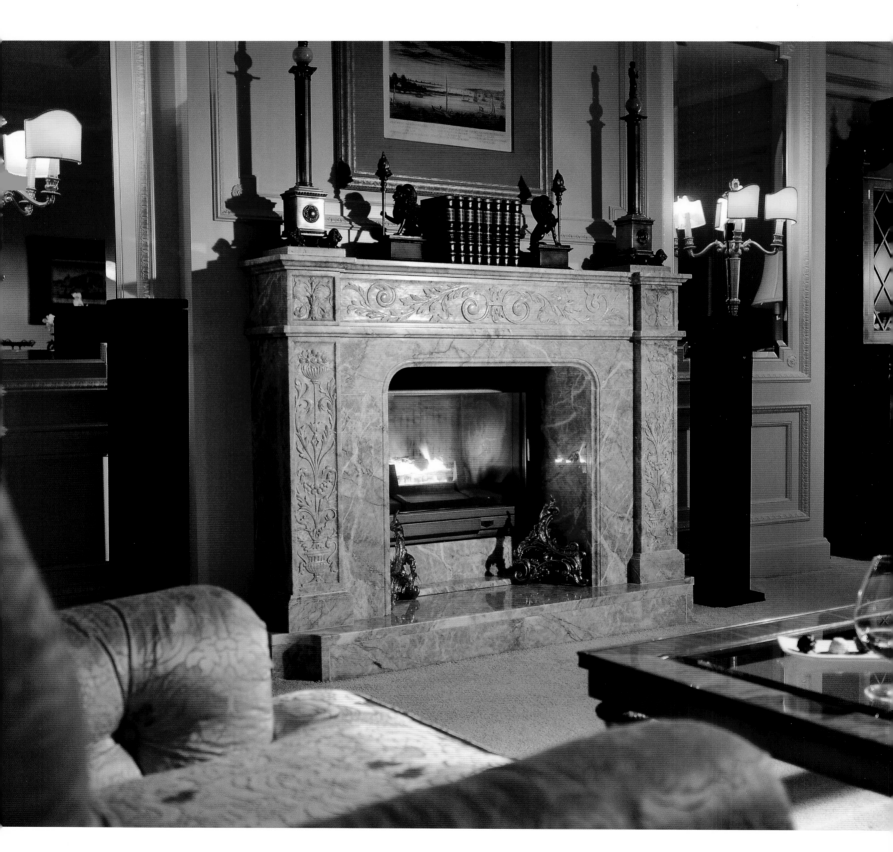

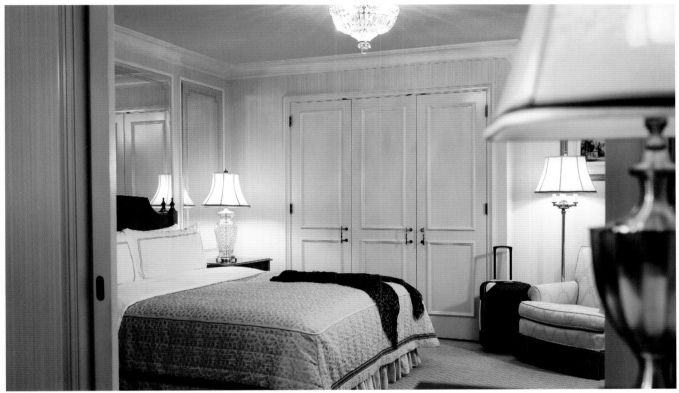

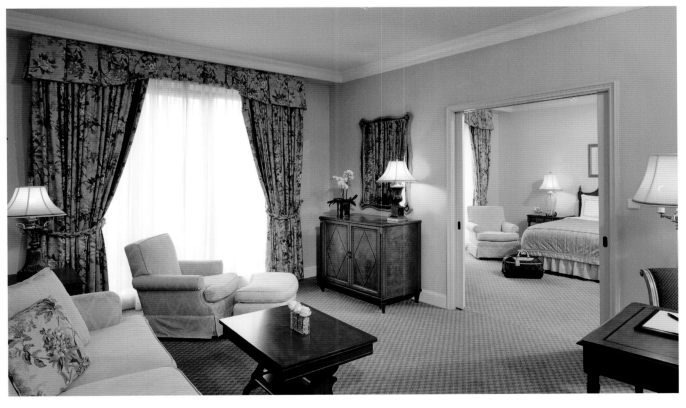

Zur Bleiche Resort & Spa

Burg im Spreewald, Germany

An island of tranquility in the middle of the Spreewald, this expansive hotel complex is only an hour's drive from Berlin. It offers the epitome of relaxation to both conference participants and weekend vacationers. The wellness offerings have been gradually expanded in recent years, culminating in the construction of a separate 25,000-square-foot bathhouse in the shape of a barn. Guests can enjoy massages or medicinal baths in the Jungbrunnen Spa, swim laps in the pool, or unwind in the fireplace room. The rooms of this country hotel are generous in size and feature an appealing design symbiosis between contemporary and rustic elements.

Eine Insel der Ruhe, mitten im Spreewald. Nur eine Fahrtstunde ist es von Berlin hierher, in das großzügige Hotelareal, das Tagungsgästen wie Wochenendurlaubern vollendeten Genuss bietet. Schrittweise wurde in der vergangenen Zeit vor allem das Wellness-Angebot ausgebaut. Glanzstück ist ein separates, 2 400 Quadratmeter großes Badehaus im Stil einer Scheune. Dort können sich die Gäste im Jungbrunnen Spa mit Massagen oder Heilwannenbädern verwöhnen lassen, im Pool ihre Bahnen schwimmen oder im Kaminzimmer ausspannen. Die Zimmer des Landhotels sind groß und in einer gelungenen, modern-rustikalen Symbiose gestaltet.

Une oasis de paix, au milieu de la Spreewald. A une heure de trajet de Berlin seulement, le complexe spacieux de l'hôtel offre à des hôtes de séminaires comme à des vacanciers du week-end un plaisir inégalé. Pas à pas, l'offre wellness en premier lieu a été élargie. Le point phare est une maison de bains séparée d'une superficie de 2 400 mètres carrés conçue sous la forme d'une grange. Là, les invités pourront se laisser cajoler dans le Jungbrunnen (« bain de jouvence ») Spa en recevant massages ou bains pleins de bienfaits, faire leurs brasses dans la piscine ou simplement se détendre devant la cheminée. Les chambres de l'hôtel campagnard sont spacieuses et conçues dans une symbiose moderne rustique très réussie.

 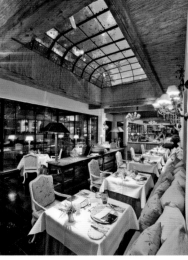

A country house style, designed in a modern way and enhanced by fine textiles and upholstery—that is the concept of the interior design.

Landhausstil, zeitgemäß umgesetzt und ergänzt durch feine Textilien und Polster — so sieht das Interieurkonzept aus.

Le concept de l'intérieur se décline comme suit : style campagnard, réalisé de manière intemporelle et complété par des textiles et des divans très raffinés.

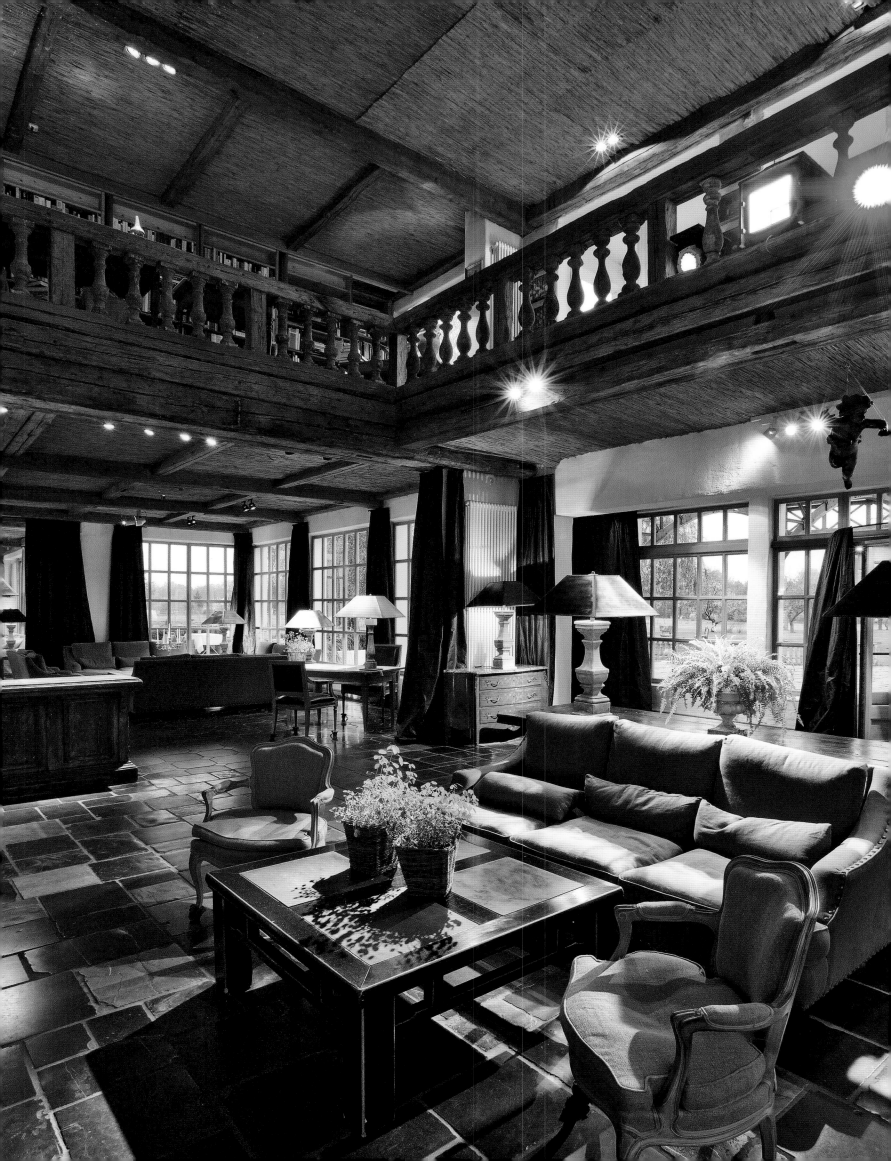

In a bath and wellness building, various beauty treatments and fitness programs are offered.

In einem Bade- und Wellnesshaus werden verschiedene Beauty-Behandlungen und Fitness-Programme angeboten.

Différents soins de beauté et des programmes de fitness sont proposés à la Maison de bains et de bien-être.

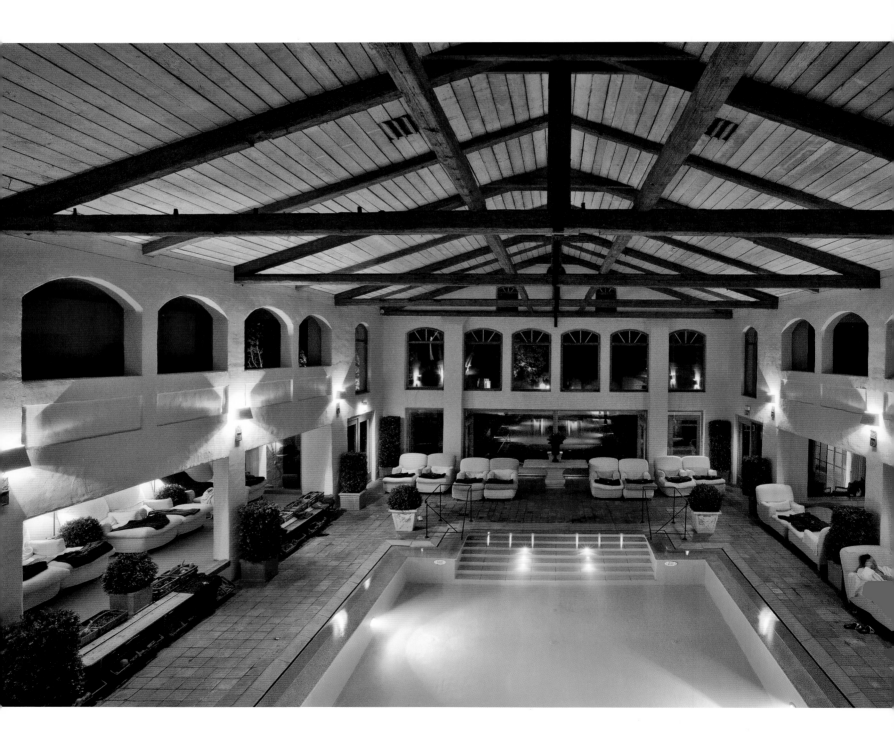

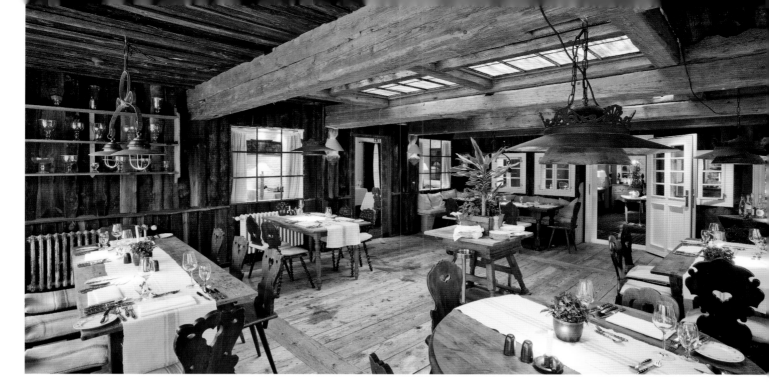

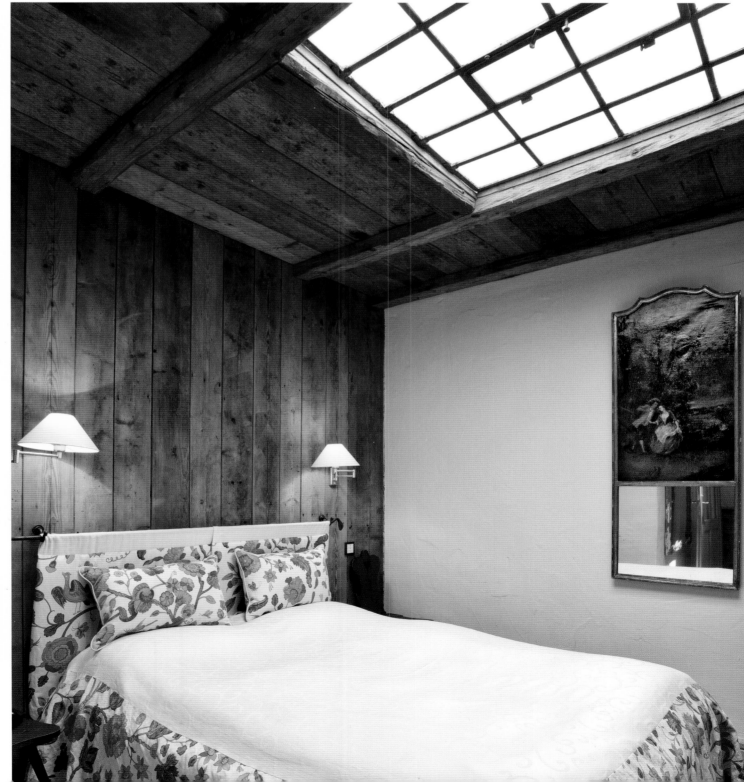

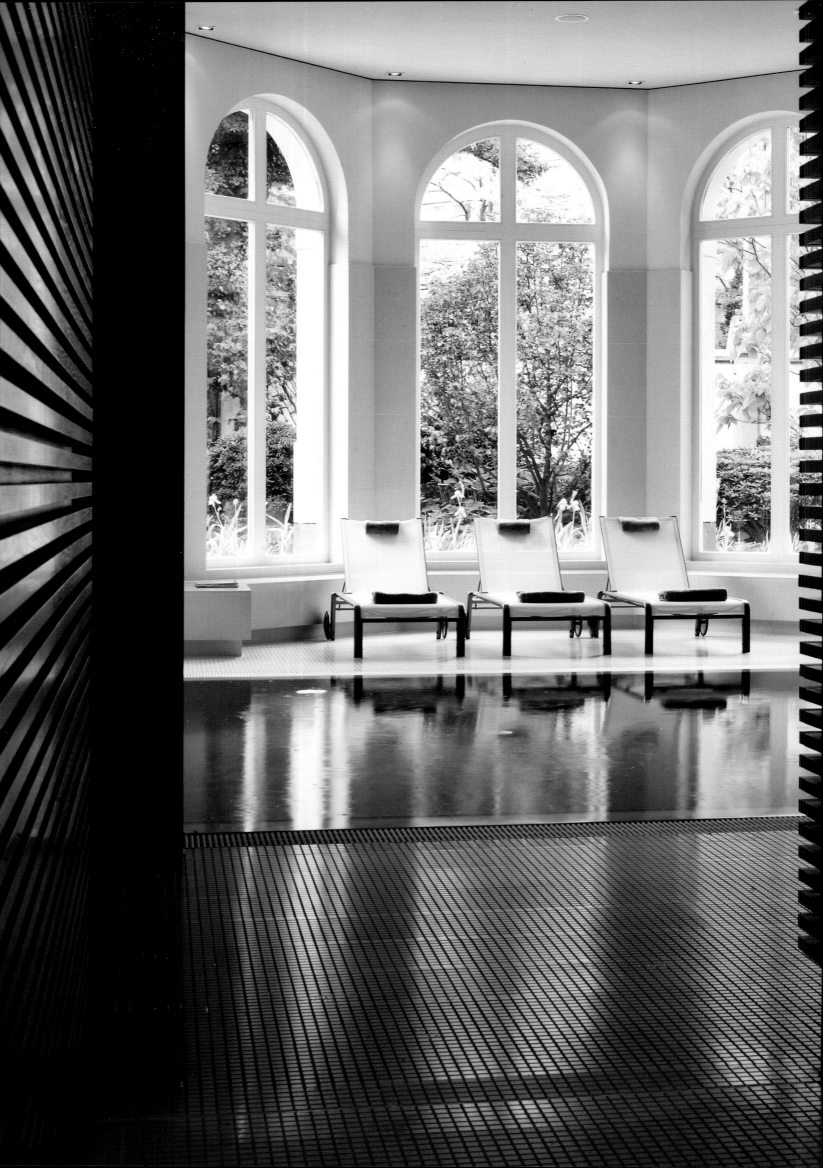

Villa Kennedy

Frankfurt, Germany

In the brief time since its opening in 2006, Sir Rocco Forte's Villa Kennedy has become the poshest address in this city on the River Main. The heart of the 163-room hotel (including 29 suites) is the historical Villa Speyer that was built for a Frankfurt banker family in 1904. The three new wings are grouped around a quiet, landscaped inner courtyard with restaurant terrace. Exquisite materials and discreet elegance characterize the interior design. The spa with its 50-foot pool offers the perfect place to relax.

In der kurzen Zeit seit ihrer Eröffnung 2006 ist Sir Rocco Fortes Villa Kennedy zur nobelsten Adresse der Mainmetropole avanciert. Kernstück des 163-Zimmer-Hotels (inklusive der 29 Suiten) ist die historische Villa Speyer, die 1904 für eine Frankfurter Bankiersfamilie erbaut wurde. Drei neue Flügelanbauten gruppieren sich um einen ruhigen, grünen Innenhof mit Restaurantterrasse. Edle Materialen und zurückhaltende Eleganz prägen den Interieur-Stil. Entspannung bietet der Spa mit seinem 15-Meter-Pool.

La Villa Kennedy de Sir Rocco Fortes est devenue l'une des adresses les plus chics de la métropole du Main, malgré le peu de temps qui s'est écoulé depuis son ouverture en 2006. Le cœur de cet hôtel de 163 chambres (dont 29 suites) est la Villa Speyer, construite en 1904 pour une famille de banquiers de Francfort. Trois nouvelles ailes sont regroupées autour d'une cour intérieure verte paisible, avec un restaurant en terrasse. Des matériaux nobles et une élégance discrète dominent à l'intérieur. Le spa, avec sa piscine de 15 mètres de long, permet de se relaxer.

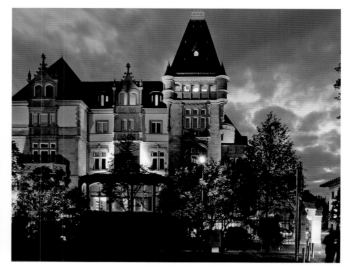

Completely secluded, the garden can only be reached from the spa—an oasis of peace in the heart of the city on the River Main.

Völlig abgeschirmt ist der Garten, den man nur vom Spa aus erreicht — eine Oase der Ruhe mitten in der Mainmetropole.

Le jardin, auquel on ne peut accéder que depuis le spa, est entièrement clos. C'est un havre de paix en plein cœur de la métropole du Main.

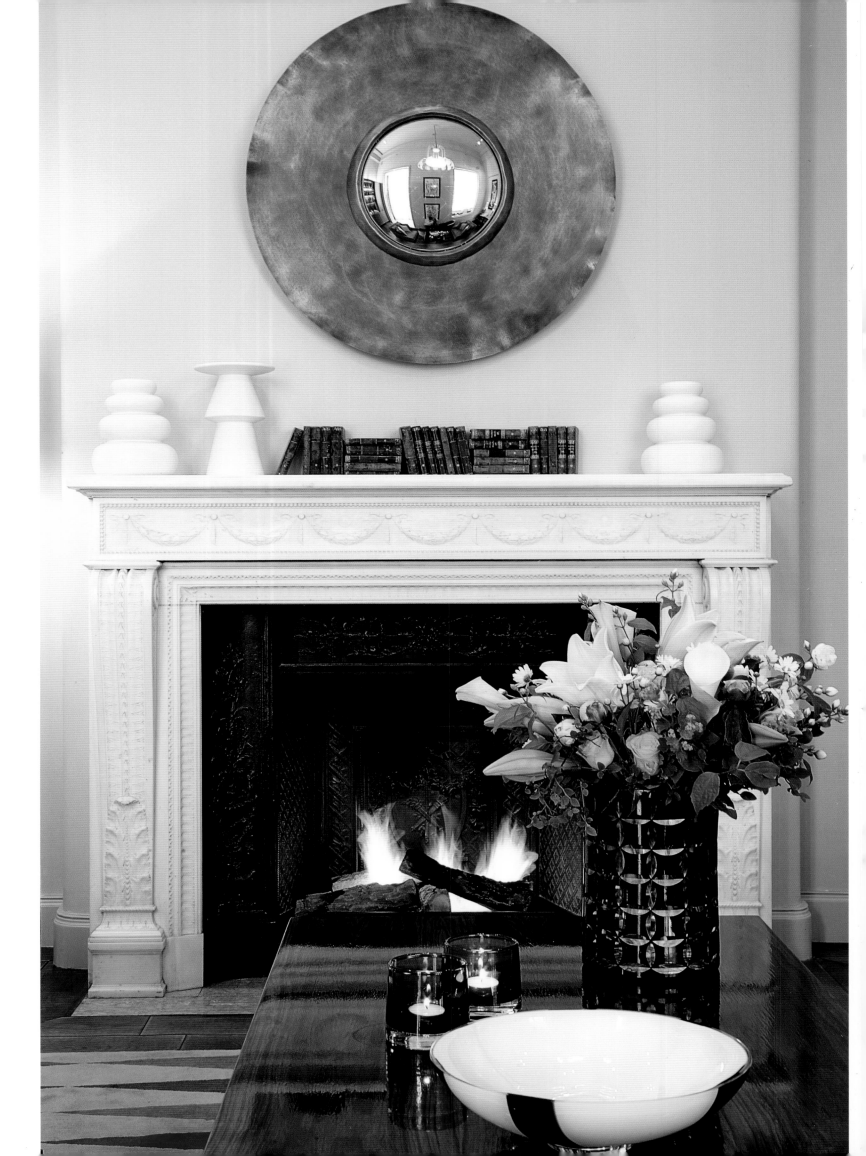

The 3,500-square-foot Presidential Suite resembles a sophisticated contemporary salon.

Wie ein anspruchsvoller zeitgemäßer Salon wurde die 326 Quadratmeter große Präsidentensuite gestaltet.

La suite présidentielle d'une surface de 326 mètres carrés a été aménagée comme un prestigieux salon contemporain.

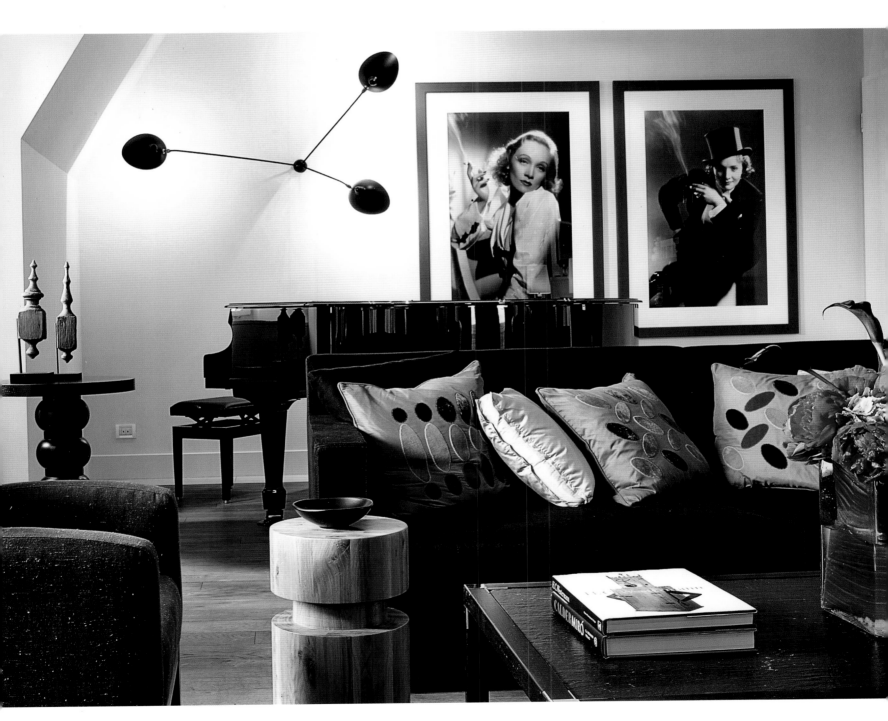

Bayerischer Hof

Munich, Germany

Desiring to create accommodations for high-ranking guests, in 1839, King Ludwig I commissioned Friedrich von Gärtner to build the Bayerischer Hof on Promenade-platz in the heart of Munich. In 1972, the adjacent Palais Montgelas became part of the hotel, whose guest list reads like a Who's Who. Since only those who don't rest on their laurels are truly successful, general manager Innegrit Volkhardt—the fourth generation Volkhardt to run the hotel—had French star designer Andrée Putman build the Blue Spa on top of the hotel, complete with an elegant rooftop terrace from which the towers of the Frauenkirche seem just an arm's reach away.

Der Wunsch von König Ludwig I. nach einer Unterkunft für hochrangige Gäste stand hinter dem Auftrag an Friedrich von Gärtner im Jahr 1839, am Münchner Promenadeplatz dieses Hotel zu errichten. Das angrenzende Palais Montgelas vergrößerte im Jahr 1972 den Bayerischen Hof noch, und die Gäste sind nicht weniger illuster. Weil Erfolg nur hat, wer sich ständig weiterentwickelt, ließ Innegrit Volkhardt, die das Haus in vierter Generation führt, von der französischen Stardesignerin Andrée Putman den Blue Spa aufs Dach bauen, samt einer schicken Dachterrasse, von der die Türme der Frauenkirche zum Greifen nah erscheinen.

La mission confiée à Friedrich von Gärtner en 1839 d'ériger un hôtel sur la Promenadeplatz de Munich résulte du souhait du roi Louis Ier de Bavière d'offrir un lieu de villégiature à ses invités de haut rang. Le palais adjacent de Montgelas permit d'agrandir l'hôtel en 1972, et les invités y sont toujours aussi illustres. Puisque succès rime avec amélioration constante, Innegrit Volkhardt, propriétaire de la quatrième génération, a demandé à la célèbre designer française Andrée Putman de construire le Blue Spa ainsi qu'une élégante terrasse sur le toit, depuis laquelle les tours de la Frauenkirche semblent si proches.

Located in the famed Mirror Hall under the atrium's dome, falk's Bar *is where the social life of the Bavarian capital plays out.*

Hier spielt sich das gesellschaftliche Leben der bayerischen Landes-hauptstadt ab — unter der Kuppel des Atriums mit der falk's Bar im berühmten Spiegelsaal.

C'est ici que se joue la vie mondaine de la capitale bavaroise — sous la coupole de l'atrium et au falk's Bar, dans la célèbre salle aux miroirs.

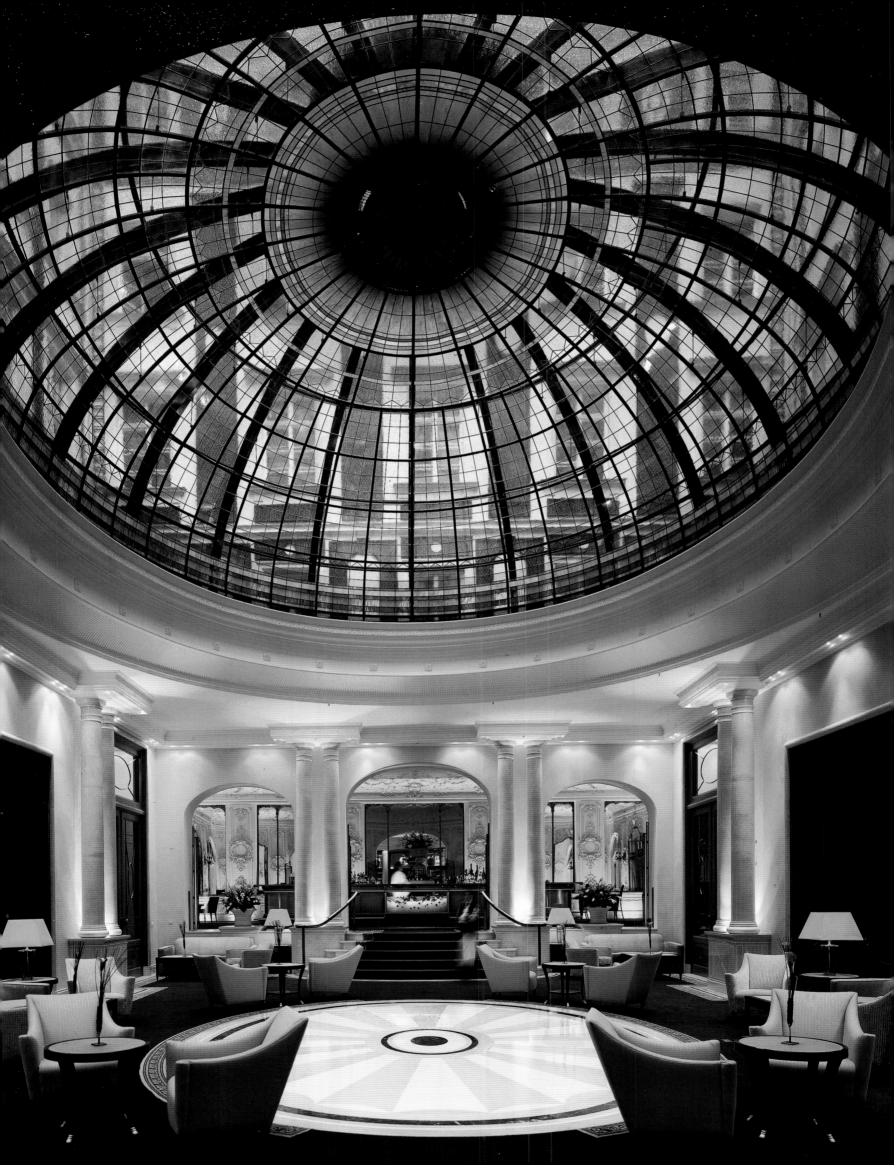

The structural engineers, among others, created a minor miracle when the Blue Spa was added to the roof of this historic building.

Nicht zuletzt waren es die Statiker, die ein kleines Wunder ermöglichten, als der Blue Spa auf das Dach des historischen Gebäudes gesetzt wurde.

Il faut noter la prouesse des ingénieurs qui ont réalisé un petit miracle : placer le Blue Spa sur le toit du bâtiment historique.

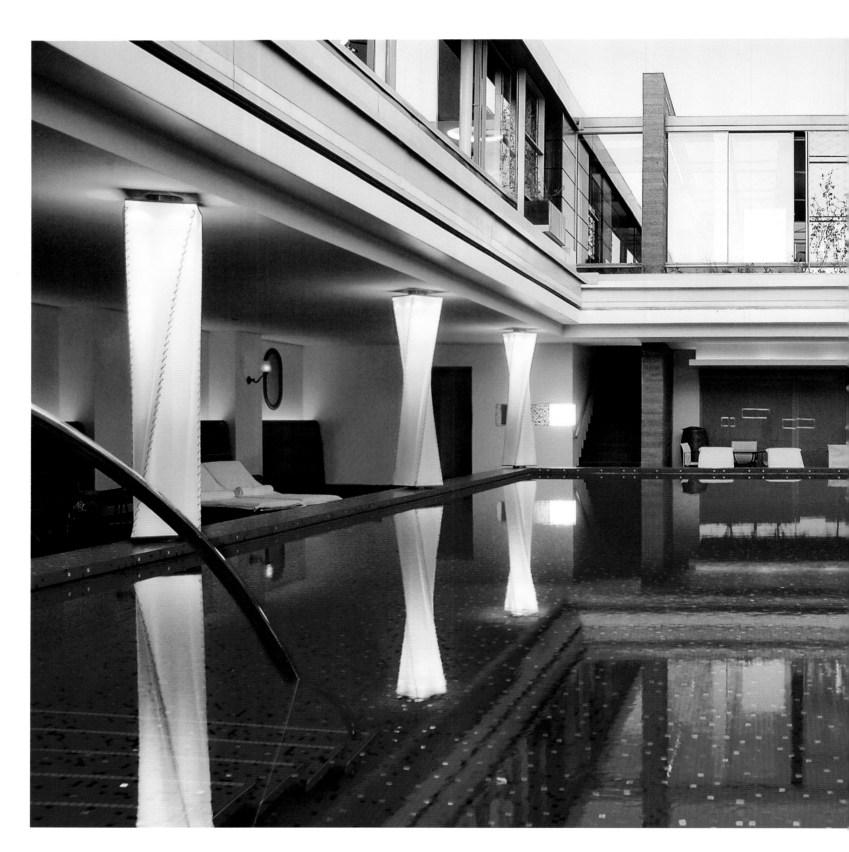

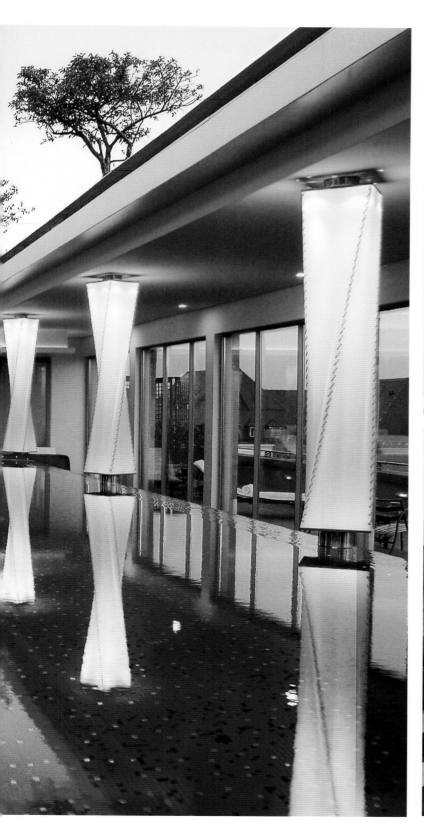

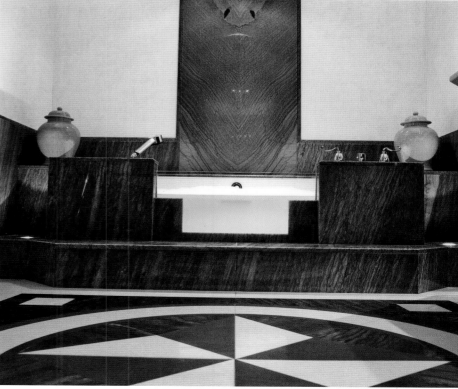

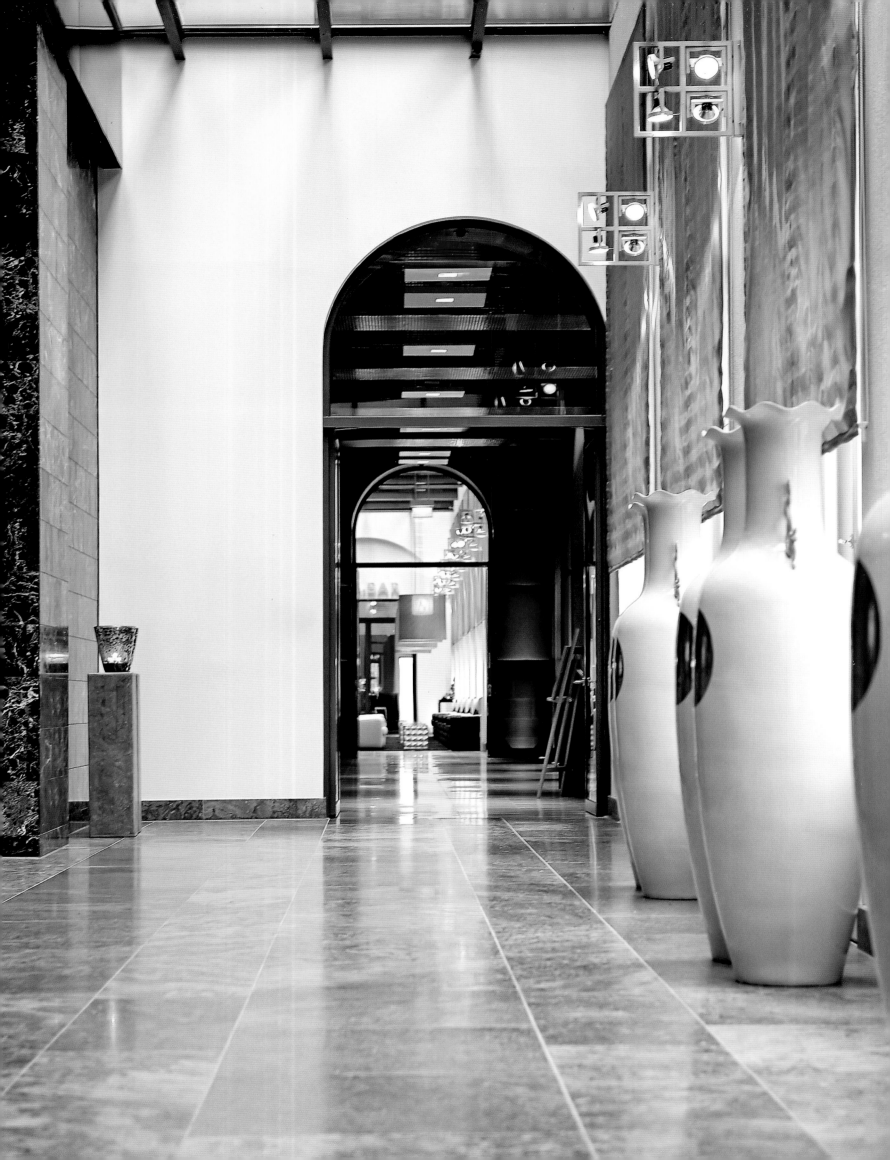

Sofitel Munich Bayerpost

Munich, Germany

The Royal Bavarian Postal Service was once the owner of this magnificent building near Munich Central Station, but no remnant of its previous history is visible in this landmarked building. The façade reflects the style of the Italian High Renaissance, yet it conceals a spacious modern atmosphere with an impressive 88-foot-high foyer. A unique lighting concept immerses the foyer in varying colors to create different moods. Expanses of paint, chrome, and glass underscore the modern look.

Die Königlich-Bayerische Post war einmal Hausherr in dem Prachtbau am Münchner Hauptbahnhof. Das sieht man dem denkmalgeschützten Gebäude heute nicht mehr an. Hinter der Fassade im Stil der italienischen Hochrenaissance erwartet Gäste ein großzügiges, modernes Ambiente mit einem eindrucksvollen, 27 Meter hohen Foyer. Ein einzigartiges Lichtkonzept taucht es in verschiedene Farben und erzeugt so unterschiedliche Stimmungen. Lack-, Chrom- und Glasflächen unterstreichen die moderne Anmutung.

Cela n'est peut-être plus visible aujourd'hui, mais par le passé, la poste royale de Bavière fut la propriétaire de ce somptueux bâtiment à côté de la gare de Munich, classé monument historique. Derrière la façade inspirée de la Haute Renaissance italienne, les invités découvriront une ambiance généreuse et moderne ainsi qu'un impressionnant foyer dont la hauteur atteint 27 mètres. Un concept lumineux unique permet de le faire apparaître sous différentes couleurs et ainsi de créer des atmosphères variées. Des surfaces de laque, de chrome et de verre viennent souligner l'impression générale de modernité.

Expansive spaces and high ceilings are what characterize the interior of this landmarked building. Half of the 339 rooms and 57 suites are located in a newly constructed wing.

Weite Flächen und hohe Räume bestimmen das denkmalgeschützte Gebäude im Innern. Die Hälfte der 339 Zimmer und 57 Suiten befinden sich in einem neu gebauten Flügel.

L'intérieur de cet édifice classé monument historique se caractérise par de vastes surfaces et des pièces hautes sous plafond. La moitié des 339 chambres et 57 suites se situe dans l'aile nouvellement construite.

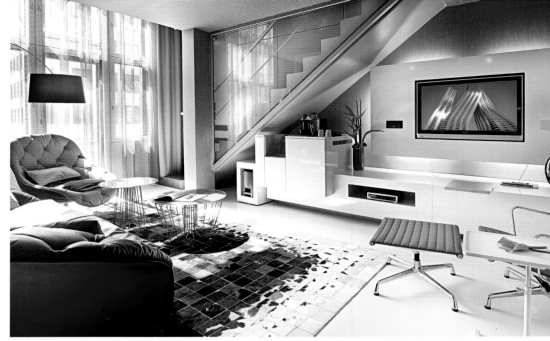

In the 1,800-square-foot Oyster Suite, an artistically distorted Statue of Liberty greets guests from the 140-square-foot video wall.

In der 175 Quadratmeter großen Oyster-Suite grüßt eine verfremdete Freiheitsstatue von der 13 Quadratmeter großen Monitorwand.

Dans la suite Oyster de 175 mètres carrés, une Statue de la Liberté détournée apparaissant sur un écran géant de 13 mètres carrés souhaite la bienvenue aux hôtes.

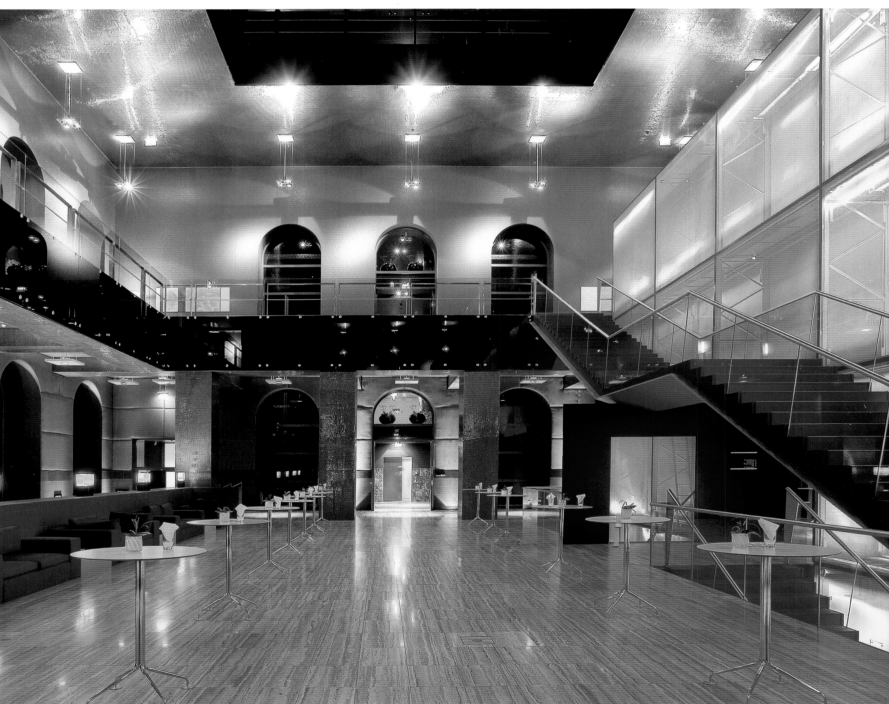

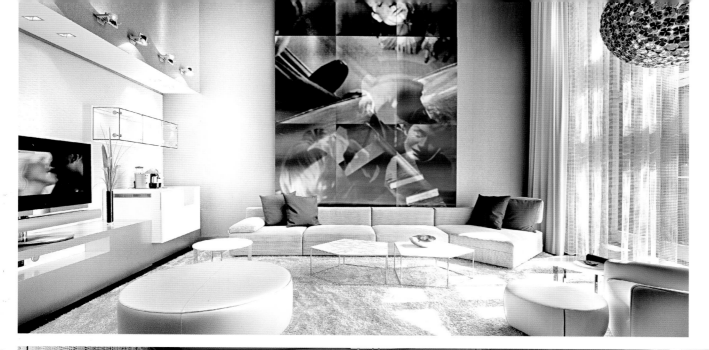

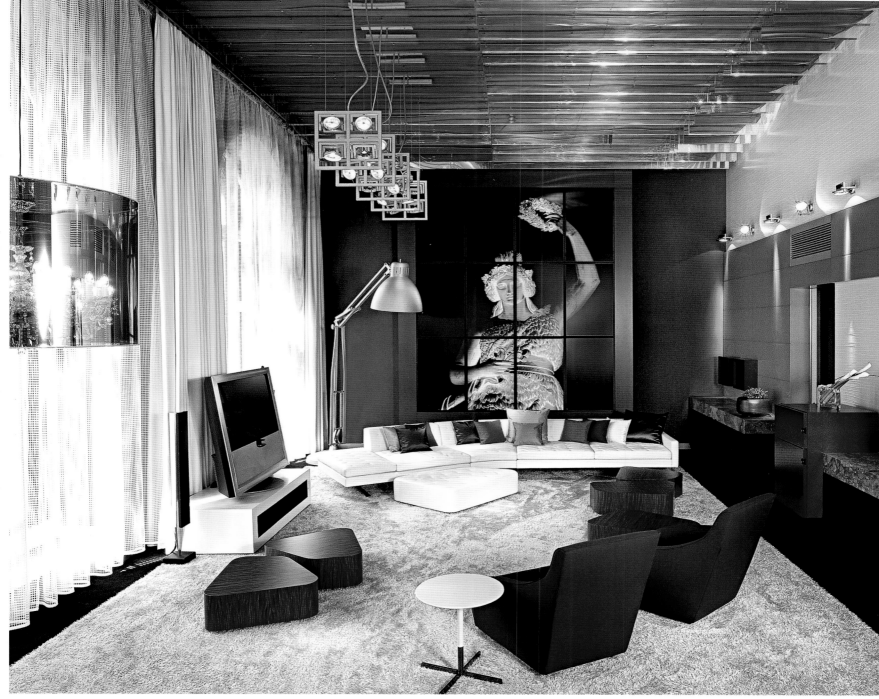

Hotel Fährhaus Sylt

Sylt, Germany

The Victorian veranda with its filigree cast-iron columns makes the idyll perfect. Ferries from the mainland used to dock at this white ferry house on Munkmarsch Harbor before the Hindenburgdamm causeway was built in 1927. Today, the ferry house has become a luxurious hotel with a hint of Frisian country house. Suites up to 1,000 square feet in size feature high-class textiles, precious woods, and valuable antiques. In the gourmet restaurant Fährhaus, guests can enjoy Alexandro Pape's cuisine, which has been awarded two Michelin stars.

Die viktorianische Veranda mit ihren filigranen gusseisernen Säulen macht die Idylle perfekt. Das weiße Fährhaus am Munkmarscher Hafen, wo bis zur Eröffnung des Hindenburgdamms 1927 die Fähren vom Festland anlegten, ist heute ein luxuriöses Hotel im friesisch angehauchten Landhausstil. Hochwertige Textilien, edle Hölzer und kostbare Antiquitäten zieren die bis zu 96 Quadratmeter großen Suiten. Im Gourmet-Restaurant Fährhaus genießt man die mit zwei Michelin-Sternen ausgezeichnete Küche Alexandro Papes.

La véranda victorienne avec ses colonnes en fonte et leur décor en filigrane rend l'ensemble véritablement idyllique. Dans le port de Munkmarsch, où les transbordeurs accostaient avant l'ouverture de la digue de Hindenburg en 1927, l'ancien terminal de ferry est aujourd'hui un hôtel de luxe aux accents frisons. Les suites, qui peuvent atteindre jusqu'à 96 mètres carrés, sont décorées de fastueux textiles, de bois précieux et d'antiquités de valeur. Le restaurant gastronomique Fährhaus permet de déguster la cuisine d'Alexandro Pape, récompensée de deux étoiles Michelin.

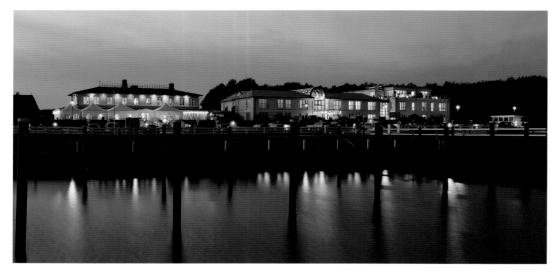

From the suites' wrap-around terraces, the view of the meadows and across the tideland is so tranquil that no one never wants to leave.

Der Blick von den umlaufenden Terrassen der Suiten auf die Wiesenlandschaft und über das Watt ist so beruhigend, dass man sie am liebsten nicht wieder verlassen würde.

Les terrasses qui entourent les suites offrent une vue sur les prairies et la mer des Waddens si apaisante que l'on aimerait y passer toute la journée.

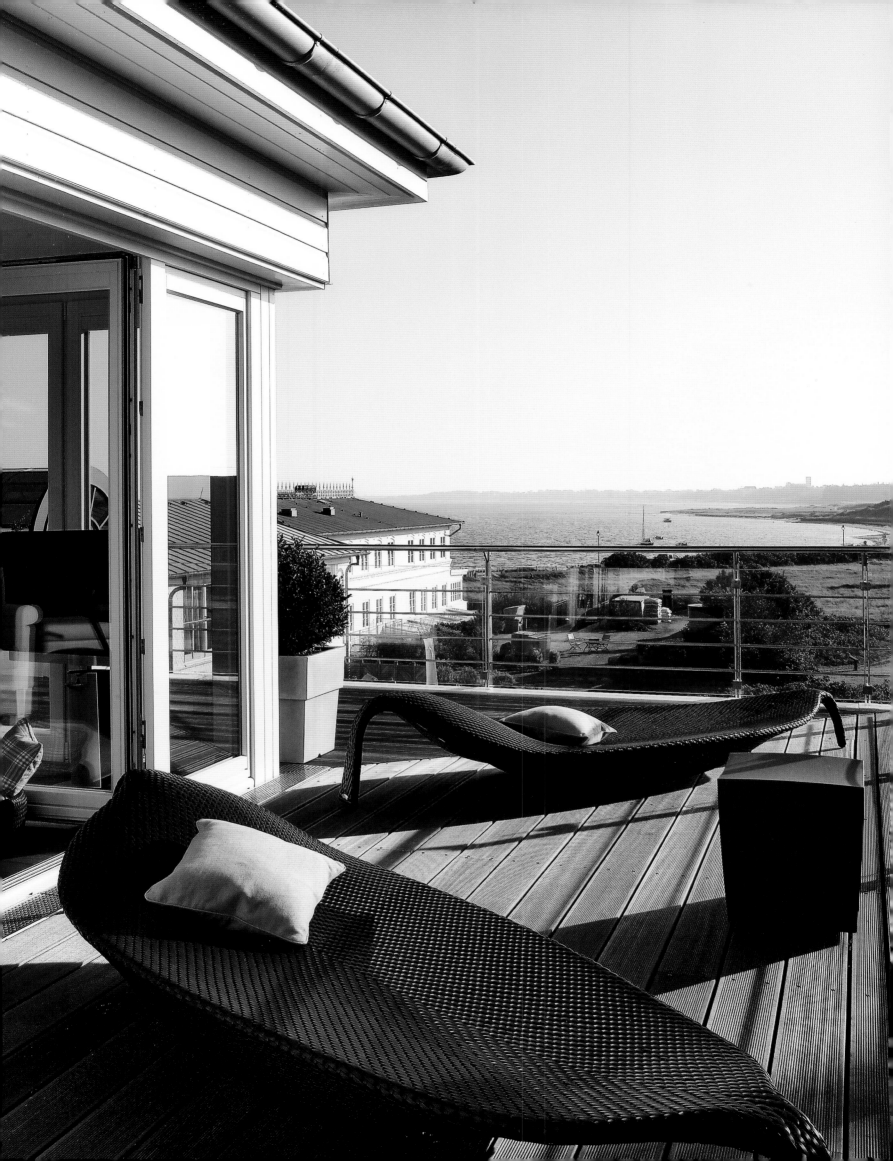

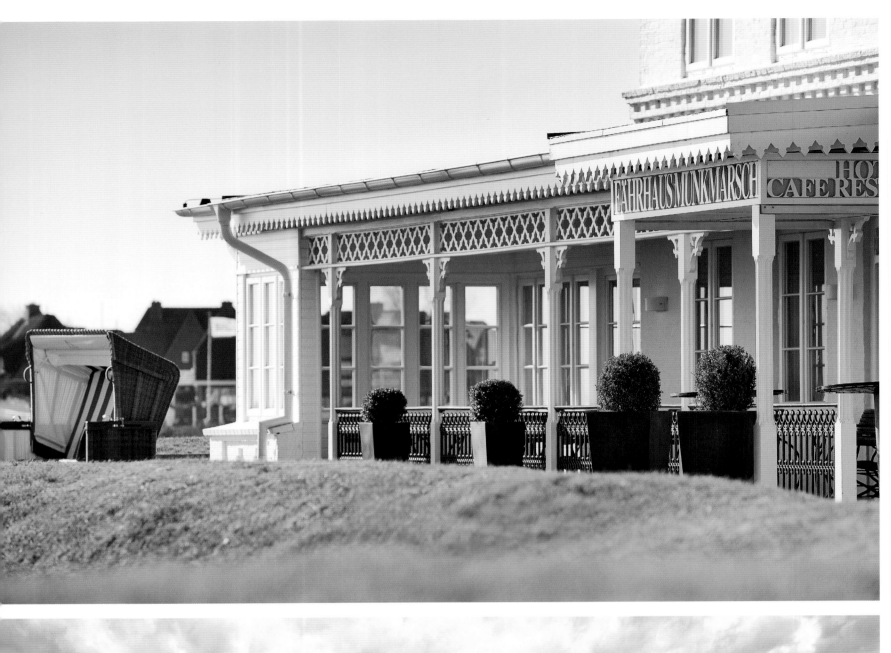

A large breakfast on the sheltered veranda of the former ferry house provides an ideal start to the day.

Besser kann ein Tag nicht beginnen als mit einem ausgedehnten Frühstück auf der windgeschützten Veranda des Fährhauses.

Rien de mieux pour commencer la journée qu'un petit-déjeuner sans hâte à l'abri du vent dans la véranda de l'hôtel.

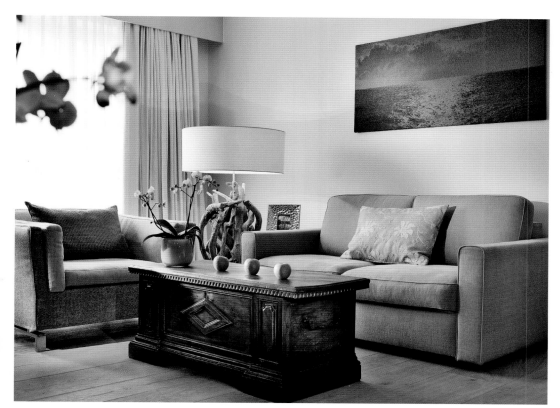

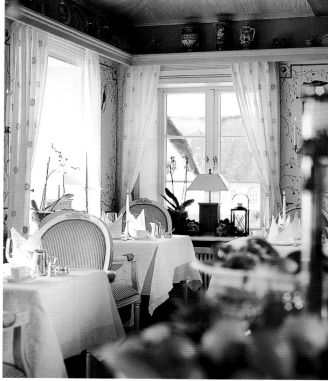

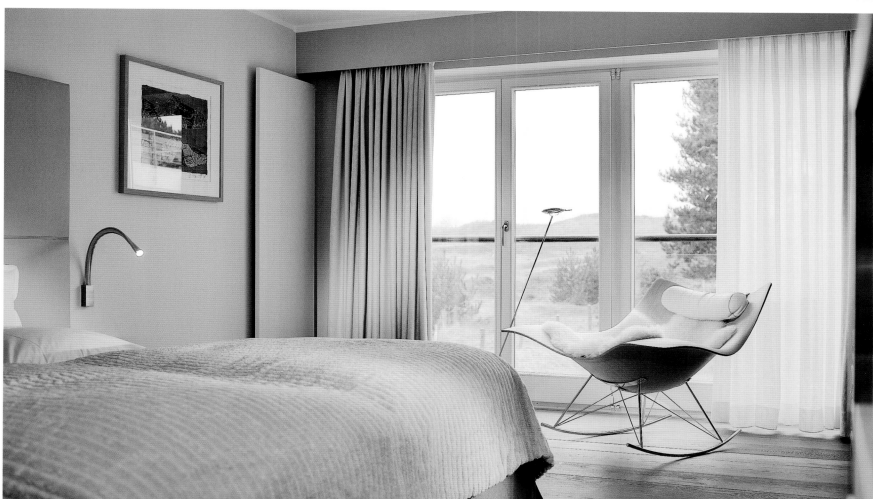

Schloss Fuschl Resort & SPA

Salzburg, Austria

After a total renovation in 2006, the luxurious palace hotel can only be seen as a total work of art. The lakeside setting on a peninsula along the Fuschlsee is simply gorgeous. The 110 rooms and suites are sumptuously furnished with valuable and carefully restored antiques. 150 museum-quality works of art by old masters as well as a collection of rare classic cars underscore the fact that this is a top-class luxury hotel. Another highlight is the baroque Sissi Suite in the historic tower with a panoramic view of the lake and the mountains.

Nach kompletter Renovierung im Jahr 2006 präsentiert sich das luxuriöse Schlosshotel als Gesamtkunstwerk. Traumhaft ist die Lage auf einer Halbinsel am Fuschlsee. Kostbar und edel ist das Interieur der 110 Zimmer, Suiten und Chalets, die mit sorgsam restaurierten Antiquitäten eingerichtet wurden. 150 Kunstwerke Alter Meister von musealem Rang wie auch eine Oldtimer-Sammlung mit wahren Raritäten unterstreichen die Extraklasse. Eines der Highlights ist die barocke Sissi-Suite im denkmalgeschützten Turm mit Panoramablick auf See und Berge.

Après une rénovation complète en 2006, ce palace hôtel luxueux se présente comme une œuvre d'art totale. Il bénéficie d'un splendide emplacement sur un promontoire au-dessus du lac de Fuschl. L'intérieur des 110 chambres et suites est opulent et élégant, et décoré d'antiquités soigneusement restaurées. 150 œuvres d'art de vieux maîtres dignes des plus grands musées, ainsi qu'une collection de voitures anciennes comportant de vraies raretés, soulignent la classe de l'hôtel. Un de ses joyaux est la suite Sissi dans la tour classée, qui offre une vue panoramique sur le lac et les montagnes.

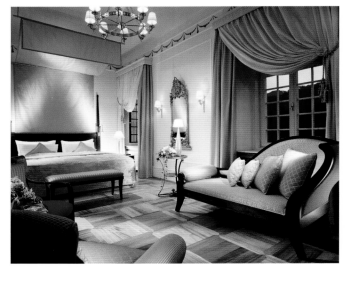

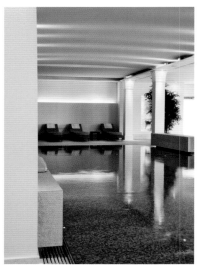

The Fuschl Collection, presented in public areas and individual suites, displays more than 150 important works of old masters.

Mehr als 150 bedeutende Werke Alter Meister zeigt die Fuschl Collection, die in öffentlichen Räumen und einzelnen Suiten präsentiert wird.

La collection Fuschl, qui se compose de plus de 150 œuvres significatives de maîtres anciens, est présentée dans les espaces communs et dans quelques-unes des suites.

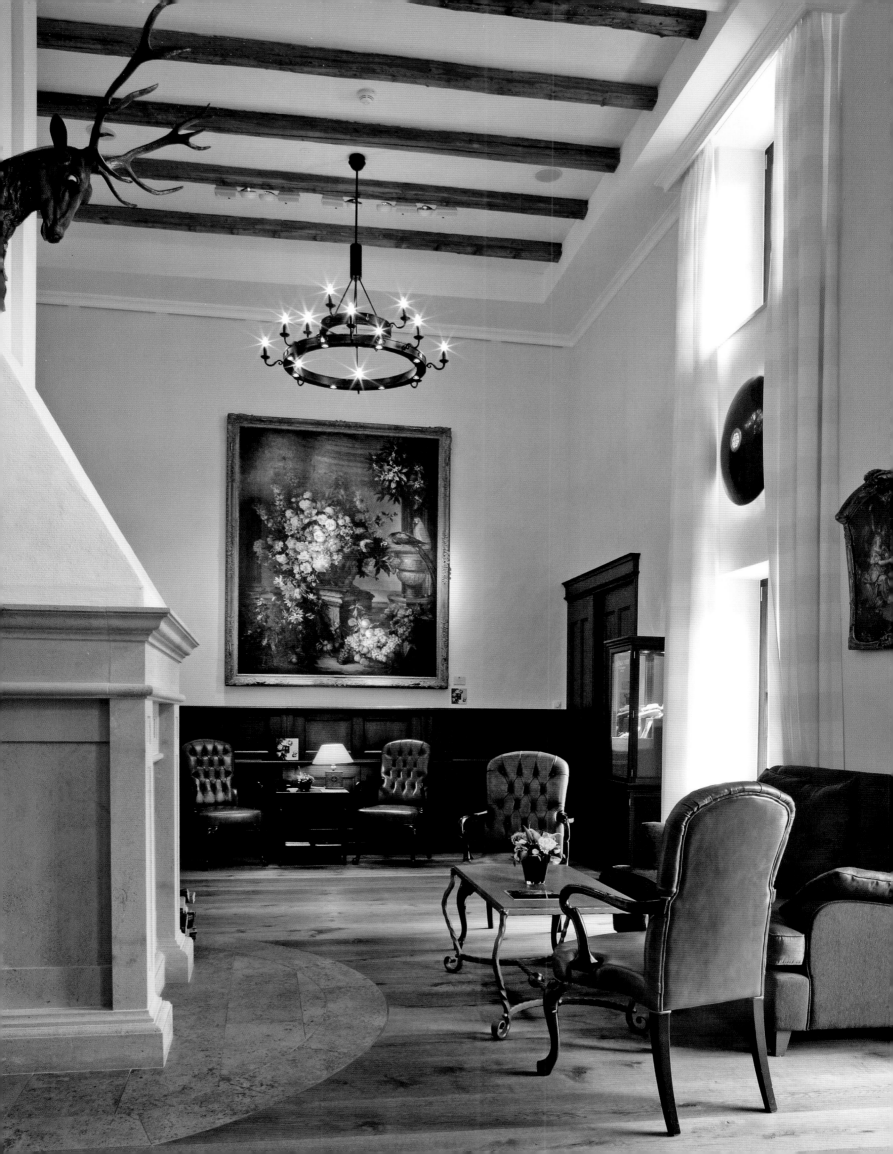

The rural architecture of the Salzkammergut characterizes the buildings clustered around the 550-year-old castle tower. Guests can dine freshly caught fish on the restaurant's terrace.

Die bäuerliche Architektur des Salzkammergutes prägt das Gebäudeensemble rund um den 550 Jahre alten Schlossturm. Fangfrischen Fisch genießt man auf der Restaurantterrasse.

L'ensemble de bâtiments qui encadre la tour du château, vieille de 550 ans, se caractérise par l'architecture campagnarde du Salzkammergut. Sur la terrasse du restaurant, on savoure du poisson fraîchement pêché.

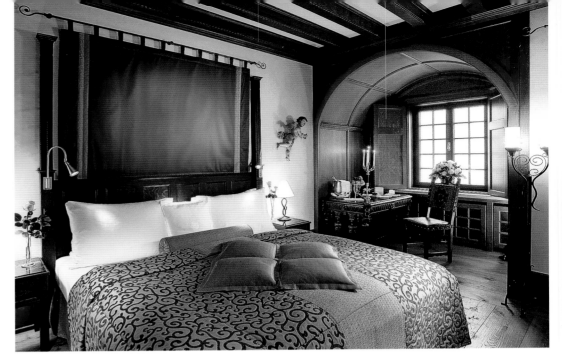

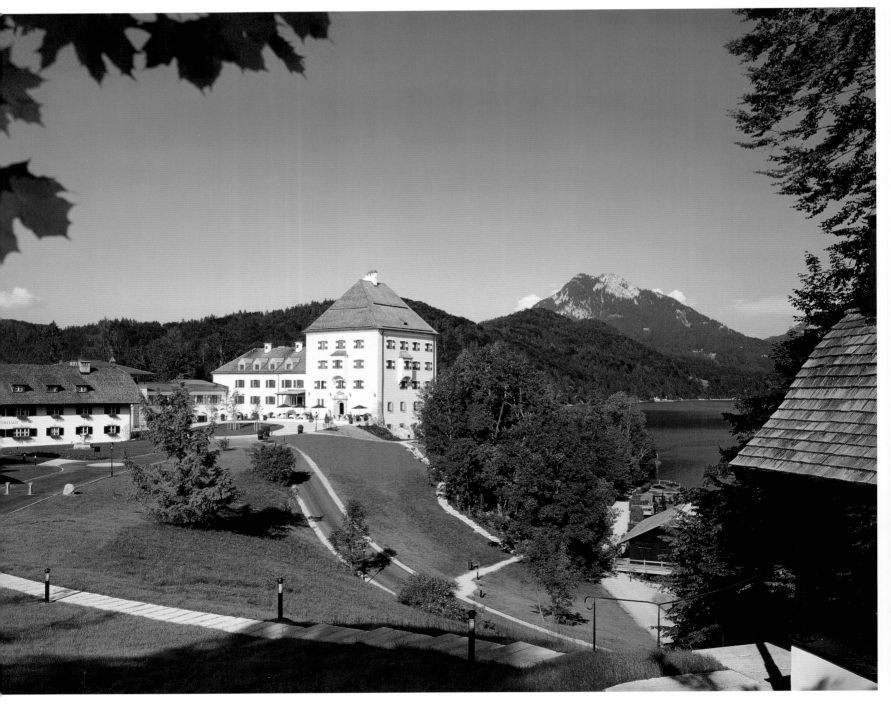

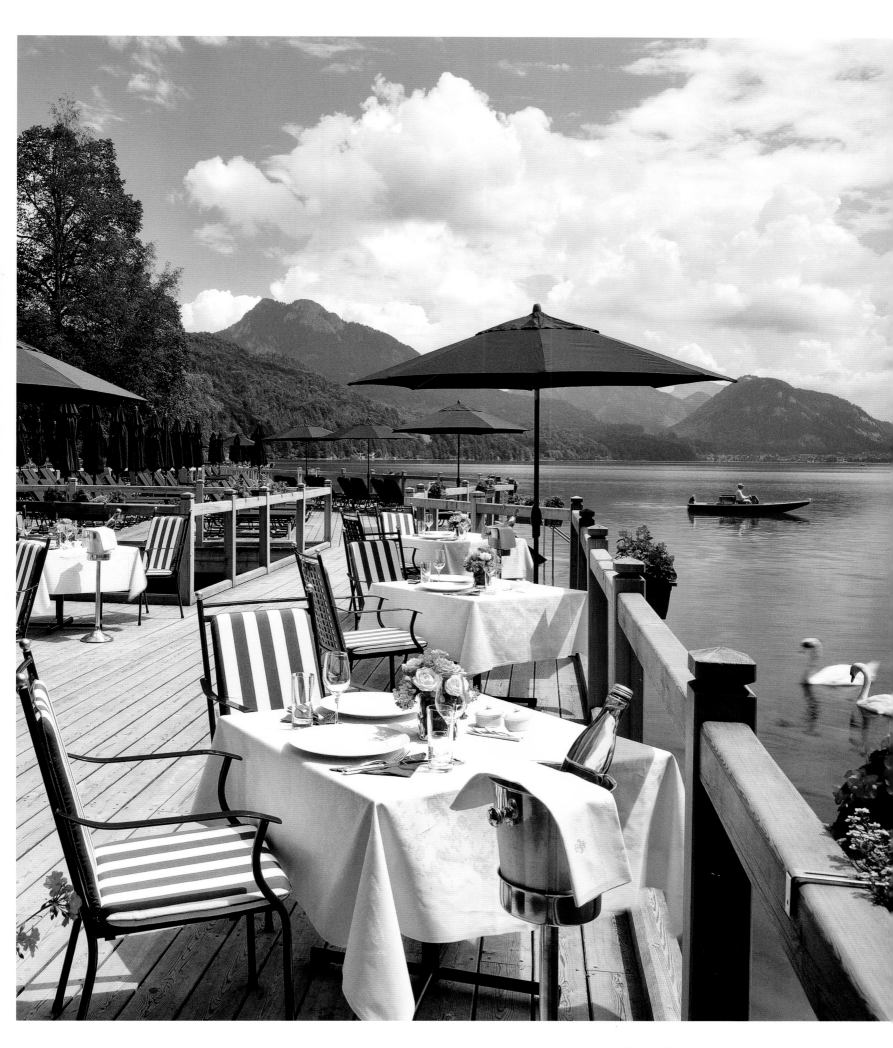

Aurelio Hotel & SPA Lech

Lech am Arlberg, Austria

A very stylish 10,700-square-foot spa with two indoor pools, a thermal suite, and a sauna landscape for just 19 rooms and suites is a clear sign that the Aurelio Hotel & SPA Lech, opened in 2008, is in a league of its own. The interior designers of Mlinaric, Henry & Zervudachi imbued all the rooms with a contemporary mountain feel, which, while shying away from superficial alpine rusticity, still imparts coziness. Every skier's dream: Right outside the door, skiers can access the ski runs of the famous Schlegelkopf in Vorarlberg.

Ein 1 000 Quadratmeter großer, durchgestylter Spa mit zwei Indoor Pools, Thermalsuite und einer Saunalandschaft für nur 19 Zimmer und Suiten zeigt, dass das 2008 eröffnete Aurelio Hotel & SPA Lech in einer eigenen Kategorie spielt. Für sämtliche Räume entwarfen die Innenarchitekten von Mlinaric, Henry & Zervudachi ein zeitgemäßes alpines Design, das sich einem vordergründig anheimelnden Alpenlook verweigert und doch Geborgenheit vermittelt. Der Traum jedes Skifahrers: Direkt vor der Tür kann man in die berühmte Vorarlberger Schlegelkopfpiste einsteigen.

Un spa de 1 000 mètres carrés au style inimitable avec deux bassins intérieurs, un centre de soin thermal et une sélection de saunas pour seulement 19 chambres et suites, voilà qui prouve que le Aurelio Hotel & SPA Lech ouvert en 2008 évolue bel et bien dans une catégorie bien à part. Les architectes d'intérieur du bureau Mlinaric, Henry & Zervudachi ont opté pour un design contemporain et alpin dans l'ensemble des pièces. Il s'en dégage une sensation apaisante qui dépasse largement le simple confort qu'inspire automatiquement le style alpin. Enfin, il ne faut pas oublier le rêve de tout amateur de ski : l'hôtel se trouve en effet au pied de la Schlegelkopf, célèbre piste de ski du Vorarlberg.

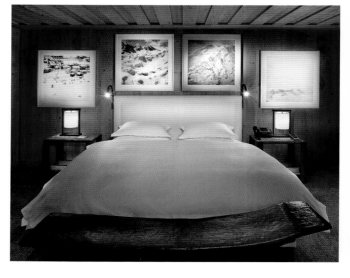 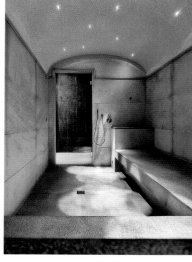

Sweeping expanses of upholstered furniture offer the perfect place to relax after a long day of skiing. Wood gives the rooms a certain chalet character.

Ausladende Polstermöbel versprechen Entspannung nach einem ausgedehnten Skitag. Holz verleiht den Zimmern einen gewissen Chalet-Charakter.

Des canapés et fauteuils généreux garantissent une détente optimale après une longue journée de ski. Le bois donne un caractère typiquement montagnard aux chambres.

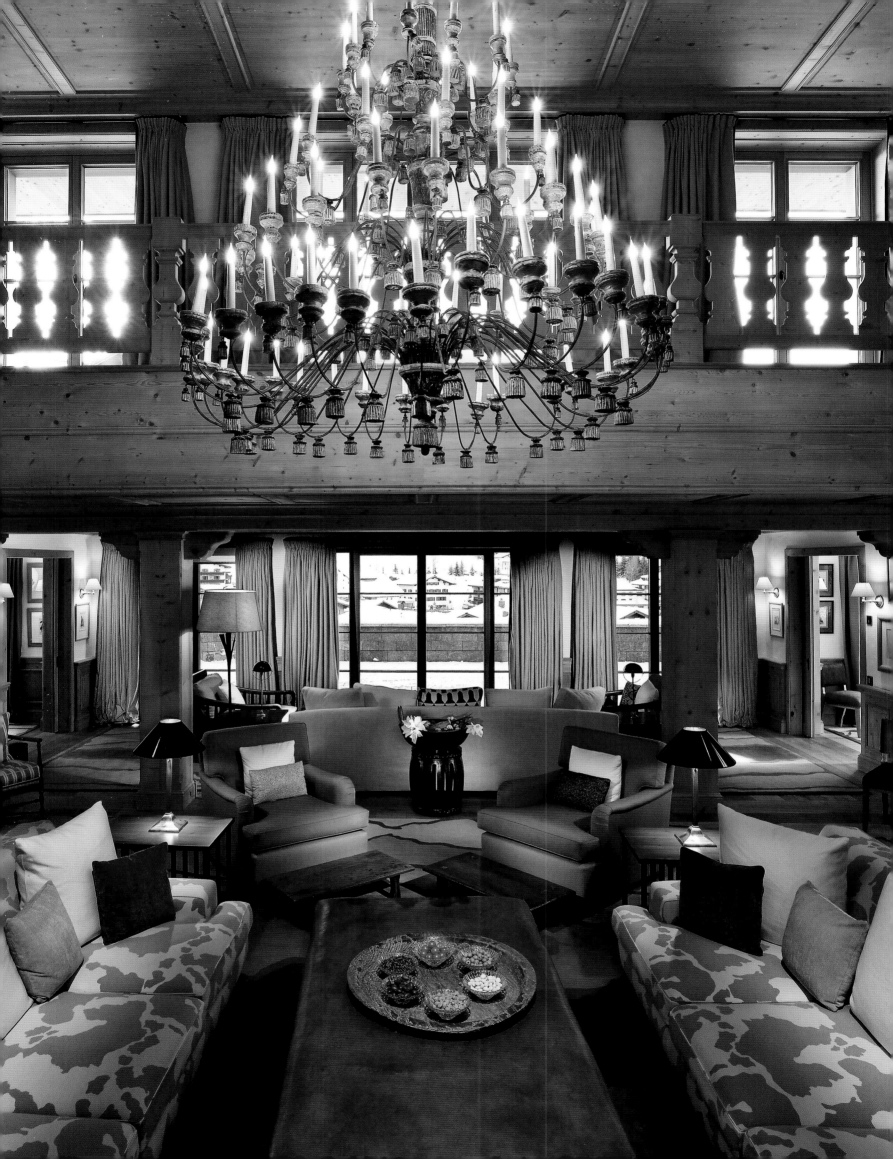

The traditionally simple design of the wood-framed houses conceals the sophisticated comfort awaiting guests inside.

Die traditionell schlicht gehaltenen Holzhäuser verraten nichts vom erlesenen Komfort, der die Gäste im Innern erwartet.

Les sobres et traditionnels chalets en bois ne dévoilent rien du confort exclusif qui attend les clients à l'intérieur.

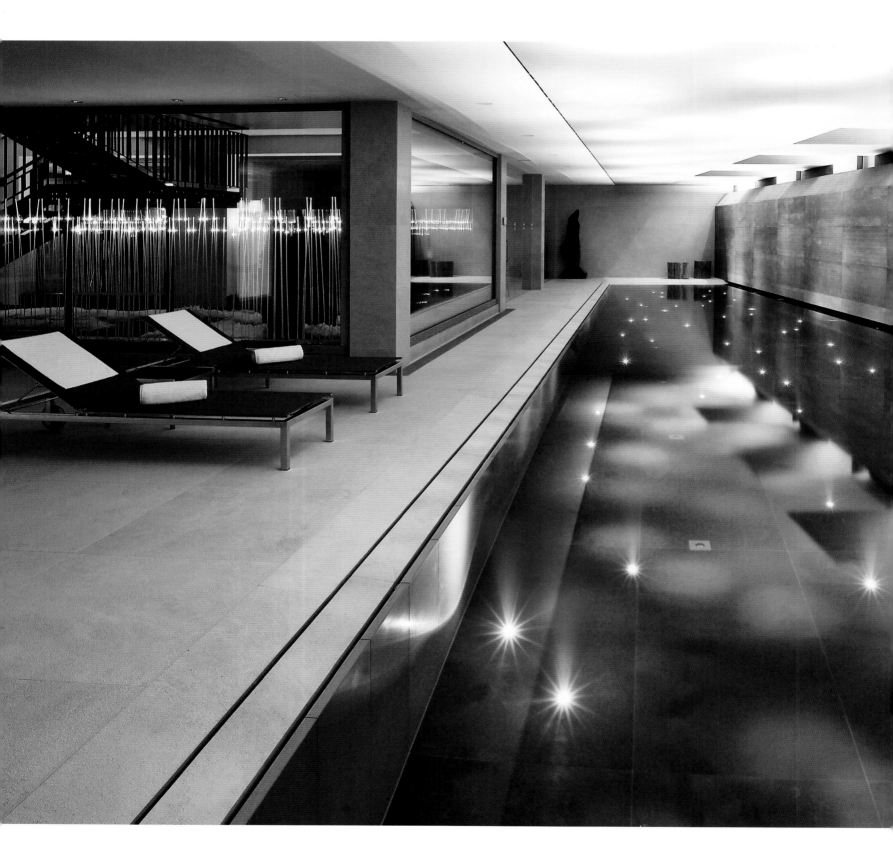

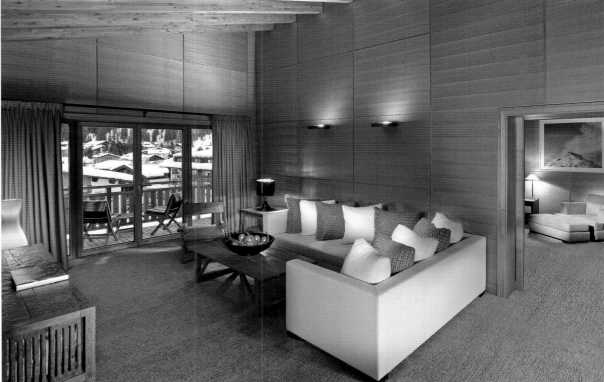

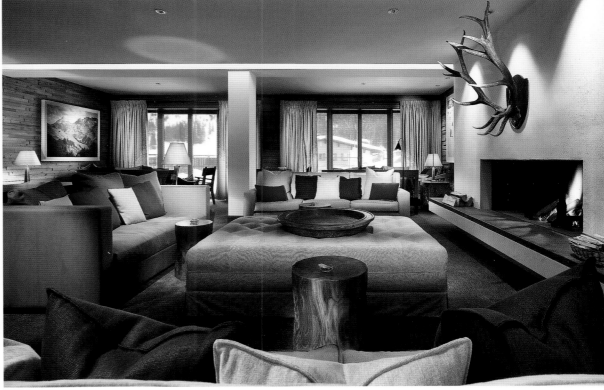

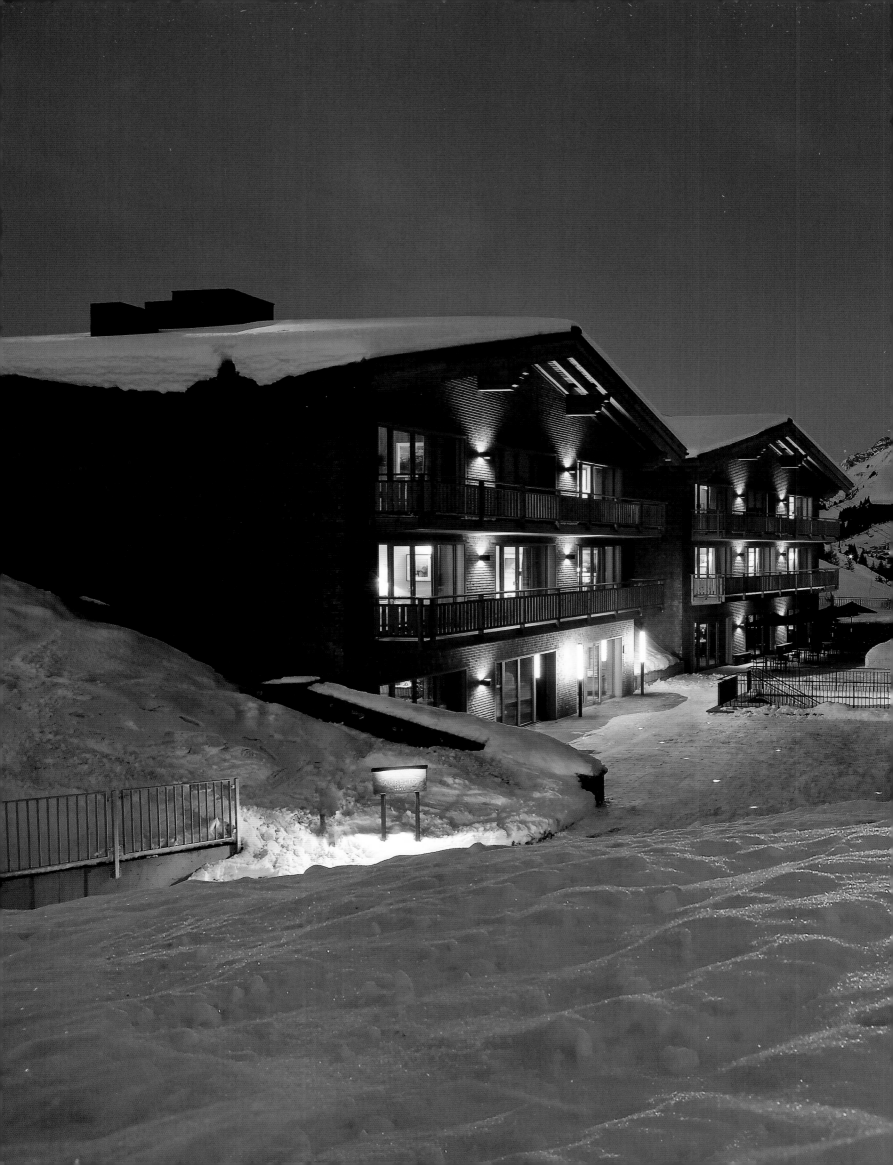

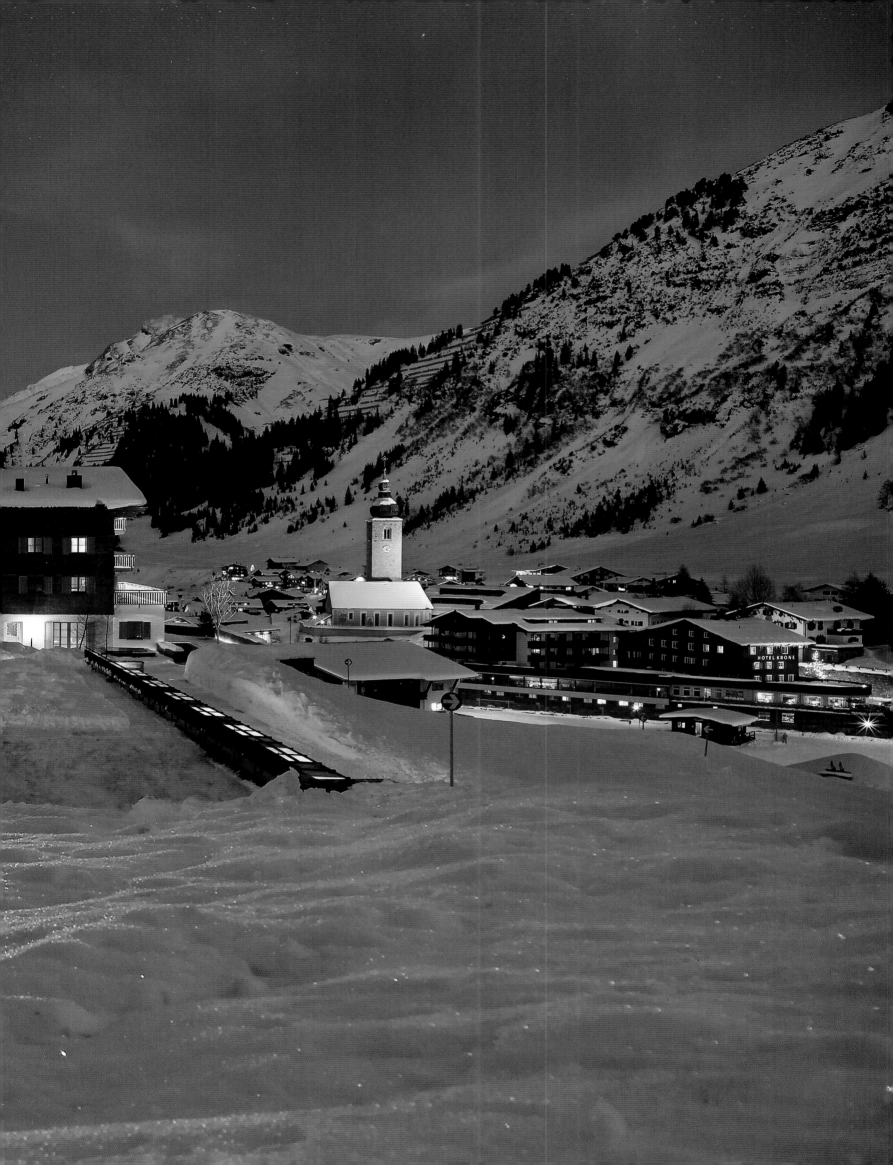

Hotel Imperial, Vienna
Vienna, Austria

Emperor Franz Joseph himself opened this grand hotel on April 28, 1873 on the occasion of the World's Fair in Vienna. It has always been a place where the rich and powerful have met. All official guests of state of the Austrian government still stay at this luxurious hotel on Vienna's Ringstraße. In 1994, the readers of "Condé Nast Traveler" named it the best hotel in the world. With 138 rooms and 32 suites, it offers plenty of space to relax in comfort after a day of strenuous negotiations. Valuable antiques and a spectacular collection of paintings give the interior the feel of 19th-century Vienna. The hotel's butler service is probably unique: The butlers iron the newspapers to prevent the ink from smudging the hands of guests.

Kaiser Franz Josef höchstpersönlich eröffnete am 28. April 1873 das Nobelhotel zum Anlass der Weltausstellung in Wien. Klar, dass es immer ein Ort gewesen ist, wo sich Reiche und Mächtige trafen. Auch heute noch residieren alle Staatsgäste Österreichs in der Luxusherberge. 1994 wählten die Leser von „Condé Nast Traveler" die Residenz an der Wiener Ringstraße zum besten Hotel rund um den Globus. 138 Zimmer und 32 Suiten bieten genügend Platz, um sich nach anstrengenden Verhandlungen gemütlich zurückzulehnen. Wertvolle Antiquitäten und eine üppige Gemäldesammlung verleihen dem Haus ein Ambiente vom Wien des 19. Jahrhunderts. Und einmalig ist wohl der Butlerservice des Hauses: Da bügeln die Butler die Zeitungen, damit sich der Gast nicht mit der Druckerschwärze der Blätter beschmutzt.

L'Empereur Francois-Joseph Ier d'Autriche en personne a inauguré ce palais royal le 28 avril 1873 à l'occasion de l'exposition mondiale qui se tenait à Vienne. Il est clair que cet hôtel était prédestiné pour devenir le rendez-vous de prédilection des riches et des puissants de ce monde. Aujourd'hui encore, tous les invités du gouvernement autrichien se rencontrent dans cette résidence de luxe. En 1994, les lecteurs du « Condé Nast Traveler » ont choisi à l'unanimité la résidence de la Wiener Ringstraße comme étant le meilleur hôtel du globe. 138 chambres et 32 suites offrent suffisamment d'espace pour se détendre en toute tranquillité après des débats ardus. Des antiquités d'une valeur inestimable et une collection de tableaux non négligeable confèrent à cette résidence une ambiance de Vienne au XIXe siècle. Le service du personnel de l'hôtel n'a pas son pareil dans le monde. Les employés repassent même les journaux afin que les hôtes ne se salissent pas au contact de l'encre des journaux !

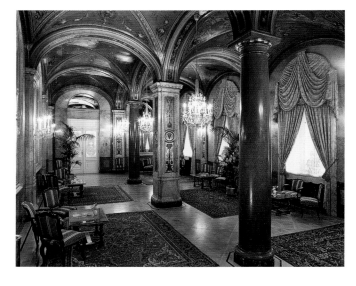

Royal is an apt description for this grand hotel on Vienna's Ringstraße. Emperor Franz Josef still watches over the well-being of the guests from his position high above.

Königlich geht es in diesem Nobelhotel an der Wiener Ringstraße zu. Nicht umsonst blickt Kaiser Franz Josef täglich auf die Gäste herunter.

Simplement royal, est le seul qualificatif convenable de l'atmosphère qui existe dans ce noble hôtel de la Wiener Ringstraße. Ce n'est pas un hasard si l'Empereur François-Joseph Ier d'Autriche y veille tous les jours, présent en toile de fond, au bien-être de ses hôtes.

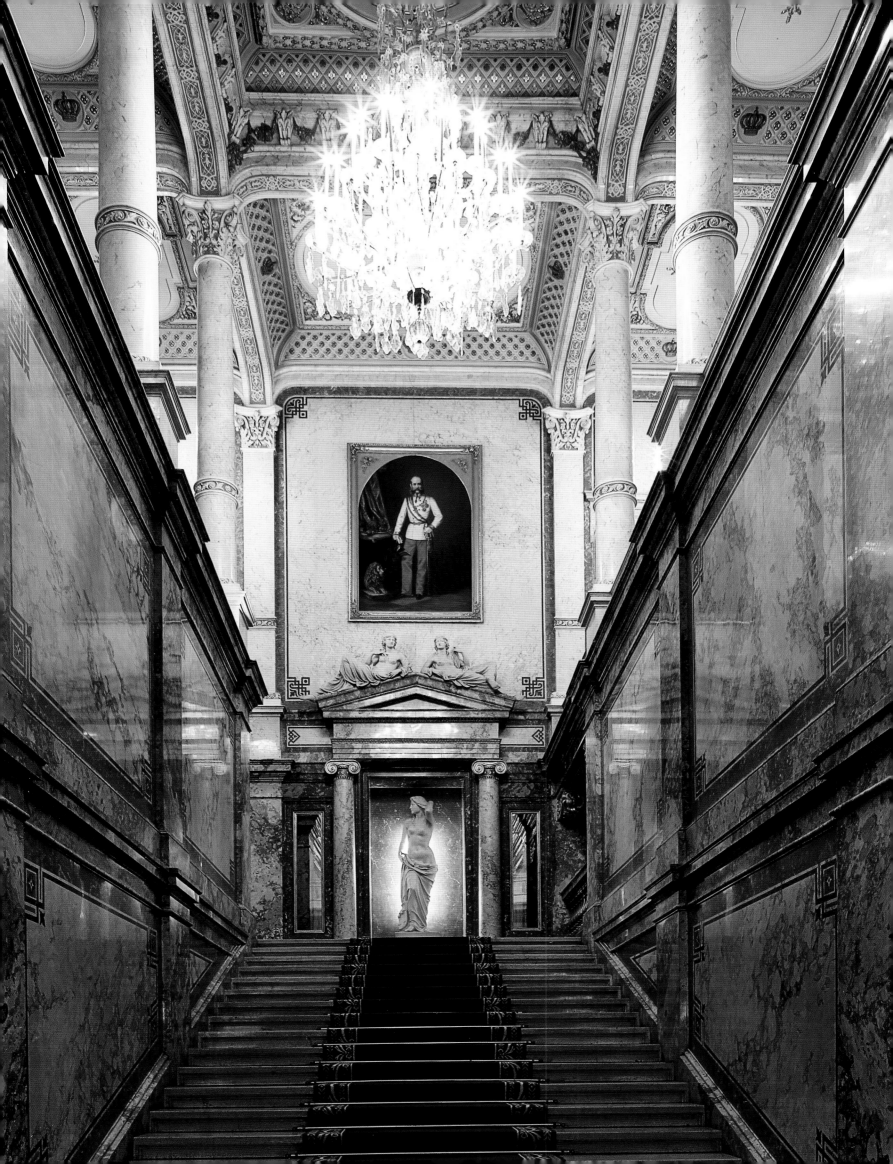

Chandeliers, stucco ceilings, antiques, and paintings: Royal grandeur with a touch of Franz Josef and Sissi emanates from every corner.

Kronleuchter, Stuckdecken, Antiquitäten und Gemälde: Königlicher Prunk mit Franz Josef- und Sissi-Flair strahlt aus allen Winkeln.

Lustres, plafonds en stuc, antiquités et tableaux caractérisent cet hôtel de luxe : Un apparat royal avec en filigrane le flair de l'Empereur François-Joseph et de Sissi est omniprésent.

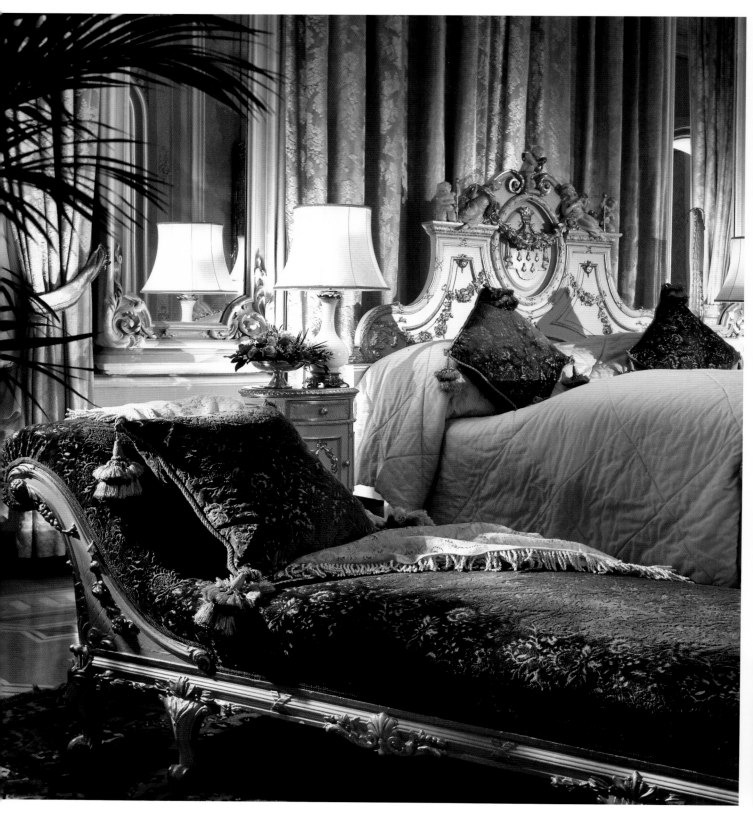

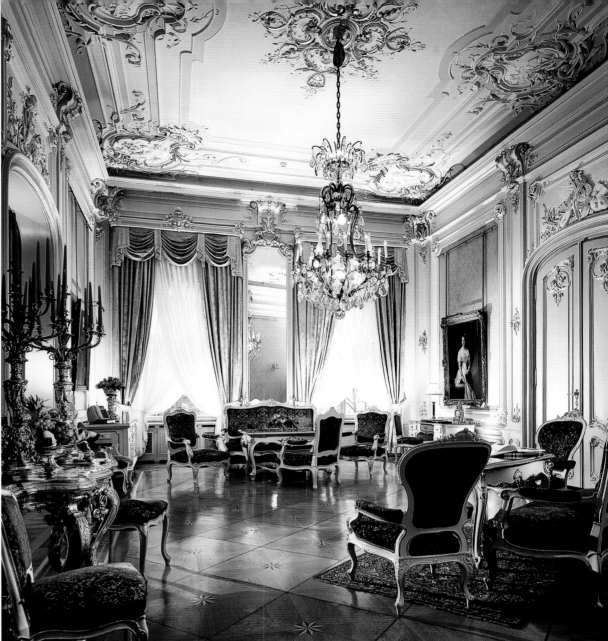

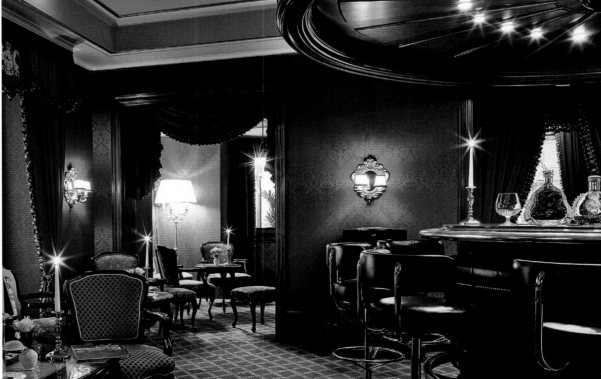

Hotel Imperial, Vienna *Vienna, Austria* 119

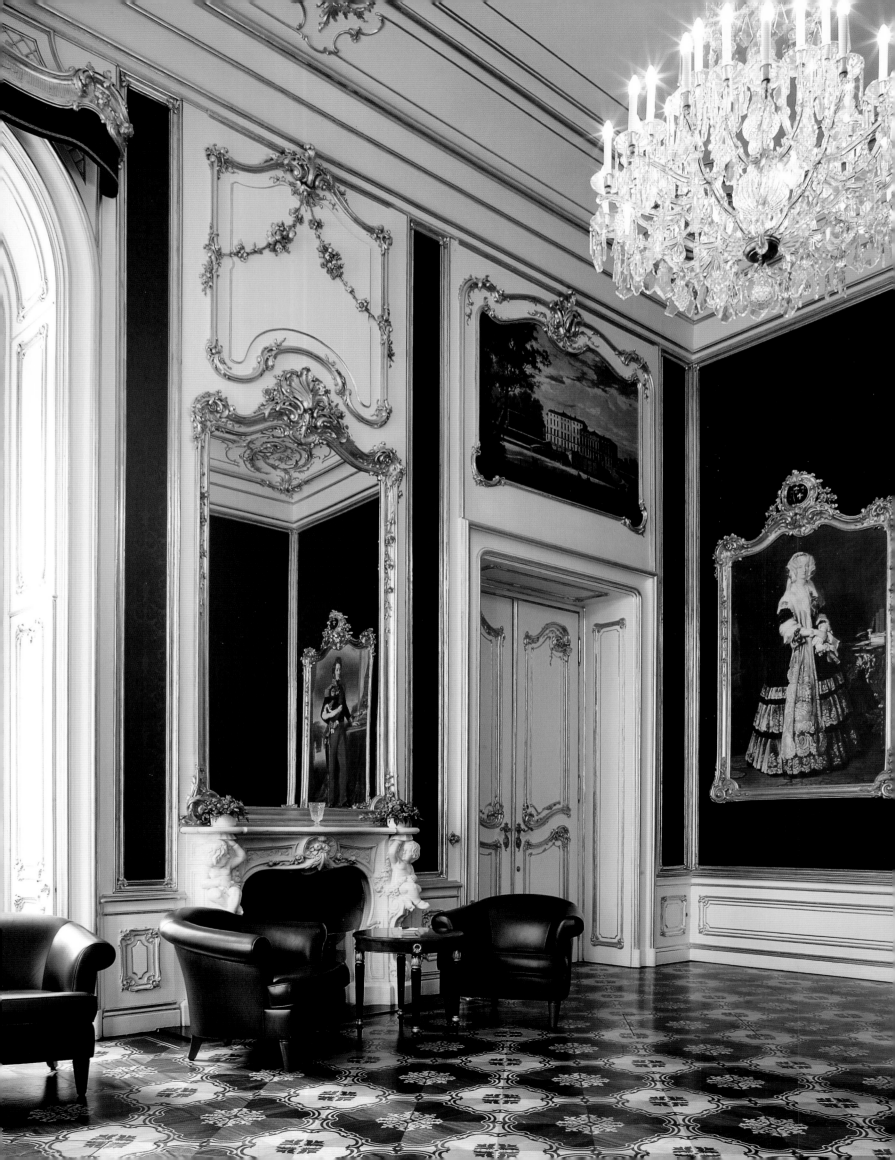

Palais Coburg

Vienna, Austria

Constructed between 1840 to 1845 by Prince Ferdinand of Saxe-Coburg and Gotha in the heart of old Vienna, the palace reflects the splendor of old Austria. The gilded stucco, magnificent paintings, and impressive stairways have been carefully restored and now contrast with modern structural details. Guests can select from 35 spacious suites featuring different styles, from elegant imperial suites to modern loft suites. The wine cellar with an inventory of 60,000 bottles is sensational.

Die ganze Pracht des alten Österreichs darf sich in dem 1840 bis 1845 von Prinz Ferdinand von Sachsen-Coburg und Gotha erbauten Palais im Herzen der Wiener Altstadt entfalten. Die vergoldeten Stuckaturen, prunkvollen Gemälde und repräsentativen Treppenaufgänge wurden sorgfältig restauriert und mit modernen Baudetails kontrastiert. Wohnen kann man in 35 großzügigen Suiten, die in unterschiedlichen Stilrichtungen gestaltet sind, von den eleganten Imperial-Suiten bis zu den modernen Loft-Suiten. Als sensationell gilt der Weinkeller mit seinen 60 000 Positionen.

Toute la gloire de la vieille Autriche s'expose dans ce palace situé au cœur de la vieille ville de Vienne, qui a été construit entre 1840 et 1845 par le prince Ferdinand de Saxe-Cobourg et Gotha. Les stucs plaquées or, les tableaux pompeux et les escaliers représentatives ont été très soigneusement rénovés et contrastent avec les détails de construction modernes. On peut séjourner dans l'une des 35 confortables suites, qui ont été créées dans différents styles, des élégantes Suites Impériales aux modernes suites loft. La cave à vins et ses 60 000 bouteilles jouissent d'une formidable réputation.

 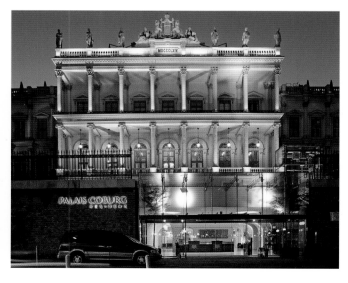

The representative rooms regularly host sophisticated culinary events such as the World Wine Festival.

Die repräsentativen Räume sind regelmäßig Schauplatz von anspruchsvollen kulinarischen Events wie dem Weltweinfestival.

Les pièces de représentation accueillent régulièrement des événements culinaires prestigieux comme le Festival mondial du vin.

Offering ultimate relaxation, the spa has a terrace with a view of Vienna's largest city park.

Entspannung auf höchstem Niveau bietet der Spa, von dessen Terrasse man auf Wiens größten Stadtpark blickt.

Le spa, dont la terrasse donne sur le plus grand parc public de Vienne, garantit un moment somptueux de détente.

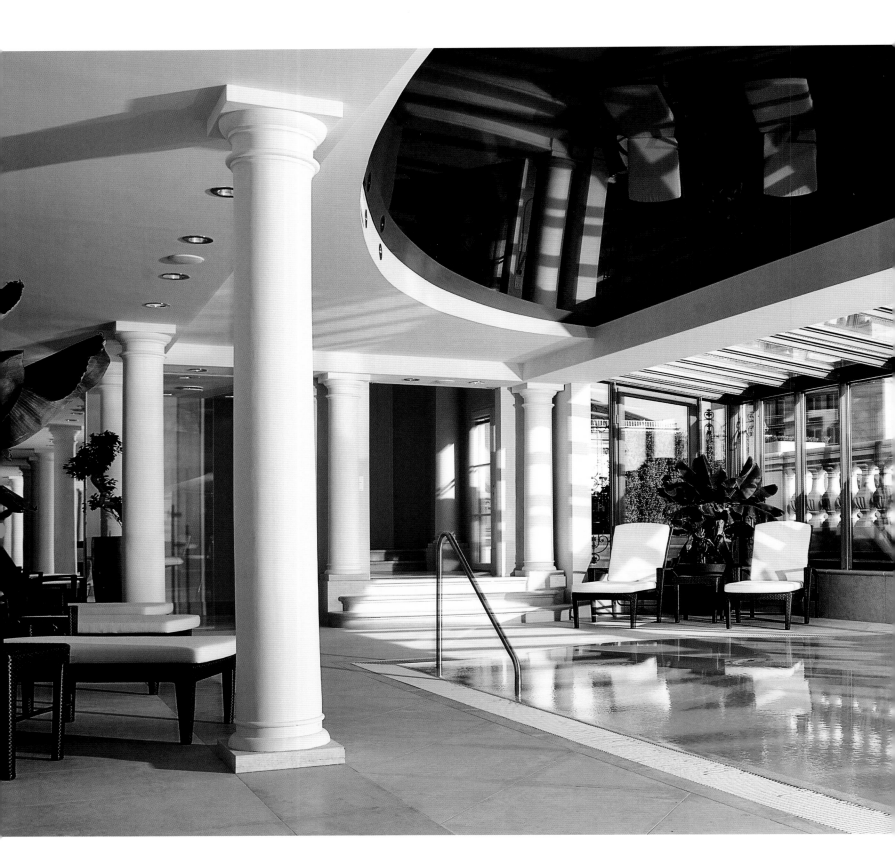

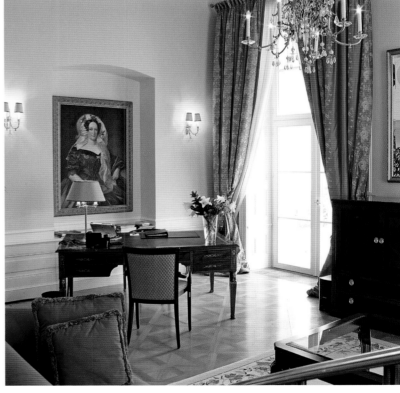

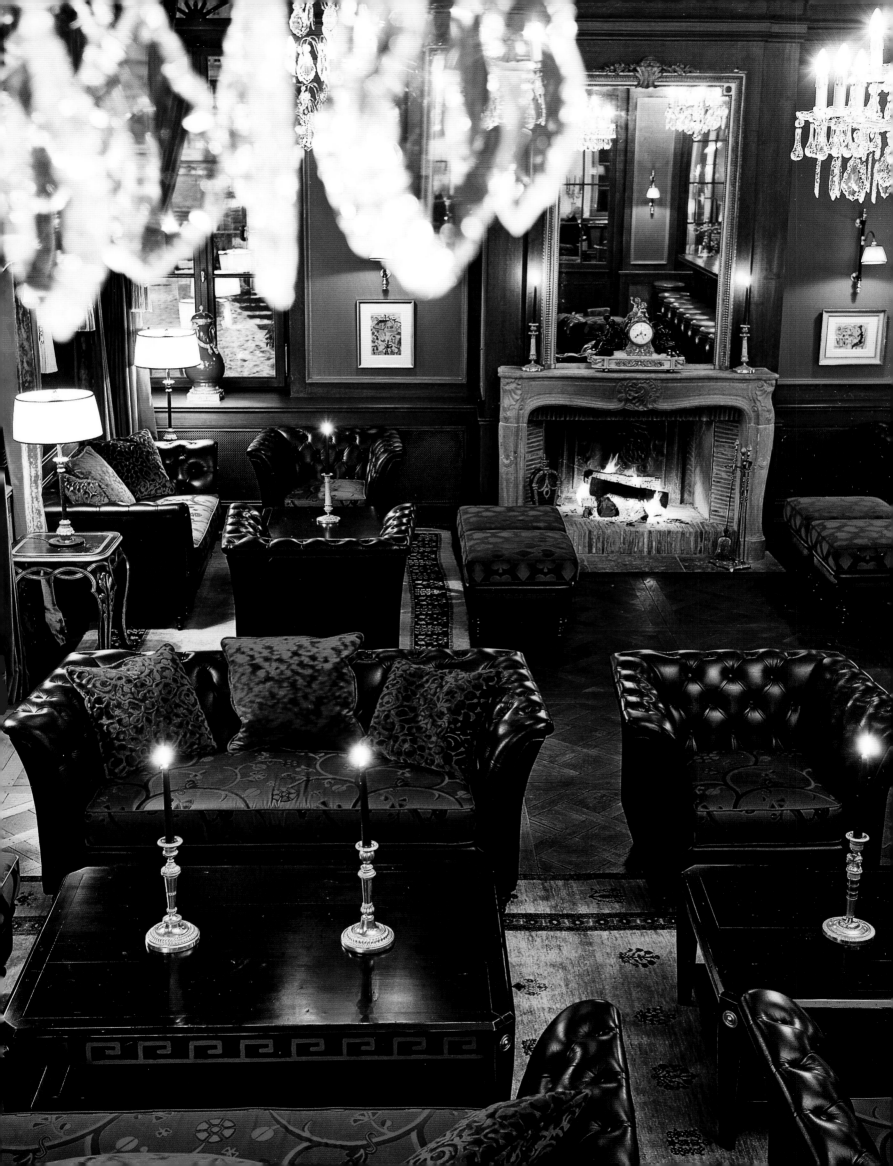

Grand Hotel Les Trois Rois

Basel, Switzerland

The Rhine, broad and solemn, flows by directly in front of the terrace. It is the perfect setting in the heart of Basel for one of the oldest hotels in Europe. When it was first opened at the end of the 17th century, it was patronized mainly by merchants. Later, it hosted royal guests as well as literary figures and artists, including Picasso and Rauschenberg. The restoration lasted two years and returned the building to its 1840 glory. The fine elegance now shown by the hotel is also reflected in the new French name.

Direkt vor der Terrasse fließt der Rhein vorbei, breit und gravitätisch. Die perfekte Lage für eines der ältesten Hotels Europas, das in seinen Anfängen im ausgehenden 17. Jahrhundert vor allem von Kaufleuten frequentiert wurde. Später folgten königliche Hoheiten, Literaten und Künstler, unter ihnen Picasso und Rauschenberg. Zwei Jahre dauerten die Restaurierungsarbeiten, die den Bauzustand um 1840 wiederherstellten und damit die feine Eleganz, die das Haus heute zeigt und sich auch im neuen, französischen Namen widerspiegelt.

Le Rhin coule devant la terrasse, majestueux et calme. Un emplacement parfait en plein cœur de Bâle pour l'un des plus anciens hôtels d'Europe, qui, à ses débuts à la fin du XVIIe siècle, était essentiellement fréquenté par des commerçants. Plus tard, ceux-ci furent remplacés par les têtes couronnées, les hommes de lettres et les artistes, parmi lesquels Picasso et Rauschenberg. Deux années de restauration ont été nécessaires pour réhabiliter ce bâtiment dans l'état de 1840. Sa finesse et son élégance font aujourd'hui la marque de fabrique de cet hôtel, comme en témoigne aussi le choix du nouveau nom français.

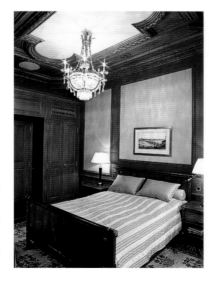 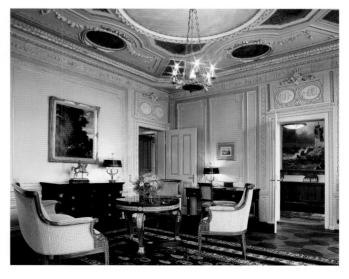

The hotel's valuable originals were restored according to criteria governing the preservation of historic landmarks.

Die kostbaren Originale des Hotels wurden nach denkmalpflegerischen Kriterien restauriert.

Le magnifique bâtiment d'origine de l'hôtel a été rénové dans le respect de son caractère historique.

Every year, high-profile artists and collectors meet in the lobby bar. Anyone who wants to stay here during Art Basel needs to make reservations well in advance.

In der Lobbybar trifft sich alljährlich die hochkarätige Kunstszene. Lange im Voraus muss reservieren, wer während der Art Basel hier logieren will.

L'élite de la scène artistique se rencontre chaque année dans le bar du lobby. Le voyageur qui souhaite y séjourner durant Art Basel doit réserver longtemps à l'avance.

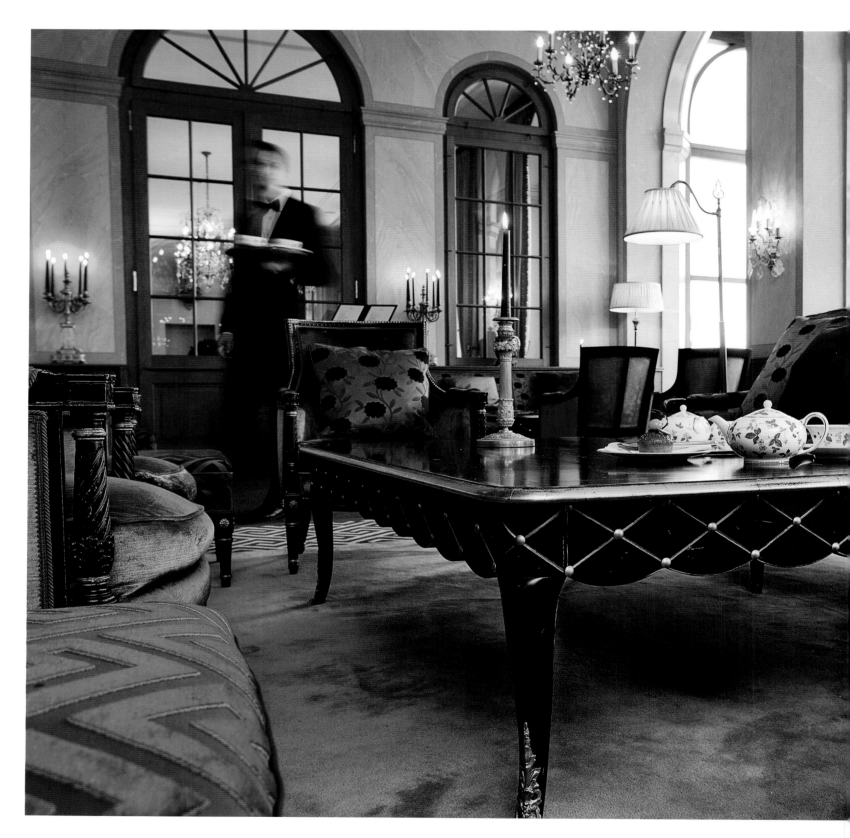

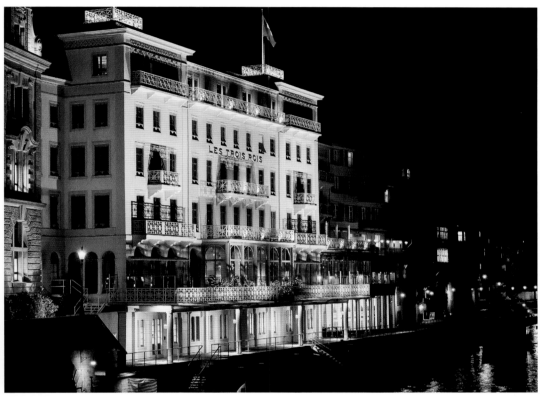

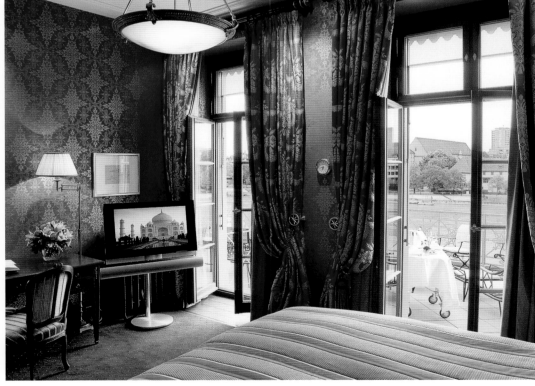

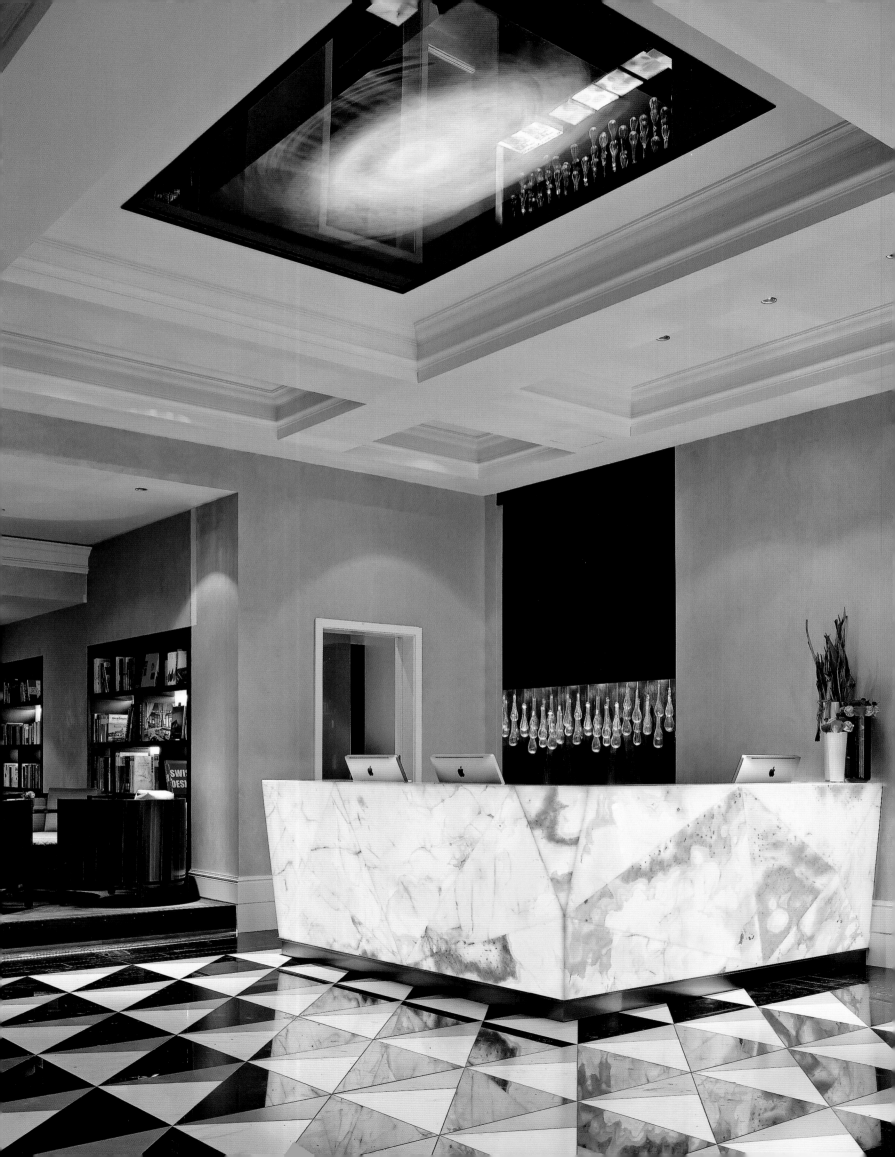

Hotel Schweizerhof Bern

Bern, Switzerland

Protected as a historic monument, the hotel's 1911 façade is a highlight in Bern's old town, which is itself a UNESCO World Heritage site. While the façade was carefully restored, the hotel's interior underwent a 50-million-franc renovation to prepare the Schweizerhof for the future. Connecting the building's history to contemporary elements is a theme that recurs throughout the entire hotel. Modern designer lamps are juxtaposed with the original chandeliers and marble columns. The expansive bathrooms in Lasa marble featuring rain showerheads and deep Japanese soaking tubs are another highlight.

Die denkmalgeschützte Fassade von 1911, ein Glanzpunkt in der unter UNESCO-Schutz stehenden Altstadt Berns, wurde sorgfältig restauriert, während im Innern der 50 Millionen Franken teure Umbau den Schweizerhof für die Zukunft fit machte. Die Geschichte des Hauses mit Zeitgenössischem zu verbinden, zieht sich wie ein Leitmotiv durch das gesamte Hotel. Heute ergänzen moderne Designerlampen die originalen Kronleuchter und Marmorsäulen. Ein Highlight sind die großzügigen Badezimmer in Lasa-Marmor mit Regenschauerduschen und tiefen japanischen Badewannen.

La façade de 1911, classée monument historique, fait partie des joyaux de la ville de Berne enregistrée à l'UNESCO. Elle a été entièrement restaurée, tandis que l'intérieur a fait l'objet d'une rénovation pour 50 millions de francs suisses afin de moderniser le Schweizerhof. La volonté de faire cohabiter l'histoire du bâtiment et sa vie contemporaine se traduit dans l'ensemble de l'hôtel. Ainsi, les colonnes de marbres et les lustres originaux côtoient aujourd'hui des lampes au design moderne. Les vastes salles de bain en marbre de Lasa dotées de douches à effet pluie et de profondes baignoires japonaises valent le détour.

A team from the prestigious London firm MKV Design helped to give this legendary hotel a successful facelift.

Ein Team des renommierten Londoner Büros MKV Design hat dem traditionsreichen Hotel zu einem erfolgreichen Facelift verholfen.

Une équipe du célèbre cabinet londonien MKV Design a contribué à la réussite du lifting de cet hôtel de longue tradition.

The 5,300-square-foot wellness area with pool, sauna, and hamam is consistently modern throughout.

Konsequent modern *ist der 500 Quadratmeter große Wellnessbereich mit Pool, Sauna und Hamam.*

Tout aussi *moderne, le grand espace bien-être de 500 mètres carrés propose piscine, sauna et hammam.*

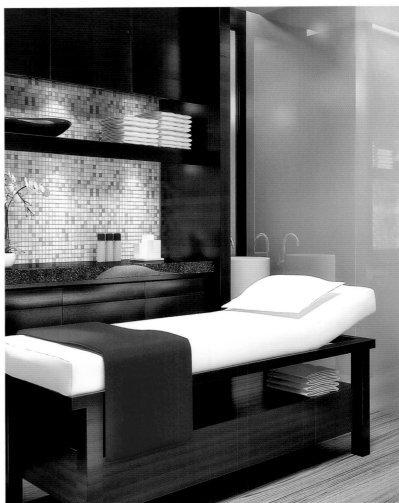

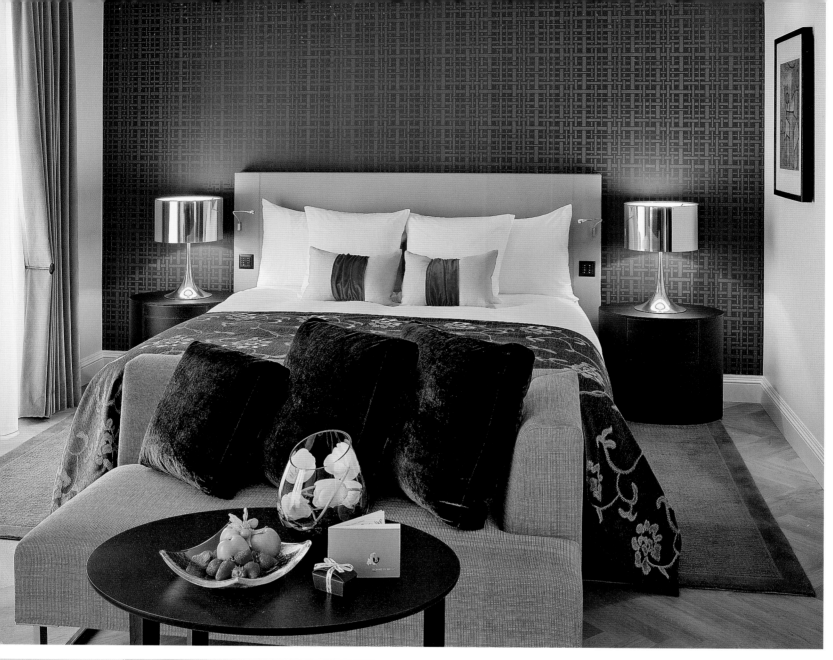

Victoria-Jungfrau
Grand Hotel & Spa
Interlaken, Switzerland

Opened in 1865, the Victoria-Jungfrau is now the grande dame of Swiss luxury hotels—glamorous, elegant, and obviously a frequent traveler to Paris, London, and Rome to pick up on trends that can be stylishly blended with Swiss tradition. Guests love the 212 rooms with their timeless design (very chic: the Bel Air junior suites with dark parquet flooring and sophisticated lighting). The 59,000-square-foot spa features East-meets-West wellness therapies, while the best foie gras in the country is served in the restaurant La Terrasse.

Das 1865 eröffnete Victoria-Jungfrau ist heute die Lady der Schweizer Luxushotellerie – glamourös, elegant und offensichtlich regelmäßig in Paris, London oder Rom unterwegs, um die Trends aus den Metropolen stilvoll mit eidgenössischen Traditionen zu verbinden. Zeitloses Design macht die 212 Zimmer zu Lieblingsplätzen (sehr chic: die Bel Air Junior-Suiten mit dunklem Parkett und raffiniertem Licht), das 5 500 Quadratmeter große Spa vereint Wellnessmethoden aus Ost und West, und im La Terrasse wird die beste Foie Gras des Landes serviert.

Le Victoria-Jungfrau, qui a ouvert en 1865, est devenue la Grande Dame de l'hôtellerie de luxe suisse : glamour, élégante et bien sûr régulièrement à Paris, Londres ou Rome, pour capter les tendances et les marier élégamment à la tradition confédérale. Un design intemporel fait de l'hôtel de 212 chambres un lieu de prédilection immédiat (comble du chic : les Junior Suites Bel Air avec un parquet sombre et un éclairage raffiné), le spa de 5 500 mètres carré allie bien-être d'Extrême-Orient et d'Occident, et au restaurant La Terrasse, le meilleur foie gras du pays est servi.

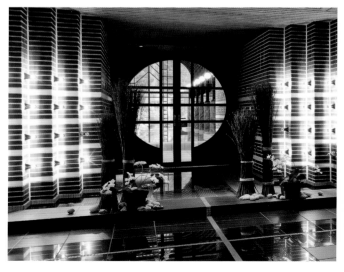

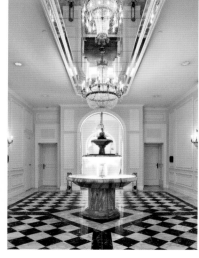

A light-flooded hall connects the two parts of the historic building, which have views of the snow-capped peaks of the Eiger, Mönch, and Jungfrau.

Eine lichtdurchflutete Halle verbindet die beiden historischen Gebäudeteile, die auf die schneebedeckten Gipfel des Dreigestirns Eiger, Mönch und Jungfrau schauen.

Un hall inondé de lumière relie les deux parties historiques du bâtiment qui donnent sur les cimes enneigées des trois géants Eiger, Mönch et Jungfrau.

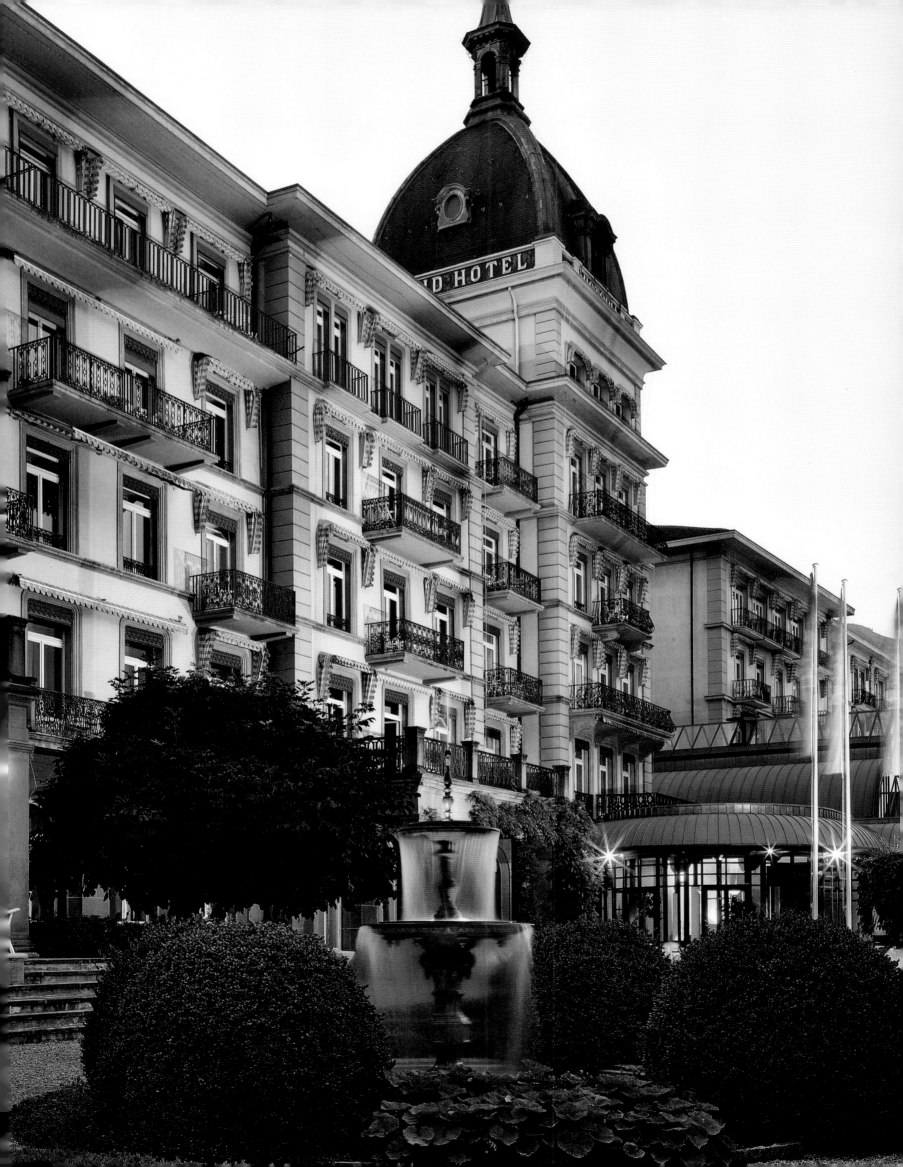

Old and new are successfully combined. The reception area of the ESPA wellness oasis resembles the deck of a luxury ship.

Alt und neu gehen eine geglückte Verbindung ein. Wie das Deck eines Luxusliners ist der Empfangsbereich der ESPA-Wellnessoase gestaltet.

L'ancien et le moderne sont associés avec brio. L'espace-accueil de ce havre de bien-être signé ESPA est aménagé comme le pont d'un luxueux bateau de croisière.

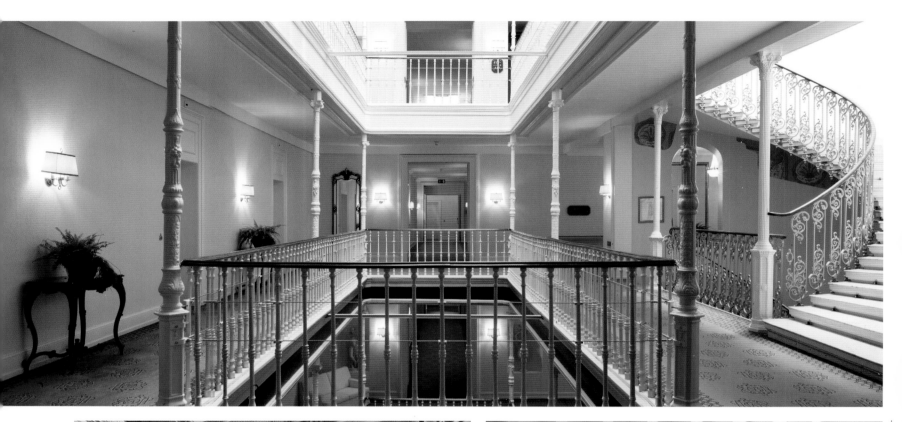

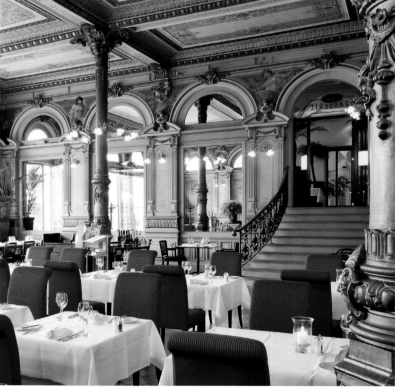

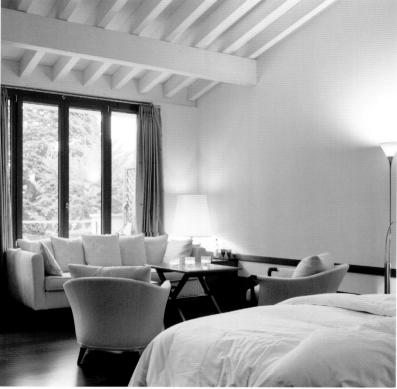

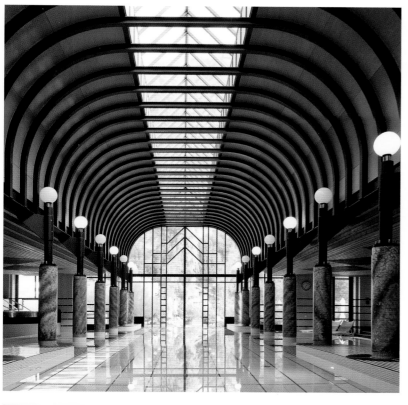

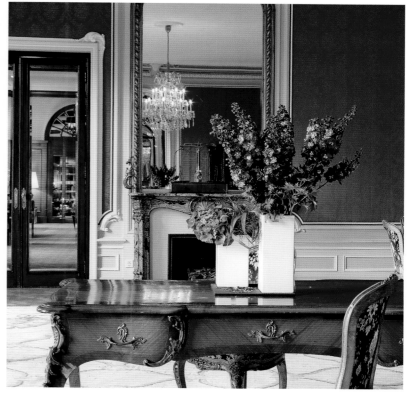

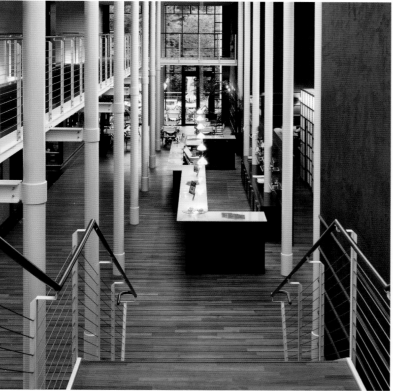

The Grand Hotel Kronenhof

Pontresina, Switzerland

The Grand Hotel Kronenhof, located in the authentic Engadine mountain village of Pontresina, dates back to the early days of winter sports when neighboring Saint Moritz took off as a winter hot spot. Guests have always treasured the rather quiet and cozy atmosphere. In 2007, the three wings of the belle époque structure received a modern addition with 28 new rooms and suites and a 21,500-square-foot spa. The entire splendor of the late 19th century unfolds in the second-floor salons furnished with original pieces, while the award-winning Kronenstübli is a feast for the senses.

Aus den Anfangszeiten des Wintersports, als das benachbarte Sankt Moritz zum winterlichen Hotspot reüssierte, stammt auch das Grand Hotel Kronenhof im Engadiner Pontresina. Gäste schätzten hier schon immer die eher ruhige und gemütliche Atmosphäre. 2007 bekamen die drei Flügel des repräsentativen Belle-Époque-Baus einen modernen Anbau mit 28 neuen Zimmer und Suiten und einem 2 000 Quadratmeter großen Spa. Die ganze Pracht des ausgehenden 19. Jahrhunderts entfaltet sich in den mit Originalen eingerichteten Salons auf der Beletage, dem Gaumen wird im ausgezeichneten Kronenstübli geschmeichelt.

Cet hôtel a vu le jour à Pontresina, non loin de la station de Sankt Moritz dans la région de l'Engadine, à l'époque où les sports d'hiver se sont popularisés. Tandis que Sankt Moritz est devenue une destination privilégiée, les hôtes du Grand Hotel Kronenhof ont toujours aimé l'ambiance plutôt calme et confortable. En 2007, les trois ailes de ce bâtiment de la Belle Époque ont été complétées par une annexe moderne de 28 nouvelles chambres et suites, ainsi que d'un spa de 2 000 mètres carrés. Le luxe de la fin du XIXᵉ siècle est parfaitement mis en valeur dans les salons du Bel-étage, décorés dans le style de l'époque ; le palais est flatté dans le Kronenstübli, restaurant étoilé.

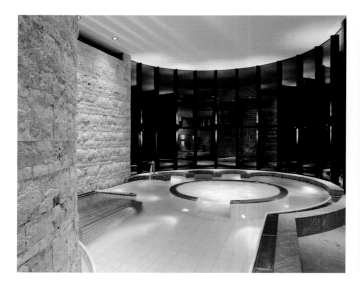

Referred to as the Ehrenhof ("Court of Honor"), the courtyard formed by the three wings of the hotel guarantees guests a classy arrival.

Der Ehrenhof, wie der Innenhof, den die drei Flügel bilden, genannt wird, garantiert Gästen eine noble Anreise.

L'Ehrenhof, la cour d'honneur, doit son nom à la noblesse de l'endroit formé par les trois ailes et garantit aux clients une arrivée qui ne manque pas de style.

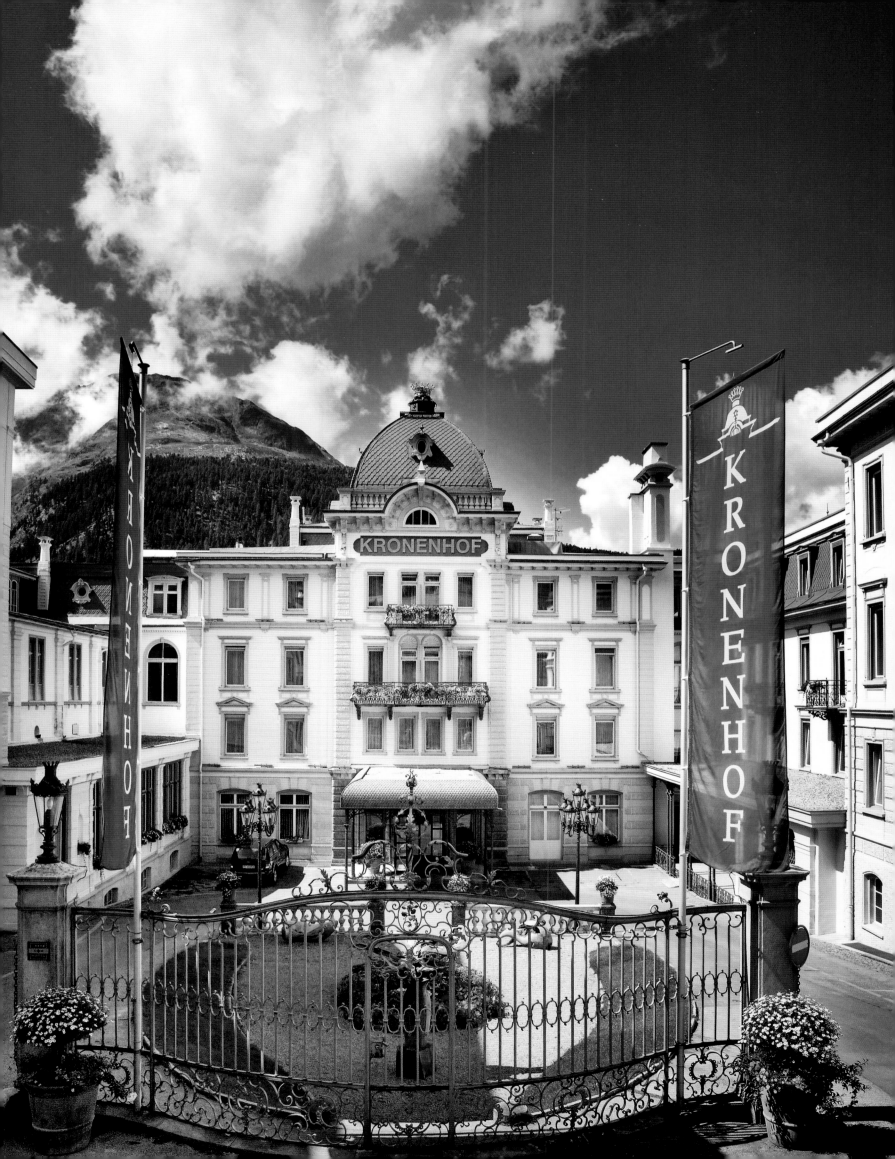

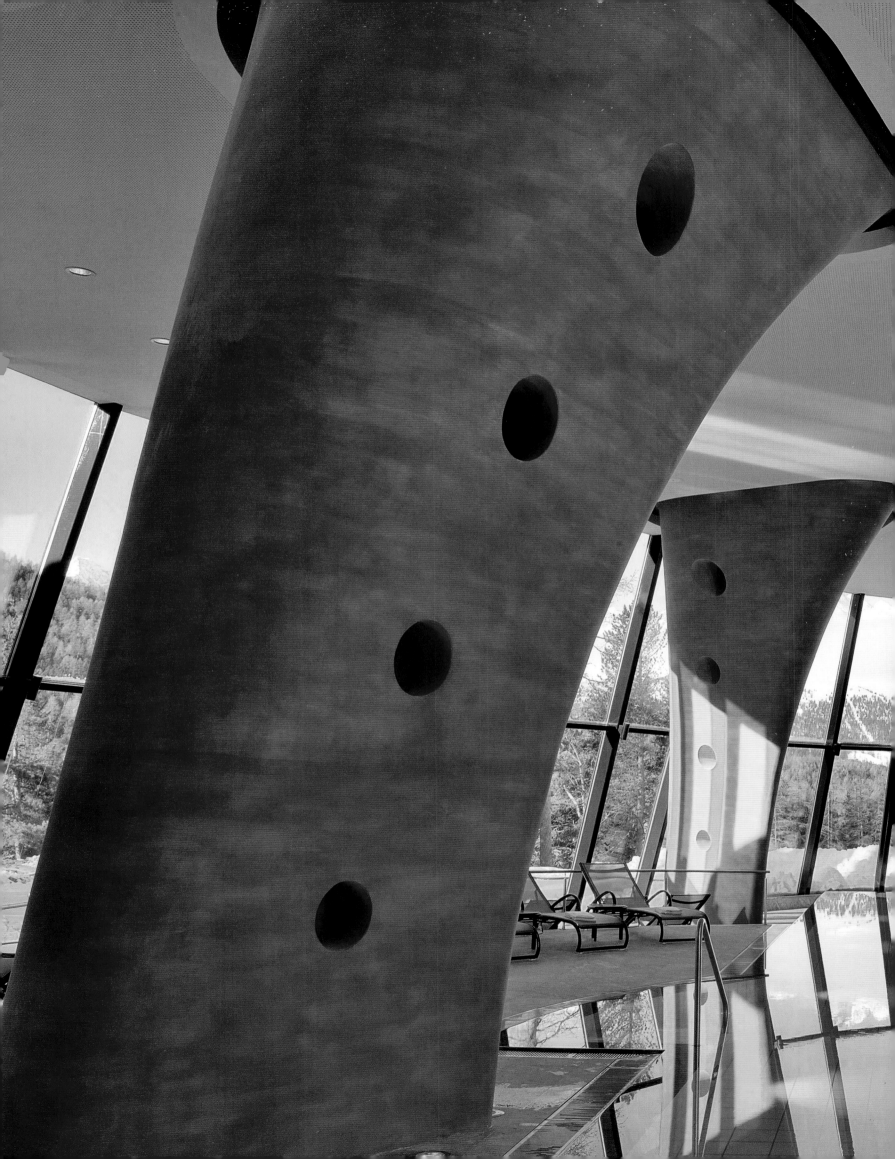

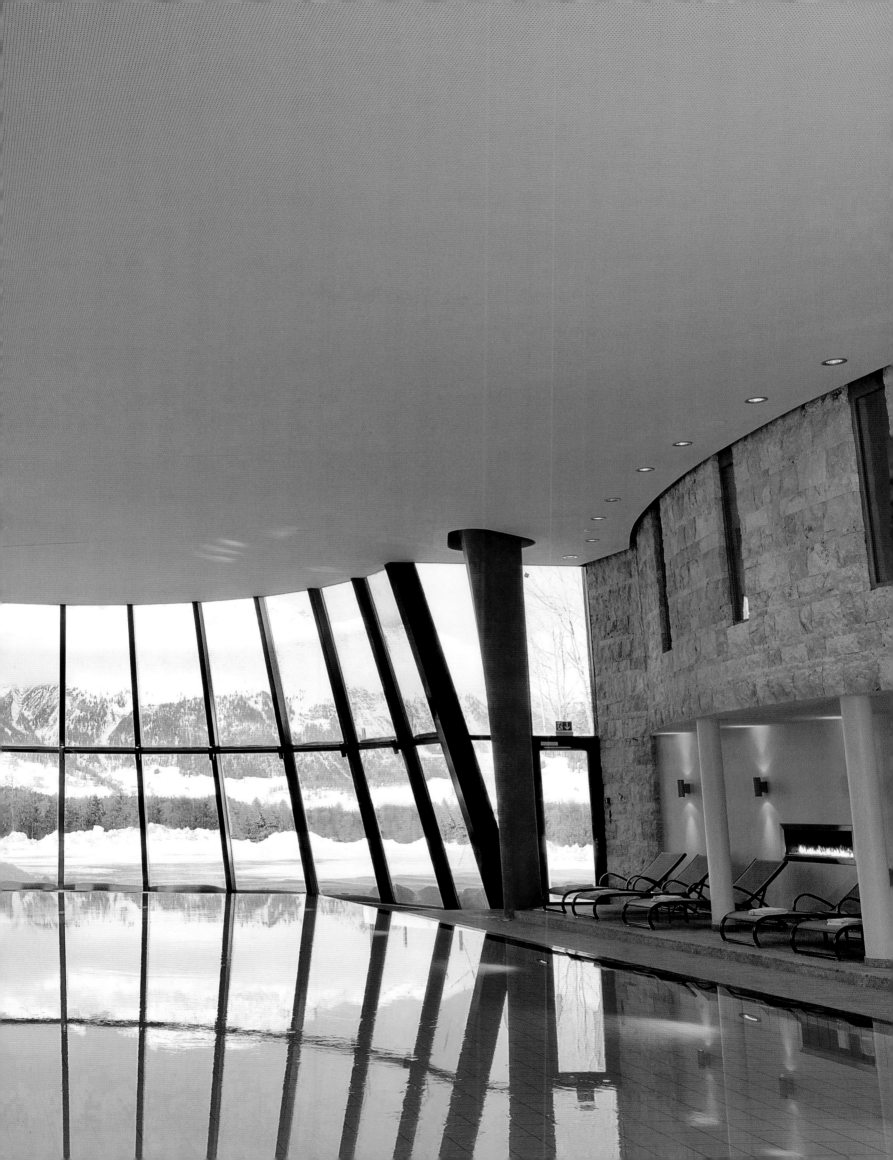

The arched glass façade of the indoor pool is stunning, framing the magnificent scenery of the Corviglia.

Großartig ist die bogenförmige Glasfassade des Indoor Pools, welche Ausblicke auf die grandiose Bergwelt der Corviglia bietet.

La majestueuse façade courbe en verre de la piscine intérieure place le visiteur au cœur du paysage grandiose de la Corviglia.

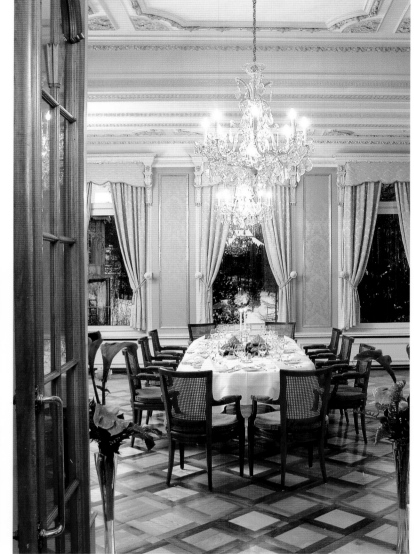

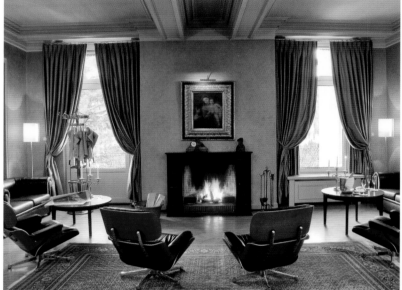

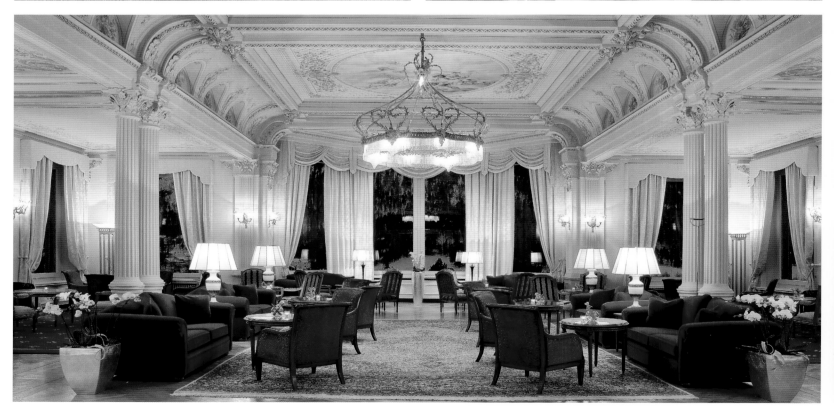

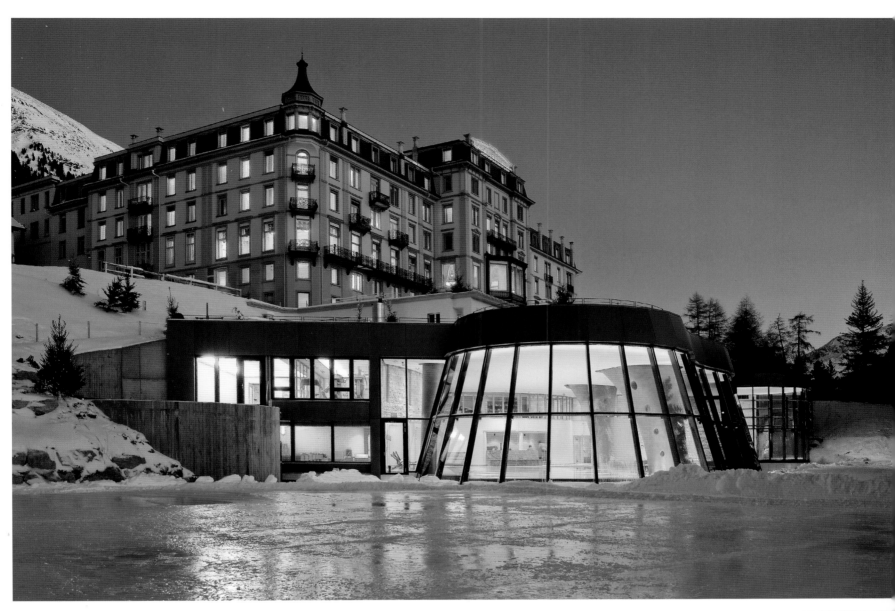

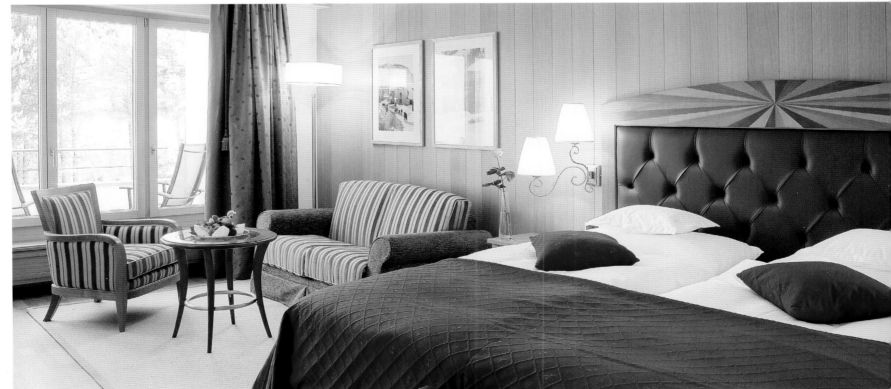

The Grand Hotel Kronenhof *Pontresina, Switzerland* 141

Baur au Lac

Zurich, Switzerland

Built in 1844, the Baur au Lac has been owned by the Kracht family for six generations. Tradition reigns supreme in this elegant hotel on Lake Zurich. The lobby, furnished with exquisite antiques and decorated with artistic flower arrangements, is a popular meeting place for Zurich's high society. In keeping with the city's zwinglian heritage, Baur au Lac offers luxury that is discreet and unobtrusive. Renovations to the tune of 160 million Swiss francs resulted in a sophisticated update styled by internationally renowned designers.

Das Baur au Lac ist bereits in sechster Generation im Besitz der Familie Kracht, deren Vorfahren es 1844 gegründet haben. Tradition wird groß geschrieben in dem noblen Hotel am Zürichsee, in dessen Halle mit ihren exquisiten Antiquitäten und fantastischen Blumengestecken sich die Zürcher Gesellschaft trifft. Dem zwinglianischen Erbe der Schweizer Metropole verpflichtet, ist es ein unaufdringlicher Luxus, der hier gepflegt wird. Eine Investition von 160 Millionen Schweizer Franken und eine Garde internationaler Designer sorgten für ein anspruchsvolles Update.

L'hôtel Baur au Lac fut fondé en 1844 par la famille Kracht qui en est propriétaire depuis six générations déjà. La tradition trouve toutes ses lettres de noblesse dans cet hôtel en bordure du lac de Zurich. La société zurichoise se retrouve d'ailleurs dans son lobby ornementé de luxueuses antiquités et de fantastiques bouquets de fleurs. Héritage zwinglienne de cette métropole suisse oblige, nous avons ici à faire à un luxe discret. Un investissement de 160 millions de Francs suisses et une armée de designers venus du monde entier se sont chargés d'une rénovation prestigieuse.

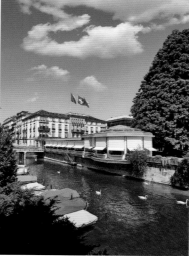

Although the chic shopping area along the Bahnhofstrasse is just minutes away, this classy city hotel on the shore of Lake Zurich feels like a resort.

Zur mondänen Shoppingmeile Bahnhofstrasse sind es nur wenige Schritte und doch wirkt das noble Stadthotel am Ufer des Zürichsees wie ein Resort.

Bien que situé à quelques pas seulement de la Bahnhofstrasse, la célèbre rue commerçante huppée, cet hôtel de luxe de centre-ville implanté au bord du lac de Zurich a des allures de complexe hôtelier.

Unique and valuable pieces—such as the magnificent Twenties-era Lalique chandelier that bathes the Pavillon restaurant in soft light— underscore the elegant atmosphere.

Wertvolle Einzelstücke *wie der grandiose Lalique-Leuchter aus den zwanziger Jahren, der das Restaurant Pavillon in sanftes Licht taucht, unterstreichen die elegante Anmutung.*

De précieuses *pièces comme le grandiose chandelier Lalique des années 20, qui diffuse sa lumière tamisée dans le restaurant Pavillon, soulignent l'élégance de l'établissement.*

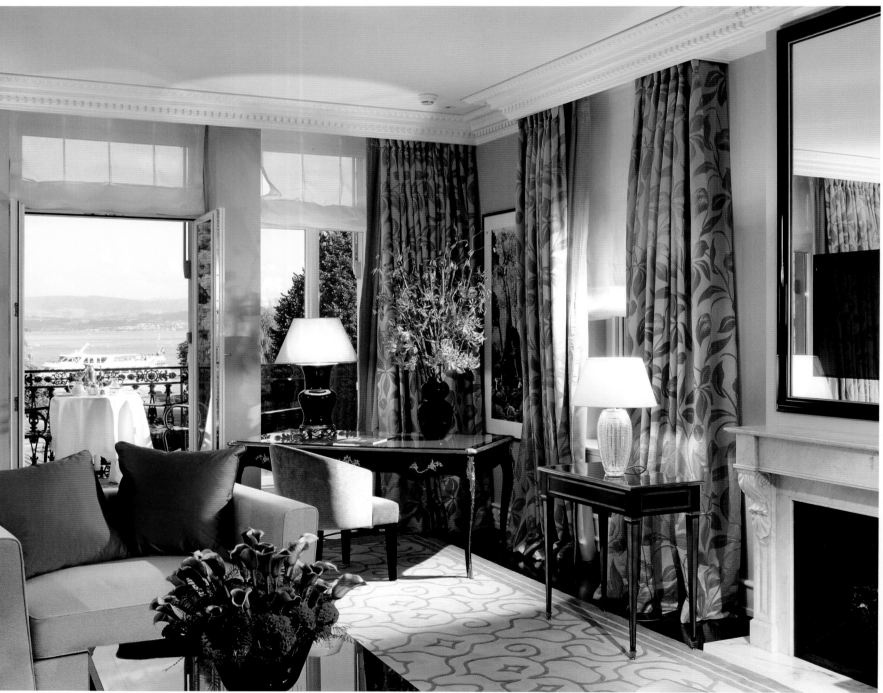

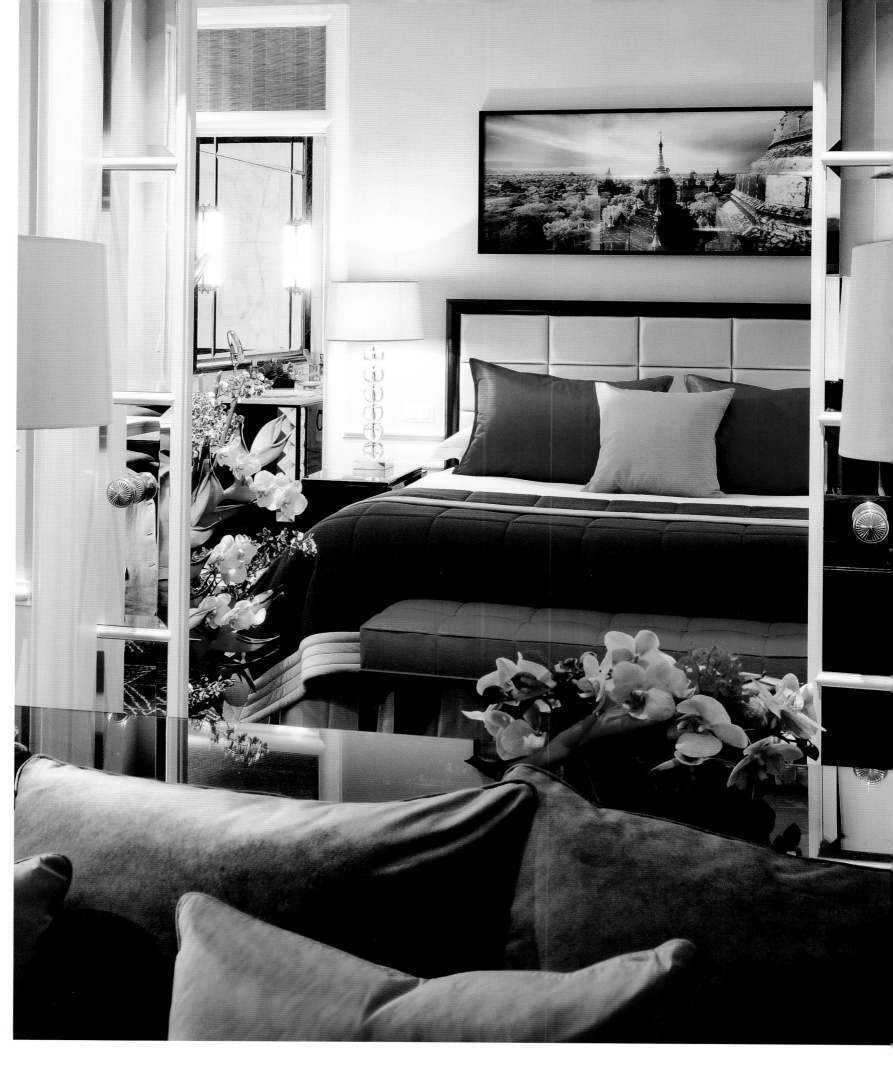

Domaine de Verchant

Castelnau-le-Lez, France

Not far from Montpellier, an avenue of old oaks leads to the Languedoc vineyards and a mansion typical for the South of France. What awaits guests behind the natural stone walls, however, is much less typical. Parisian interior designer Raymond Morel created a consistently modern ambience. Fans of modern furnishings will discover icons from 50 years of design history in the rooms, from Hansen's Egg Chair to seating by Poltrona Frau. Guests can sample the products from the hotel's own vineyards in the wine bar as well as in the gourmet restaurant.

Nahe Montpellier führt eine alte Eichenallee in die Weinberge des Languedoc zu einem typischen südfranzösischen Herrenhaus. Was den Gast hinter den hellen Natursteinmauern erwartet, ist allerdings weniger typisch. Der Pariser Innenarchitekt Raymond Morel schuf ein konsequent modernes Ambiente. Liebhaber modernen Mobiliars entdecken in den Räumen Ikonen aus 50 Jahren Designgeschichte, von Hansens Egg Chair bis zu Sitzmöbeln von Poltrona Frau. Die Gewächse aus dem eigenen Weinberg verkostet man in der Vinothek sowie im Gourmet-Restaurant.

Non loin de Montpellier, une allée bordée de vieux chênes emmène les visiteurs à travers les vignobles du Languedoc vers un de ces manoirs typiques du sud de la France. Ce qui attend les hôtes derrière les murs en pierre naturelle est en revanche moins typique, l'architecte d'intérieur parisien Raymond Morel ayant opté pour une ambiance résolument moderne. Les amateurs de mobilier contemporain découvriront des icônes retraçant 50 années d'histoire du design, avec chaises Œuf de la maison Hansen et autres sièges Poltrona Frau. Les invités pourront également déguster les crus du vignoble du domaine dans la vinothèque ou le restaurant gastronomique.

The spa treatments are tailored to the needs of each guest.

Die Spa-Behandlungen werden für die Gäste maßgeschneidert.

Les soins spa sont personnalisés pour les clients.

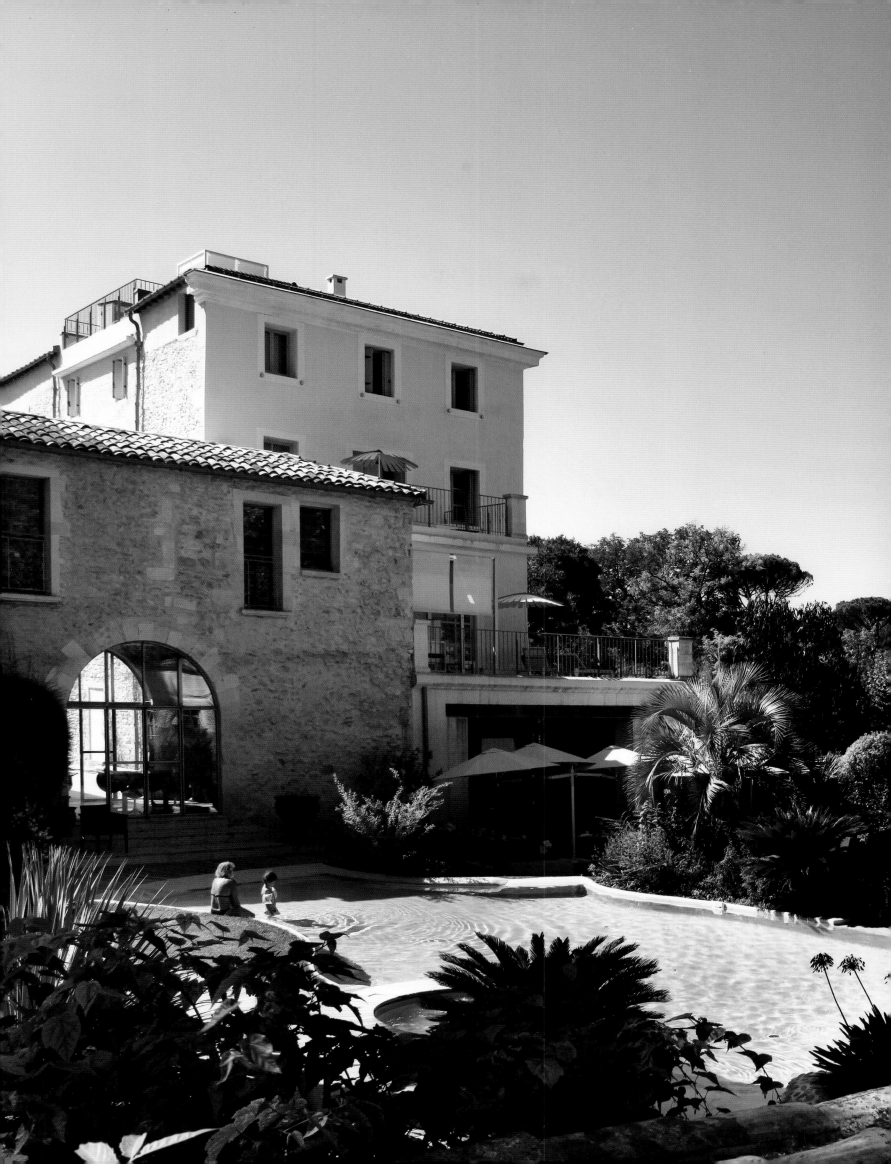

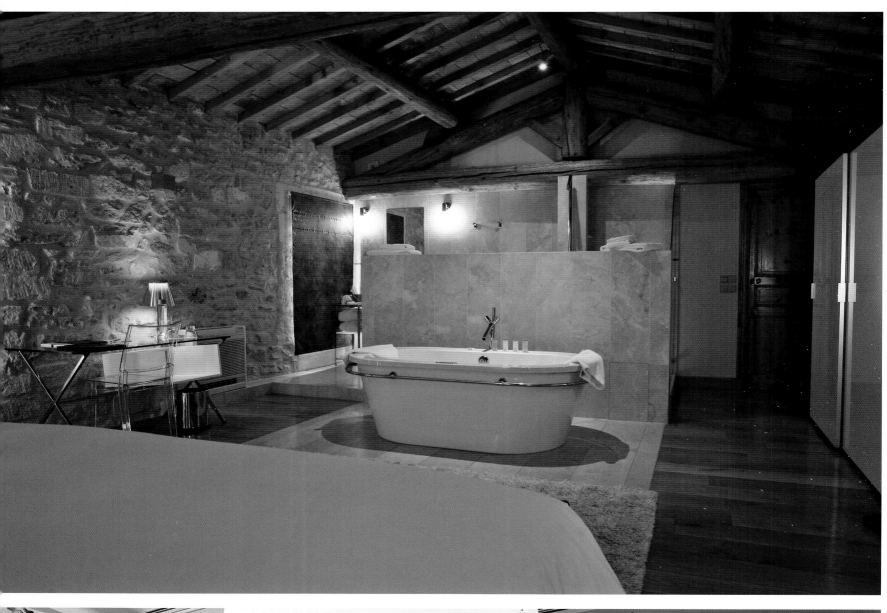

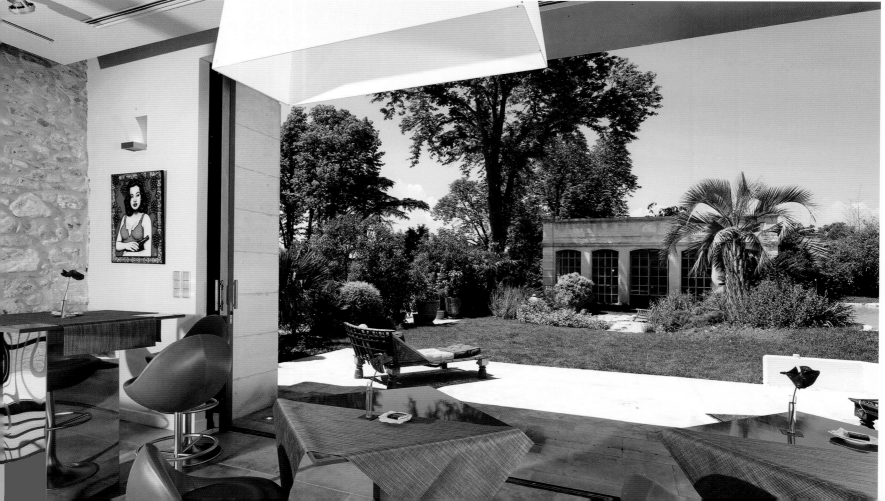

The 200-year-old, hand-crafted stonework forms an exciting contrast to the modern interior.

Das zwei Jahrhunderte alte, von Hand bearbeitete Mauerwerk bildet einen spannenden Kontrast zum modernen Interieur.

La bâtisse deux fois centenaire construite à la main offre un contraste intéressant avec l'intérieur moderne.

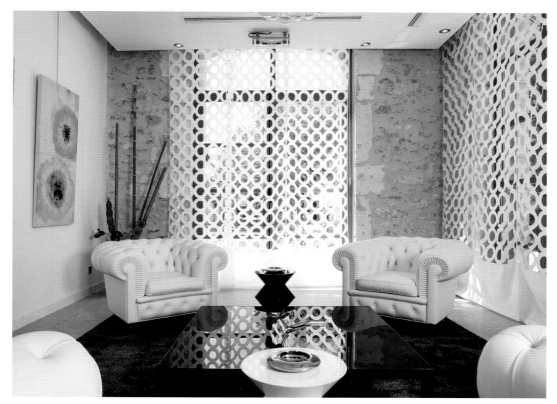

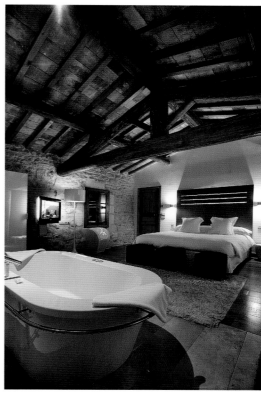

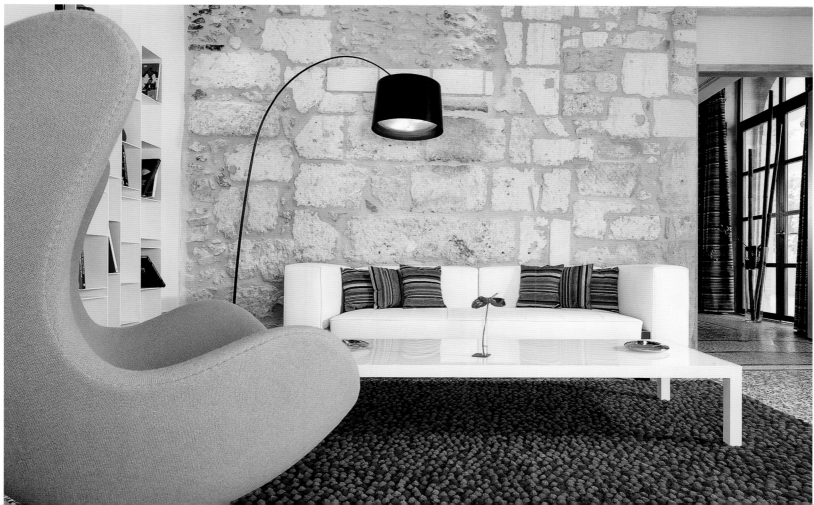

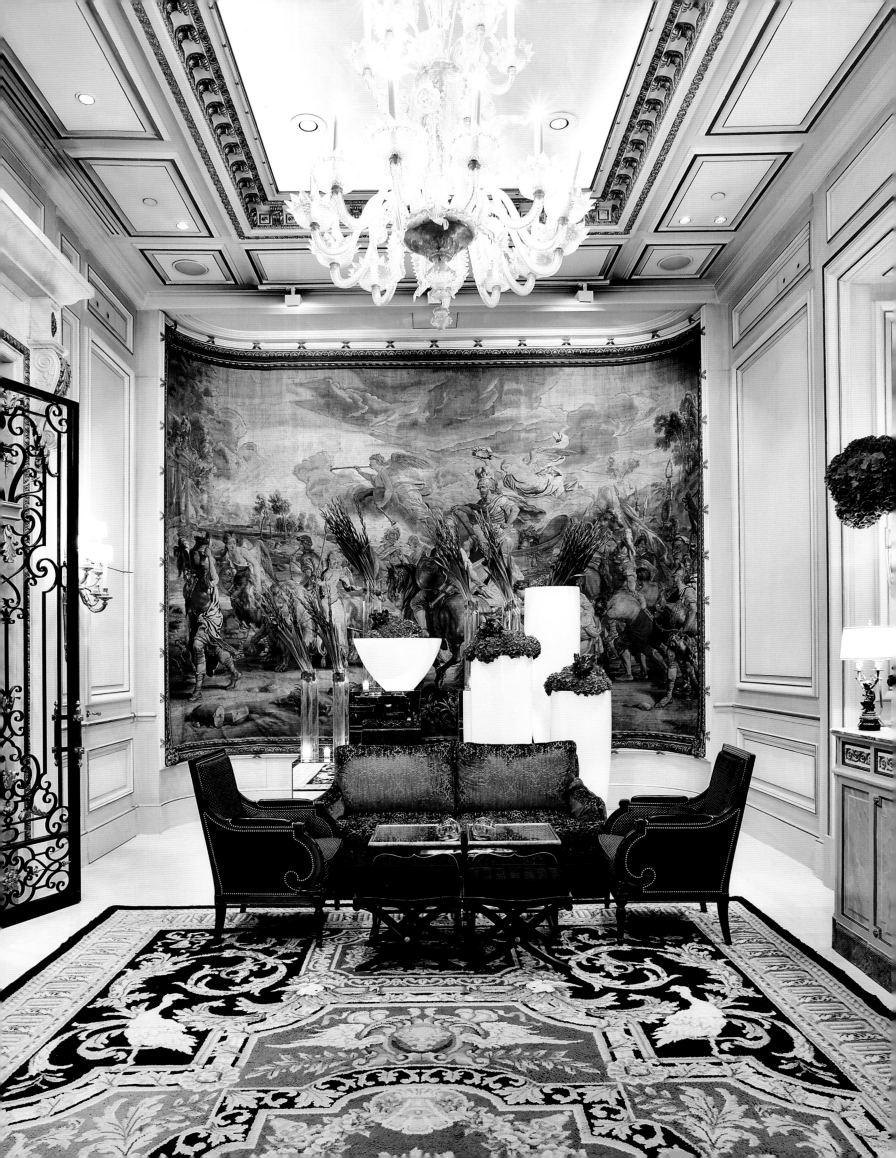

Four Seasons Hotel George V

Paris, France

With a magnificent location in the golden triangle of the eighth arrondissement, the façade of this hotel has been completely renovated in archetypical Parisian art deco style. With their original antiques and precious carpets, the public rooms surpass one another in elegance. Yet the reason why the Four Seasons Hotel George V regularly tops the rankings of the best city hotels in the world is primarily the highly personal service which is incredibly efficient and, despite its perfection, always emotionally in tune with the guests.

Die Lage im Goldenen Dreieck des VIII. Arrondissements ist grandios, die Fassade zeigt sich nach der Komplettrenovierung im schönsten Pariser Art déco, und die öffentlichen Räume überbieten sich an Eleganz mit Antiquitäten aus der Anfangszeit und kostbaren Teppichen. Aber dass das Four Seasons Hotel George V regelmäßig die Rankings der besten Stadthotels weltweit anführt, hat vor allem mit dem sehr persönlichen Service zu tun, der unfassbar effizient, aber trotz aller Perfektion immer auch emotional, sprich dem Gast zugewandt ist.

Une situation idéale dans le triangle d'or du VIII^e arrondissement, une façade Art déco parisien du plus bel effet depuis sa rénovation complète, des pièces communes qui rivalisent d'élégance à grand renfort d'antiquités et de tapis précieux : voilà qui pourrait résumer le Four Seasons Hotel George V. Mais ce qui permet à cet hôtel de se retrouver régulièrement en tête des classements des meilleurs établissements en ville du monde, c'est aussi et surtout son service personnalisé, d'une efficacité incomparable et dont la perfection n'a d'égal que son dévouement aux clients.

 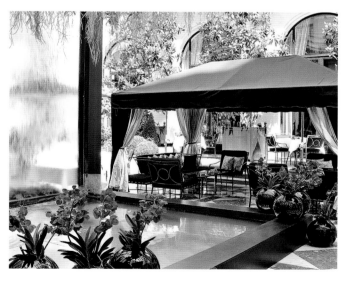

Tremendous expense goes into every detail: Fresh flowers and plants for the famous flower arrangements are delivered by the truckload from Rotterdam, Holland.

Hinter jedem Detail steckt ein ungeheurer Aufwand: Lastwagenweise werden die Blumen und Pflanzen für den berühmten Blumenschmuck frisch aus Rotterdam angeliefert.

Chaque détail sous-entend d'immenses efforts : les fleurs et plantes pour la célèbre décoration florale sont livrées directement de Rotterdam par camions entiers.

The precious 17ʰ-century tapestries come from Flanders. Awarded two Michelin stars, gourmet restaurant Le Cinq serves classic French cuisine.

Die wertvollen Tapisserien aus dem 17. Jahrhundert stammen aus Flandern. Mit zwei Michelin-Sternen ist das Gourmet-Restaurant Le Cinq gekrönt, das klassische französische Küche serviert.

Les précieuses tapisseries du XVIIᵉ siècle proviennent de Flandre. Le restaurant gastronomique Le Cinq, distingué par deux étoiles Michelin, sert une cuisine française classique.

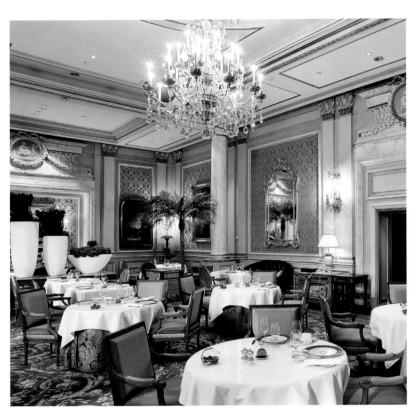

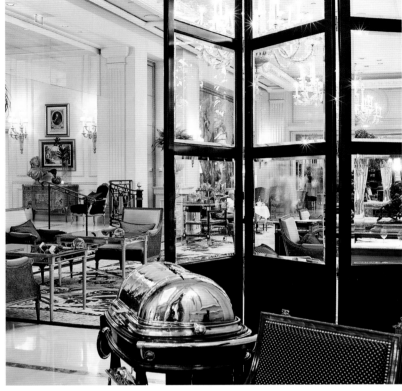

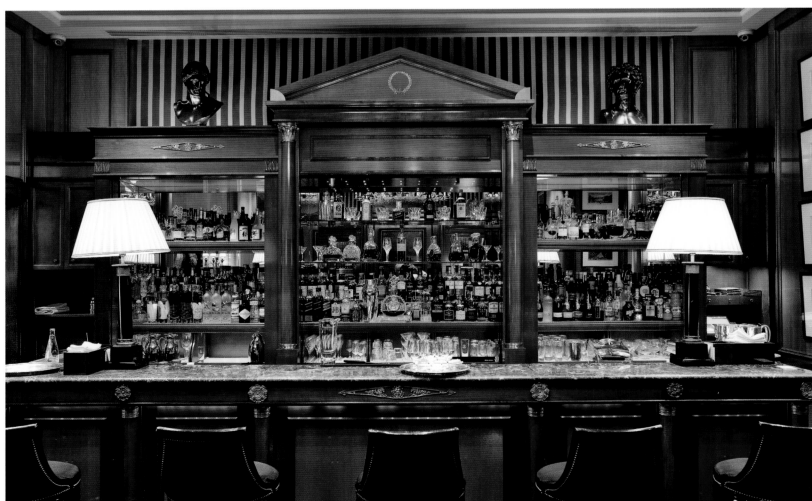

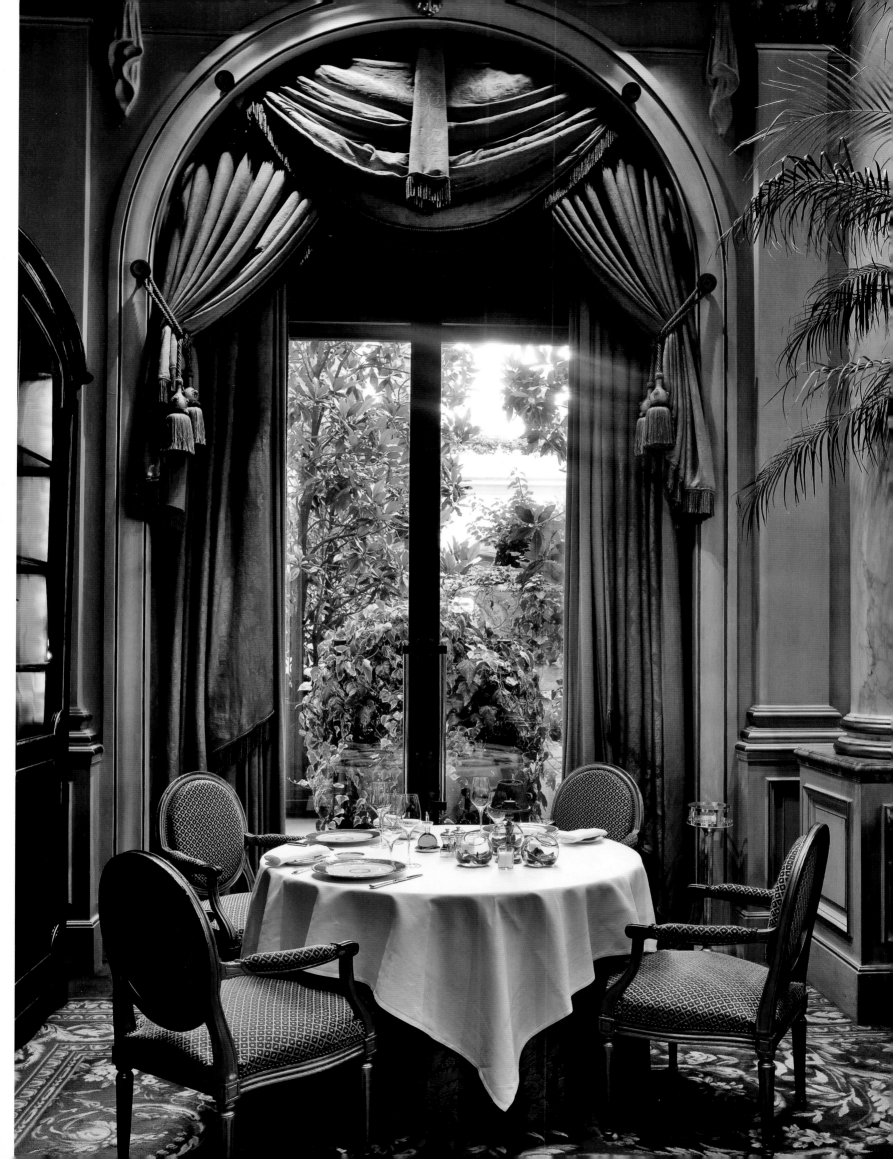

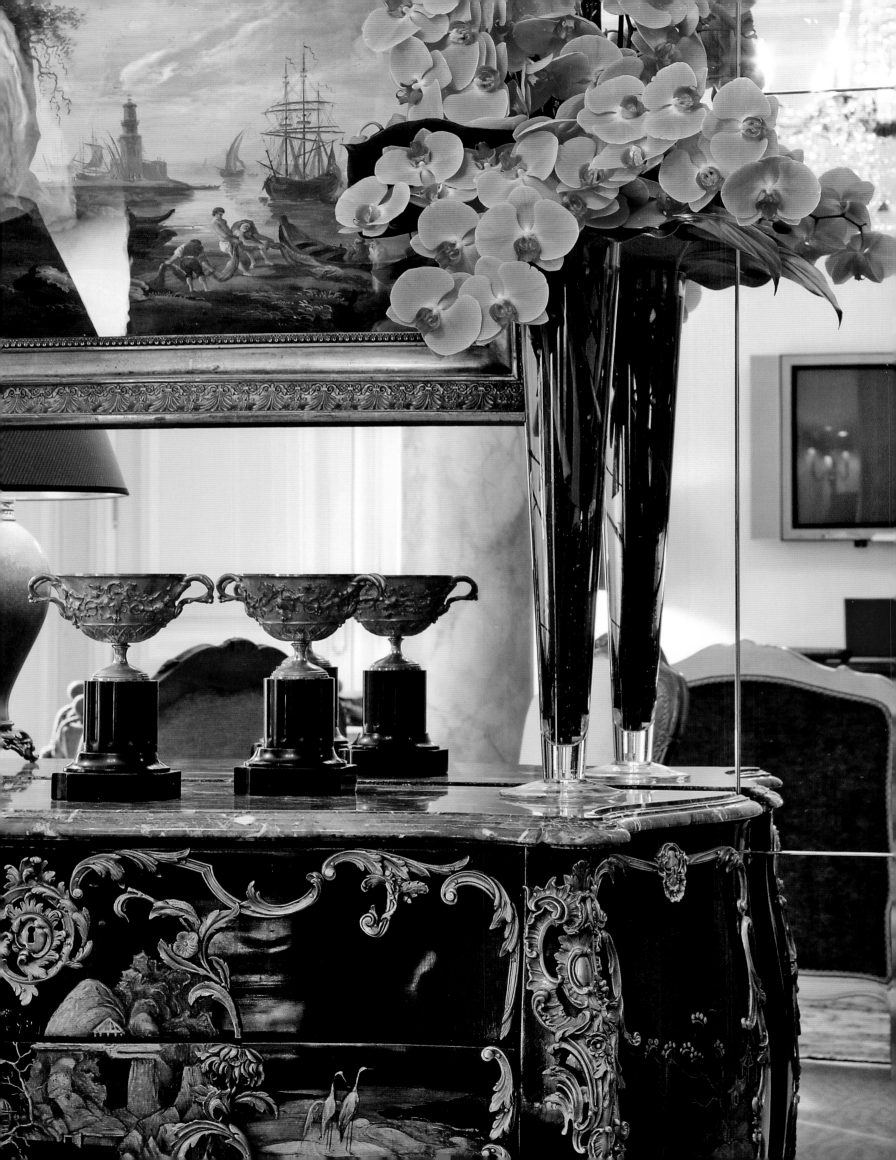

Hotel Plaza Athénée Paris

Paris, France

Since hip Parisian interior designer Patrick Jouin completely redesigned the Bar du Plaza, it has become a popular hotspot for Parisian high society and a major attraction at the legendary hotel. Founded in 1911, this luxury establishment is situated on Avenue Montaigne, surrounded by trendy boutiques, fine restaurants, and businesses. The extensive renovation of Plaza Athénée carefully preserved the glamour of bygone eras. The hotel's furniture and accessories reference the classical French style. Some of the 430-square-foot deluxe rooms offer idyllic views of the gardens.

Der angesagte Pariser Designer Patrick Jouin gestaltete die Bar du Plaza neu. Seitdem ist sie eine Muss-Adresse für die Pariser Gesellschaft und ein Aushängeschild des legendären Hotels. Die 1911 in Betrieb genommene Luxusherberge liegt an der Avenue Montaigne, umgeben von Trendboutiquen, feinen Restaurants und Geschäftshäusern. Trotz einer umfangreichen Sanierung ist im Plaza Athénée der Glanz vergangener Zeiten zu spüren. Möbel und Accessoires im Hotel greifen den klassischen, französischen Stil auf. Einige der 40 Quadratmeter großen Deluxe-Zimmer bieten einen idyllischen Blick in den Garten.

Patrick Jouin, renommé styliste d'intérieur parisien, a remodelé le Bar du Plaza. Depuis lors, cette adresse est un must pour la société parisienne et sert d'image de marque pour le légendaire hôtel. Cette résidence de luxe, qui a ouvert ses portes en 1911, se trouve à l'Avenue Montaigne, entourée de boutiques au top de la tendance, de nobles restaurants et d'immeubles de bureaux. Malgré les travaux d'assainissement de très grande envergure qui y ont été effectués, on ressent à la Plaza Athénée la splendeur du passé. Les meubles et accessoires à l'intérieur de l'hôtel reprennent le style classique français. Certaines des chambres « Deluxe » de 40 mètres carrés offrent une vue idyllique sur le jardin.

All rooms were completely modernized and updated with state-of-the-art technology to ensure that business travelers have everything they need when they visit Paris.

Alle Zimmer wurden modernisiert und technisch aufgerüstet. So finden Geschäftsreisende optimale Bedingungen vor, wenn sie in Paris sind.

Toutes les chambres ont été modernisées et dotées d'un équipement technique amélioré. Les V.R.P. seront maintenant hébergés dans des conditions optimales lorsqu'ils sont à Paris.

The hotel offers many different areas to relax. In the summer, guests enjoy sitting in the courtyard.

Das Hotel bietet genügend Plätze für schöne Stunden. Im Sommer sitzen die Gäste gerne im Innenhof.

L'hôtel offre suffisamment de places pour passer des heures agréables. En été, les hôtes se prélassent **avec plaisir** sur les bancs de la cour intérieure.

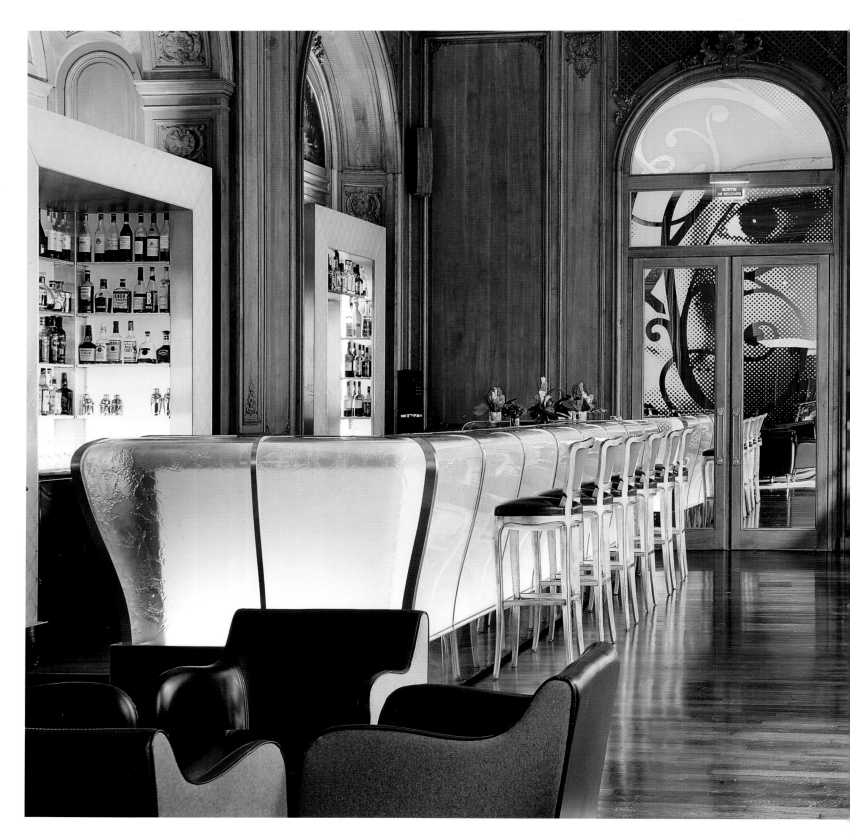

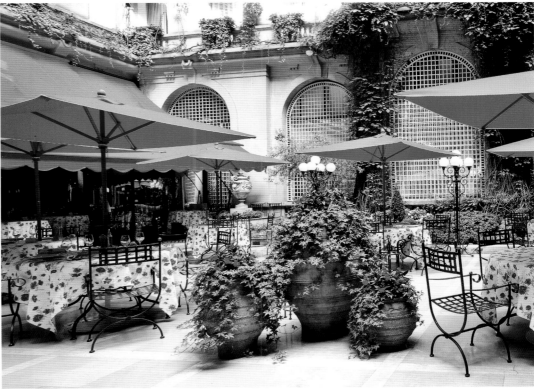

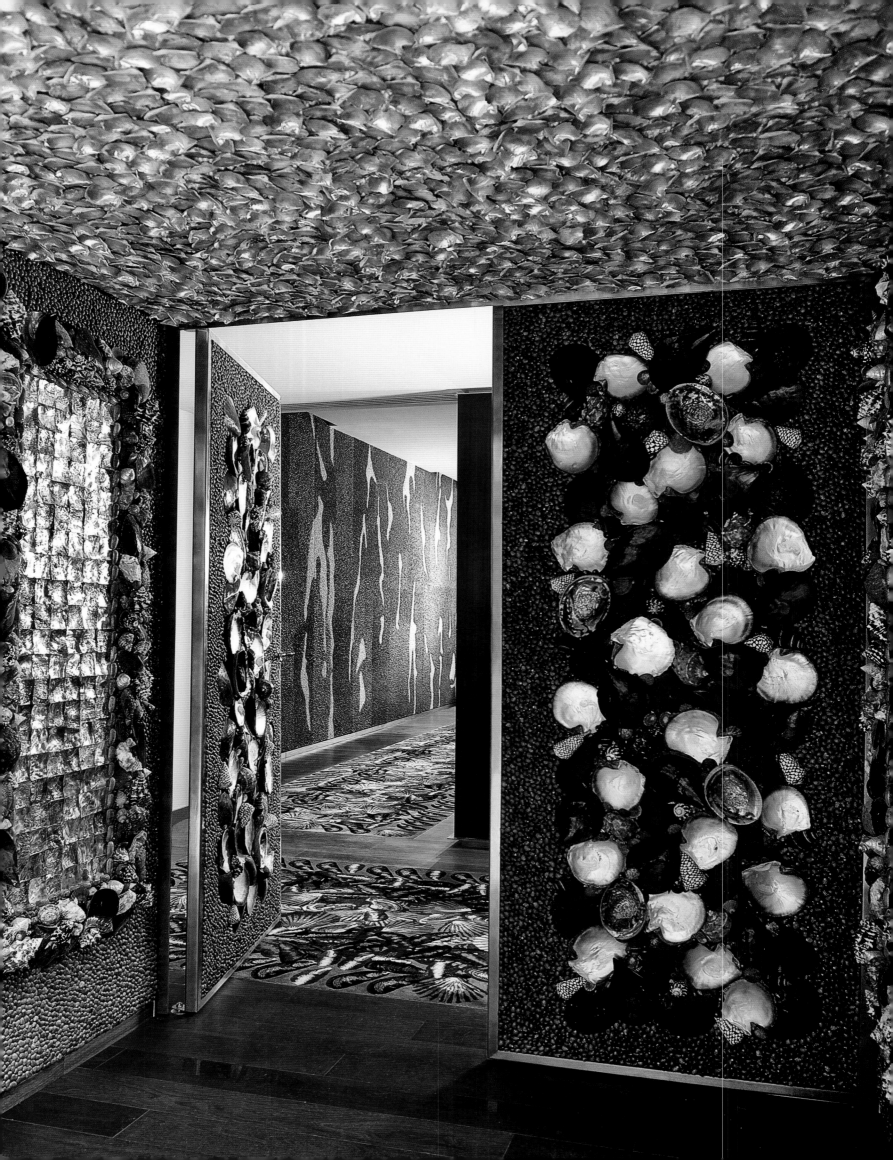

Le Royal Monceau – Raffles Paris

Paris, France

How do you take the idea of a glamorous grand hotel into the third millennium? In the newly reopened Royal Monceau, the European flagship of the Raffles Group, Philippe Starck gives an unconventional answer. All the rooms glimmer, shimmer, and sparkle. A sophisticated art concept lends depth to the glamour; it comprises a collection of 320 photographs, a bookstore featuring books about art, architecture, and design, a gallery, and, last but not least, an "art concierge" who has the best connections to the art scene.

Wie transportiert man die Idee des glamourösen Grandhotels ins dritte Jahrtausend? Philippe Starck gibt im wiedereröffneten Royal Monceau, dem Flagship der Raffles-Gruppe in Europa, eine eigenwillige Antwort. In allen Räumen glitzert, schimmert und funkelt es. Ein anspruchsvolles Kunstkonzept verleiht dem Glamour Tiefe: Dazu gehören eine Kollektion von 320 Fotografien, ein Buchladen mit Kunst-, Architektur- und Designbänden, eine Galerie und nicht zuletzt ein „Art Concierge", der die besten Kontakte zur Kunstszene pflegt.

Comment transposer un hôtel de luxe glamour au troisième millénaire ? Au Royal Monceau, fleuron du groupe Raffles en Europe qui a récemment rouvert ses portes, Philippe Starck apporte une réponse de son propre cru. Toutes les pièces étincellent, brillent et scintillent. Un concept artistique raffiné donne de la profondeur à tout ce glamour. Celui-ci comprend une collection de 320 photographies, une librairie proposant des ouvrages dans les domaines de l'art, de l'architecture ou du design, une galerie d'exposition, sans oublier un « concierge d'art » qui entretient les meilleurs contacts avec la scène artistique.

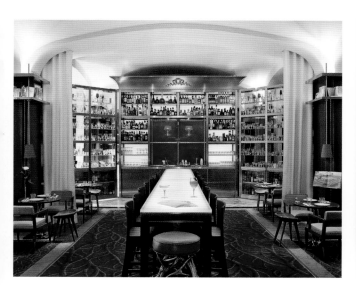

Philippe Starck's budget appears to have been unlimited: Mother-of-pearl makes the walls and ceilings of the Italian restaurant Il Carpaccio shimmer. Le Bar Long breaks with conventions—guests sit at a long table.

Unbegrenzt scheint das Budget von Philippe Starck gewesen zu sein: Perlmutt bringt Wände und Decken des italienischen Restaurants Il Carpaccio zum Schimmern. Le Bar Long bricht mit den Konventionen — Gäste sitzen an einem langen Tisch.

Le budget de Philippe Starck semble avoir été illimité : de la nacre fait briller murs et plafonds du restaurant italien Il Carpaccio. Le Bar Long rompt les conventions, les clients sont assis à une longue table.

Sparkling crystal chandeliers and lavish expanses of mirrors in the rooms and bathrooms contrast with op art stripes on various floors, including the floor of the Italian restaurant.

Glitzernde Kristalllüster kontrastieren ebenso wie die großzügig über Räume und Bäder verteilten Spiegel mit den Op-Art-Mustern, die beispielsweise den Boden des italienischen Restaurants zieren.

À l'instar des généreuses surfaces de miroirs dans les salles de bain et les chambres, les lustres de cristal dispendieux contrastent avec les motifs Op Art, qui décorent par exemple le sol du restaurant.

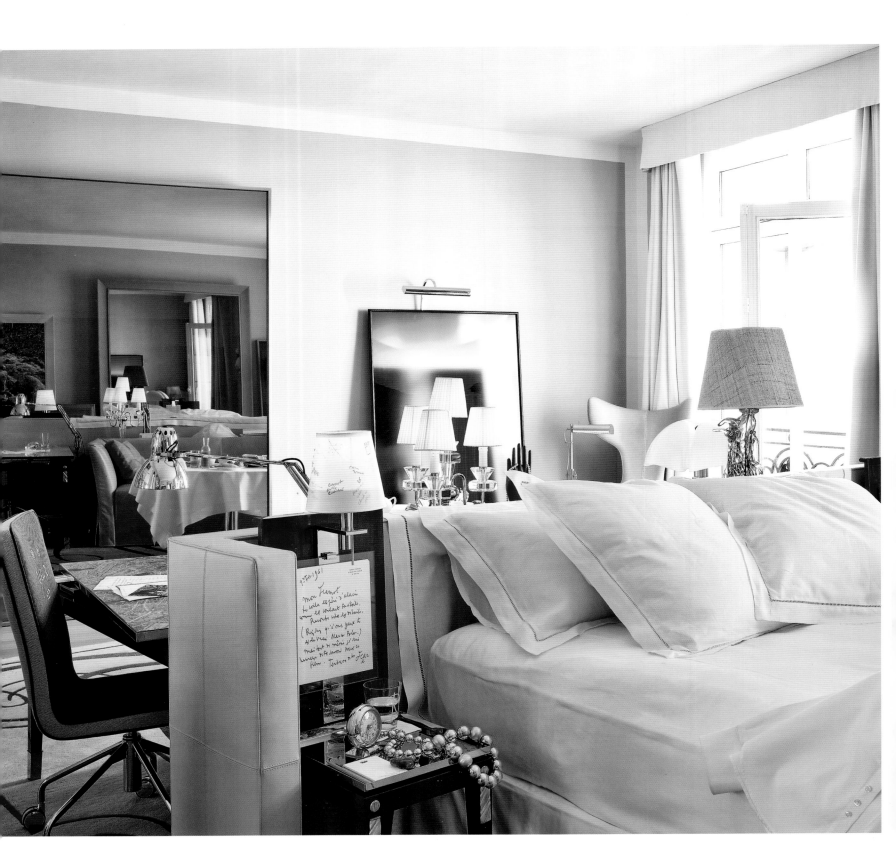

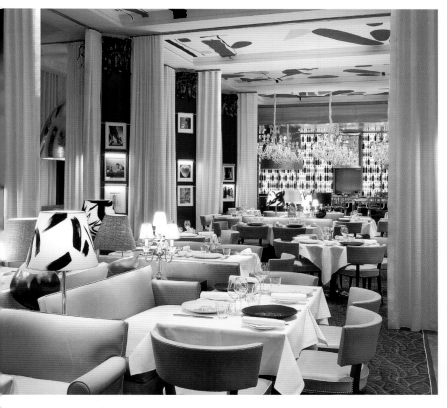

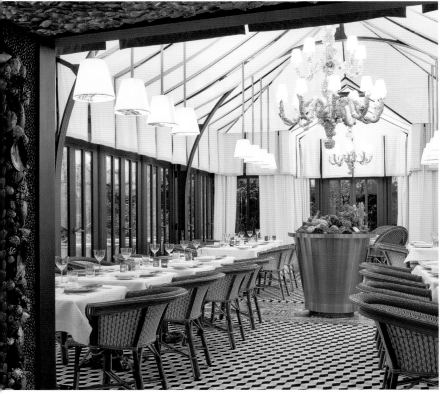

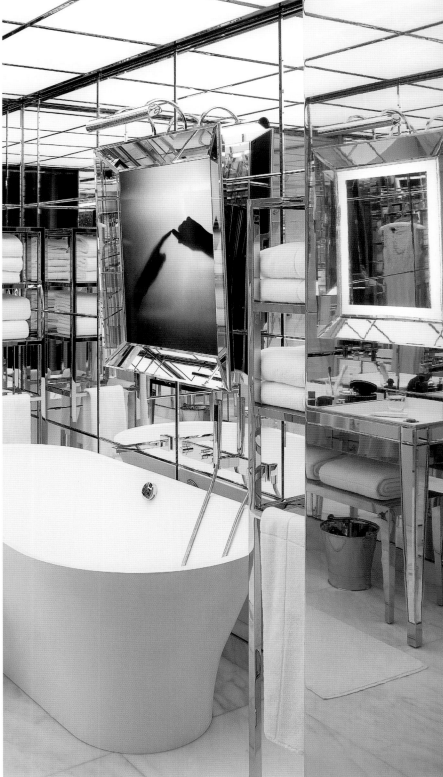

Le Royal Monceau – Raffles Paris *Paris, France* 161

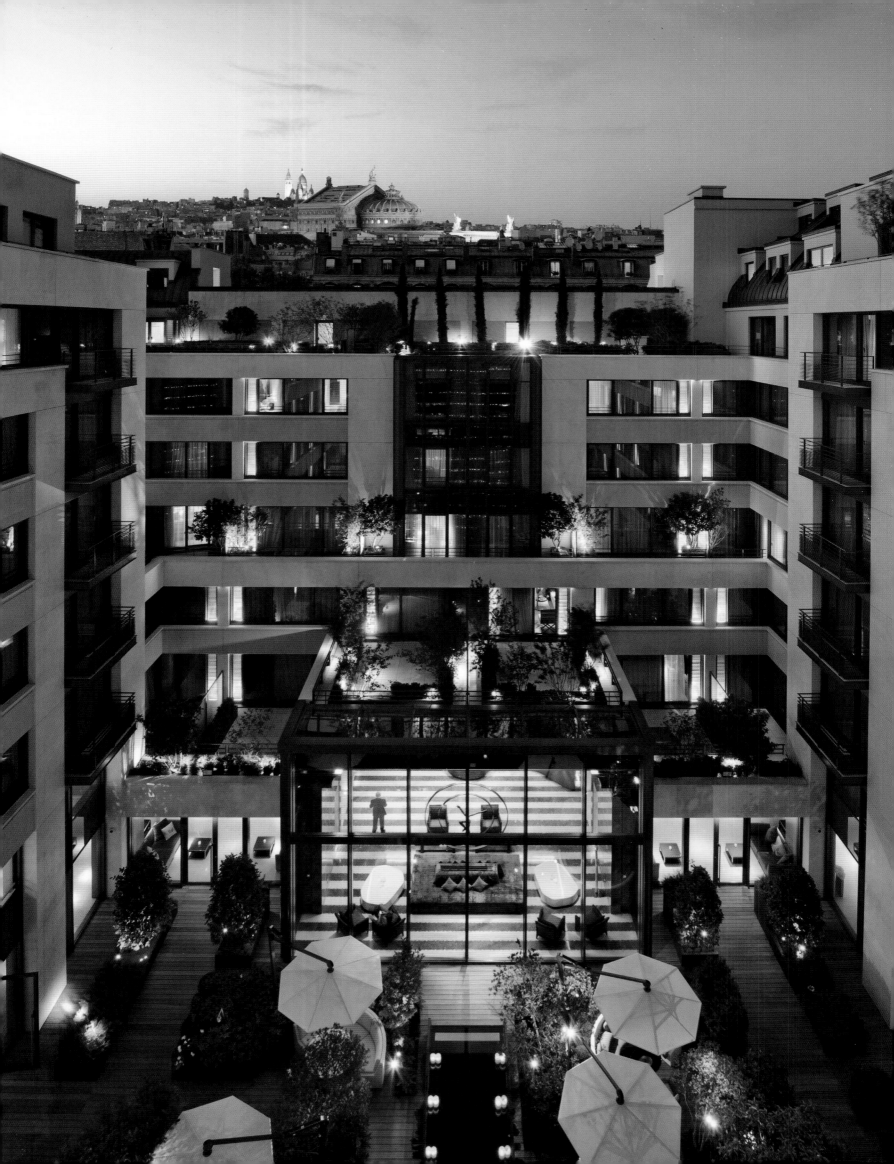

Mandarin Oriental, Paris

Paris, France

A former 1928 bank building on the elegant Rue Saint-Honoré houses the Mandarin Oriental, opened in June 2011. The guiding principle behind the design concept for the 99 rooms and 39 suites was to capture the special vibe of Paris. Far Eastern style elements, particularly in the 9,700-square-foot spa, allude to the origins of the Asian hotel group. The action-packed cuisine of Thierry Marx—a true Bruce Willis behind the stove—is absolutely sensational and finds the perfect framework in the completely white avant-garde restaurant.

Ein ehemaliges Bankgebäude von 1928 beherbergt das im Juni 2011 eröffnete Mandarin Oriental an der feinen Rue Saint-Honoré. Den ganz speziellen Vibe von Paris einzufangen war Leitgedanke des Designkonzepts der 99 Zimmer und 39 Suiten. Fernöstliche Stilelemente, vor allem im 900 Quadratmeter großen Spa, spielen auf die Herkunft der Hotelgruppe aus Asien an. Aufsehenerregend ist die actiongeladene Küche von Thierry Marx, der als Bruce Willis hinterm Herd gilt. Sie findet im ganz in Weiß gehaltenen Avantgarde-Restaurant den passenden Rahmen.

Un ancien établissement bancaire datant de 1928 abrite désormais le Mandarin Oriental, qui a ouvert ses portes en juin 2011 dans la célèbre rue Saint-Honoré. La volonté de reproduire les particularités de l'atmosphère parisienne s'est révélée essentielle au moment d'imaginer le design des 99 chambres et 39 suites. Des éléments de style extrême-oriental, notamment dans le spa de 900 mètres carrés, viennent également rappeler l'origine asiatique du groupe hôtelier. La cuisine atypique et sensationnelle de Thierry Marx, que beaucoup confondent avec Bruce Willis, trouve un cadre parfait dans le restaurant avant-gardiste entièrement blanc de l'hôtel.

 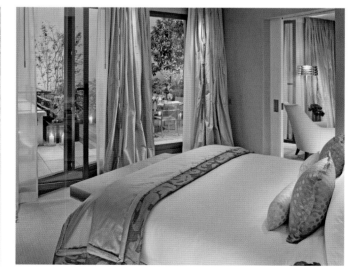

The stairway to the spa gets guests in the mood for the seven rooms, where they will be pampered with relaxing treatments.

Die Treppe zum Spa stimmt auf die entspannenden Behandlungen ein, mit denen sich Gäste in den sieben Treatment-Räumen verhätscheln lassen.

L'escalier menant au spa prépare déjà aux soins relaxants prodigués dans les sept salles où sont choyés les clients.

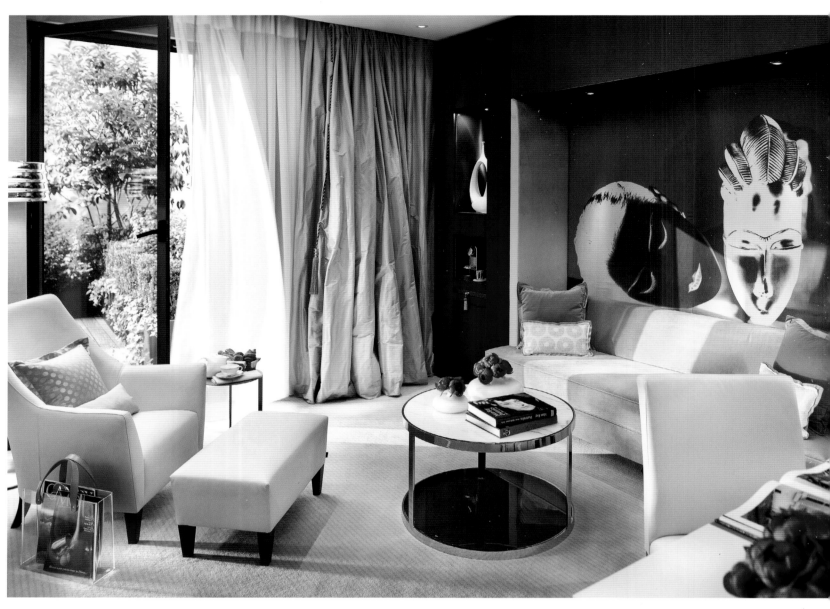

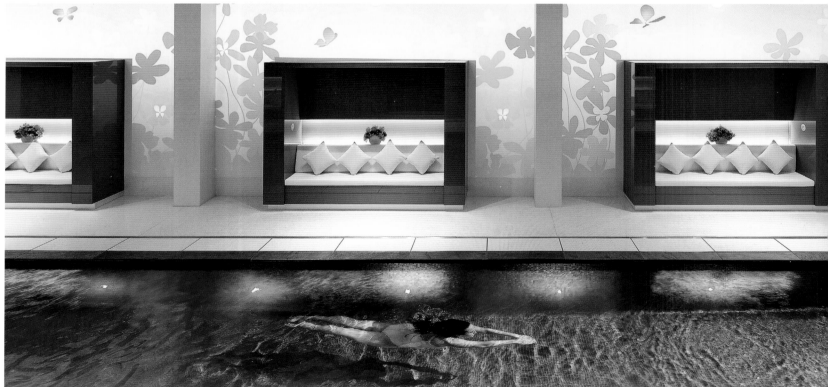

The photos of Iranian fashion photographer Ali Mahdavi allude to Paris as the city of haute couture. In the courtyard, a living wall becomes a waterfall of green.

Die Fotos des iranischen Modefotografen Ali Mahdavi spielen auf Paris als Stadt der Haute Couture an. Im Innenhof wird eine bepflanzte Wand zum grünen Wasserfall.

Les photos du photographe de mode iranien Ali Mahdavi évoquent Paris en tant que ville de la haute couture. Dans la cour intérieure, un mur végétal se transforme en cascade verte.

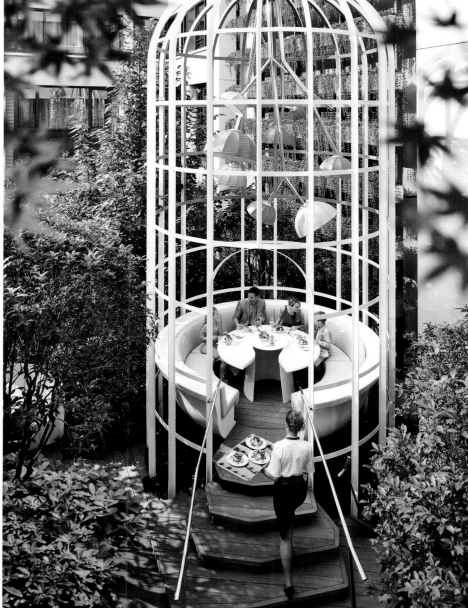

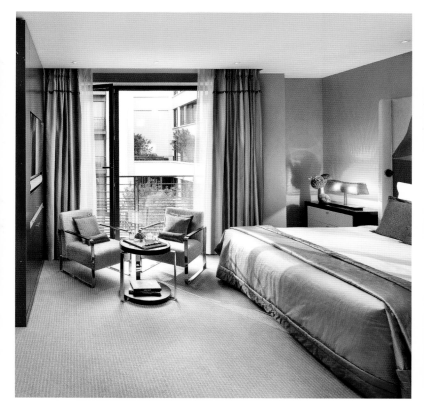

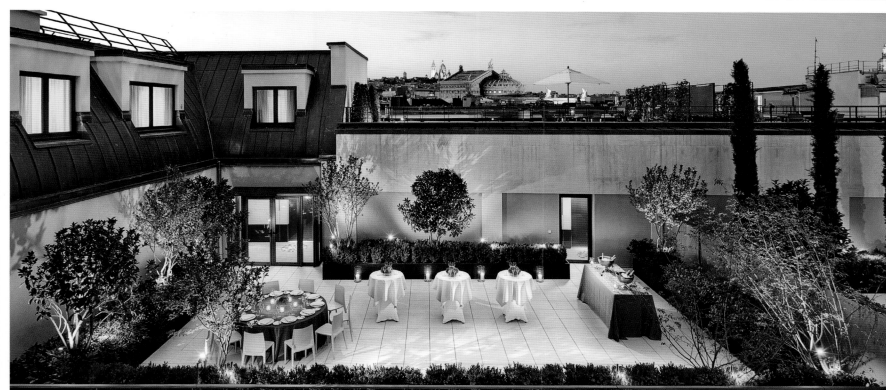

La Réserve Ramatuelle

Ramatuelle, France

Saint-Tropez is the unchallenged hot spot of the rich and famous on the Côte d'Azur, and there is no better place than La Réserve Ramatuelle to cultivate one's own fitness and beauty for the exciting party nights in the legendary bars and clubs. Set on a pine-forested hill overlooking the glamorous fishing village, the 23-room refuge is a minimalistic white-and-beige oasis of tranquility. Considering the number of rooms, the spa has gigantic proportions. All treatments in the eleven cabins are geared to the motivational goal of turning back the biological clock a bit—to rejuvenate, slim down, energize.

Saint-Tropez ist der unangefochtene Hotspot der Schönen und Reichen an der Côte d'Azur und es gibt keinen besseren Ort als das Réserve Ramatuelle, um sich fit und schön pflegen zu lassen für die aufreibenden Partynächte in den legendären Bars und Clubs. Auf einem mit Pinien bestandenen Hügel mit Blick über das glamouröse Fischerdorf zeigt sich das 23-Zimmer-Refugium als minimalistisch weiß-beige Oase der Ruhe. Der Spa hat gemessen an der Zimmerzahl riesige Ausmaße. Alle Behandlungen in den elf Räumen sind auf das motivierende Ziel ausgerichtet, die biologische Uhr ein wenig zurückzudrehen – zu verjüngen, schlanker zu werden, neue Energie zu tanken.

Saint-Tropez est le centre incontesté des beaux et des riches sur la côte d'Azur et il n'y a pas de meilleur endroit que la Réserve Ramatuelle pour se remettre en forme et se faire une beauté pour les nuits de fête fatigantes dans les bars et boîtes de nuits légendaires. C'est sur une colline de pins parasol avec vue sublime sur le village de pêcheurs que se trouve ce refuge de 23 cabines, véritable havre de paix aux couleurs blanche et beige tout empreint de minimalisme. Le spa est très grand par rapport au nombre de chambre. Tous les soins, proposés dans les onze pièces, sont orientés sur l'objectif motivant de retarder un peu l'horloge biologique – afin de rajeunir, de mincir et de recharger les batteries.

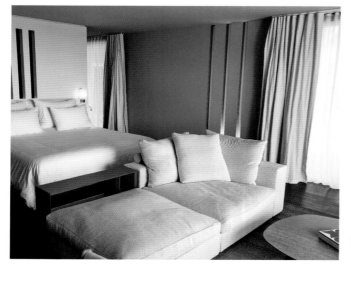

An earth-colored cube from the Seventies houses the retreat on the Côte d'Azur, where everything revolves around purification and rejuvenation.

Ein erdfarbener Kubus aus den siebziger Jahren beherbergt die Rückzugsoase an der Côte d'Azur, in der sich alles ums Entschlacken und Verjüngen dreht.

Sur la Côte d'Azur, un cube aux tons ocre datant des années 70 abrite un havre de paix où purification et rajeunissement sont les maîtres mots.

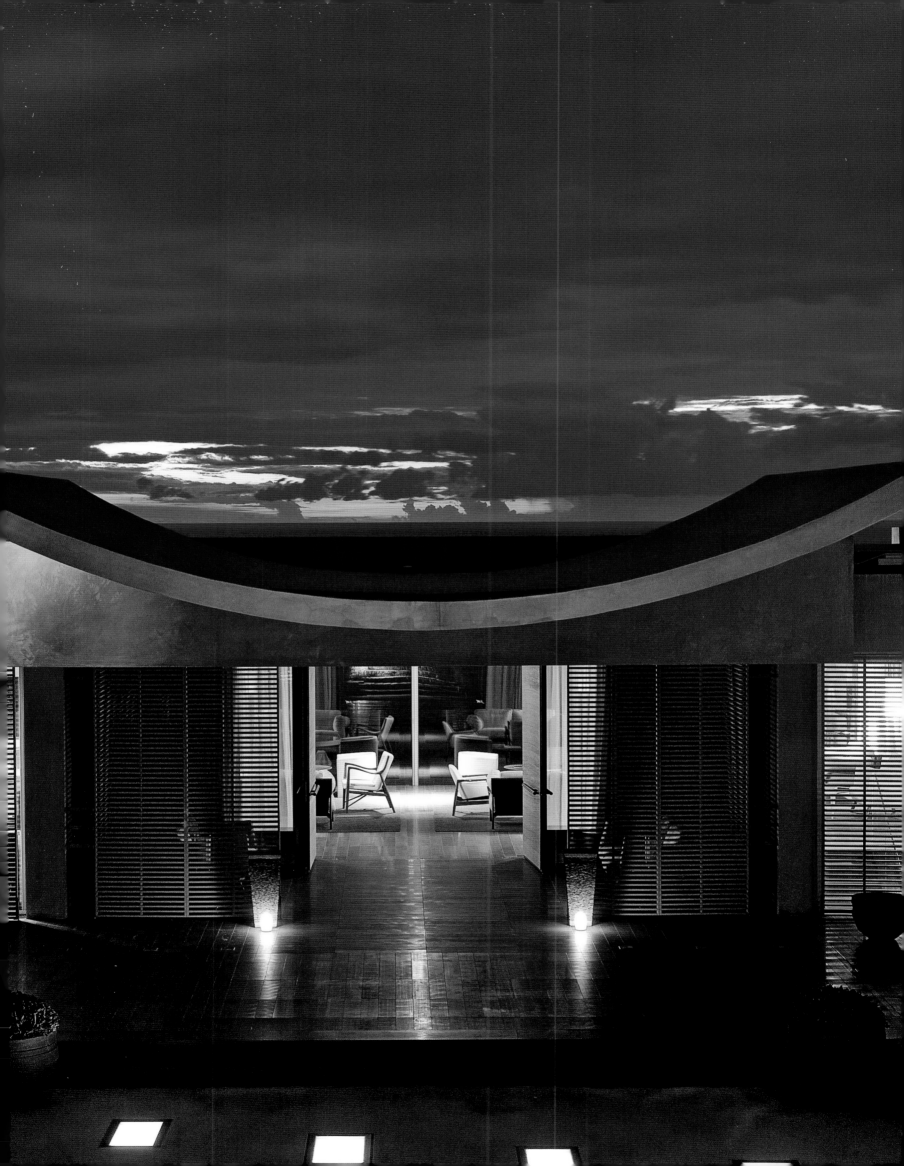

Floor-to-ceiling windows *offer a panoramic view of the bay of Pampelonne and provide a seamless transition between the indoors and outdoors.*

Raumhohe Fenster *eröffnen einen weiten Blick auf die Bucht von Pampelonne, lassen die Übergänge zwischen drinnen und draußen fließend werden.*

De grandes *baies vitrées offrent une vue lointaine sur la baie de Pampelonne et font disparaître la frontière entre intérieur et extérieur.*

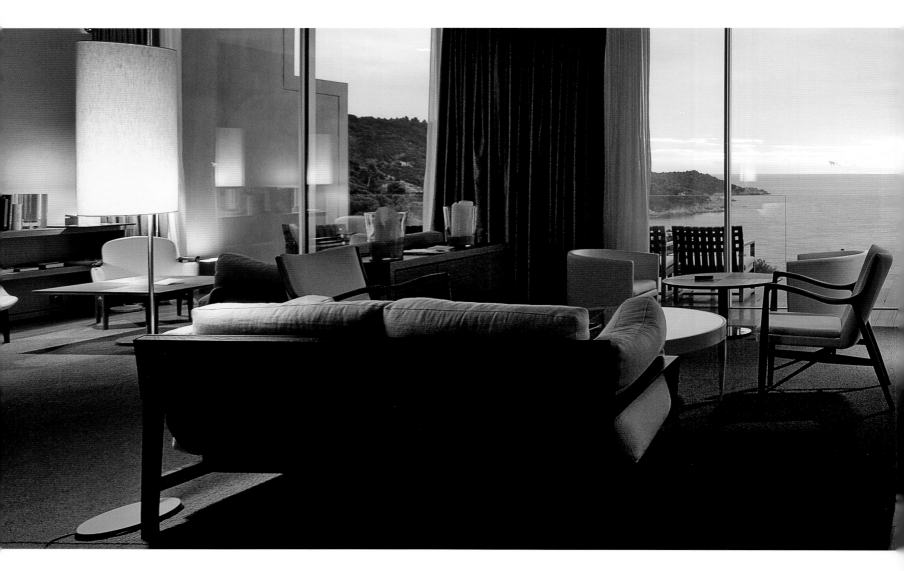

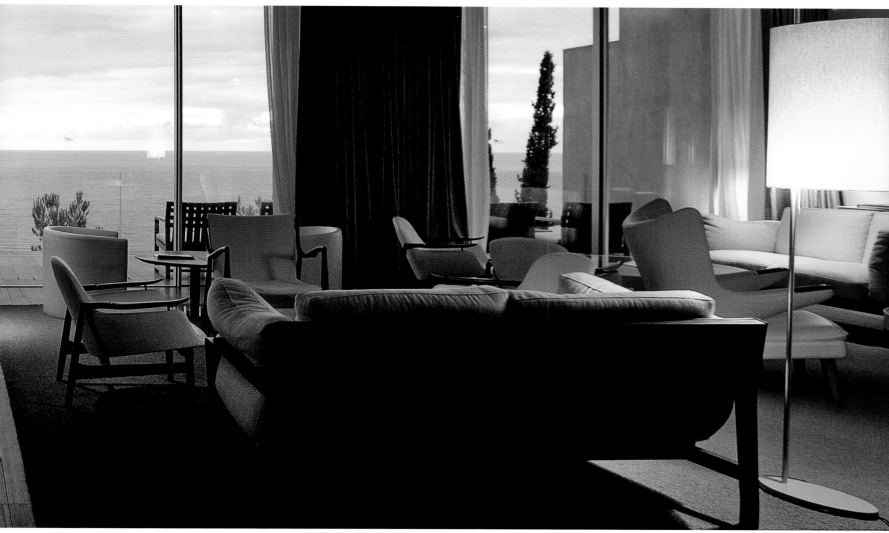

The interior's minimalist chic is reflected in the concept of the landscape design.

Der minimalistische Chic des Interieurs spiegelt sich auch im Konzept der Landschaftsarchitektur wieder.

On retrouve le chic minimaliste de l'intérieur dans le concept d'architecture paysagère.

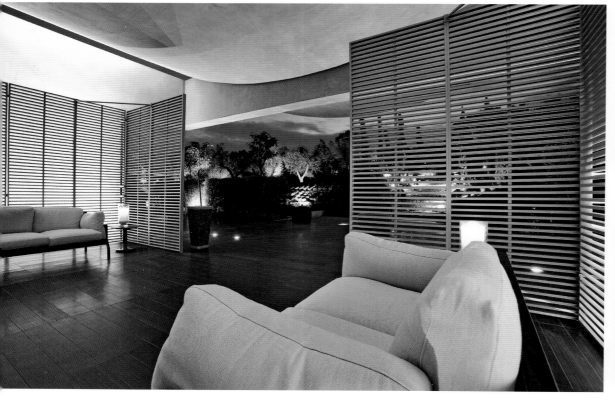

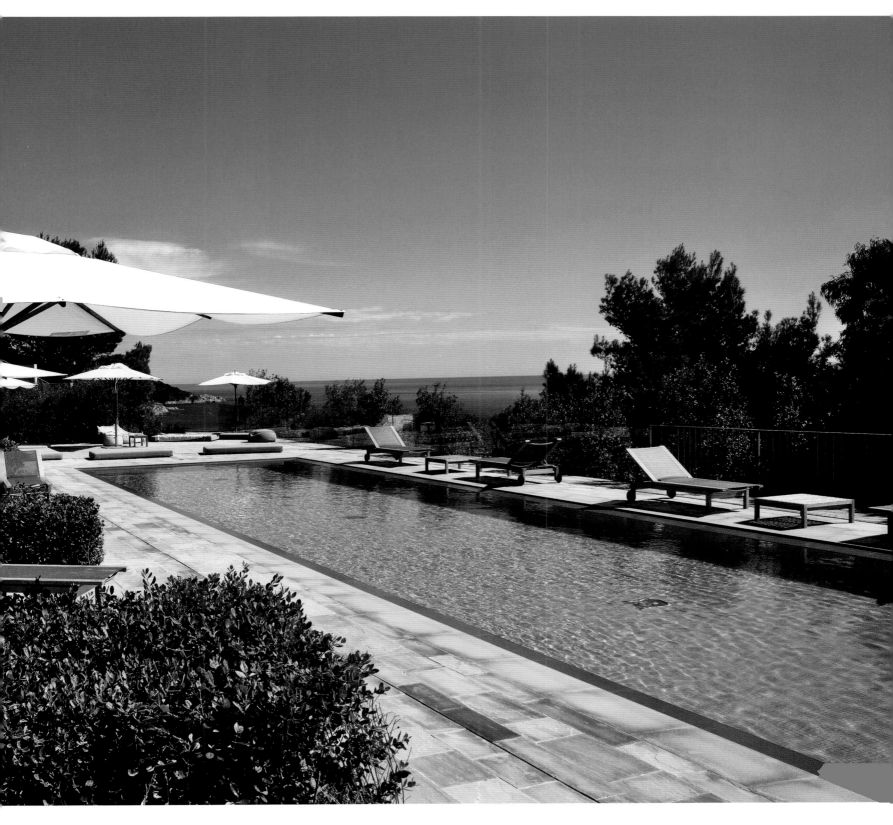

Hôtel Hermitage

Monte Carlo, Monaco

The Hermitage in Monaco is a true gem from the belle époque, just steps away from the famous Casino de Monte-Carlo. The beautiful and rich who like to frequent the principality often meet in the hotel's salons and restaurants. The preferred spot is the Vistamar Restaurant whose terrace boasts a marvelous view over the harbor and the ultra-expensive yachts anchored there. Hotel guests receive a golden card which they can use to access the 71,000-square-foot Thermes Marins Monte-Carlo, a wellness oasis that specializes in seawater treatments.

Das Hermitage in Monaco ist ein wahres Belle Époque-Kleinod, nur wenige Schritte vom berühmten Casino de Monte-Carlo entfernt. In seinen Salons und Restaurants treffen sich die Schönen und Reichen, die das Fürstentum gerne frequentieren. Bevorzugter Spot ist das Restaurant Vistamar, von dessen Terrasse sich ein Traumblick über den Hafen und die millionenschweren Yachten eröffnet. Hotelgäste erhalten eine goldene Karte, die den Zutritt zur 6 600 Quadratmeter großen Thermes Marins Monte-Carlo ermöglicht, einer Wellnessoase, die auf Anwendungen mit Meerwasser spezialisiert ist.

L'Hôtel Hermitage à Monaco est un véritable petit bijou de la Belle Époque, à quelques pas seulement du célèbre Casino de Monte-Carlo. Les grands de ce monde qui se plaisent à séjourner dans la Principauté se retrouvent fréquemment dans ses salons et restaurants. Le restaurant Vistamar est d'ailleurs un lieu privilégié, car sa terrasse offre une vue somptueuse sur le port et ses yachts luxueux. Les clients de l'hôtel bénéficient d'un accès aux Thermes Marins de Monte-Carlo, une oasis de bien-être de 6 600 mètres carrés spécialisée en thalassothérapie.

The art nouveau winter garden features a glass dome constructed by none other than Gustave Eiffel.

Aufsehenerregend ist der Art nouveau-Wintergarten mit einer Glaskuppel, die kein Geringerer als Gustave Eiffel konstruierte.

La véranda de style Art nouveau dotée d'une coupole de verre réalisée par nul autre que Gustave Eiffel est sensationnelle.

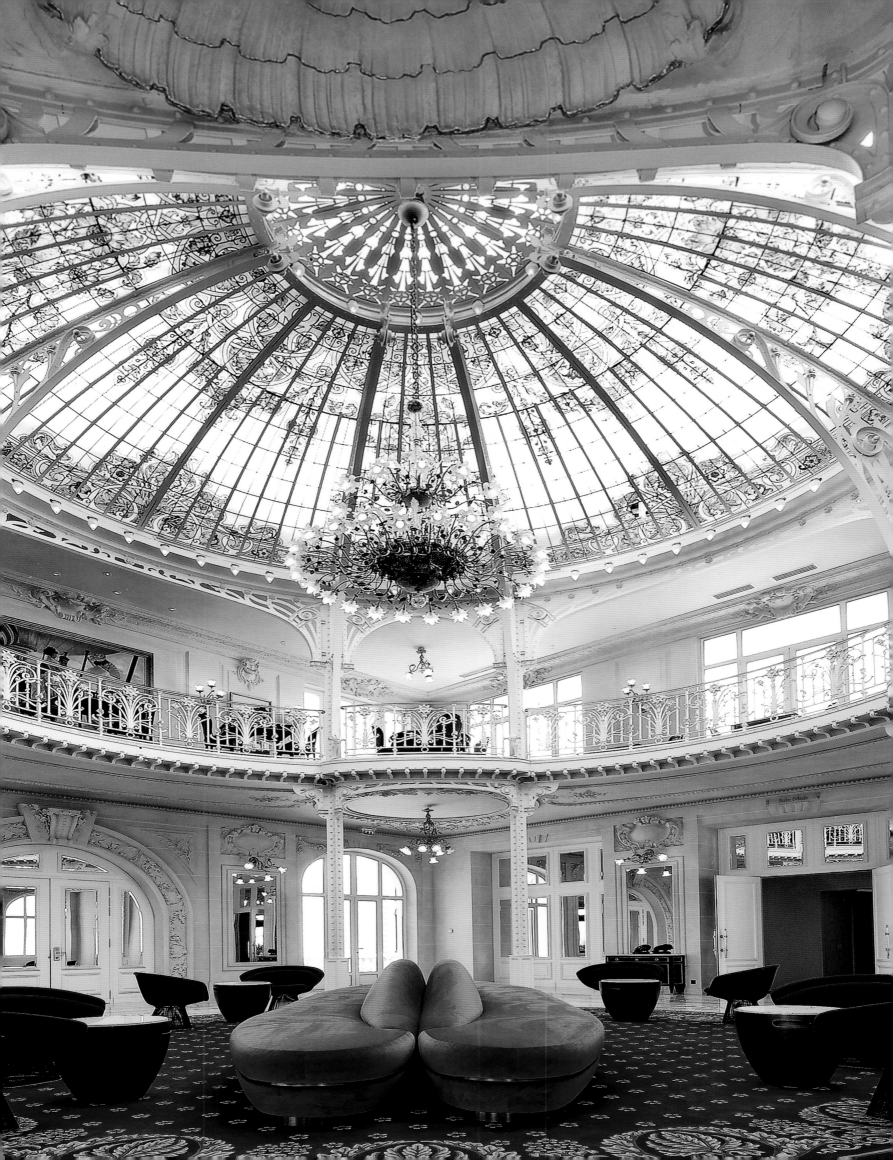

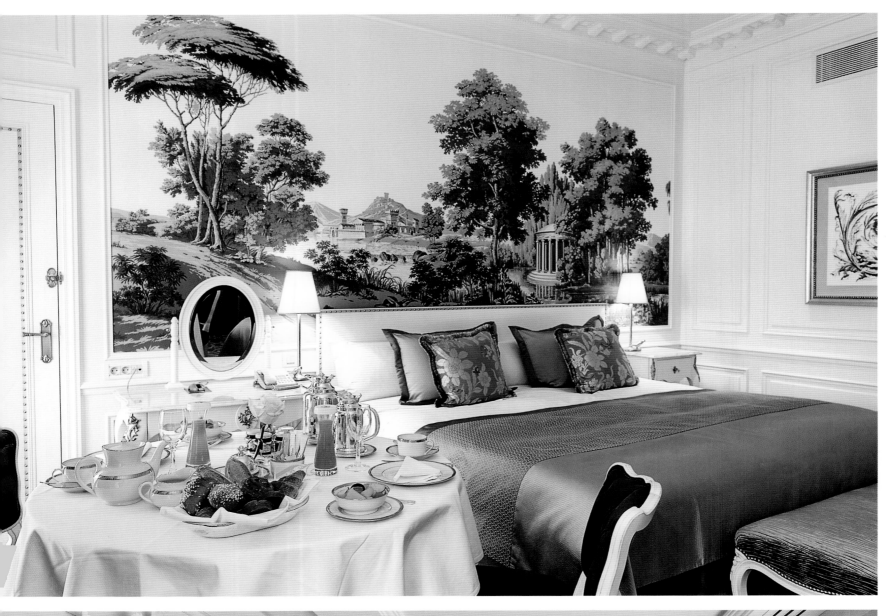

Polished surfaces, shimmering fabrics, and precious materials provide for timeless elegance in the 280 rooms and suites.

Polierte Oberflächen, schimmernde Stoffe und edle Materialien sorgen für zeitlose Eleganz in den 280 Zimmern und Suiten.

Surfaces polies, étoffes brillantes et matériaux élégants confèrent une élégance intemporelle aux 280 chambres et suites.

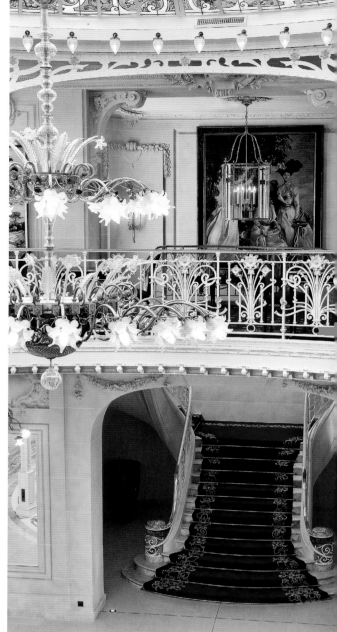

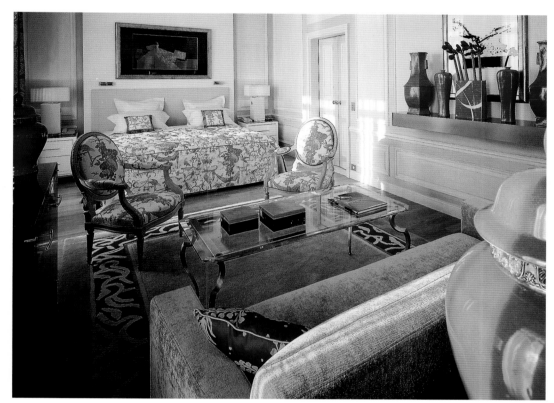

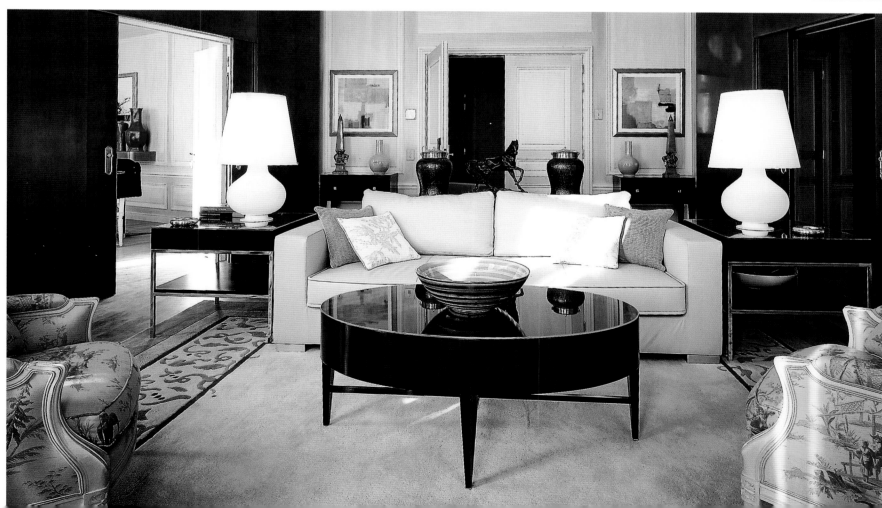

Capri Palace Hotel & Spa

Capri, Italy

The glamorous image enjoyed by the Capri Palace Hotel has everything to do with its guest list, which includes A-list celebrities such as Julia Roberts, Mariah Carey, and Oprah Winfrey. They enjoy retreating to this white hotel perched on a cliff in Anacapri, sheltered from the crowds of tourists who fill the narrow streets of the island during the summer months. Guests can enjoy being pampered at the award-winning Capri Beauty Farm, considered one of the best medical spas in Europe. The hotel's Il Ricco Beach Club offers a view of the famous Blue Grotto.

Sein glamouröses Image verdankt das Palace seiner Gästeliste, die A-list Celebrities wie Julia Roberts, Mariah Carey und Oprah Winfrey verzeichnet. Sie ziehen sich gerne in das weiße, auf eine Klippe gebaute Hotel in Anacapri zurück, abgeschirmt von den Touristenmassen, die während der Sommermonate die schmalen Gassen der Insel bevölkern, und lassen sich in der preisgekrönten Capri Beauty Farm verwöhnen, die als eines der besten Medical Spas Europas gilt. Vom hoteleigenen Beach Club Il Ricco schaut man auf die berühmte Blaue Grotte.

Ce palace doit sa réputation glamour à sa liste d'invitées prestigieuses telles que Julia Roberts, Mariah Carey ou encore Oprah Winfrey. Ces dames aiment en effet séjourner au calme dans cet hôtel d'Anacapri d'un blanc éclatant, construit sur un rocher à l'abri de la masse des touristes qui envahit les étroites ruelles de l'île durant l'été. Les invités se font choyer dans la Capri Beauty Farm, un spa-médical plusieurs fois primé et considéré comme l'un des meilleurs d'Europe. La plage de l'hôtel Il Ricco offre une belle vue sur la célèbre Grotte bleue.

Objects and works of art from the owner's collection enliven the public areas.

Objekte und Kunstwerke aus der Sammlung des Besitzers beleben die öffentlichen Bereiche.

Les objets et œuvres d'art de la collection du propriétaire donnent vie aux espaces publics.

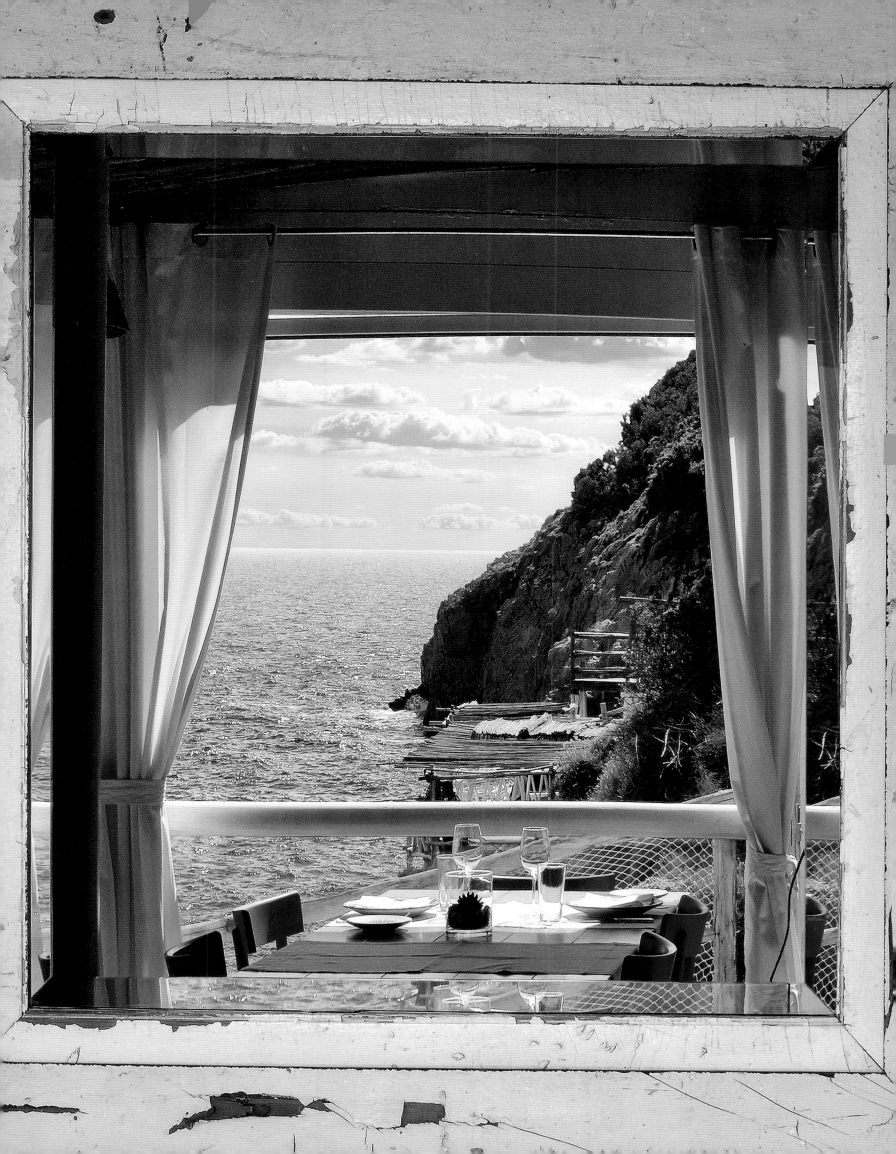

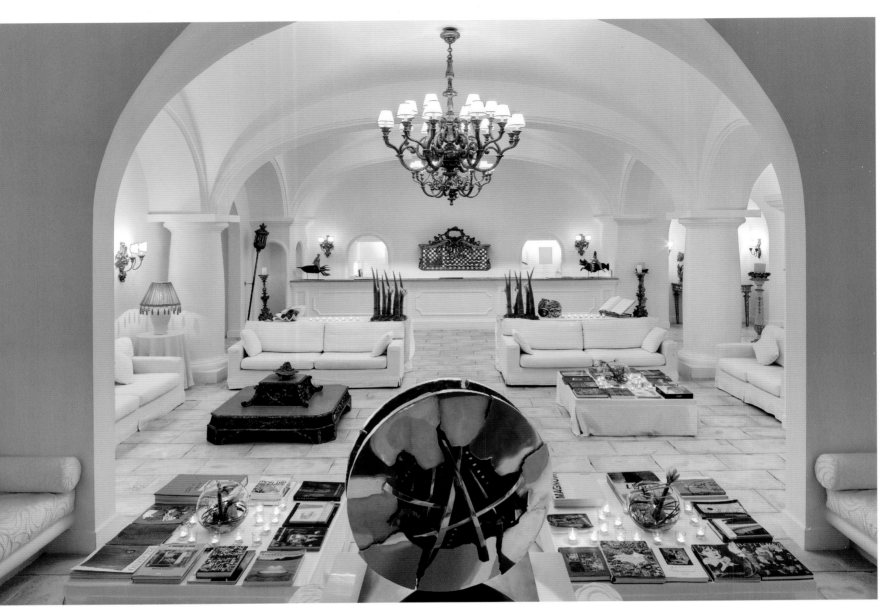

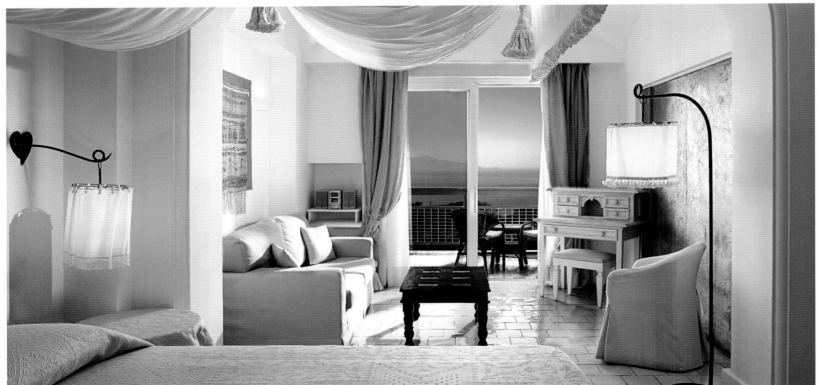

The completely refurbished terrace of the Bistrot Ragù has an incomparable panoramic view of the Gulf of Naples and the island of Ischia.

Von der neu gestalteten Terrasse des Bistrots Ragù bietet sich ein unvergleichlicher Panoramablick auf den Golf von Neapel und die Insel Ischia.

La terrasse réaménagée du Bistrot Ragù offre une vue panoramique unique sur le golf de Naples et l'île d'Ischia.

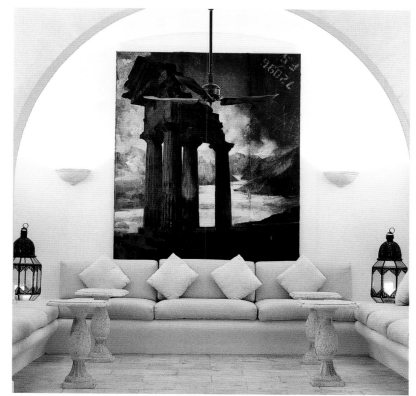

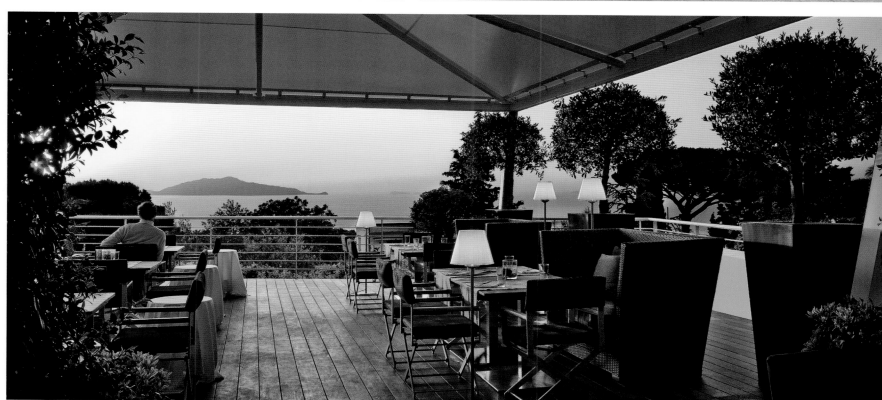

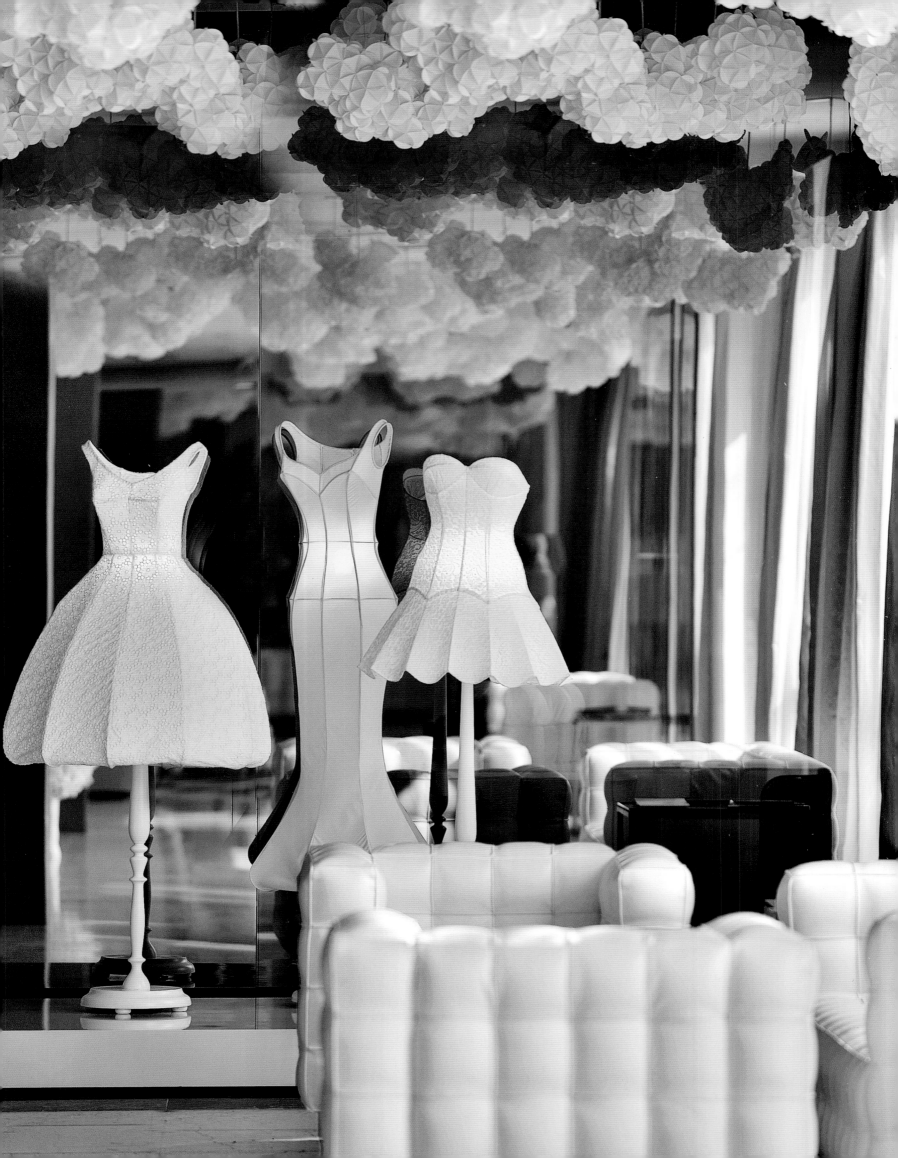

Maison Moschino

Milan, Italy

It is amazing that it took so long for the fashion metropolis of Milan to get a fashion hotel. Since 2010, an explosion of ideas has enchanted guests not far from Corso Como. The concentrated creativity of the Moschino team surrounding Rossella Jardini flowed into the design: Lamps wear Moschino dresses; in one of the 65 rooms, guests wander through a stylized enchanted forest; in another room, cupcake-like pillows tempt guests to take a bite. Simply ravishing: a red velvet gown that functions as a headboard.

Erstaunlich, wie lange es gedauert hat, bis die Modemetropole Mailand ein Fashion-Hotel erhielt. Ein Feuerwerk an Ideen verzaubert die Gäste seit 2010 nicht weit vom Corso Como. Die geballte Kreativität des Moschino-Teams um Rossella Jardini floss in die Gestaltung: Lampen tragen Moschino-Kleider, in einem der 65 Zimmer wandelt man durch einen stilisierten Zauberwald, ein anderes verführt mit Kissen in Cupcake-Form zum Naschen. Einfach nur hinreißend ist eine rote Samtrobe, die als Kopfende fungiert.

Il est étonnant de constater combien de temps Milan, capitale de la mode, a dû attendre avant d'avoir un fashion-hôtel. Une multitude de concepts émerveille les hôtes depuis 2010 à deux pas du Corso Como. Toute la créativité de l'équipe Moschino réunie autour de Rossella Jardini se retrouve dans la décoration : les lampes sont habillées de créations Moschino, l'une des 65 chambres permet de se promener dans une forêt enchantée stylisée, une autre est une véritable ode à la gourmandise avec ses coussins en forme de gâteaux. La robe de velours rouge qui fait office de tête de lit est simplement irrésistible.

The entry area is like a graceful stage set where white sheep are on hand to welcome guests.

Einem anmutigen Bühnenbild gleicht der Eingangsbereich, in dem weiße Schafe den Gast willkommen heißen.

Un décor théâtral empreint de grâce illumine l'entrée dans laquelle des moutons blancs accueillent les hôtes.

Playful details *reveal themselves in all the rooms. Nothing remains that might remind guests of the landmarked building's former history as a railroad station.*

In sämtlichen *Räumen können sich die verspielten Details entfalten. Nichts deutet mehr auf die frühere Nutzung des denkmalgeschützten Gebäudes als Bahnhof hin.*

Toutes les *chambres dévoilent une foule de sympathiques détails. Plus rien n'indique que cette bâtisse classée monument historique était autrefois une gare.*

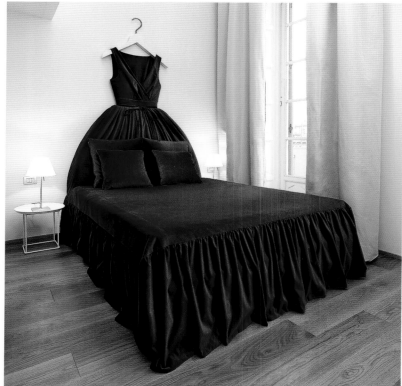

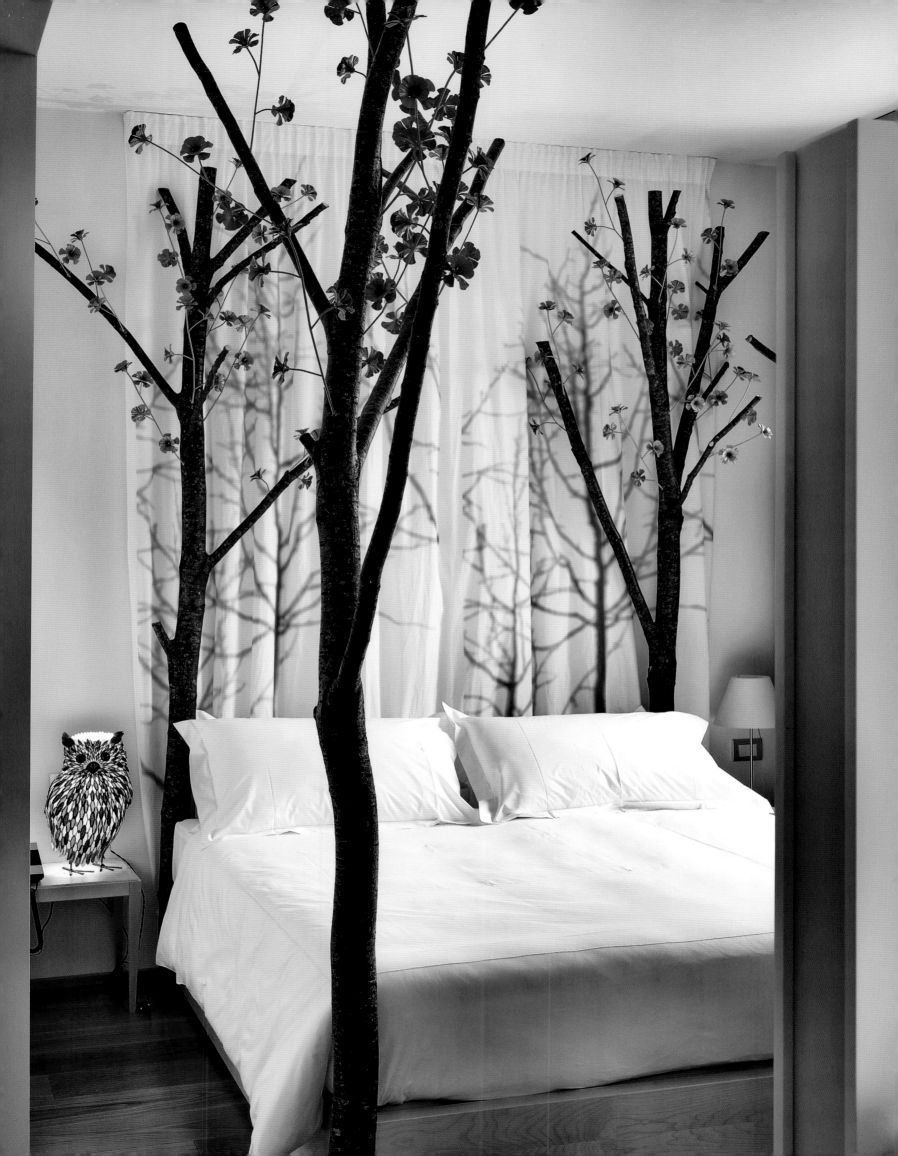

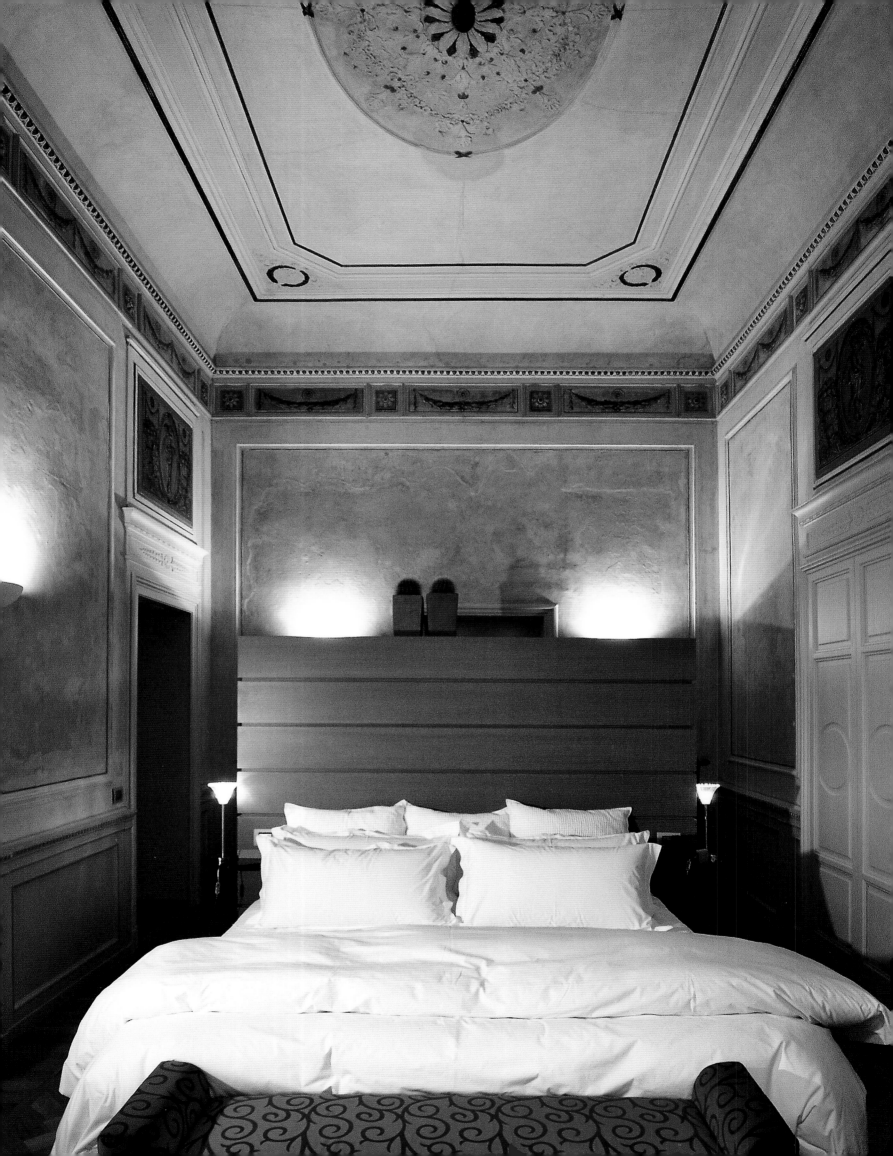

Townhouse 8

Milan, Italy

What once only seemed possible in Dubai has now been realized in Europe: The Seven Stars Galleria by Town House is the first European seven-star hotel. Above it is the Town House 8 in Galleria, a luxury five-star hotel. In the heart of the fashion capital of Milan, its location in the exclusive Galleria Vittorio Emanuele II, opened in 1876, is spectacular. Personal butlers already know their guests' preferences when they arrive, reserve tickets for the Scala, and fulfill every request, from bed linens to favorite dishes. It comes as no surprise that all of the 24 suites, decorated with oak wainscoting, are equipped with Italian espresso machines and leather-covered laptops.

Was bisher nur in Dubai möglich schien, wurde nun auch in Europa realisiert. Das Town House Gallerie ist das erste Sieben-Sterne-Hotel Europas. Darüber befindet sich das luxuriöse Fünf-Sterne-Hotel Town House 8 in Galleria. Schon die Lage in der exklusiven Galleria Vittorio Emanuele II von 1876, mitten im Zentrum der Modemetropole, ist spektakulär. Ein persönlicher Butler kennt die Vorlieben der Gäste schon bei der Ankunft, reserviert Karten für die Scala und sucht Bettwäsche und Lieblingsspeisen wunschgemäß aus. Selbstverständlich stehen in so einem Haus italienische Espresso-Maschinen und lederbezogene Laptops in allen der 24 eichenvertäfelten Suiten bereit.

Ce qui semblait uniquement possible à Dubai, est maintenant devenu réalité en Europe. Le Town House Galleria est le premier hôtel sept étoiles du continent. Ci-dessus, le Town House 8, un hôtel cinq étoiles de luxe. Son seul emplacement, dans la splendide Galleria Vittorio Emanuele II datant de 1876, au centre de la métropole de la mode, est spectaculaire. Un majordome personnel connaît les préférences des clients, dès la réception ; il réserve des places pour la Scala et choisit le linge de lit et les plats préférés des clients. Dans un tel hôtel, il y a bien sûr des machines à espresso italiennes et des ordinateurs portables vêtus de cuir dans les 24 suites couvertes de lambris de chêne.

 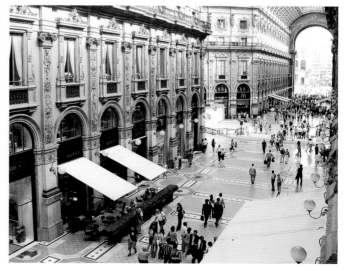

There is no lobby and no reception desk. Guests enjoy personalized service designed to make them forget that they are staying at a hotel.

Es gibt keine Lobby, keine Rezeption. Gäste genießen einen personalisierten Service, der vergessen machen soll, dass man in einem Hotel wohnt.

Il n'y a ici ni lobby ni réception. Les clients profitent d'un service personnalisé qui fait oublier que l'on séjourne dans un hôtel.

The eleven rooms, including the Junior Suite, face either the peaceful inner courtyard or the bustling galleria; all display an inspiring mixture of traditional and contemporary elements.

Die elf Zimmer inklusive der Junior Suite, die entweder zum ruhigen Innenhof oder auf die belebte Galleria schauen, zeigen einen inspirierenden Mix von traditionellen und zeitgenössischen Elementen.

Les onze suites, dont la Junior Suite, donnent soit sur la paisible cour intérieure, soit sur la galerie animée. Elles associent intelligemment des éléments traditionnels et contemporains.

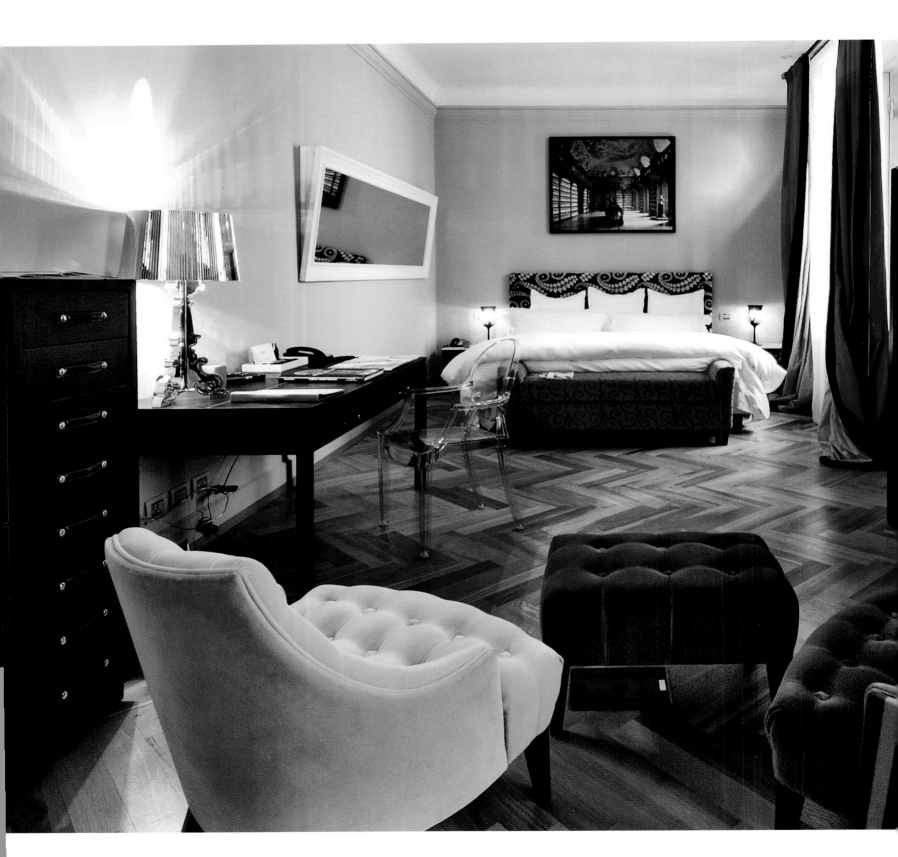

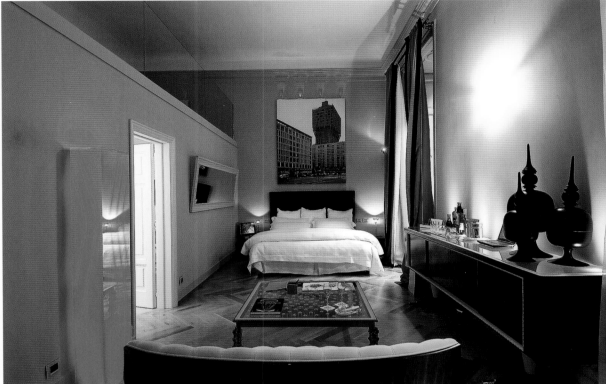

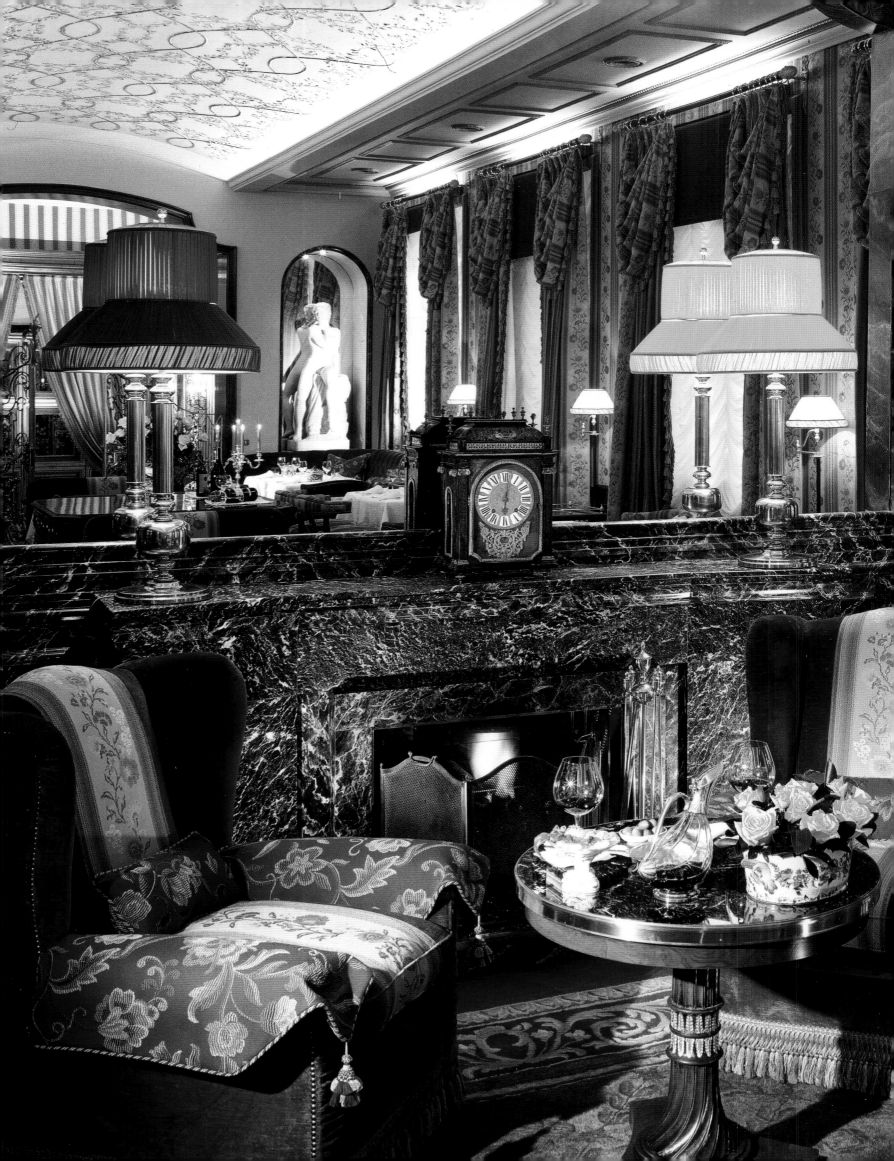

Hassler Roma

Rome, Italy

The location of the grande dame of Roman luxury hotels is one of a kind: right at the top of the Spanish Steps, with the towers of the church of Santa Trinità dei Monti almost close enough to touch. The Hassler is run by owner Roberto E. Wirth himself, a thoughtful and visible host. Furnished with rich fabrics, dark upholstery, and original paintings, the lobby presents itself in the patrician decor typical of ancient Rome. Some of the 82 rooms and 13 suites have been renovated in an art deco style with contemporary influences.

Die Lage der ewig jungen Dame der römischen Luxushotellerie ist nicht zu übertreffen: direkt oberhalb der Spanischen Treppe, den Türmen der Kirche Santa Trinità dei Monti zum Greifen nah. Zudem wird das Hassler vom Besitzer Roberto E. Wirth selbst geführt, der ein umsichtiger, präsenter Gastgeber ist. Mit kostbaren Stoffen, dunklen Polstermöbeln und Originalgemälden zeigt sich die Lobby im besten patrizisch-altrömischen Dekor. Von den 82 Zimmern und 13 Suiten wurden einige in einem zeitgemäß interpretierten Art déco-Stil renoviert.

Il est difficile de manquer cet écrin de l'hôtellerie de luxe romaine : surplombant directement l'escalier monumental de la place d'Espagne, juste à côté des tours de l'église de Santa Trinità dei Monti. De plus, le Hassler est dirigé par son propriétaire Roberto E. Wirth en personne, un hôte prévenant et présent. Le lobby se présente dans un superbe décor patricien de la Rome antique, avec des étoffes précieuses, des meubles sombres rembourrés et des peintures originales. Certaines des 82 chambres et 13 suites ont été rénovées dans un style Art déco moderne.

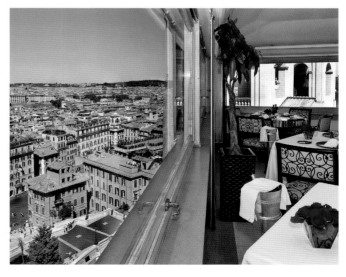

From the Imàgo rooftop garden restaurant, diners can enjoy spectacular views of Rome spread out below. Modern art deco furniture gives new luster to the renovated suites.

Rom liegt einem zu Füßen, wenn man im Dachgarten-Restaurant Imàgo speist. Moderne Möbel im Art déco-Stil geben den renovierten Suiten neuen Glanz.

Du restaurant Imàgo, situé sur le toit-jardin, Rome est à vos pieds. Des meubles modernes Art déco donnent un nouvel éclat aux suites rénovées.

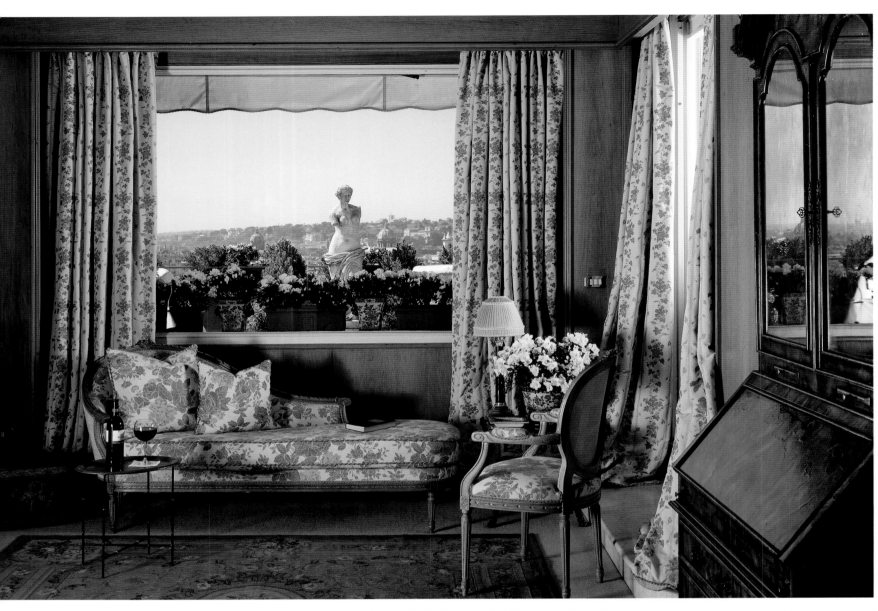

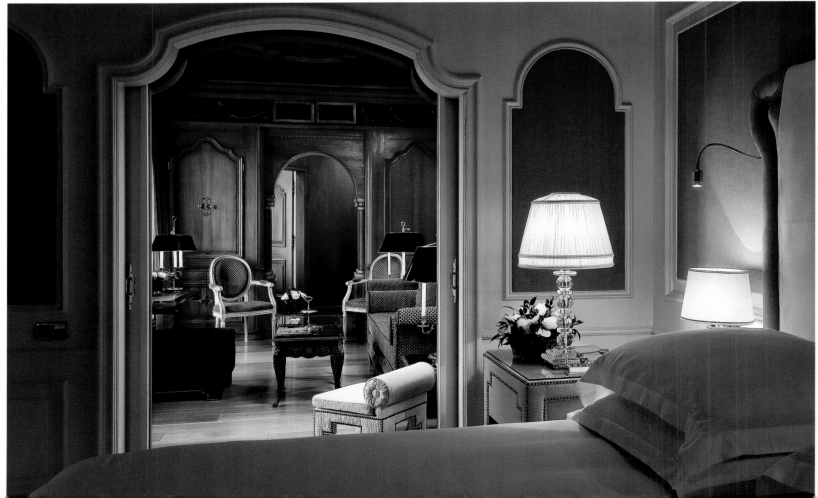

The public rooms of this grand hotel located above the Spanish Steps reflect the elegance of Ancient Rome.

Die öffentlichen Räume des Grandhotels oberhalb der Spanischen Treppe erstrahlen in altrömischer Eleganz.

Les espaces publics resplendissent au-dessus des Marches Espagnoles dans une élégance propre à la Rome antique.

Castello del Nero Hotel & Spa

Tavarnelle Val di Pesa, Italy

In the heart of the Chianti region, halfway between Florence and Siena, lies this seat of aristocratic power from the 12th century, overlooking one of the world's most beautifully cultivated landscapes—the gently rolling Tuscan hills on which the silhouettes of cypress trees set picturesque exclamation marks. The preserved original frescoes, painted coffered ceilings, and beautifully aged terracotta floors are complemented with modern fabrics and furnishings in the 50 rooms and suites. The spa beneath the hotel terrace is uncompromisingly modern with wood, glass, and green mosaics and is connected to the main building through an underground passageway.

Im Herzen des Chianti, auf halbem Weg zwischen Florenz und Siena, thront der Adelssitz aus dem 12. Jahrhundert und überblickt eine Kulturlandschaft, die zu den schönsten der Welt gehört: die sanft geschwungenen Hügel der Toskana, auf denen die Silhouetten der Zypressen malerische Ausrufezeichen setzen. Die im Original erhaltenen Fresken, bemalten Kassettendecken und schön gealterten Terracottaböden wurden in den 50 Zimmern und Suiten mit modernen Stoffen und Mobiliar ergänzt. Kompromisslos modern ist der mit Holz, Glas und grünen Mosaiken gestaltete Spa unter der Hotelterrasse, der durch einen unterirdischen Gang mit dem Haupthaus verbunden ist.

C'est au cœur du Chianti, à mi-chemin entre Florence et Sienne, que trône le domaine aristocratique datant du XIIe siècle. Il surplombe l'un des plus beaux paysages culturels au monde : les collines légèrement arrondies de la Toscane où les cyprès sont en forme de points d'exclamation pittoresques. Les fresques conservées à l'état original, les plafonds à caissons peints et les sols décatis en terre cuite ont été garnis de tissus et d'un mobilier modernes dans les 50 chambres et suites. Le spa décoré de bois, verre et mosaïques vertes, qui se trouve sous la terrasse de l'hôtel, est lié à la maison principale par un passage souterrain et est absolument moderne.

Belgian interior designer Alain Mertens, whose projects include the private home of Sting, designed the 32 rooms and 18 suites, the majority of which retain the original frescos.

Der belgische Innenarchitekt Alain Mertens, zu dessen Projekten auch das Privathaus von Sting gehört, gestaltete die 32 Zimmer und 18 Suiten, in denen großteils die Originalfresken erhalten sind.

Alain Mertens, l'architecte d'intérieur d'origine belge qui a réalisé notamment la maison particulière de Sting, a conçu les 32 chambres et 18 suites, dans lesquelles les fresques originales ont été en majeure partie conservées.

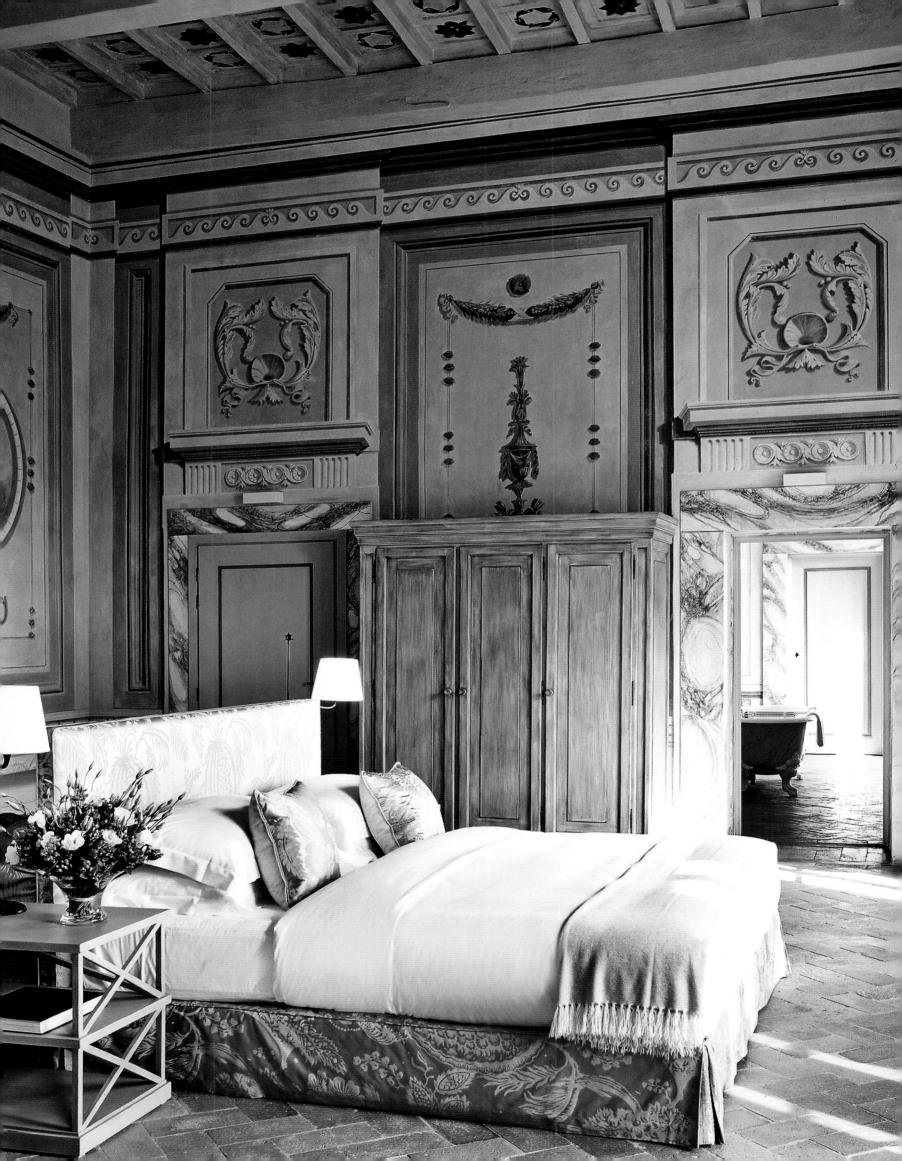

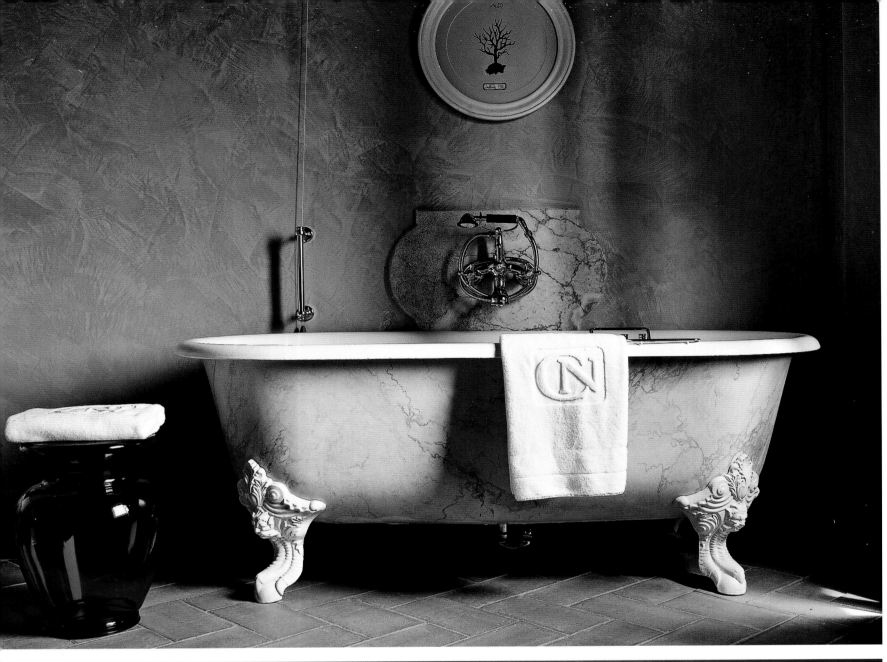
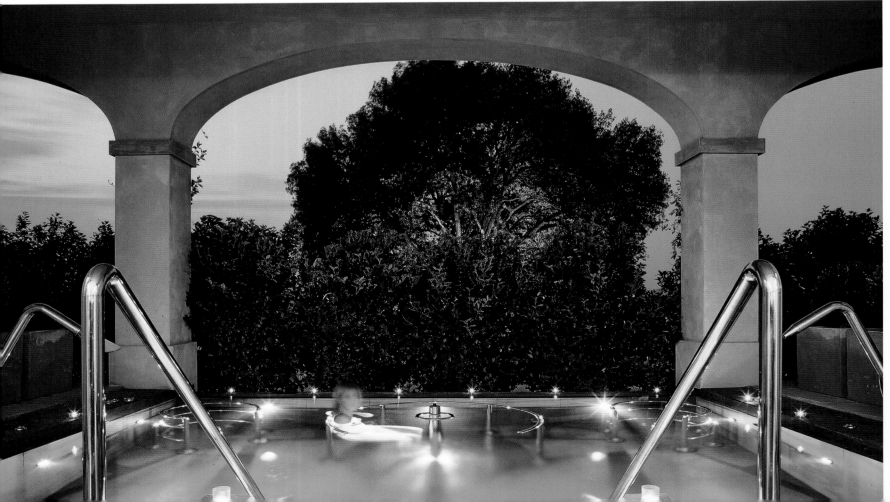

There are so many ways to relax: in the shade of the pines at the pool, at the ESPA, or over a light lunch on the terrace.

Vielfältig sind die Möglichkeiten zum Entspannen: Im Schatten von Pinien am Pool, im ESPA oder bei einem leichten Lunch auf der Terrasse.

Pour la détente, de multiples options s'offrent aux hôtes : l'ombre du pin près de la piscine, le centre ESPA ou un déjeuner léger sur la terrasse.

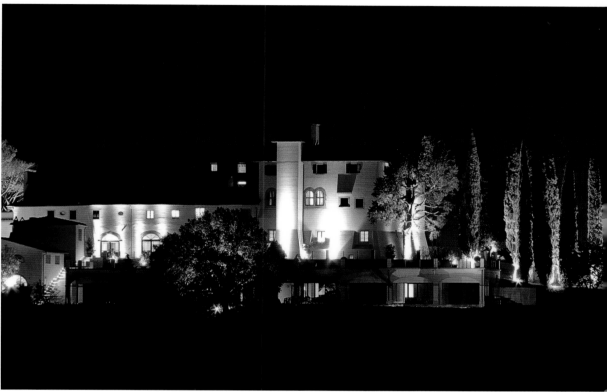
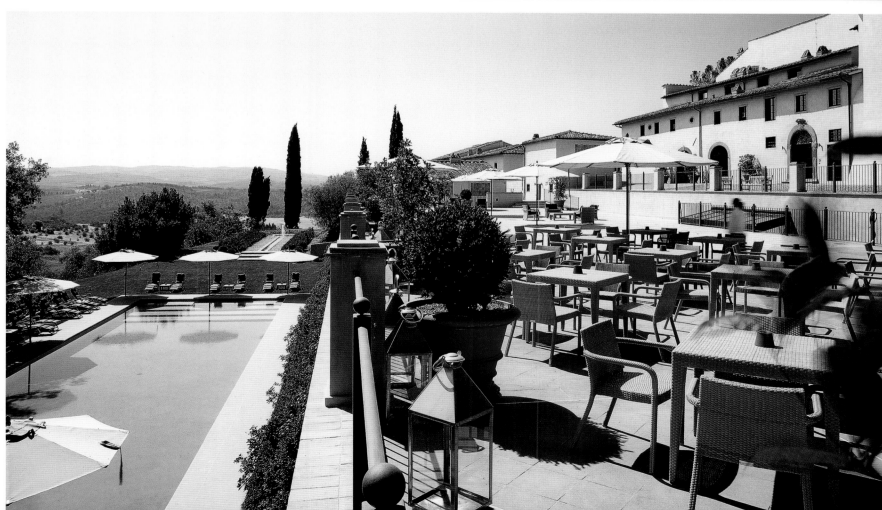

Bauer Il Palazzo

Venice, Italy

Venetian grandezza unfolds behind the Gothic-Byzantine façade of this 18th-century palazzo. The entire breadth of Venetian craftsmanship is on display in the 72 rooms and suites. They are opulently decorated with Murano chandeliers and mirrors; the walls are covered with precious fabrics by Rubelli and Bevilacqua. With its own landing dock right on the Grand Canal, the hotel couldn't have a more ideal location. Settimo Cielo, the lounge on the rooftop terrace, offers stunning views of the hustle and bustle on the Grand Canal and the lagoon.

Venezianische Grandezza entfaltet sich hinter der gotisch-byzantinischen Fassade des Palazzos aus dem 18. Jahrhundert. In den 72 Zimmern und Suiten zeigt sich die ganze Bandbreite venezianischer Handwerkskunst. Sie sind opulent dekoriert mit Murano-Lüstern und Spiegeln, die Wände bespannt mit kostbaren Stoffen von Rubelli oder Bevilacqua. Die Lage direkt am Canal Grande mit eigenem Anlegesteg könnte nicht besser sein. Vom Settimo Cielo, der Dachterrassen-Lounge, bietet sich eine Traumsicht auf das rege Treiben auf dem Canal Grande sowie die Lagune.

Derrière la façade de style gothique byzantin de ce palais du XVIII^e siècle se déploie la grandeur vénitienne. Les 72 chambres et suites abritent un large éventail d'artisanat d'art vénitien. La décoration luxurieuse est composée de lustres Murano et de miroirs, les murs sont recouverts d'étoffes raffinées de Rubelli ou Bevilacqua. Situé au bord du Canal Grande avec son ponton d'embarquement, l'hôtel n'aurait pu rêver meilleur emplacement. Le bar lounge sur le toit, Settimo Cielo, offre une vue magnifique sur le canal au trafic intense ainsi que sur la lagune.

It's worth booking a room on one of the upper floors: The breathtaking view over the tiled roofs and domes of Venice is priceless.

Es lohnt sich, ein Zimmer in den oberen Etagen zu buchen: Der Traumblick über die Ziegeldächer und Kuppeln der Serenissima ist unbezahlbar.

Réserver une chambre aux étages supérieurs vaut le détour. La vue sur les toits de tuiles et les coupoles de la Serenissima est sensationnelle.

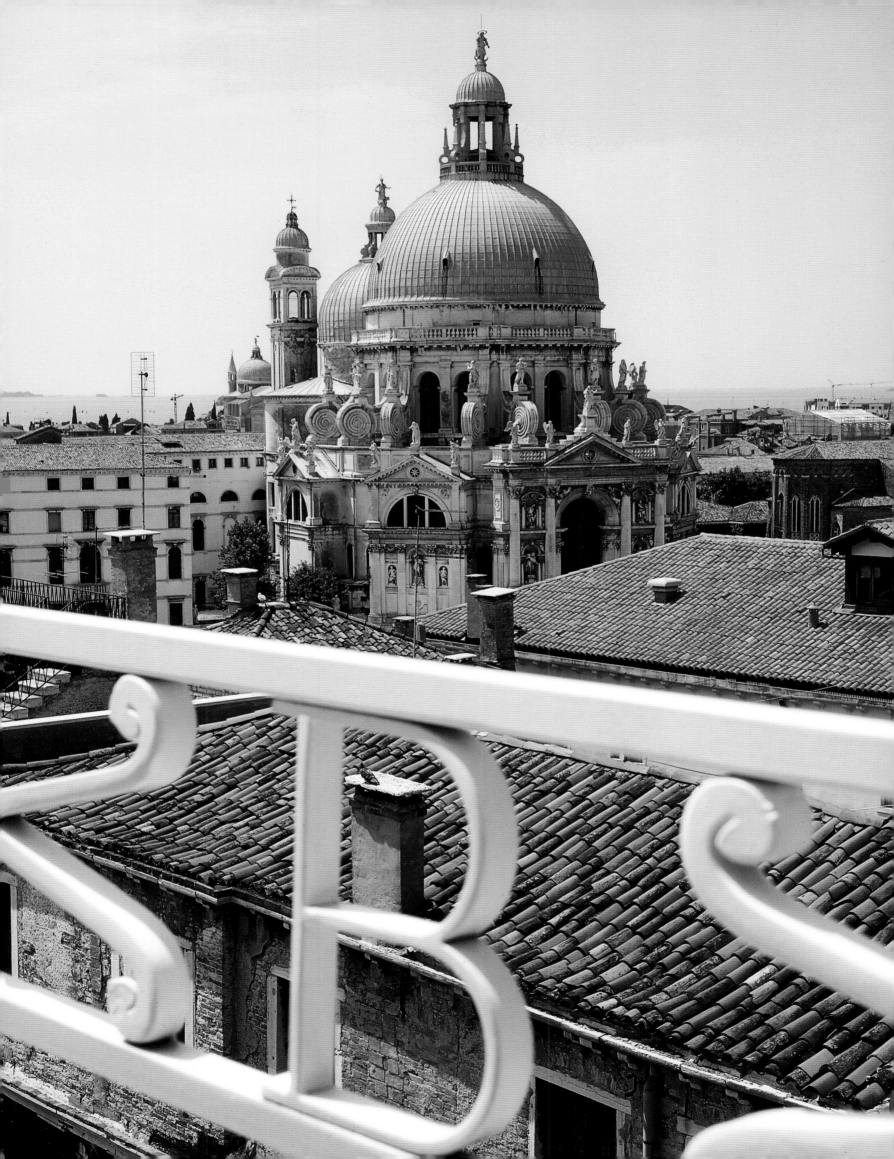

The full glory of 18th-century Venice is revealed in the opulently decorated rooms. The walls are covered with precious fabrics from Rubelli and Bevilacqua.

In den opulent ausgestatteten Räumen entfaltet sich die ganze Pracht des venezianischen 18. Jahrhunderts. Die Wände wurden mit kostbaren Stoffen von Rubelli und Bevilacqua bespannt.

Les pièces aménagées de façon opulente expriment toute la somptuosité du XVIIIᵉ siècle vénitien. Les murs ont été recouverts de précieuses tapisseries de Rubelli et Bevilacqua.

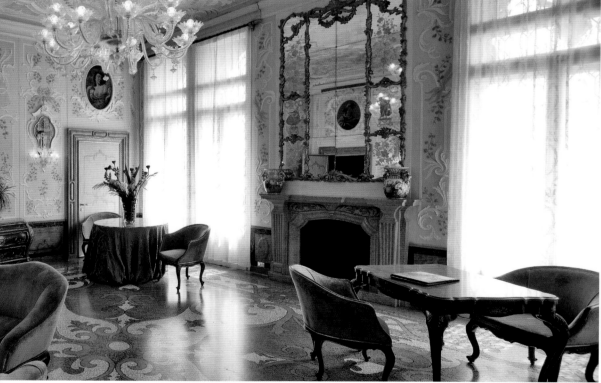

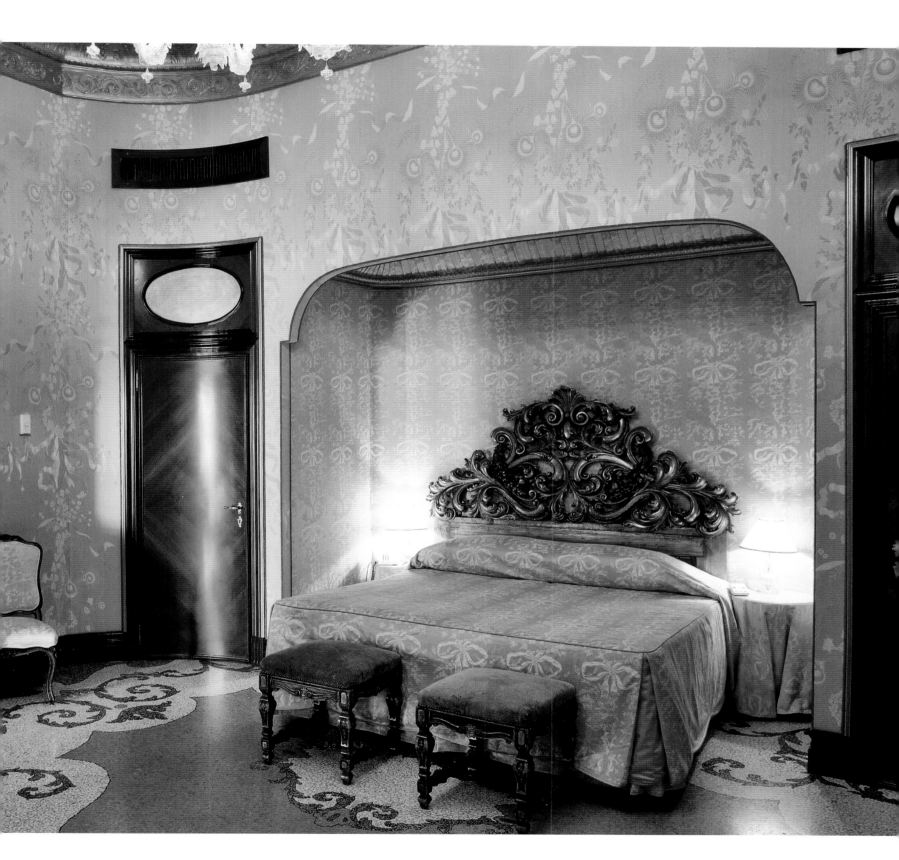

The Xara Palace Relais & Châteaux

Mdina, Malta

The history of Malta is reflected in The Xara Palace Relais & Châteaux. Parts of the 17th-century palace are integrated into the bastion walls of Mdina, which was the capital of the island until 1571. Magnificent antique church doors dating from the 18th century are clearly visible upon entering this small refuge where 17 rooms feature antiques and original paintings from Maltese masters. Perched on Mdina's bastions, gourmet restaurant de Mondion serves modern Mediterranean cuisine to accompany the incredible view over the island; on clear days, diners can even see the Mediterranean Sea.

Die Geschichte Maltas spiegelt sich im The Xara Palace Relais & Châteaux wider. Teile des Stadtpalais aus dem 17. Jahrhundert sind in die Festungsmauern Mdinas integriert, die bis 1571 die Hauptstadt des Inselreiches war. Herrliche antike Kirchenportale aus dem 18. Jahrhundert im Blick gelangt man in das kleine Refugium, dessen 17 Zimmer mit Originalgemälden von maltesischen Meistern und Antiquitäten eingerichtet sind. Vom auf den Befestigungsmauern gelegenen Gourmet-Restaurant de Mondion, das eine moderne mediterrane Küche serviert, eröffnet sich ein weiter Blick über die Insel und an klaren Tagen bis zum Mittelmeer.

L'histoire de l'île de Malte se reflète dans le The Xara Palace Relais & Châteaux. Certaines parties de cet hôtel particulier du XVII⁰ siècle sont en effet intégrées aux remparts de la ville de Mdina, qui fut jusqu'en 1571 la capitale de l'île. Des magnifiques portes d'église du XVIII⁰ siècle embellissent l'entrée du petit sanctuaire dont les 17 chambres sont décorées de tableaux originaux de maîtres maltais ainsi que d'antiquités. Outre sa cuisine méditerranéenne moderne, le restaurant gastronomique de Mondion situé sur les fortifications offre une vue imprenable sur l'île ainsi que sur la Mer Méditerranée lorsque le ciel est dégagé.

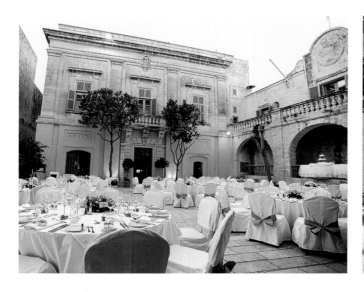

The historic buildings along the piazza form an impressive open-air backdrop for festivals and receptions.

Die historischen Häuser der Piazza bilden eine eindrucksvolle Kulisse für Feste und Empfänge unter freiem Himmel.

Les bâtisses historiques de la Piazza créent un sublime décor pour les fêtes et réceptions en plein air.

Armoires with a patina of white and light wall colors bring a Mediterranean atmosphere to the historic rooms.

Weiß patinierte Schränke und lichte Wandfarben bringen mediterrane Leichtigkeit in die historischen Räume.

Des armoires patinées de blanc et des murs aux coloris lumineux font entrer la légèreté méditerranéenne dans ces lieux historiques.

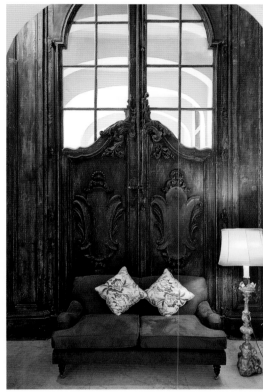
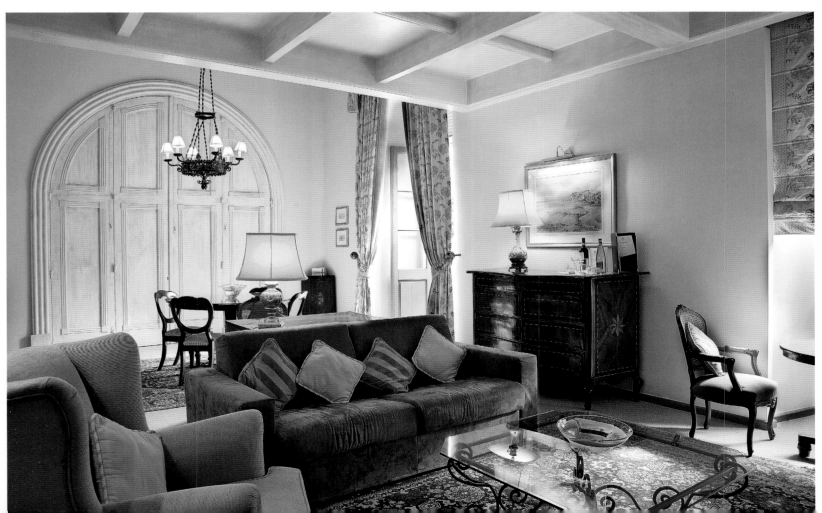

Hotel Casa Fuster

Barcelona, Spain

It all started with a grand love story: In 1908, Majorcan aristocrat Mariano Fuster commissioned architect Lluís Domènech i Montaner to convert an old chocolate factory into the city's most spectacular home as a gift for his adorable wife. In 2004, Casa Fuster became a flamboyant and opulent luxury hotel. Woody Allen was so taken with it that he filmed a key scene for "Vicky Cristina Barcelona" in the hotel's Café Vienés.

Eine große Liebesgeschichte: 1908 beauftragte der mallorquinische Aristokrat Mariano Fuster den Architekten Lluís Domènech i Montaner, eine alte Schokoladen- fabrik in das spektakulärste Haus der Stadt zu verwandeln – als Geschenk für seine anbetungswürdige Frau. Seit 2004 ist die Casa Fuster ein flamboyant-opulentes Luxushotel. Woody Allen war so angetan, dass er im Café Vienés eine Schlüsselszene für „Vicky Cristina Barcelona" drehte.

Une grande histoire d'amour. En 1908, l'aristocrate mallorcain Mariano Fuster charge Lluís Domènech i Montaner de transformer une ancienne fabrique de chocolat en la maison la plus spectaculaire de la ville – un cadeau à son épouse. Depuis 2004, la Casa Fuster est un opulent hôtel de luxe. Woody Allen a tellement aimé l'endroit qu'il a tourné une des scènes clés de « Vicky Cristina Barcelona » dans le Café Vienés.

 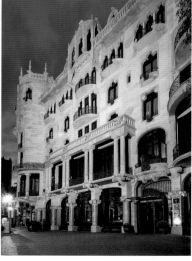

This magnificent building overlooking the Passeig de Gràcia is con- sidered to be the masterpiece of Lluís Domènech i Montaner, the most important representative of Modernisme next to Antoni Gaudí.

Der Prachtbau, der den Passeig de Gràcia überblickt, gilt als Mei- sterwerk Lluís Domènech i Montaners, neben Antoni Gaudì der wich- tigste Vertreter des Modernisme.

Ce somptueux édifice, qui surplombe le Passeig de Gràcia, est une œuvre de Lluís Domènech i Montaner. Avec Antoni Gaudí, il est le principaux représentant du Modernisme.

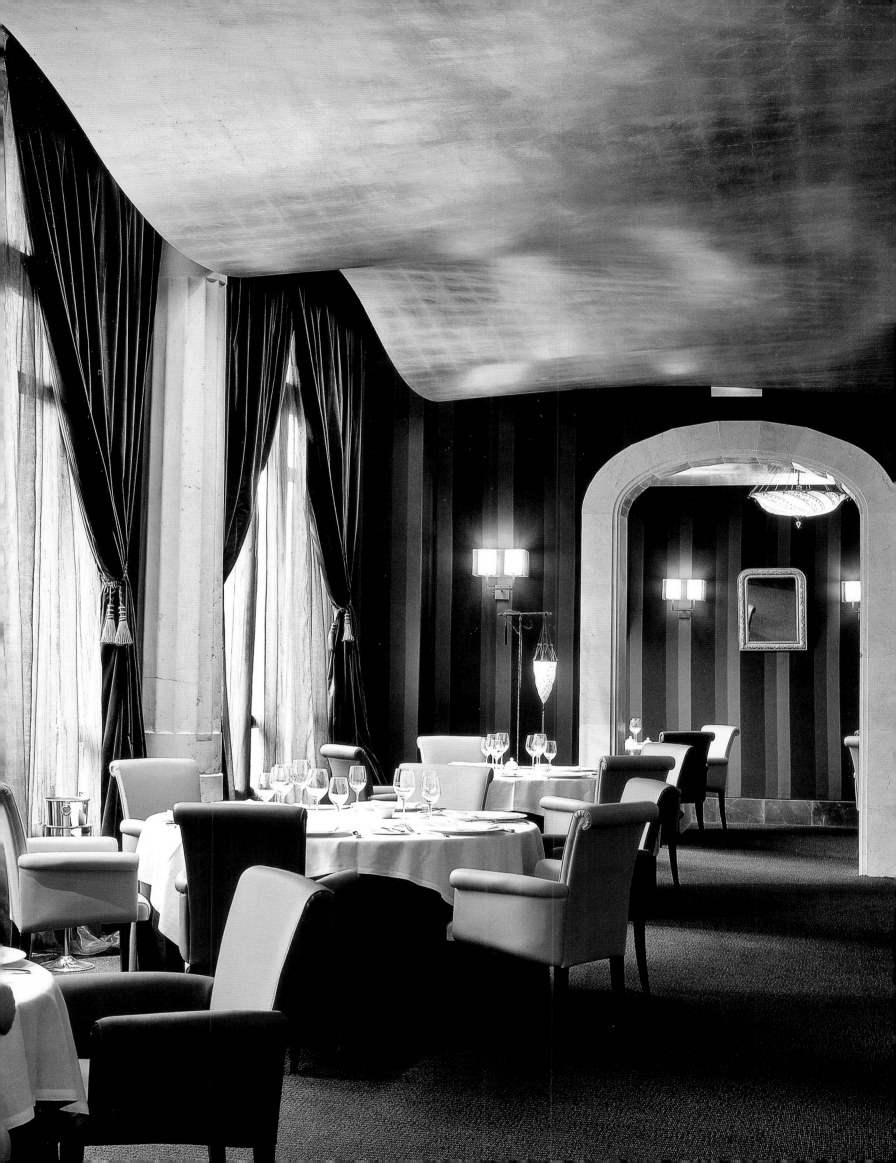

The hotel's complete renovation retained the Twenties atmosphere in the use of heavy velvet fabrics and saturated colors.

Auch nach der umfassenden Restaurierung blieb die Atmosphäre der zwanziger Jahre erhalten, wie sie sich in den schweren Samtstoffen und satten Farben zeigt.

Après une restauration complète, l'atmosphère des années 20 est toujours bien présente, comme le montrent les lourdes étoffes de velours et les couleurs intenses.

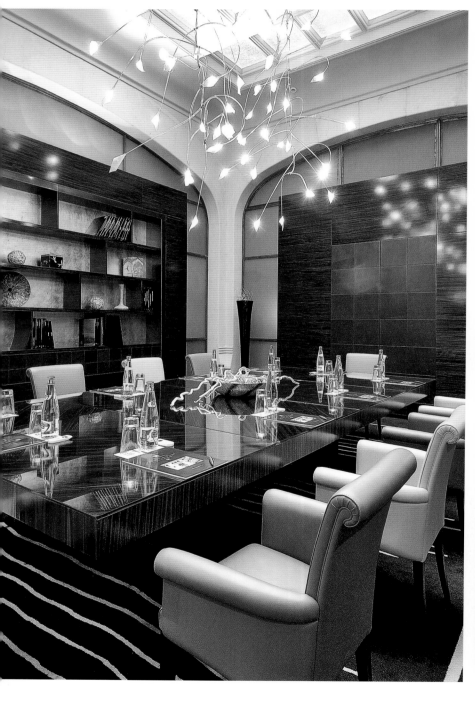

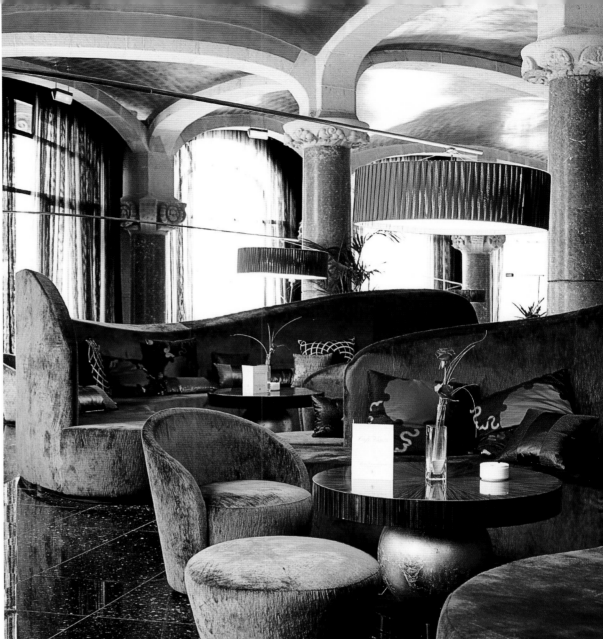

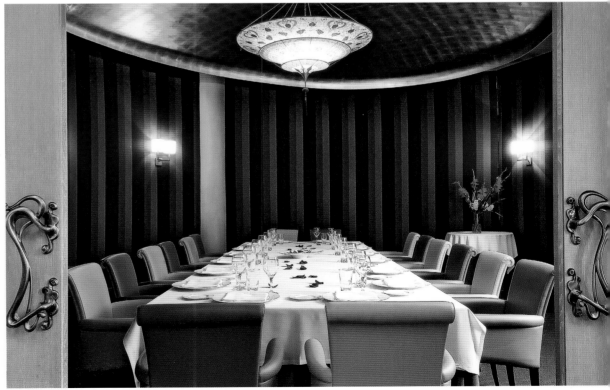

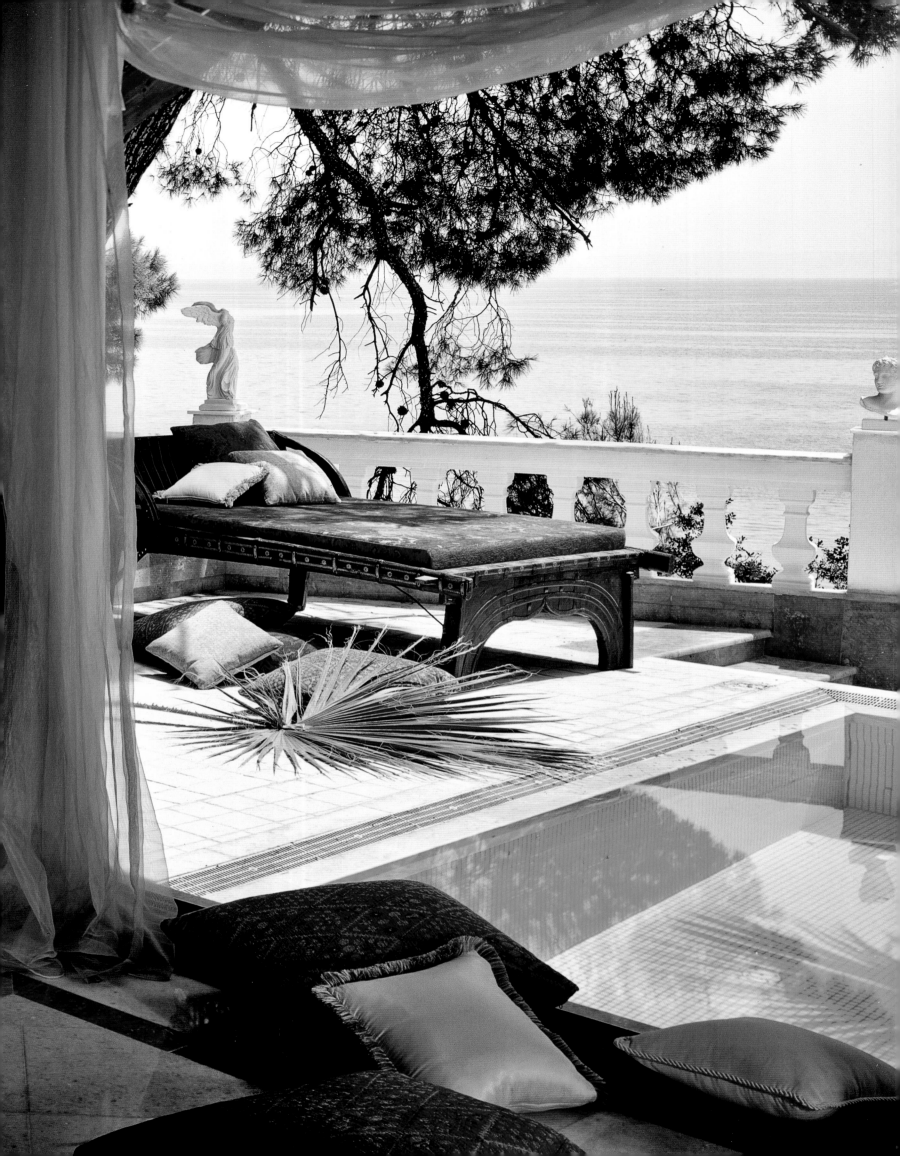

Danai Beach Resort Suites & Villas

Nikiti, Greece

The three fingers of the Chalkidiki peninsula extend deep into the blue Aegean. Sithonia, the middle peninsula, is still largely untouched. Guests travel over winding streets to reach the resort, a true hideaway thanks to its location on a cliff with a magnificent view of the Aegean. The 55 rooms and suites as well as the five private villas are exquisitely decorated with marble, noble woods, and silk fabrics. Light floods in through expansive glass panels.

Weit in die tiefblaue Ägäis strecken sich die drei Finger der Halbinsel Chalkidike. Noch weitgehend unberührt ist Sithonia, die mittlere der Halbinseln. Über kurvige Straßen erreicht man das Resort, dessen Lage auf einer Klippe mit Traumblick auf die Ägäis es zu einem wahren Refugium macht. Die 55 Zimmer und Suiten sind ebenso wie die fünf Privatvillen mit Marmor, edlen Hölzern und Seidenstoffen eingerichtet. Breite Glasfronten lassen das Licht hereinfluten.

Les trois doigts de la presqu'île de Chalcidique s'étirent dans le bleu profond de la mer Egée. La péninsule du milieu, Sithonia, est encore vierge dans une large mesure. Une route sinueuse mène jusqu'au complexe qui, situé sur une falaise, constitue un véritable refuge offrant une vue fantastique sur la mer Egée. Les 55 chambres et suites ainsi que les cinq villas sont toutes décorées de marbre, de bois précieux et de soieries, l'ensemble étant mis en valeur par de larges baies vitrés qui baignent les lieux de lumière.

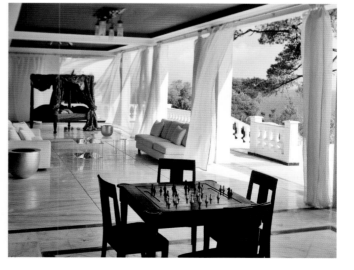

The five villas, up to 10,200 square feet in size, offer the ultimate in privacy with expansive terraces and private pools.

Größtmögliche Privatsphäre bieten die fünf bis zu 950 Quadratmeter messenden Villen mit Privatpools und großzügigen Terrassen.

Les cinq villas d'une superficie allant jusqu'à 950 mètres carrés, dotées de piscines privées et généreuses terrasses, offrent la plus grande intimité.

Guests who want to relax will have a difficult time choosing between the resort's private golden sandy beach, the terrace of the exclusive villa, or the private pool.

Wer entspannen will, hat die Qual der Wahl: am resorteigenen, goldenen Sandstrand, auf der Terrasse der eigenen Villa, am privaten Pool.

Pour la détente, on a l'embarras du choix : la plage privé de sable doré, la terrasse exclusive de la villa ou la piscine privée.

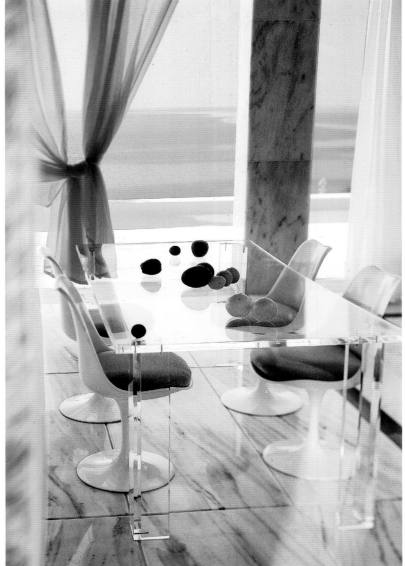

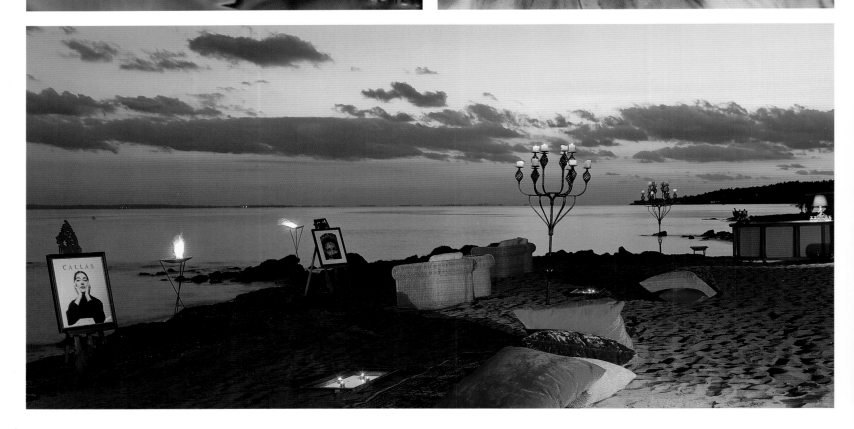

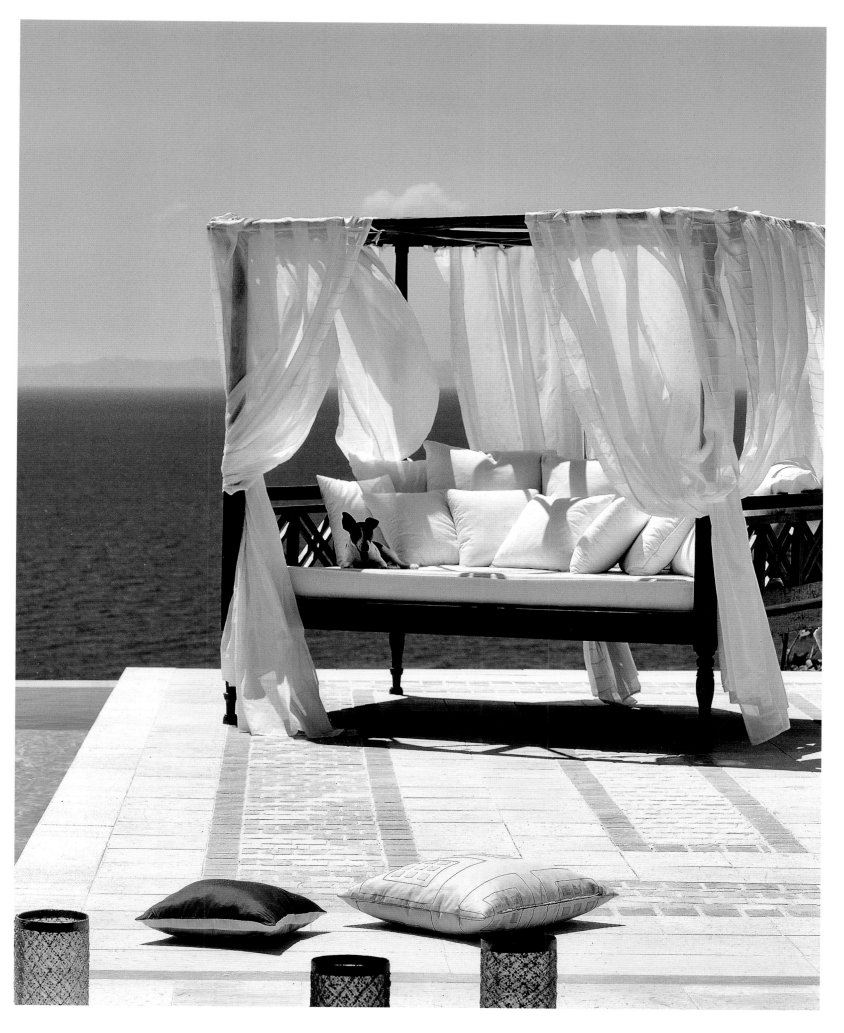

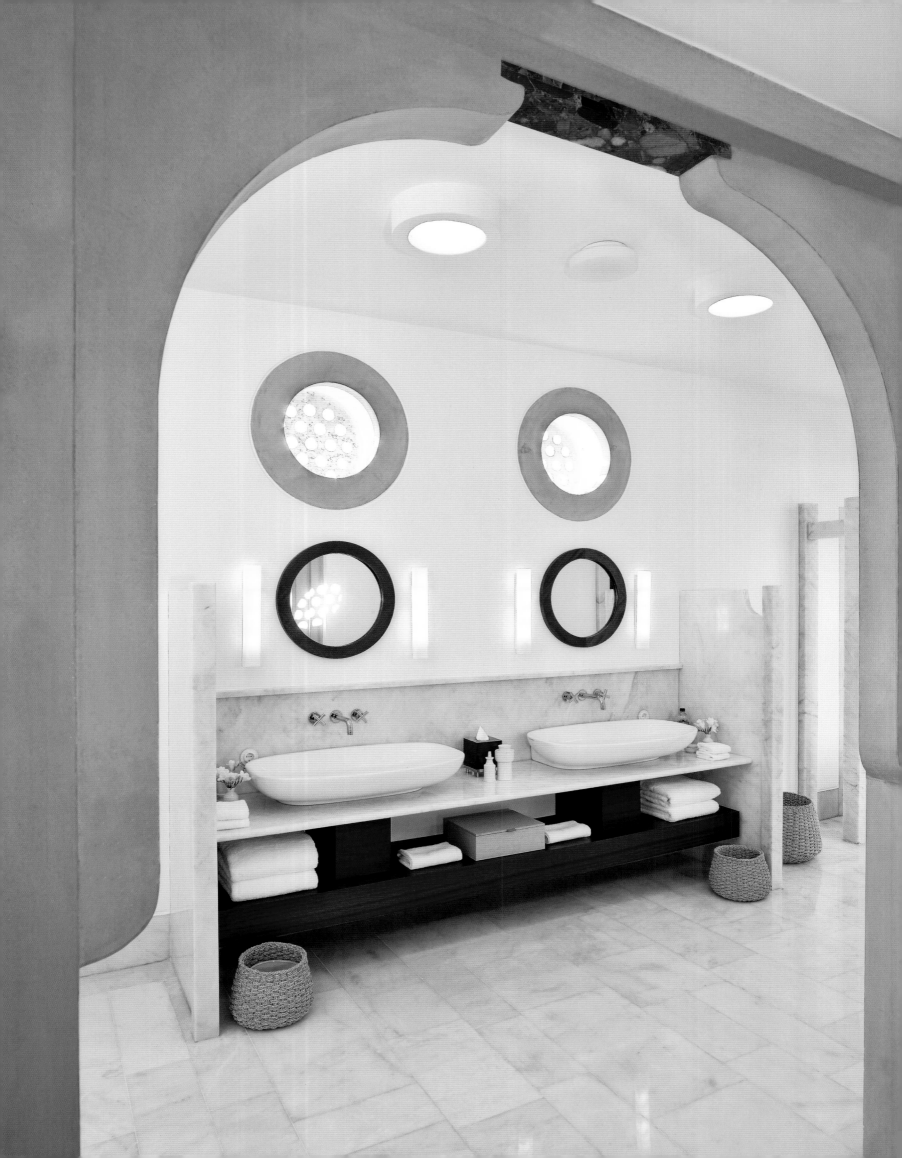

Amanruya

Bodrum, Turkey

Along the southeastern Aegean coast, scenic beauty and relics of ancient civilizations combine in a rare and unique way. This is a perfect location for the 24th Aman resort, which opened in December 2011 on the northern coast of the Bodrum Peninsula. Perched on a hill with a view of the sea, the 36 pool terrace cottages are surrounded by a pine forest and ancient olive trees. Constructed of rough-hewn stones, all the cottages feature a private pool, terraces, a patio, and a garden.

Landschaftliche Schönheit und Zeugnisse der Antike gehen in der südöstlichen Ägäis eine besonders glückliche Verbindung ein. Ein perfekter Ort für das 24. Aman-Resort, das im Dezember 2011 an der Nordküste der Halbinsel Bodrum eröffnete. Die 36 Pool Terrace Cottages liegen umgeben von einem Pinienwald und uralten Olivenbäumen auf einer Anhöhe mit weitem Blick über das Meer. Sie wurden aus rustikal behauenen Steinen errichtet und verfügen alle über einen Privatpool, Terrassen, ein Patio und einen Garten.

Beauté du paysage et vestiges de l'antiquité proposent un mariage des plus heureux au sud-est de la mer Egée. Une situation de rêve pour ce 24e hôtel du groupe Amanresorts qui a ouvert ses portes en décembre 2011 sur la côte nord de la péninsule de Bodrum. Les 36 cottages entourés de pins et d'oliviers anciens offrent une vue dégagée sur la mer grâce à leur construction sur les hauteurs. Ils sont faits de rustiques pierres de taille et disposent tous d'une piscine privée, de terrasses, d'un patio et d'un jardin.

Classic simplicity characterizes the ambience. The floors are made of Turkish marble and the custom furniture of mahogany.

Edle Schlichtheit bestimmt das Ambiente. Die Böden sind aus türkischem Marmor, die maßgefertigten Möbel aus Mahagoniholz.

Son ambiance se caractérise par une sobriété élégante. Les sols sont en marbre turc, les meubles sur mesure, en acajou.

High sandstone walls shield the 800-square-foot cottages. Everything radiates tranquillity.

Hohe Sandsteinmauern schirmen die 75 Quadratmeter großen Gästehäuser ab. Alles strahlt Ruhe aus.

De hauts murs en grès abritent les maisons d'hôtes de 75 mètres carrés. Ici, tout respire le calme.

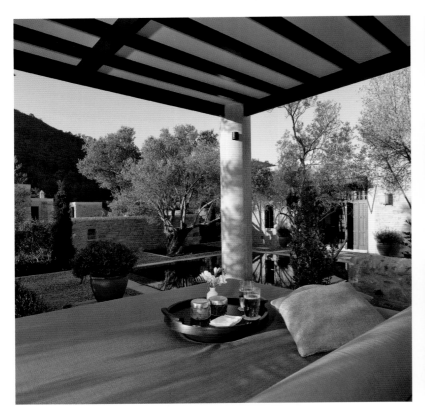

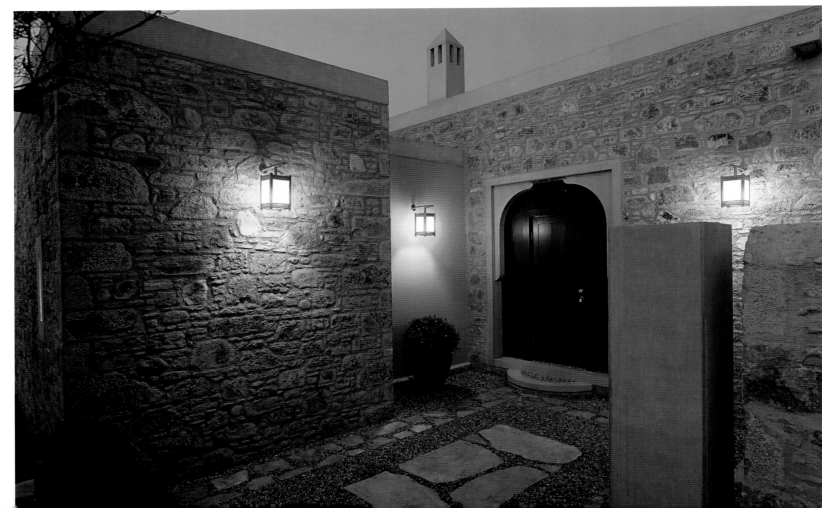

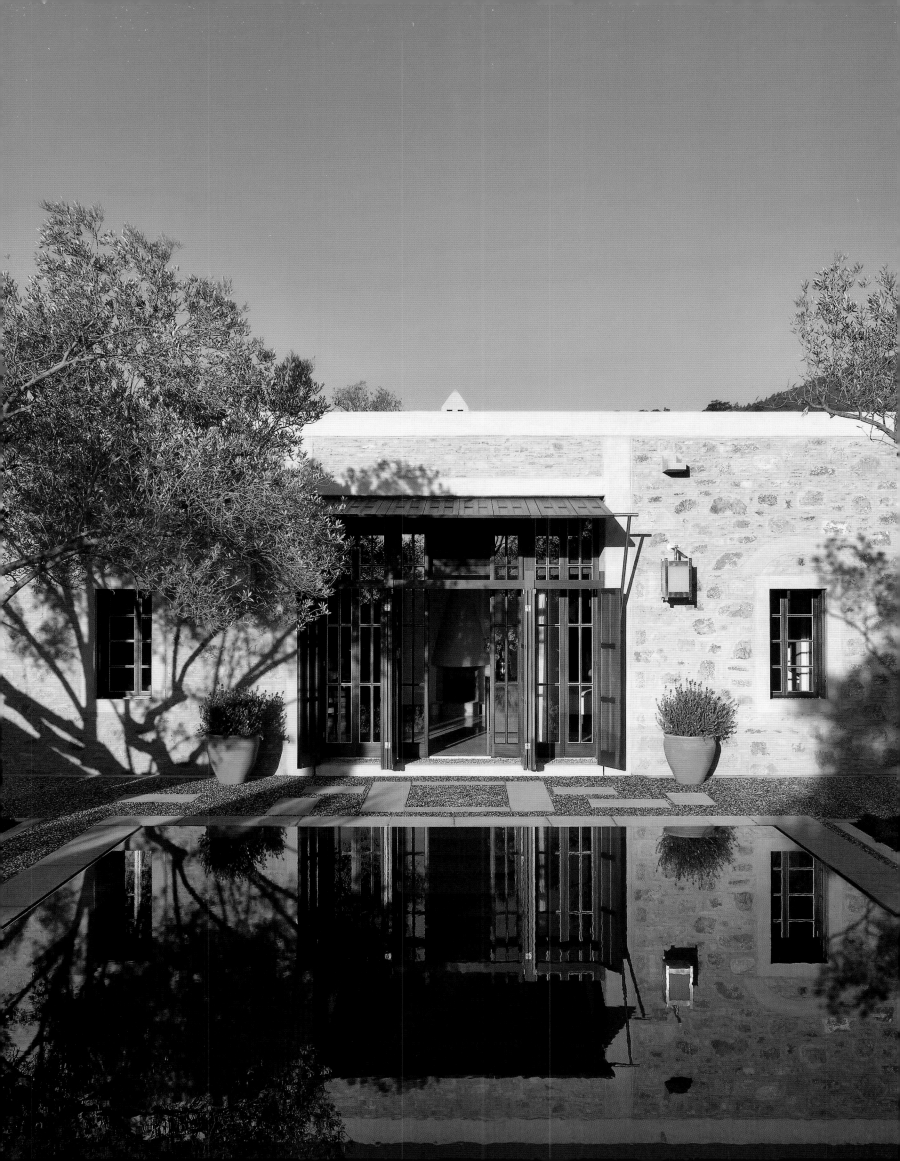

Index

United Kingdom

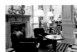
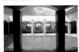
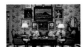
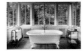

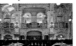
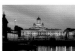

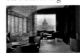

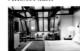

Belgium

Spa

Manoir de Lébioles
Domaine de Lébioles 1/5, B-4900 Spa
T +32 877 919 00, manoir@manoirdelebioles.com
www.manoirdelebioles.com

16 rooms and suites. Restaurant, bar, library, spa, gym, indoor pool, parking lot. 24 h front desk, free wi-fi. 45 minutes from Liege Airport.

Germany

Berlin

Regent Berlin
Charlottenstraße 49, 10117 Berlin
T +49 302 0338, info.berlin@regenthotels.com
www.regenthotels.com/berlin

156 rooms and 39 suites. Restaurant, bar, spa. 24 h front desk and concierge service, valet parking, baby and dog sitting. 30 minutes from Berlin Airport.

Germany

Burg im Spreewald

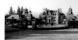

Zur Bleiche Resort & Spa
Bleichestraße 16, 03096 Burg im Spreewald
T +49 356 036 20, reservierung@hotel-zur-bleiche.com
www.hotel-zur-bleiche.de

94 rooms and suites. Restaurant, bar, library, spa, gym, indoor and outdoor pool, parking lot. 24 h front desk, bycicles rental. 120 kilometers from Berlin Airport.

Germany

Frankfurt

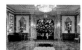

Villa Kennedy
Kennedyallee 70, 60596 Frankfurt
T +49 697 171 20, reservations.villakennedy@roccofortehotels.com
www.villakennedyhotel.com

163 rooms including 35 suites and 1 presidential suite. Spa, indoor pool, gym, restaurant, bar, library, and parking lot. 24 h reception. 11 kilometers from Frankfurt International Airport.

Germany

Munich

Bayerischer Hof
Promenadeplatz 2-6, 80333 Munich
T +49 892 1200, info@bayerischerhof.de
www.bayerischerhof.de/en/hotel/index.php

395 rooms. 5 restaurants and 6 bars, Blue Spa, Night Club with live Jazz, film theatre astor@Cinema Lounge, gym, A&T Hair Spa and business center. 24 h reception, bike rental. 40 minutes from Franz Josef Strauß Airport.

Germany

Munich

Sofitel Munich Bayerpost
Bayerstraße 12, 80335 Munich
T +49 895 994 80, h5413@sofitel.com
www.sofitel.com

396 rooms. 2 restaurants, 1 bar, indoor pool, spa, gym, parking lot. 24 h room service. City center, 100 meters from central station. 42 kilometers from Munich Airport.

Germany

Sylt / Munkmarsch

Hotel Fährhaus Sylt
Bi Heef 1, 25980 Sylt / Munkmarsch
T +49 465 1939 70, info@faehrhaus-sylt.de
www.faehrhaus-hotel-collection.de

27 double rooms and 12 suites. 3 restaurants, 1 bar, spa, indoor pool, parking lot, airport shuttle. 15 minutes from Sylt airport.

Austria

Hof bei Salzburg

Schloss Fuschl Resort & SPA
Schloss Strasse 19, 5322 Hof bei Salzburg
T +43 622 922 530, schlossfuschlsalzburg@luxurycollection.com
www.schlossfuschlsalzburg.com

110 rooms, suites and chalets. Spa, gym, golf course, 2 restaurants, 1 bar, old-master painting collection. 24 h reception, vintage cars and limousines rental, fishery. 15 kilometers from Salzburg and Salzburg Airport W. A. Mozart.

Austria

Lech am Arlberg

Aurelio Hotel & SPA Lech
Tannberg 130, 6764 Lech am Arlberg
T +43 558 322 14, reservation@aureliolech.com
www.aureliolech.com

19 rooms and suites. Restaurant, bar, terrace, spa, pool, library, salon, rooms for disabled. 24 h front desk, airport transfer, currency exchange, baby sitting, ski school. 1.5 hours from Innsbruck Airport.

Austria

Vienna

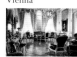

Hotel Imperial, Vienna
Kärntner Ring 16, 1010 Vienna
T +43 150 110 0, reservations@claridges.co.uk
www.hotelimperialwien.at

76 rooms and 62 suites. Business center, gym, Concierge and butler service, 24 h room service, baby sitting service, 24 h reception. City center, 20 kilometers from Vienna Airport.

Austria

Vienna

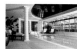

Palais Coburg
Coburgbastei 4, 1010 Vienna
T +43 151 8180, hotel.residenz@palais-coburg.com
www.palais-coburg.com

35 suites. 2 restaurants, spa, indoor pool, sun terrace. Babysitting, shopping service, private dining, 24 h concierge service. City center, 20 kilometers from Vienna Airport.

Switzerland

Basel

Grand Hotel Les Trois Rois
Blumenrain 8, 4001 Basel
T +41 612 605 050, info@lestroisrois.com
www.lestroisrois.com

101 rooms and suites. 3 restaurants, 1 bar, gym, business center. 24 h reception, concierge service. 15 minutes from central station, 15 minutes from EuroAirport Basel–Mulhouse–Freiburg.

Switzerland

Berne

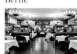

Hotel Schweizerhof Bern
Bahnhofplatz 11, 3001 Berne
T +41 313 268 080, info@schweizerhof-bern.ch
www.schweizerhof-bern.ch

99 rooms and suites. 1 restaurants, 1 bar, 1 cigar lounge, meeting- and event facilities, spa including indulgence pool ready by February 2012. 24 h front desk. City center, 10 kilometers from Berne Belp Airport.

Switzerland

Interlaken

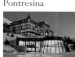

Victoria-Jungfrau Grand Hotel & Spa
Höheweg 41, 3800 Interlaken
T +41 338 282 828, reservation@victoria-jungfrau.ch
www.victoria-jungfrau.ch

212 rooms and suites. Three restaurants, two bars, spa, indoor pool, tennis courts, kids club, and parking lot. 24 h reception, room service from 7 am to midnight. City center, 2 h from Zurich Airport, 2.5 h from Genf Airport, 3.5 h from Airport Mailand-Malpensa.

Switzerland

Pontresina

The Grand Hotel Kronenhof
Via Maistra 130, 7504 Pontresina
T +41 818 3030 30, info@kronenhof.com
www.kronenhof.com

112 rooms and suites. Parking lot, indoor pool, 3 restaurants, bar, gym, park, business center. 24 h reception, free transfer from and to train station, free ski shutte service, car rental, baby sitting. 6 kilometers from Engadin Airport.

Switzerland

Zurich

Baur au Lac
Talstrasse 1, 8001 Zurich
T +41 442 205 020, info@bauraulac.ch
www.bauraulac.ch

120 rooms. 4 restaurants. 24 h concierge service, valet parking, IT-Butler, wi-fi. 25 minutes from Zurich Airport.

France

Castelnau-le-Lez

Domaine de Verchant
1 boulevard Philippe Lamour, 34170 Castelnau-le-Lez
T +33 467 072 600, reservation@verchant.com
www.domainedeverchant.com

22 rooms and apartments. Restaurant, spa, pool, vineyard, playground, parking lot, library. 24 h reception, car rental. 6 kilometers from Airport Montpellier Méditerranée, 10 kilometers from the sea.

France

Paris

Four Seasons Hotel George V
31, avenue George V, 75008 Paris
T +33 149 527 000, reservations@claridges.co.uk
www.fourseasons.com/paris

245 rooms and suites. Spa, bar, Le Cinq restaurant, gym, pool, business center. 24 h front desk and room service baby sitting. 30 minutes from Charles De Gaulle Airport.

France

Paris

Hotel Plaza Athénée Paris
25 avenue Montaigne, 75008 Paris
T +33 153 676 665, reservations@plaza-athenee-paris.com
www.plaza-athenee-paris.com

191 rooms and suites. 5 restaurants, bar, gym, spa, parking lot, garden, 24 h reception and room service, valet parking, 30 kilometers from airport Paris-Charles de Gaulle, 20 kilometers from airport Paris-Orly.

France

Paris

Le Royal Monceau – Raffles Paris
37 avenue Hoche, 75008 Paris
T +33 142 998 800, paris@raffles.com
www.leroyalmonceau.com

149 rooms and suites, including 2 presidential suites. 2 restaurants, bar, spa "My Blend by Clarins", parking lot, business center. 24 h reception, rooms for disabled, baby sitting. City center, 45 kilometers from Airport Paris-Charles de Gaulle, 30 kilometers from Airport Le Bourget, 40 kilometers from Airport Paris-Orly.

France

Paris

Mandarin Oriental, Paris
251 rue Saint-Honoré, 75001 Paris
T +33 170 9878 88, mopar-reservations@mohg.com
www.mandarinoriental.com/paris

138 rooms and 39 suites. 2 restaurants, 1 bar, garden, spa, indoor pool, gym. 24 h reception. City center, close to the Louvre, 20 kilometers from Airport Paris-Orly and Le Bourget, 30 kilometers from Airport Paris-Charles De Gaulle.

France

Ramatuelle

La Réserve Ramatuelle
Chemin de la Quessine, 83350 Ramatuelle
T +33 494 449 444, inforamatuelle@lareserve.ch
www.lareserve.ch

9 spacious rooms and 20 suites, 12 villas. Restaurant and bar, spa including 13 treatment cabins, fitness studio, steam bath and indoor pool. Treatment of metabolic and muscular tension, 6-day regenerating program and Mediterranean diet. On a hilltop in Ramatuelle, 150 kilometers to Nice Airport.

Monaco

Montecarlo

Hôtel Hermitage
Square Beaumarchais, 98000 Montecarlo
T +37 798 064 000, resort@sbm.mc
www.hotelhermitagemontecarlo.com

248 rooms. Business center, parking garage, valet parking, 1 restaurant, 2 bars, pool, spa. Helicopter service, 24 h room service, concierge service, currency exchange. 30 minutes from Nice-Côte d'Azur International Airport.

Italy

Capri

Capri Palace Hotel & Spa
via Capodimonte, 14, 80071 Capri
T +39 819 780 111, info@capripalace.com
www.capripalace.com

78 rooms including 11 suites. 3 restaurants, 1 bar, spa, Capri Palace beauty farm, art gallery, pool. 24 h reception, baby sitting. 50 kilometers from Naples Airport Capodichino.

Italy

Milan

Maison Moschino
Viale Monte Grappa 12, 20124 Milan
T +39 022 9009 858, maisonmoschino@mobygest.it
www.maisonmoschino.com

65 rooms divided into 16 different designs. Restaurant, spa, parking lot. 24 h reception. Corso Como district, 16 kilometers from Linate Airport, 49 kilometers from Malpensa Airport.

Italy

Milan

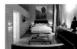

Townhouse 8
Via Silvio Pellico 8, 20121 Milan
T +39 023 6594 690, townhouse8@townhouse.it
www.townhouse.it/th8

11 rooms. 1 restaurant, lounge, bar, terrace, library. 24 h concierge service, 24 h room service, butler, private transportation from/to international airports (for a fee), City center, 2.5 kilometers from central station, 6 kilometers from Linate Airport, 40 kilometers from Malpensa Airport, 45 kilometers from Caravaggio International Airport Bergamo Orio al Serio.

Italy

Rome

Hassler Roma
Piazza Trinità dei Monti, 6, 00187 Rome
T +39 066 993 40, info@hotelhassler.it
www.hotelhasslerroma.com

95 rooms and suites. Michelin-starred restaurant Imàgo, bars, Armorvero Spa, Hassler Gift Boutique. 24 h room service. 30 minutes from Ciampino Airport.

Italy

Tavarnelle Val
di Pesa (Florence)

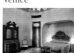

Castello del Nero Hotel & Spa
Strada di Spicciano 7, 50028 Tavarnelle Val di Pesa (Florence)
T +39 055 806 470, info@castellodelnero.com
www.castellodelnero.com

50 rooms and suites. 2 restaurants, bar, spa, 2 tennis courts, gym, pool. 24 h reception, car rental and baby sitting on request. In the heart of the Chianti wine region, 45 kilometers from Amerigo Vespucci, 25 minutes to Florence and Siena.

Italy

Venice

Bauer Il Palazzo
Piazza San Marco, 2058, 30124 Venice
T +39 041 5207 022, reservations@claridges.co.uk
www.ilpalazzovenezia.com

72 rooms and suites. Restaurant and 2 bars. Concierge service, all natural beauty products and eco-friendly endeavors. Private water taxi from Piazzale Roma to the hotel dock: about 15 minutes.

Malta

Mdina

The Xara Palace Relais & Châteaux
Misrah il-Kunsill, Mdina, MDN 1050 Mdina
T +35 621 450 560, info@xarapalace.com.mt
www.xarapalace.com.mt

17 rooms and suites. 2 restaurants, bar, gym. 24 h front desk, chauffeur service, concierge, on-site medical assistance. 9 kilometers from Malta International Airport.

Spain

Barcelona

Hotel Casa Fuster
Passeig de Gràcia, 132, 08008 Barcelona
T +34 932 553 000, reservations@claridges.co.uk
www.hotelescenter.com/casafuster

105 rooms and suites. Restaurant, Café Vienés, bar with rooftop terrace, jazz club, pool, gym, sauna, parking lot. 24 h front desk, car rental, vegetarian food. City center, 15 kilometers from Airport Barcelona-El Prat.

Greece

Nikiti

Danai Beach Resort Suites & Villas
1 Nikiti Chalkidiki, 63088 Nikiti
T +30 237 5020 400 2, info@dr.gr
www.dbr.gr

55 rooms and suites, five private villas. Parking lot, Danai Spa, 4 restaurants, Sea Side Bar, heated pool with sea water, tennis court. 24 h reception and butler service, car rental, medical treatment. Location between two villages: Metamorfosis and Nikiti, at the beach, 50 minutes from Thessaloniki Airport.

Turkey

Bodrum

Amanruya
Bülent Ecevit Cad., Demir Mevkii, Göltürkbükü, TR-48483 Bodrum
T +90 252 3111 212, amanruya@amanresorts.com
www.amanresorts.com/amanruya/home.aspx

36 cottages. Pool, library, terrace, beach club, wine lounge, boutique, art gallery, spa, restaurants, bar. 24 h front desk. 42 kilometers from Milas-Bodrum International Airport.

Photo Credits & Imprint

Cover photo: (Claridges) by Gavin Jackson
Back cover photo: (La Réserve Ramatuelle) by
Martin Nicholas Kunz

pp. 10–13 (Claridges) by Gavin Jackson
pp. 14–17 (The Berkeley) courtesy Berkeley
pp. 18–21 (The Savoy) pp. 18 and 21 top by Niall Clutton,
pp. 19 left and 20 by Richard Bryant/arcaid, all others
courtesy Fairmont
pp. 22–25 (Lime Wood) p 23 right by Mark Bolton
Photography, all others courtesy Lime Wood
pp. 26–29 (Amberley Castle) courtesy Amberley Castle
pp. 30–33 (Hotel Kämp) courtesy Hotel Kämp
pp. 34–37 (Lydmar Hotel) by David Burghardt
pp. 38–41 (Nobis Hotel) by David Burghardt
pp. 42–45 (W St. Petersburg) courtesy W St. Petersburg
pp. 46–49 (Augustine Hotel Prague) courtesy Rocco Forte
Collection
pp. 50–55 (Aman Sveti Stefan) by Richard Se
pp. 56–59 (Boscolo Budapest) by Martin N. Kunz
pp. 60–65 (Four Seasons Hotel Gresham Palace Budapest)
by Martin N. Kunz
pp. 66–69 (Hotel Pulitzer) courtesy Hotel Pulitzer
pp. 70–73 (Kruisherenhotel Maastricht) by Roland F. Bauer
pp. 74–77 (Hotel Amigo) courtesy Hotel Amigo
pp. 78–81 (Manoir de Lébioles) by Photo Eliophot -
Aix-en-Provence
pp. 82–85 (Regent Berlin) courtesy The Regent Berlin
pp. 86–89 (Zur Bleiche Resort & Spa) by David Burghardt
pp. 90–93 (Villa Kennedy) by Roland F. Bauer

pp. 94–97 (Bayerischer Hof) courtesy Bayerischer Hof
pp. 98–101 (Sofitel Munich Bayerpost)
pp. 99 right by Fabrice Rambert, 100 bottom by
Jack Burlot, all others by Stephen Huljak
pp. 102–105 (Hotel Fährhaus Sylt)
by YDO SOL IMAGES/Hotel Fährhaus Sylt
pp. 106–109 (Schloss Fuschl Resort & SPA)
pp. 106 right, 107 by Roland F. Bauer, 108 top by Andreas
Schatzl - foto-crew, all others courtesy Schloss Fuschl
pp. 110–115 (Aurelio Hotel & SPA Lech) courtesy
Hotel Aurelio Lech
pp. 116–119 (Hotel Imperial, Vienna) pp. 116 left, 118 left,
119 top courtesy Imperial Vienna, all others by Roland F. Bauer
pp. 120–123 (Palais Coburg) p 122 courtesy Palais Coburg,
all others by Roland F. Bauer
pp. 124–127 (Grand Hotel Les Trois Rois) p 127 top
by Andreas Thumm, all others courtesy Grand Hotel
Les Trois Rois
pp. 128–131 (Hotel Schweizerhof Bern) p 129 right
by Oliver Oettli Photography, all others courtesy
Hotel Schweizerhof
pp. 132–135 (Victoria-Jungfrau Grand Hotel & Spa) by
Roland F. Bauer
pp. 136–141 (The Grand Hotel Kronenhof) courtesy
Grand Hotel Kronenhof
pp. 142–145 (Baur au Lac) p 144 top by Roland F. Bauer,
all others courtesy Baur au Lac
pp. 146–149 (Domaine de Verchant) by WIM PRODUCTIONS
pp. 150–153 (Four Seasons Hotel George V) by Andreas Burz
pp. 154–157 (Hotel Plaza Athénée Paris) by Roland F. Bauer

pp. 158–161 (Le Royal Monceau – Raffles Paris)
pp. 159 right by Laurent Attias/LaSociétéAnonyme,
all others by Philippe Garcia/LaSociétéAnonyme
pp. 162–165 (Mandarin Oriental, Paris) by George
Apostolidis/
courtesy Mandarin Oriental Hotel Group
pp. 166–171 (La Réserve Ramatuelle) by Martin N. Kunz
pp. 172–175 (Hôtel Hermitage) p 172 right by Jean-Marc
Bernard/realis 2007, pp. 172 left, 175 left top and bottom
courtesy Hotel Hermitage, all others by CAP CREA
pp. 176–179 (Capri Palace Hotel & Spa) p 178 bottom by
UIDO FUA'/EIKONA, all others courtesy Capri Palace
Hotel & Spa
pp. 180–183 (Maison Moschino) p 182 bottom right by
Ake E:son Lindman, pp. 180, 181 left, 182 top left by
Henri Del Olmo, all others by Massimo Listri
pp. 184–187 (Townhouse 8) courtesy TownHouse
pp. 188–191 (Hassler Roma) courtesy Hassler Roma
pp. 192–195 (Castello del Nero Hotel & Spa) courtesy
Castello del Nero Boutique Hotel & Spa
pp. 196–199 (Bauer Il Palazzo) by Martin N. Kunz &
Roland F. Bauer
pp. 200–203 (The Xara Palace Relais & Châteaux)
courtesy The Xara Palace Relais & Châteaux
pp. 204–207 (Hotel Casa Fuster) courtesy Casa Fuster,
Barcelona
pp. 208–211 (Danai Beach Resort Suites & Villas) p 210
bottom by Birgit Hofmann Birkenhall, all others courtesy
Danai Beach Resort
pp. 212–215 (Amanruya) by Richard Se

Editors	Martin Nicholas Kunz
Texts	Bärbel Holzberg
Copy Editing	Haike Falkenberg, Janosch Müller
Editorial Management	Miriam Bischoff
Editorial Advise	Patricia Massó
Art Direction	Martin Nicholas Kunz
Layout & Prepress	Djamila Schuler, Christin Steirat
Photo Editing	David Burghardt, Julie Huehnken
Imaging	Tridix, Berlin
Translations by	RR Communications Romina Russo
English	Heather Bock, Romina Russo
French	Élodie Gallois, Romina Russo, Samantha Michaux

Published by teNeues Publishing Group

teNeues Verlag GmbH + Co. KG
Am Selder 37, 47906 Kempen, Germany
Phone: +49 (0)2152 916 0, Fax: +49 (0)2152 916 111
e-mail: books@teneues.de

Press department: Andrea Rehn
Phone: +49 (0)2152 916 202
e-mail: arehn@teneues.de

teNeues Digital Media GmbH
Kohlfurter Straße 41-43, 10999 Berlin, Germany
Phone: +49 (0)30 700 77 65 0

teNeues Publishing Company
7 West 18th Street, New York, NY 10011, USA
Phone: +1 212 627 9090, Fax: +1 212 627 9511

teNeues Publishing UK Ltd.
21 Marlowe Court, Lymer Avenue, London SE19 1LP, UK
Phone: +44 (0)20 8670 7522, Fax: +44-(0)20 8670 7523

teNeues France S.A.R.L.
39, rue des Billets, 18250 Henrichemont, France
Phone: +33 (0)2 4826 9348, Fax: +33 (0)1 7072 3482

www.teneues.com

© 2012 teNeues Verlag GmbH + Co. KG, Kempen

ISBN: 978-3-8327-9613-6
Library of Congress Control Number: 2011944670

Printed in the Czech Republic.

Bibliographic information published by the Deutsche
Nationalbibliothek.

The Deutsche Nationalbibliothek lists this publication in the
Deutsche Nationalbibliografie; detailed bibliographic data are
available in the Internet at http://dnb.d-nb.de.